Praise for

A THEATER CRIT
ARTS JOURNALISM PRIMER

"Bob Abelman and Cheryl Kushner's accessible and information-rich primer is useful to beginners eager to develop their critical voices. It's also worthwhile to those of us who have been practicing criticism for years but need to recall the basics: Why we write criticism, how to do it well, and why it matters."

—David Cote, theater editor and chief drama critic, *Time Out New York*

"*A Theater Criticism/Arts Journalism Primer* provides an element-by-element analysis of what goes into constructing an artful, journalistically sound review. The book's insights into how critics prepare and then react to a work of art are valid and valuable. The authors also acknowledge that the best criticism, like the work it analyzes, requires creativity."

—Christine Dolen, theater critic, *The Miami Herald*

"The authors' passion and obsession are what make this book invaluable."

—Sasha Anawalt, director, Arts Journalism Programs, University of Southern California Annenberg School for Communication & Journalism

"The art and practice of criticism are undergoing fundamental change. Before we figure out where it's going we have to understand what it's been and how it's been done. *A Theater Criticism/Arts Journalism Primer* is a valuable and compelling place from which to start."

—Douglas McLennan, editor, ArtsJournal.com

"Bob Abelman and Cheryl Kushner have delivered a book of remarkable clarity, a detailed survey and breakdown of critic-craft that's granular without ever getting grainy. Even if we end up living in that much-feared near-future where 'Everyone's a Critic,' *A Theater Criticism/Arts Journalism Primer* will be required reading for every drive-by Twitterer and citizen-kvetcher."

—Scott Brown, theater critic, *New York Magazine*

"I can only hope that both critics and artists take the time to truly digest the insightful information in this book—to more fully understand not only where the ideals of criticism come from, but where critics fit in today's theatrical ecosystem."

—Eric Coble, playwright (*Bright Ideas, The Velocity of Autumn*)

A THEATER CRITICISM/ ARTS JOURNALISM PRIMER

This book is part of the Peter Lang Media and Communication list.
Every volume is peer reviewed and meets
the highest quality standards for content and production.

PETER LANG
New York • Washington, D.C./Baltimore • Bern
Frankfurt • Berlin • Brussels • Vienna • Oxford

BOB ABELMAN & CHERYL KUSHNER

A THEATER CRITICISM/ ARTS JOURNALISM PRIMER

Refereeing the Muses

PETER LANG
New York • Washington, D.C./Baltimore • Bern
Frankfurt • Berlin • Brussels • Vienna • Oxford

Library of Congress Cataloging-in-Publication Data

Abelman, Robert.
A theater criticism/arts journalism primer: refereeing the muses /
Bob Abelman, Cheryl Kushner.
pages cm
Includes bibliographical references and index.
1. Art criticism. I. Kushner, Cheryl. II. Title.
NX640.A24 700.1—dc23 2013007657
ISBN 978-1-4331-1550-9 (hardcover)
ISBN 978-1-4331-1549-3 (paperback)
ISBN 978-1-4539-1108-2 (e-book)

Bibliographic information published by **Die Deutsche Nationalbibliothek**.
Die Deutsche Nationalbibliothek lists this publication in the "Deutsche
Nationalbibliografie"; detailed bibliographic data is available
on the Internet at http://dnb.d-nb.de/.

© 2013 Peter Lang Publishing, Inc., New York
29 Broadway, 18th floor, New York, NY 10006
www.peterlang.com

Printed in the United States of America

Table of Contents

List of "In Profiles"

Preface

*"I would especially like to recourt the Muse of poetry, who
ran off with the mailman four years ago, and drops me
only a scribbled postcard from time to time."*

~John Updike, author[1]

The sub-title chosen for this book is *Refereeing the Muses*. It seemed a fitting
description for what it is that professional arts critics do and what, after completing your reading of this book, you are likely to be doing as well.

In ancient Greece, where many of the arts were conceived or refined, poets
validated their work by claiming it was inspired by the muses—the goddesses who
presided over all of the arts and all the sciences. Socrates (469–399 B.C.E.), one
of the founders of Western philosophy, reasoned that poetry is created when the
gods remove from the poet of choice all human senses and replace them with divine
inspiration. Indeed, the word "inspiration" is akin to "respiration" and means to be
divinely filled with breath.

The muses[2] were daughters of Zeus, the ruler of the Olympian gods, and Mnemosyne, the goddess of memory. They include: Calliope (muse of epic poetry); Clio (muse of history); Erato (muse of love poetry); Euterpe (muse of music); Melpomene (muse of tragedy); Polymnia (muse of sacred poetry); Terpsichore (muse of dance); Thalia (muse of comedy); and Urania (muse of astronomy). It is the faces of Thalia and Melpomene that are believed to have inspired the paired masks of comedy and tragedy that have come to represent the theater arts.

The muses were benign, helpful beings, who—according to legend—approached a deserving poet and, after removing all human senses, conferred on him three gifts: a laurel branch to use as a sceptre, which was a sign of authority; knowledge of the future and the past with which to generate insightful and inspirational verse; and a wondrous voice with which to share this verse. The muses were the equivalent of ancient Greek Guggenheim grants.[3]

Testimonials to their perceived influence on the arts can be found throughout history. Near the end of the 8th century B.C.E., Homer invoked the muses in the first words of Book 1 of the *Odyssey*, the West's first great work of literary art: "Sing to me of the man, Muse, of twists and turns driven time and again off course." The lyric poet Pindar, in the 5th century B.C.E., referred to himself as the prophet and herald of the muses, who has special knowledge which sets him apart from other men.[4] At the outset of his *Metamporphoses*, the Roman poet Ovid greedily embraced not one muse, but all nine, as his inspiration. Virgil, in his late-first century B.C.E. epic, the *Aeneid*, did the same. In the second canto of Dante Alighieri's *Divine Comedy*, completed in the early 14th century, he calls out: "O Muses, O high genius, aid me now."[5] Milton, Shakespeare, and Chaucer have all, in their works, specifically beseeched the muses for their favor and credited them for their successes, as have many others.

Over time, the nature of the muses and the avenue of their divine inspiration have gone through changes. For some, the pagan nine were replaced with the Holy Trinity of the Father, Son, and the Holy Ghost for divine artistic inspiration. This is most clearly reflected in Christian art throughout the Byzantine Empire around the 4th to 6th centuries, in the Gothic architecture and sculpture in the 10th and 11th centuries, and among Flemish artists of the 14th and 15th centuries.

During the 15th and 16th centuries, Italian Renaissance painters such as Raphael favored a more earth-bound form of muse-worship that has retained much of its popularity in the modern era: attractive flesh and blood women. The model for two of Raphael's most famous Madonnas and the confessed source of his inspiration was not Mary, but a Sienese baker's daughter named Margharita di Luti.

At the turn of the 20th century, psychologist Sigmund Freud demystified artistic inspiration by claiming to have actually located the source of all inspiration

in the inner psyche of the artist. He noted that inspiration came from unresolved psychological conflict and, particularly, from childhood trauma. Freud's contemporary, Carl Gustav Jung, suggested that artists are particularly attuned to genetic memory and, through dreams, acquaint themselves with and are inspired by the unconscious. Poet Samuel Taylor Coleridge, author Robert Louis Stevenson, and musician Paul McCartney have each credited an ambiguous, sleep-induced unconsciousness for helping them conceive the ideas for *Kubla Khan*, *Dr. Jekyll and Mr. Hyde*, and the entire melody for *Yesterday* (the most covered Beatles song in their entire catalog), respectively.[6]

"Poets have stopped invoking the spiritual muses," suggested contemporary journalist Lee Siegel, "eventually turning instead to caffeine, alcohol, and amphetamines."[7] More specifically, in the 1960s, hallucinogens inspired the psychedelic art movement, led by artists Peter Max, Pablo Amaringo, Mati Klarwein, Rick Griffin, and others.[8] Rock groups such as the Doors, Jefferson Airplane, and the Jimi Hendrix Experience, inspired by chemical muses, popularized the notion of a psychedelic consciousness through the sounds and lyrics of their music and, as a visual phenomenon, through their advertising, album cover art, and on-stage theatrics.

It was also at this time that, in the United States at least, the muses became federalized. Throughout history, other developed nations routinely devoted large portions of their gross national products on cultural endeavors. The French and Austrian monarchies, for example, generously patronized the arts for centuries. The United States shied away from such action until the establishment of the National Endowment for the Arts (NEA) in 1965, when the federal government became a significant patron of the arts.[9] The NEA funds dance, design, folk and traditional arts, literature, local arts agencies, media arts, multidisciplinary, museums, music, musical theater, opera, theater, and the visual arts. The muses became money managers and, in the eyes of skeptics and fiscal conservatives, sugar daddies.

In February 2011, the U.S. House of Representatives approved by a close vote of 217–209 Rep. Tim Walberg's amendment to cut an additional $20.5 million from the already reduced budget of the NEA.[10] The NEA has not seen this kind of deep cut in 16 years. Also on the table was the complete elimination of funding for the NEA ($167.5 million), the National Endowment for the Humanities ($167.5 million), and the Public Broadcast System ($445 million), which GOP Presidential candidate Mitt Romney swore he would put into effect if elected.[11] In response to the budget cuts, on April 4, 2011, Arts Advocacy Day was declared in Washington, D.C. and Emmy Award-winning actor Kevin Spacey, who serves as artistic director of the Old Vic Theatre in London, gave an impassioned keynote lecture at the Kennedy Center in defense of the arts and the federal funding of them.[12] Spacey outlined how all great nations have valued public funding of the arts and how leaders of all

political parties have championed that effort in the past, particularly during difficult financial times. Winston Churchill, noted Spacey, responded to the recommendation to cut funding for the arts during the Second World War by asking "what are we fighting for?"

No matter what form the muses take—nine goddesses, the Holy Trinity, unresolved conflict, dream-stalkers, hallucinogens, federal grants, Kennedy, Churchill, or Spacey—arts critics have long held the responsibility of experiencing, contemplating, and evaluating the outcome of their handiwork. And no matter the art—poetry, literature, painting, music, film, television program, or videogame—arts criticism has been instrumental in influencing its form, function, and consumption.

As referees of the muses, arts critics are on the front line of the arts themselves. Their writing and commentary facilitates exposure to the arts. Their insight shares and spreads art appreciation and education. Their passion and perspective fosters arts advocacy and, thus, bolsters the efforts of the muses. And, by effectively and judiciously serving as the referees of the muses, critics have—upon occasion—taken on the function of the muses themselves by guiding and inspiring artists and helping shape the arts. This book examines the skill set associated with being a critic, explores the history, evolution, and future of the profession in the United States, and dissects the preparation, observation, and writing process associated with generating thoughtful and interesting arts criticism. It is written to offer insight and useful information for those casual critics thinking about starting a blog or looking to become more thoughtful, critical consumers of the arts, those university newspaper arts writers and editors hoping to improve their craft, or aspiring critics hoping to work for *The New York Times*, Broadway.com, or their hometown newspaper.

The title of this book suggests that it is an arts journalism primer, but with a focus on theater criticism. Indeed, this book is written with the hope that those with a background or interest in any of the performing, visual, or fine arts will find that much of the information is pertinent to their particular pursuits and passions as critics. After all, the act of criticism is, itself, an enterprise that is applicable to all the arts and whose roots are as old as the arts themselves. In addition, all artistic work employs creativity, imagination, aesthetics, and artisanship in its effort to effectively engage an audience. All works of art integrate our emotions with our intelligence and use the human spirit as its springboard. All works of art reflect or refract the human condition and call upon consumers to bring their own life experiences to the table when interpreting a work.

Most of the chapters of the book are applicable to all arts journalism and tend to use theater as the best example. However, even those that concentrate specifically on the performing arts—that is, Chapters 5 and 6 (which explore the evolution

of theater criticism), as well as Chapters 7 and 8 (which examine the storytelling conventions and stage crafters of theater)—reveal much about the arts in general.

It could also be argued that, as a particularly collaborative and inclusive enterprise, theater embraces and incorporates the full spectrum of the arts. Its reliance on the written and spoken word, as contributed by a playwright and delivered by performers, entails an understanding and appreciation of the art of oral storytelling. Dance, as depicted in stage movement and choreography, is instrumental in all theatrical performances. The visual arts come into play with the creation of time, place, and temperament in the form of scenic design, costume design, and lighting design. Music and sound are also instrumental in theater, whether used for ambience, segue, or as an integral narrative device. Technological innovation has always been embraced by theater as well. In short, many art forms are employed under the auspices of theater and are considered during the engagement of critical analysis. There are, after all, nine muses who are related to one another. This book hopes to shed light on most of them.

NOTES

1 Cited in Lewis Nicholsipswich, "Talk With John Updike," *The New York Times*, April 7, 1968, BR34, http://select.nytimes.com/gst/abstract.html?res=F10D17FD385913748DDDAE0894D C405B888AF1D3 (accessed December 23, 2010).

2 The image of the muses that appears in the Preface is *The Dance of Apollo with the Muses*, by Italian painter and architect Baldassare Tommaso Peruzzi, early 1500s.

3 Accredited to Lee Siegel, "Where Have All the Muses Gone?" *The Wall Street Journal*, May 16, 2009, http://online.wsj.com/article/SB124242927020125473.html (accessed on December 23, 2010).

4 Cited in Penelope Murray and T.S. Dorsch, *Classical Literary Criticism* (New York: Penguin Putnam, Inc., 2000), iv.

5 Ibid.

6 Cited in http://www.thejanuarist.com/dreams-and-the-origin-of-artistic-inspiration/ (accessed December 23, 2010).

7 Siegel, "Where Have All the Muses Gone?" W3.

8 See Doris Lanier, *Absinthe—The Cocaine of the 19th Century: A History of the Hallucinogenic Drug and its Effect on Arts and Writers in Europe and the United States* (Jefferson, NC: McFarland Press, 1995); David S. Rubin, *Psychedelic: Optical and Visionary Art Since the 1960s* (Cambridge, MA: MIT Press, 2010); Robert E.L. Masters and Jean Houston, *Psychedelic Art* (New York: Grove Press, Inc., 1968).

9 See Donna M. Binkiewicz, *Federalizing The Muse: United States Art Policy and The National Endowment For The Arts 1965–1980* (Chapel Hill, NC: University of North Carolina Press, 2004).

10 In 1995, Congress cut budget allocations for the National Endowment for the Arts and slashed funding for individual artists.

11 In the spending bill that was approved in December 2011, The National Endowment for the Arts and National Endowment for the Humanities each saw a 5.6% budget reduction for fiscal 2012. Under the bill, each agency had $146.3 million to spend, down from $155 million. Each agency began 2011 with budgets of $167.5 million. As of 2012, the combined cuts total 12.7%. Cited in http://latimesblogs.latimes.com/culturemonster/2011/12/federal-budget-arts-spending-nea-neh-smithsonian.html

12 See http://www.youtube.com/watch?v=SmrJ7OHdlkk&feature=share

Acknowledgments

The authors would like to thank the following arts journalists, playwrights, artistic directors, directors, music directors, choreographers, scenic designers, actors, publicists and students, whose valuable insights into their enterprise and kind assistance made a significant contribution to this endeavor: Peter Marks, Jacqi Loewy, Vicky Bussert, Rajiv Joseph, Eric Coble, Tom Jacobson, Hilton Als, Carol Pribble, Lisa Craig, Christine Dolen, Kerry Lengel, Julie Kistler, Jay Handelman, Betsey Maupin, Damon Chua, Donald Jordan, Eric van Baars, Oliver Mayer, Seth Gordon, Patrick Dooley, Nick A. Olivero, Neil LaBute, Mark Jackson, Charlie Fee, Fabio Polanco, David Anthony Smith, Jonathan Cerullo, Tracee Patterson, Jeanne Beechwood, Stuart Bousel, Jessica Ryan, Jon Bastian, Che'Rae Adams, Patrick Seitz, Ava Roy, Mark Wilson, Sheila Callaghan, Tim Dang, Adria Dawn, Oliver Mayer, Jeff Revels, Jen Maisel, Matthew Wright, Sidonie Garrett, Josh Rhett Noble, Celeste Cosentino, Jodi Dominick, Fred Sternfeld, Dorothy Silver, Cameo Ibsen, Risa Brainin, Martin Friedman, Martín Céspedes, TJ Jozsa, Clyde Simon, Benjamin Rexroad, John H. Binkley, Derdriu Ring, Bebe Weinberg Katz, Leonard Jacobs, Leonard Conolly, Larry Laneer, Robert Waddell, Lindsey Christians, Nicole Gluckstern, Angie Fiedler Sutton, Mayank Keshaviah, Misha Berson, Thomas Sudik, Amanda Bura, Lillshell Gray, Kayleigh Joyce, and Mollie Ames.

Permissions

Cover art is *La promenade du Critique influent* (*The Promenade of the Influential Critic*), by French lithographer Honoré Daumier from *Le Charivari* magazine, June 24, 1865. It is reprinted with permission by the Bridgeman Art Library.

Photography for the Preface title page is reprinted with permission by the Bridgeman Art Library.

Photography for the Chapter 1 title page courtesy of Matt Lambros Photography and is used by permission.

Photography for the Chapter 2 title page courtesy of Karen Messerman Photography and is used by permission.

Photography for the Chapter 3 title page courtesy of Karen Messerman Photography and is used by permission.

Photography for the Chapter 4 title page courtesy of Karen Messerman Photography and is used by permission.

Photograph of the *Saturday Press* appearing in Chapter 5 courtesy of Ed Whitley at Lehigh University. The image originated from microfilm at Emory University and the original work stored at the Historical Society of Pennsylvania, and is used by permission.

Headshot photography for the Chapter 6 title page used by permission of the subjects and the New York Drama Critics' Circle. Michael Feingold's photo courtesy of photographer Stephen Paley. Terry Teachout's photo courtesy of photographer Ken Howard.

Illustration for the Chapter 7 title page courtesy of Chris Morris/Cleveland *Plain Dealer* and is used by permission.

Photography for the Chapter 8 title page courtesy of Jeffrey Fauver, Communications Director of Steppenwolf Theatre Company. Photo by Joel Moorman and is used by permission.

Photography for the Chapter 9 title page courtesy of AJ Abelman Photography and is used by permission.

Photography for the Chapter 10 title page courtesy of AJ Abelman Photography and is used by permission.

Photography for the Chapter 11 title page courtesy of the Arena Stage/Goodman Theatre and is used by permission.

Promotional photograph of the George Street Playhouse/Cleveland Play House production of *Red* was taken by T. Charles Erickson and reprinted with permission. The actors are Bob Ari and Randy Harrison.

Promotional photograph of the Arena Stage/Goodman Theatre production of *Red* was taken by Liz Lauren and reprinted with permission. The actors are Edward Gero and Patrick Andrews.

"What Kind of Man," written by John Kander and Fred Ebb. Used by permission of Bro 'N Sis Music, Inc. Reprinted by permission.

Excerpts from *Word Savvy: Use the Right Word Every Times, All the Time* Copyright © 2011 Nancy Ragno. All rights reserved. Reprinted by permission.

"Ensnaring Theatre Critics in the Spider-Man Web," *The Huffington Post*, January 14, 2011, http://www.huffingtonpost.com/leonard-jacobs/ensnaring-theatre-critics_b_806101.html. Used by permission of the author.

"Who Doth Inhabit the Primary Position" Copyright © 2011 David Foubert, Jason King Jones, and Jay Leibowitz. All rights reserved. Reprinted by permission of Playscripts, Inc.

David Cote, "Critical Juncture," *American Theatre Magazine*, November 2011, 32 (Don Aucoin, Misha Berson, Christine Dolen), 34 (Peter Marks). Used by permission of Theatre Communications Group.

Peter Marks, "The Hues Blend Evocatively in Arena Stage's *Red*," *The Washington Post*, January 20, 2012, http://www.washingtonpost.com/gog/performing-arts/red,1212400/critic-review.html#reviewNum1. Used by permission of PARS International Corp.

Bob Abelman, "CPH's 'Red' Paints a Vivid Treatise on Art Creation, Appreciation," *The News-Herald*, March 23, 2012, http://www.news-herald.com/articles/2012/03/23/life/ doc4f-6cb52861c65784310313.txt?viewmode=fullstory. Used by permission of *The News-Herald*.

Hilton Als, "Color Vision," *New Yorker*, November 8, 2010, 42-44. Used by permission of the author.

Information related to Arena Stage at the Mead Center for American Theater's production and promotion of John Logan's *Red* is used by permission of Arena Stage.

Leonard Conolly, "Shaw as Critic," from http://www.post-gazette.com/pg/06201/707270-325.stm#ixzz1MeHbevId, based on Leonard Conolly's paper for the American Theater Critics Association meeting June 15, 2006. Used by permission of the author.

Chapter 11 quotes by Peter Marks, chief theater critic of *The Washington Post*, used by permission of the author.

Jason Robert Brown, "How I Insulted Sondheim (and the Wisdom Received Thereby)," posted October 31, 2012, http://jasonrobertbrown.com/2012/10/31/how-i-insulted-sondheim-and-the-wisdom-received-thereby/. Used by permission of the author.

"While we're engaged in making or attending theater, or any of the arts for that matter, we are not engaged in war, persecution, crime, wife-beating, drinking, pornography, or any of the social or personal vices we could be engaged in instead. For this reason alone, the more time and energy we as a society devote to theater and the arts, the better off we will be."

~Howard Shalwitz, artistic director, Woolly Mammoth Theatre Company[1]

Chapter 1 Abstract

A variety of obstacles have arisen in the recent past that has relegated theater and other performing arts to the periphery of popular awareness, interest, and consumption. This chapter identifies and describes the most significant obstacles and examines how arts critics can counter their impact by instigating discussion, inspiring consumption, facilitating analysis, and placing the arts center-most in public discourse.

The Arts at Arm's Length

Western theater has been around for approximately 2,500 years. In fact, Aristotle gives us the date of 534 B.C.E. to mark when Thespis stepped out of the Dithyrambic chorus to impersonate the god Dionysus and simultaneously invent theater (formerly ritual), dialogue (formerly monologue), and character (formerly caricature). Although there is no extant proof as to the accuracy of this tale, we know that by the 5th century B.C.E. the theater was a fully developed entity at the center of Greek thought and identity and has remained a constant in Western culture.

Given theater's impressive pedigree, it could be assumed that the performing arts—and the visual and literary arts—are at the forefront of our modern-day enterprise. It could also be assumed that contemporary audiences have developed the desire and skills necessary to understand, respond to, and appreciate the arts aesthetically, historically, and critically.

Such is not the case.

In fact, do contemporary audiences even recognize the name "Thespis," know about the Dithyrambic chorus, or understand what any of the Greek gods have to do with the origins of theater? Probably not. More to the point, do contemporary audiences understand why today's theater is what it is, does what it does, and manages to be as effective and impactful an art form as it has the potential to be? Not so much.

Theater is certainly a part of our cultural landscape but, like so many of the fine and performing arts, remains in the far distance. Contemporary audiences do not flock to the theater as their first choice for entertainment, social commentary, and introspection. Many of us are not even familiar or comfortable with this mode of storytelling, despite its presence in our schools and local communities, and its prevalence in our cities. Others may enjoy the experience of live theater but may not necessarily be equipped to articulate why they do or understand all that goes into the creation of that experience.

> *"In less than a hundred years, theater has gone from being the dominant popular mass medium to something on the margins. Even Broadway is at the margins of culture. It may make a billion dollars in ticket sales and attract 12 million people to theaters, and have plenty of big-name stars, but it is not central to culture."*
>
> ~Jeffrey Eric Jenkins, head of the Department of Theatre, The University of Illinois[2]

Keeping the Arts at Arm's Length

A variety of obstacles have arisen in the recent past that has relegated the theater and other performing and visual arts to the periphery of popular awareness, interest, and consumption, particularly for the current generation of potential patrons. They include:

The Demise of Vaudeville

Previous generations grew up with theater and other forms of staged presentation as a primary form of entertainment. In the larger U.S. cities in the late-1800s and into the early-1900s, opera, ballet, dramatic theatrical performances, and the early forms of musical theater were readily available for those who could afford it. For others, musical revues, the variety shows of vaudeville[3] and the more risqué burlesque, and various forms of ethic entertainment—such as Yiddish theater in New York[4] and the German theater of Chicago—were bountiful. Before television, before radio, and before the golden age of motion pictures, theater was what people did for entertainment. The novelty and the grandeur of the motion picture and the omnipresence and in-home accessibility of broadcasting killed off many forms of theater, or severely marginalized them and other arts, by stealing their audiences and, in many cases, stealing their talent, their form, and their content.[5]

More recently, audiences have been given access to a wide variety of entertainment options through an increasing array of personal and social media. Add to the equation the economic woes that have faced this country over the past few years and it is little wonder that more than half of all theaters across the U.S. operated in the red in 2008 and 2009, with total attendance falling 7% over the last 10 years.[6] Even attendance on Broadway has faltered,[7] although blockbuster musicals targeting families and tourists[8] such as *Wicked*, *The Lion King*, and *The Book of Mormon* helped Broadway to an increase in gross revenues for 2010, 2011, and 2012.[9] Consequently,

fewer artistic risks are being taken on the professional stage.[10] With each passing generation, attending an arts event has become less and less a part of our cultural DNA.

Theater Has Been Relegated to High Culture Status

As a result of this marginalization, many perceive theater to be too high culture for the average American—that is, it is seen as an elite art that is sophisticated, an acquired taste, and prohibitively expensive. The elite art of high culture is thought to be unique, technically and thematically complex, produced by an identifiable artist of stature and personal vision, and in limited supply.[11] Elite art is prized for its exclusiveness, is often created for art's sake, and is inspired by passion, conviction, and emotional duress. Its exclusiveness tends to justify the high cost to experience elite art. Classical music, the opera, and the ballet are examples of performing arts traditionally relegated to high culture.

Unlike the elite arts of high culture, the arts of popular culture strive to be familiar, common, and conventional, and are typically produced by unknown and unrenowned artists for commercial distribution and consumption on a large scale. It is often created for profit and, as such, is devalued by the very nature of its popularity. Commercial broadcast television programming is the quintessence of popular art. Its content is purposefully manufactured and packaged to be attractive to a massive, heterogeneous audience so as to deliver them to advertisers. Indeed, the very success of a television program depends on its ability to attract, be accessible to, and sustain as massive an audience as possible, and success often breeds repetition. Popular art typically spawns other art in its image, such as television's tendency for spinoffs and franchise programs such as *CSI*, *CSI: Miami*, and *CSI: New York*.

..

"The triumph of the episodic series over anthology drama seems logical. Series, which tend to reuse the same sets, stars and production schedules, invite the economics of industrial production."
~David Marc and Robert J. Thompson, authors of *Prime Time, Prime Movers*[12]

..

Clearly, theater shares many attributes of elite art. It can be unique and technically and thematically complex. It is often produced by an identifiable artist of stature and personal vision who is inspired by passion, conviction, and emotional duress. Some theater, such as a Broadway musical, can be expensive. However, theater is not intentionally elitist or inaccessible. In fact, during television's formative years, theater was as much a part of popular culture as were quiz shows and situ-

ation comedies. Live anthology programs, offering a different, original hour-long play each week, peppered the airwaves in the late-1940s and early-1950s as the young medium attempted to find its audience.[13] The *Philco/Goodyear Television Playhouse* on NBC was one of the most distinguished and attracted young playwrights including Paddy Chayefsky, Horton Foote, and Gore Vidal as well as established actors from the New York stage. NBC's *Kraft Television Theater* and CBS's *Studio One* were also immensely popular programs.

During this same era, commercial television tried to embrace more traditional elite arts, but the results were disappointing and reinforced the clash between these modes of cultural expression. In the mid-1950s, Ed Sullivan made a deal with the Metropolitan Opera[14] to devote 18 minutes to each of five different operas on separate weeks of his popular Sunday evening TV variety show. The first, November 26, 1956, featured *Tosca* and the TV debut of singer Maria Callas and cost *The Ed Sullivan Show* (CBS) six ratings points. The second week featured Dorothy Kirstin in *Madame Butterfly* and single-handedly knocked the program out of first place in its time period. By the third Sunday, *La Boheme* was cut down to a four-minute duet and the program went back to featuring fire eaters, contemporary musicians, and stand-up comics.

Theater faded from television when the film industry started making episodic programs for television in the mid-1950s, complete with the production values and visual aesthetics that Hollywood was known for. The Tony Awards ceremony, which has been nationally broadcast since 1967, is, perhaps, theater's last remaining venture into the popular culture of prime-time television programming. However, even this annual Sunday night homage to Broadway theater has been losing its audience.[15] In 2010, for example, the *64th Annual Tony Awards'* average viewership was 7 million people, down 6% from the previous year and the latest example of a steadily downward trend. The viewership of those 18 to 49 years of age was down 8%. This live CBS broadcast did manage to beat in the ratings a repeat of *Losing It With Jillian*—an NBC fitness reality show at 9 p.m.—and tie a repeat of the NBC talent show *Last Comic Standing* at 10 p.m. Still, it was consistently beaten by Fox's schedule of repeats of animated programs, including *The Simpsons, The Cleveland Show, Family Guy,* and *American Dad,* as well as the fifth game of the seven-game *NBA Finals* on ABC. The 2011 broadcast brought in 6.9 million viewers and, in 2012, the audience dropped to just 6 million viewers. To put the numbers in perspective, the Academy Awards show on ABC drew an estimated 39.3 million viewers in 2012, up slightly from the previous year. Even that year's Academy of Country Music Awards, on CBS, attracted 13 million viewers.[16]

Theater's diminished representation on the technology that delivers and helps define popular culture has advanced its marginalization (see *The West Wing*, in profile) and its classification as elite art in the minds of many Americans.

The Broadway Musical

Broadway has long thrived on offering entertainment for the masses. Domestic and international tourists flood New York City each year and, for many, their first and potentially only experience with theater is the big Broadway musical.

According to Martin Gottfried, in his tome *Broadway Musicals*,[17] a Broadway musical isn't merely a musical that plays on Broadway:

> There is the Broadway sound, a Broadway look, a Broadway feel. This "Broadway" quality…is the rhythmic spiel of New York; it is the broad, basic, and gusty approach of a theater meant not for art but for public entertainment…. But historic as their conception was, and as much as we love them, there have not yet been any musicals to rank with the great classics of the dramatic literature. There are many beloved shows—even great ones—but they are not works of art.

Other theatrical offerings on the local or regional stage pale by comparison to the big budgeted, high production aesthetics of the Broadway musical. And, recently, an increasing number of Broadway musicals have been drawing their inspiration from the realm of popular culture, including *Spider-Man: Turn off the Dark*, *The Addams Family*, *Shrek*, *Ghost*, *Legally Blonde*, *Mary Poppins*, and *Newsies*. The Broadway musical and national tours of the Broadway musical have become a performing arts paradox by single-handedly raising casual theater audiences' entertainment expectations while lowering their standards.

Art Is Demanding

Theater, like many of the arts, requires more from its audience than many other forms of entertainment. In particular, it requires a greater degree of suspension of disbelief—that is, the need to ignore the fact that one is watching something artificial and temporarily accept it as reality in order to be entertained.

In a film, for example, if there is a scene requiring the Alps, it is usually expected that the cast and crew will be sent to the Alps or that a carefully crafted soundstage with a digitally created environment will mimic the location to such an extent that it can be taken for the real thing. The same can be said for historical and purely fictive locations. Although the film image is two-dimensional, when facilitated by a large screen with wide dimensions, Technicolor, and Surround Sound, the audience quickly forgets its actual physical circumstances and is easily transported into the world of film. The popularity of 3-D films facilitates this even more.

The West Wing, in profile

Airing from 1999–2006, NBC's *The West Wing* was a multi-award-winning hour-long political TV drama series. Created by Aaron Sorkin, the series was largely set during the administration of fictitious U.S. president Josiah "Jed" Bartlet, a liberal Democrat and a devout Catholic from New Hampshire.

During the program's third season, the President is up for reelection. In episode #322, "Posse Comitatus," directed by Alex Graves, the President ponders a life-and-death situation during a Catholic charity benefit performance of a Shakespeare play about another conflicted leader, Henry VI. At the performance, Bartlet encounters his Republican rival, Governor Robert Ritchie. In these two excerpts from the original script,[18] theater is recognized as a cultural divide in the United States; one that separates the educated President and his home-grown rival.

CUT TO: INT. BROADWAY THEATER—NIGHT

The stage lights are dim as a man speaks.

MAN: Hung be the heavens with black, yield day and night.

The audience applauds as the trumpets play, marking the start of the Shakespeare Company play. The curtain rises for the first scene. The stage actors, all in period clothing, stay frozen, as a man center stage raises his sword and starts his monologue. While he does, the camera pans up to the theater balconies, passes by the President, and into the rearmost, where Sam (Deputy Communications Director) walks up and pokes Toby (Communications Director) on the shoulder.

MAN: Comets, importing changes of time and states, brandish your crystal tresses in the sky, and with them scourge the bad revolting stars that have consented unto Henry's death. King Henry the fifth, too famous to live long, virtue he had, deserving to command. He ne'er lift up his hand, but conquered.

In the back balcony, Toby stands and follows Sam outside.

CUT TO: INT. THEATER HALLWAY—CONTINUOUS

Sam and Toby walk down a small flight of stairs into a well-decorated hallway.

SAM: He went to the Yankee game.

TOBY: Ritchie?

SAM: Yes.

TOBY: He's at the Yankee game right now?

SAM: Local news covered it. He said this was how ordinary Americans got their entertainment.

TOBY: I've been to 441 baseball games in Yankee Stadium. There's not a single person there who's ordinary.

CUT TO: INT. THEATER MESS—NIGHT

Bartlet walks down a flight of stairs, past the men's bathroom. A shadow of a man is cast on the bathroom door, while the man washes his hands. Bartlet lights his cigarette in the mess. A female employee spots him.

BARTLET: [smiling] Caught me.

Behind Bartlet, Governor Robert Ritchie exits the bathroom. Ritchie sees the President and approaches.

RITCHIE: Mr. President.

BARTLET: Governor.

RITCHIE: You enjoying the play?

BARTLET: I am. How about you?

RITCHIE: We just got here. We were at the Yankee game. We were, you know, hung up in traffic.

BARTLET: Yeah, I know. Listen, politics aside, and I don't want to make a big deal out of it, but you probably insulted the church, and you can head it off at the pass if you speak to the Cardinal tonight.

RITCHIE: Well, I didn't mean to insult anybody.

BARTLET: No.

RITCHIE: And it's a baseball game. It's how ordinary Americans...

BARTLET: Yeah. [beat] No, I don't understand that. The center fielder for the Yankees is an accomplished classical guitarist. People who like baseball can't like books?

The theatrical experience, by comparison, is usually fraught with artificiality, which regularly reminds the audience that they *are* an audience viewing a fictive work full of artifice and illusion. Even the best designed and professionally executed theatrical settings can rarely, if ever, achieve realism. It is more likely that those Alps will be represented by a dramatically stylized representation.

A transition from one scene to the next in a film is a seamless edit. A theatrical audience will more than likely witness the transformation process on stage or be subjected to blackouts while it hears and sees the actors and stagehands wrestle with unwieldy set pieces.

In film, the camera allows the actor to convey thought and emotion in exquisite nuance. The actor in film can experience an idea, emotion, or other activity and the camera captures that experience without the actor necessarily having to think about a means for its delivery to an audience. Twentieth century actor training facilitated the metamorphosis of performance for the camera, including the method acting developed by Constantin Stanislavski and Lee Strasberg. These approaches eschew any semblance of "performance" and, through various exercises such as "sense memory," "emotional memory," and "public solitude," advocate that the actor actually experience the emotions and given circumstances of the character rather than portray them.

The exigencies of the theatrical experience require a different technique which can sometimes seem archaic or disconcerting to an audience whose primary exposure to acting is for film or television. Generally speaking, the proximity of the audience to the stage requires an actor to make bigger choices and to take a more active role in the conveyance of character. At the most basic level, a stage actor must project lines in order to be heard and utilize physical movement to be seen even in the most intimate theatrical settings. Without the camera to manipulate where the audience focuses, the actor must do so with voice, expression, and movement, and do so broadly.

In film, the audience is generally asked to be a passive receiver who allows the medium and its investment of time, talent, and budget to convey the reality of the event. The theater presents a multitude of obstacles to the audience's belief, and asks its audience to dismiss the artifice and accept as real what is clearly fabrication. The theatrical presentation is harder for a theater audience than a film audience. The film largely operates in the actual, while the theater operates in the illusive. Film conveys its environment by showing, while theater conveys it by inferring. Film requires us to give in to it; theater requires us to participate with it. Not everyone is willing or equally capable of doing so.

The State of the Arts in Academia

When colleges and universities are faced with budget cuts, it is usually the arts that are earmarked. The year 2009 is a perfect case in point where the nation's economic woes severely impacted budgets at state institutions.[19] At Washington State University, for example, the department of theater arts and dance was eliminated. At Florida State University, the undergraduate program in art education and two graduate theater programs were phased out. The University of Arizona cut three-quarters of its funds, more than $500,000, for visiting classical music, dance and theater perform-

ers. Wesleyan University's Center for the Arts, which supports four arts departments, lost 14% of its $1.2 million budget. The Louisiana State University's Museum of Art, one of the largest university-affiliated collections in the South, saw 20% of its state financing disappear. Similarly, many private institutions encountered larger classes and trimmed offerings in the arts in addition to higher tuition and fewer services.

The academy has increasingly mirrored a market-based model of measuring success in tangible productivity of goods and services. Most research institutions are supported in whole or in part by grants and other monies provided by private sector and government businesses that rely on academic laboratories for experimentation and innovation. The results of these initiatives are tangible and verifiable. How does one quantify the impact of music, theater, dance, philosophy, and other pursuits in the arts and humanities on the individual? On the community? On our culture? As colleges and universities become more allied with the profit goals of government and corporations, the esoteric pursuit of the arts is increasingly seen as intangible and, therefore, tangential to the primary business of education.

> *"If I had not been in a school music program, I would never have been elected president. Because it taught me discipline and order. It made me listen better. And once I got into jazz, I realized you had to make some things up along the way, but while you were making them up, you had to stay in the right key and still play in tune."*
> ~Former President Bill Clinton, keynote address at the Arkansas Arts Summit[20]

As a result, the traditional instrumental benefits of the arts—such as increased creativity, social skills, abstract thinking, confidence, and problem solving—have been relegated to secondary or extraneous outcomes for graduating students. So, too, have the more intrinsic benefits of the arts[21] that include:

- **Captivation.** The initial response of rapt absorption to a work of art can briefly but powerfully move us away from habitual, everyday reality and into a state of focused attention and captivation. This, in turn, can connect us more deeply to the world and open us to new ways of seeing and experiencing that world;
- **Pleasure.** The artist provides us with an imaginative experience that is often a more intense, revealing, and meaningful version of actual experience. This can produce pleasure in the sense of deep satisfaction, even for works of art the individual might find unsettling, disorienting, or tragic;

- **Expanded capacity for empathy.** The arts expand our capacity for empathy by drawing us into the experiences of people vastly different from ourselves and cultures vastly different from our own. These experiences give us new references that can make us more receptive to unfamiliar people, attitudes, and cultures;

- **Cognitive growth.** The intrinsic benefits described previously all have cognitive dimensions. When we focus our attention on a work of art, we are "invited" to make sense of what is before us. Because meanings are embedded in the experience rather than explicitly stated, we can gain an entirely new perspective on the world;

- **Creation of social bonds.** When people share the experience of works of art, either by discussing them or by communally experiencing them, one of the intrinsic benefits is the social bond—the connectedness—that is created; and

- **Expression of communal meanings.** Intrinsic benefits accrue to the public sphere when works of art convey what whole communities of people yearn to express. Examples of what can produce these benefits are art that commemorates events significant to a nation's history or a community's identity, art that celebrates individuals and their contributions within a community; art that provides a voice to communities the culture at large has ignored; and art that critiques the culture for the express purpose of changing people's views.

Instead of these instrumental and intrinsic benefits, students denied the opportunity to witness or engage in the arts as part of their higher education are less likely to perceive the importance of arts. This, in turn, impacts on their consumption and support of the arts, which has economic ramifications including: diminished direct benefits, where the arts are a source of employment, tax revenue, and spending within a community; diminished indirect benefits, where the arts attract individuals and

> *"Although the arts bestow important secondary benefits—economic, educational, social, and therapeutic—it is their intrinsic value that makes them essential and irreplaceable. The arts enhance, enlarge, and awaken our humanity in ways no other activities can equal. That is why the arts exist, and why we must support them."*
>
> ~Dana Gioia, chairperson,
> National Endowment for the Arts[22]

firms to locations where the arts are available; and the demise of a variety of "public-good" benefits, including having the arts available for the next generation and the contribution the arts make to a community's quality of life.

Summary

Critics can counter this negative trend. The etymological roots to the word *critic* are two-fold. *Critic* is believed to come from the Greek *kritikos*, which means "able to discuss," as well as the Greek *kritos*, which means "a judge." Indeed, the primary function and, perhaps, the greatest contribution of arts critics is to incite or instigate discussion by passing judgment, thereby inspiring consumption and placing the arts center-most in public discourse. To do this, however, critics must be skilled in evaluating the qualities or merits of a creative work. They must also be eloquent and interesting in their presentation of that judgment, for their thoughts are shared works and a valuable commodity. They are particularly valuable because they incite and instigate our own critical thinking about the arts.

When we all become critical thinkers about the arts we:

- recognize the arts as valuable enterprises worthy of our attention, support, and patronage;
- make independent and purposeful choices with regard to the selection of exhibitions of art to attend;
- develop the skills that allow us to make sense of and interpret the information we receive through artistic expression;
- generate a greater awareness of the potential impact of art on the individual, society, and culture;
- cultivate an enhanced enjoyment, understanding, and appreciation of the arts, allowing us to recognize the spark that makes an art combust rather than merely consume time and energy; and
- think outside the box regarding the activities that typically take place within the proscenium arch and gallery.

This affords us the insight and perspective required to recognize art in places beyond the proscenium arch and gallery—the boardroom, the picket line, and the political arena, for example—and consider its ramifications. Not everyone's a critic, but everyone can be. In light of faltering attendance and support of the arts, it could be argued that everyone should become one. This book provides the necessary information to do so, with the next chapter offering a viable argument for why this needs to be done sooner rather than later.

KEY CONCEPTS FROM THIS CHAPTER

Anthology series

Broadway musical as paradox

Burlesque

Critic

Direct economic benefits

Elite art

Ethnic theater

High culture

Indirect economic benefits

Instrumental benefits of the arts

Intrinsic benefits of the arts

Method acting

Popular culture

"Public good" economic benefits

Suspension of disbelief

Vaudeville

NOTES

1 Howard Shalwitz, "Seven Reasons Why Theatre Makes Our Life Better," *TheatreWashington*, October 27, 2011, http://theatrewashington.org/content/7-reasons-why-theatre-makes-our-lives-better (accessed January 27, 2012).

The image on the title page is of the dilapidated Variety Theatre, which opened on November 24, 1927 in the Jefferson neighborhood of Cleveland, Ohio. According to http://www.mlambrosphotography.com/abandoned-theaters, the 1,900 seat theater was built for vaudeville and motion pictures by Sam Stecker, Meyer Fine, and Abe Kramer of the Variety Amusement Company. It was designed in the Spanish gothic style by Cleveland-based architect Nicola Petti, who also designed the nearby Cedar Lee Theatre. The Variety building also included retail space and 12 apartments. A judge ordered the theater closed in 1986.

2 Cited in David Cote, "Critical Juncture," *American Theatre*, November 2011, http://www.tcg.org/publications/at/nov11/critical_juncture.cfm (accessed January 27, 2012).

3 Vaudeville consisted of variety shows that were popular in the U.S., Canada, and parts of Europe from the 1880s until the early 1930s. Performances were made up of unrelated acts grouped together on a common bill, and included dancers, animal acts, magicians, acrobats, jugglers, and one-act plays. Some shows toured the country by train, stopping in one location for a week or two before moving on.

4 In 1927, there were 24 Yiddish theaters across America, 11 of them in New York, four in Chicago, three in Philadelphia, and one each in Baltimore, Boston, Cleveland, Detroit, Los Angeles, Newark, and St. Louis. From http://www.jewish-theater.com/visitor/article_display.aspx?articleID=1411 (accessed November 13, 2010).

5 For a good explanation of how vaudeville inspired the TV sitcom, see Robert Abelman and David Atkin, *The Televiewing Audience: The Art and Science of Watching TV*, 2nd edition (New York: Peter Lang Publishing, 2010).

6 Zannie Giraud Voss and Glenn B. Voss, with Christopher Shuff and Ilana B. Rose, *A Report on Practices and Performance in the American Not-For-Profit Theater Based on the Annual TCG Fiscal Survey* (New York: Theater Communication Group, 2010), http://www.tcg.org/tools/facts/index.cfm (accessed August 23, 2010).

7 Patricia Cohen, "Broadway's Rough Road Ahead," *The New York Times*, November 5, 2008, http://query.nytimes.com/gst/fullpage.html?res=9400E3DC163DF936A35752C1A96E9C8B63&sec=&spon=&pagewanted=1 (accessed August 23, 2010).

8 According to The Broadway League's 15th annual demographics report, *The Demographics of the Broadway Audience 2011–2012* (http://www.broadwayleague.com/index.php?url_identifier=the-demographics-of-the-broadway-audience), tourists accounted for 63.4% of all Broadway tickets from 2011–2012.

9 Cited in http://www.reuters.com/article/2011/01/04/us-stage-broadway-idUSTRE7030CB20110104 (accessed May 16, 2012).

10 Eleanor Turney, "Will the Recession Mean Theater Takes Fewer Risks?" *The Guardian*, July 20, 2010, http://www.guardian.co.uk/stage/theaterblog/2010/jul/20/recession-theater-risks (accessed August 23, 2010). See, also, Brian Collins, "Broadway Review: 'Spider-Man: Turn Off the Dark'," http://www.badassdigest.com/2010/12/13/broadway-review-spider-man-turn-off-the-dark (accessed August 23, 2010).

11 Michael R. Real, *Mass Mediated Culture* (Englewood Cliffs, NJ: Prentice-Hall, 1976).

12 David Marc and Robert J. Thompson, *Prime Time, Prime Movers* (New York: Syracuse University Press, 1995), 129–130.

13 See Barbara Moore, Marvin R. Bensman, and Jim Van Dyke, *Prime-Time Television: A Concise History* (Westport, CT: Praeger, 2006).

14 Cited in John Leonard, *Smoke and Mirrors* (New York: New Press, 1977), 31.

15 Bill Gorman, "TV Ratings Sunday: NBC Finals Leap, *Tony Awards* Sag," *TV By The Numbers*, June 14, 2010, http://tvbythenumbers.com/2010/06/14/tv-ratings-sunday-nba-finals-leap-tony-awards-sag/53960 (accessed October 26, 2010).

16 David Ng, "Tony Awards 2012: Telecast, in Continued Decline, Slides Toward Lows," *The Los Angeles Times*, June 11, 2012, http://www.latimes.com/entertainment/arts/culture/la-et-cm-tony-awards-ratings-falls-to-lowest-level-in-more-than-20-years-20120611,0,6372406.story (accessed June 15, 2012). The 2013 telecast delivered a 20% rise in ratings.

17 Martin Gottfried, *Broadway Musicals* (New York: Harry N. Abrams, Inc., 1979), 6–7.

18 Original Airdate: May 22, 2002, 9:00 PM EST, http://www.twiztv.com/cgi-bin/transcript.cgi?episode=http://dmca.free.fr/scripts/thewestwing/season3/thewestwing-321.txt

19 See Patricia Cohen, "Arts Programs in Academia Are Forced to Nip Here, Adjust There," *The New York Times*, August 9, 2009, http://www.nytimes.com/2009/08/10/arts/10cuts.html?pagewanted=1&_r=1 (accessed August 24, 2010); Richard Morrison, "Fear That's Gripping Academia and the Arts," *The Sunday Times*, February 24, 2010, http://www.timesonline.co.uk/tol/comment/columnists/richard_morrison/ article7037829.ece (accessed August 24, 2010).

20 Andrew DeMillo, "Bill Clinton: Arts Programs Help Students Succeed," *Associated Press*, April 17, 2012, http://www.baxterbulletin.com/article/20120418/NEWS01/304180020/Bill-Clinton-Arts-programs-help-students-succeed (accessed April 17, 2012).

21 Cited in Kevin F. McCarthy, Elizabeth Heneghan Ondaatje, Laura Zakaras, and Arthur Brooks, *Gifts of the Muse: Reframing the Debate About the Benefits of the Arts* (Santa Monica, CA: Rand Corporation, 2004), http://www.rand.org/pubs/monographs/2005/RAND_MG218.pdf (accessed April 17, 2012).

22 Ibid.

"The theater is everywhere, from entertainment districts to the fringes, from the rituals of government to the ceremony of the courtroom, from the spectacle of the sporting arena to the theaters of war. Across these many forms stretches a theatrical continuum through which cultures both assert and question themselves."
~Jen Harvie and Dan Rebellato, theater educators[1]

Chapter 2 Abstract

Obstacles exist that keep many theatergoers and other arts patrons from critically thinking about and discussing the arts—that is, having the wherewithal and vocabulary to contemplate and explain whether the arts are well done or not, valuable or not, effective or not, and impactful or not. Many of these obstacles have evolved in just the past decade. This chapter suggests that, in light of the decrease of national print media and the critical essays they carried, and the explosion of uncredentialed, uninformed, and undisciplined online opinions, we need to develop our own knowledge base, foster our own critical thinking skills, and apply them to the arts.

- CHAPTER 2

Criticizing the Arts, or Not

In addition to theater and many other traditional arts being marginalized and relegated to the periphery of popular awareness and participation, as was discussed in the previous chapter, there are obstacles that keep theatergoers and other arts patrons from critically thinking about the arts. That is, not only do many of us not have the interest to experience performances and exhibitions, but we also fail to possess the wherewithal or vocabulary to contemplate and explain whether they were well done or not, are valuable or not, are effective or not, are impactful or not.

The Obstacles of Critical Thinking About the Arts

The Era of the Internet

We live in an era of instant information access, when a second's delay on an Internet download seems an eternity. We scan. We tweet. We instant message. We do not afford ourselves the luxury to ponder, reflect, consider, or evaluate the information or entertainment we receive through technology. Suggests Nicholas Carr, in his essay *Is Google Making Us Stupid?*, our thinking has "taken on a 'staccato' quality, reflecting the way we quickly scan short passages of text from many sources online."[2] Literary critic Sven Birkerts cataloged the losses that a reader in the electronic millennium has suffered: divorce from historical consciousness, a fragmented sense of time, and a loss of deep concentration.[3]

Clearly, then, we are potentially losing the patience and the potential to take in information at the pace deemed appropriate by the source which, in the case of theater, can be intentionally and purposefully slow and meticulous. The television industry responded to the changing audience by shifting its archaic "by appointment" model that had the networks simply offering a program at a certain time on a certain day on a certain channel. Program recording via TiVo was developed, as was the offering of programming on-demand and through more portable technology, like cell phones.

Live theater and other performance arts, by their very nature, have no such options. The National Endowment for the Arts recently reported that arts attendance in the United States in general has hit new lows in recent years, with 34% attending an arts event once a week, down from 39% a decade ago. The report also noted a spike in audiences procuring their arts fix on their own terms, through the Internet.[4] Some arts journalists have responded in kind by offering reviews and commentary on Twitter.[5] Some theaters are offering seats specifically delegated to tweeting patrons.[6]

Another side-effect of modern technology is the obsessive desire of constant connectivity, where we need to persistently check our phones or our emails or our Facebook pages. William Powers, a former staff writer at *The Washington Post*, suggests in his book *Hamlet's BlackBerry*[7] that evolutionary cognitive programming may be partly responsible for this. We are biochemically wired, he notes, to pay attention to new stimuli, thereby helping us to respond quickly to predators or to engage in the hunt. The iPhone ping and the "you have mail" notifications might actually be injecting our brains with what Powers calls a "dopamine squirt." Thanks to technology, we have become so inundated with stimuli that require us to be immediately responsive that we may be in danger of no longer connecting deeply to other things around us or patiently awaiting gratification. So much for the thoughtful enterprise of live performance.

The adverse effect of communication technology on cognition is not new. Neil Postman's *Amusing Ourselves to Death*[8] and Jerzy Kozinski's *Being There*[9] warned us of television's potential to erode not only public discourse but thinking itself, creating a culture of "videots." In the 1800s, Ralph Waldo Emerson warned against books, believing that intellectual dependency on the printed word removes us from first-hand experience and could turn an entire generation into unthinking "bibliomaniacs."[10] In Plato's *Phaedrus*, Socrates feared that the development of writing would result in the replacement of the written word for genuine knowledge. This, in turn, would allow readers to "receive a quality of information without proper instruction" and would be "filled with the conceit of wisdom instead of real wisdom."[11]

It's Only Entertainment

Many people simply do not give serious consideration to theater and other arts because they are only entertainment and there are other, more significant things

> "*Serious criticism…steers its readers toward thoughts, insights, and associations they hadn't considered before, and is therefore unafraid to be frequently unfashionable.*"
> ~Jonathan Kalb, critic,[12]
> *The Village Voice* and *The New York Post*

that warrant our attention and mental energy. Yet, in the past, other forms of entertainment have been considered anything but benign. Hitler's propagandist films have been credited with placing a fire under the fledgling fascist movement in 1930s Germany. In the 1940s and 1950s, popular radio programs and films were credited with having the potential to undermine democracy and propagate Communism during the "Red Scare," resulting in the investigation and interrogation of the creative community by the U.S. House Un-American Activities Committee. In the former Soviet Union and in China in the 1960s and 1970s, artists were shot or exiled because of the power of their art to undermine Communism.

Interestingly, art often emerges at times when it is needed most. In ancient Greece—an empire ensconced in domestic barbarism and military adventurism—it was theater that reformulated the public debates of that era with humanity and intelligence. More recently, the power-challenging, world-influencing plays of Athol Fugard in apartheid-era South Africa emerged from one of the most despotic regimes of its time.[13] In the United States, the arts have reflected and in some cases championed various social movements, including civil rights, feminism, and gay rights (see Gay Theater and the Diffusion of Innovation, in profile).

Mainstream Misinformation

Television and film have become the social *lingua franca*—that is, the common language—for several generations of Americans who possess a surprisingly well-developed knowledge and vocabulary about the subject. One need only glance at Facebook to see how many people will list the latest film they saw along with their critique of it, or how many people describe the way their lives were changed by watching the final episode of a favorite television show.

It is not unusual to hear or read opinions about script construction (even in so-called "unscripted" reality programs), character development, under scoring, and even camera technique. A typical audience member would most likely know the difference between a "close up" and a "pan," as well as the basic jobs of the producer, director, designers, casting, and casting director. The processes of acting technique are discussed so regularly on talk shows, interviews, and specialty cable channels that audiences have a working knowledge of how actors prepare for their screen roles. It could also be argued that the acting process has lost a great deal of its mystique due to the occurrence of sports celebrities and stand-up comics starring in films. Even actors' private lives are relentlessly displayed, discussed, and debated on a myriad of "inside" entertainment shows or depicted in programs like HBO's *Entourage* and NBC's *Smash*. This produces an unparalleled perception of intimacy between actor and audience who are given the opportunity to see how different or similar the actor's "real" personality is from his or her "reel" portrayal.

Gay Theater and the Diffusion of Innovation, in profile

According to *The New York Times*,[14] a new breed of plays and musicals about gay life is replacing the explicit political messages of 1980s and 1990s dramas, such as *The Normal Heart* and *Angels in America*, with more personal appeals for social progress.

These productions buck the long thematic tradition of portraying explicitly gay or presumably gay characters as long-suffering, self-hating, and suicidal souls. Such tragic plot points were particularly common in the theater of the early- and mid-20th century, from Lillian Hellman's *The Children's Hour* (1934) and Tennessee Williams' *Suddenly Last Summer* (1958).

These new plays do not focus on H.I.V., AIDS, or activism. In fact, militant crusading is portrayed with ambivalence more than ardor. Suggests *Times* theater reporter Patrick Healy, the politics of these shows "are subtler, more nuanced: they place the everyday concerns of Americans in a gay context, thereby pressing the case that gay love and gay marriage, gay parenthood and gay adoption are no different from their straight variations." He writes:

> While persecution remains a reality for most of these gay characters, just as it does in many movies and television shows featuring gay love stories, the widening acceptance of AIDS as a pandemic rather than a gay disease—and the broadening debate on gay marriage and gay soldiers—have led, and have to some extent freed, writers and producers to use a wider lens to explore a broader landscape.

For example, in the Broadway play *Next Fall*, which opened in 2010, sharp religious differences test a gay couple's romantic bond—not AIDS, irate parents, the system, or an angry mob. "I think we have a better chance of attracting straight and gay audience members with universal emotions, like love and loyalty, that touch the lives of these gay men and show how we are all equal, rather than do it through polarizing arguments," said Richard Willis, one of the lead producers of the play.[15] Other new plays about gay life that are more personal than overtly political include *Yank*, *The Pride*, *The Temperamentals*, and *Looped*.

One plausible explanation for this dramatic change in the dramatic arts can be found in a communication theory known as "diffusion of innovations."[16] It suggests that new ideas—or, for that matter, new technologies such as the first generation of iPod, new consumable products like the first lite beer, or the notion of a first black or female presidential candidate—surface, spread through society, and then work their way into a state of normalcy in our culture through five distinct stages: awareness, interest, evaluation, trial, and adoption.

According to social scientists, if an innovation is effectively communicated through a credible source (i.e., the New York stage) and is shared among members

of a social system (i.e., New York theatergoers and tourists), over time that innovation (i.e., the mainstreaming of the gay lifestyle) goes from being invisible to being perceived as novel and potentially threatening. If perceived as interesting, valuable, compatible to existing beliefs, and/or accepted by others, that innovation is accepted. Once accepted, it becomes normative and makes room for the next stage of evolution in that innovation. Such is the case, it seems, with gay-themed theater.

It might be assumed that this pervasive understanding of TV and film would help in an understanding of the theater. It has actually created obstacles to that understanding. Each of these forms of storytelling utilizes actors portraying characters in a scripted narrative, in environments created by designers, and overseen by a director. However, beyond these foundational similarities, the audience engages in very different experiences for each medium which are not easily transferable to live theater.

Furthermore, while old "backstage musical" TV programs like NBC's *Fame* and the more recent *Glee* on Fox—which revolve around high school performing arts students—have inspired many young people to try out for high school shows or pursue theater as a profession, they provide an unrealistic view of what is really required to make it in the business. The same phenomena occurred in the 1930s and 1940s, when an adolescent Judy Garland and Mickey Rooney did a series of "backyard musical" films where the logical solution for what ails you was to "put on a show." *Babes in Arms*, their earliest film, found the two teens and their buddies staging a musical to help revive vaudeville after it had succumbed to motion pictures. In *Strike up the Band*, the kids do a musical revue to finance a high school band competition and pay for a pal's life-saving surgery. Apparently putting on a show just requires a song in your heart and a pocket full of good intention. Not so.

Critical Thinking is Not Taught Here

According to theater critic Jonathan Kalb,[17] "University lectures on theater criticism aren't common, partly because the subject falls into the crevices between edgily linked disciplines—literary studies and theater practice, scholarship and journalism, art and entertainment." As such, few touch on this.

It can also be argued that arts criticism demands two cognitive tools that are often undervalued, if not out and out discouraged, in secondary and university education: qualitative judgment and critical thinking. The genesis of this is tied to the American public school system's reliance on standardized tests to measure achievement and justify academic advancement, where there is only one right answer and everything else is wrong. This aesthetic has been further validated by a systemic emphasis on teaching hard sciences, mathematics, and business in order to reduce

Academically Adrift, in profile

In their book *Academically Adrift: Limited Learning on College Campuses,*[18] Richard Arum and Josipa Roksa present a study that followed 2,300 students at 24 universities over the course of four years and measured, among other things, their critical thinking skills.

According to the authors, teaching students to think critically is a principal goal of higher education. From the Commission on the Future of Higher Education's recent report *A Test of Leadership* to the halls of Ivy League institutions, all corners of higher education endorse the importance of this skill. When promoting student exchange across the world, former Secretary of Education Margaret Spellings urged foreign students to take advantage of "the creativity and diversity of American higher education, its focus on critical thinking, and its unparalleled access to world- class research." The American Association of University Professors agrees: ". . . critical thinking . . . is the hallmark of American education—an education designed to create thinking citizens for a free society." Indeed, 99% of college faculty say that developing students' ability to think critically is an essential goal of undergraduate education.[19]

"Our country today is part of a global economic system, where we no longer have the luxury to put large numbers of kids through college and university and not demand of them that they are developing these higher order skills that are necessary not just for them, but for our society as a whole," note the book's authors.[20]

Interestingly, more than a third of students in their study showed no improvement in critical thinking skills over their four years in college. Part of the reason could be a decrease in academic rigor; 35% of students reported studying only five hours per week or less, and 50% said they didn't have a single course that required 20 pages of writing.

Another reason, according to the authors, is the massive expansion of higher education. Although institutional barriers and inequalities in access persist and concerns about affordability continue to mount, American higher education today educates more than 18 million students in more than 4,300 degree-granting institutions. Educational expectations have been on the rise, with more than 90% of high school students *expecting* to attend college. Higher education has been transformed from a privilege into an assumed right—and, for a growing proportion of young adults, into an expected obligation. However, many students are not prepared for college-level work and many others have no clear plan for the future.

Academically Adrift reports that only 44% of students had aligned ambitions, meaning that they expected to attain as much education as was typically required of their intended occupation. Many students entering higher education today seem to understand that college education is important but have little specific information about or commitment to a particular vision of the future. They are drifting through their education without picking up the necessary skills.

the disparity between American and international students in those areas. Here, if a thesis can be tested, proven, and verified by repeated methodology, it is considered to be successful.

This approach can prove problematic when applied to the arts and humanities, where the intended outcome is often to raise questions rather than to provide answers. It becomes even more problematic when attempting to lump all the arts together or compare one art form with another, some of which have quantifiable techniques and approaches that can be objectively discerned and some which do not. Without the development of qualitative judgment and critical thinking, it is difficult if not impossible to see artistic choices as valid or invalid, correct or incorrect, depending on a particular text designed by particular artists and interpreted by particular actors and directors for a given audience in a given location and time. Criteria for effective or ineffective art and interesting or uninteresting forms of artistic expression are not as clear cut as solutions to mathematical formulas.

Similarly, the study of arts journalism in general and arts criticism in particular, as an academic pursuit, has not been given its due. Since its beginnings, the writing of American arts journalism history has been produced as a distinct subfield of historical studies. It has been located on the periphery of the intellectual domain of social and cultural historians[21] and often ignored by journalism historians. Contemporary arts journalism operates on the margins of a considerably larger field of social history and the documentation and historical review of arts criticism have most often been performed by the critics themselves.[22]

"American critics are like American universities. They both have dull and half-dead faculties."
~Edward Albee, playwright[23]

The Disappearing Professional Critic

The biggest obstacle that keeps audiences from critically thinking about the arts is the diminished presence of the professional arts critic. Professional criticism in the nation's leading daily newspapers and magazines was once a thriving enterprise. In the early 20th-century, the professional arts critics' opinions were revered and often feared by their respective industries. They helped inform audience opinions, dictated box office sales, kept the arts the topic of discussion, and—for critics the likes of George Bernard Shaw (theater),[24] Clement Greenberg (art),[25] H.T. Parker (music),[26] Carl Van Vechten (dance),[27] James Agee (film),[28] and Northrop Frye (lit-

erature)[29]—shaped the arts themselves. A few short decades ago, critics were part of an elite corps of taste makers and culture shapers for the general public.

The demise of professional theater criticism began in earnest in the 1990s, along with claims of the death of theater itself. "The death of the theater has been celebrated so many times now," noted former *The New Republic* critic Robert Brustein,[30] "that nobody bothers to mention it anymore. Instead, the print and broadcast media are behaving as though grass is already growing on the grave." He continues:

> The Arts and Leisure section of *The New York Times*—who remembers when it was once called the Theater section?—can barely squeeze out an article about the stage.... *Newsweek* has drastically reduced the space of its regular theater critic, Jack Kroll.... As for the serious magazines, neither *Harper's* nor *Atlantic* has carried a theater article in years.... The end of concerted intelligent reflection on the state of our theater coincided with the deterioration of the commercial stage and the loss of a central platform for aspiring American theater artists.

As collateral damage in the more recent digital revolution that has sent the newspaper business into financial turmoil, as total print advertising revenue declined 9.4% to $42 billion from 2006 to 2007,[31] the ranks of professional theater critics have dwindled even more. For example, *Variety* laid off its theater critic David Rooney.[32] In 2011, after 18 years, the *Denver Post* released John Moore. Steven Leigh Morris, the longtime theater editor and critic at the *LA Weekly*, was let go and his position eliminated. In his blog at the time of his departure he wrote:[33]

> In the program of the off-Broadway production of my play *Beachwood Drive* last year, I wrote in my bio, somewhat facetiously, that among my proudest accomplishments was surviving six rounds of layoffs at the *LA Weekly*. The joke is now on me. That survival streak ended yesterday, when the newspaper's corporate uberseers in Phoenix eliminated the position of Theater Editor at the paper. Over six years, the "transitions" at this and other papers in the chain have become the alt-weekly's answer to the French Revolution.

The fate of the nation's theater critics mirrors that of arts critics and entertainment journalists in general. Between 2008–2010: *Variety* stunned the industry by laying off its chief film critic Todd McCarthy;[34] two longtime film critics at *Newsday*, Jan Stuart and Gene Seymour, took buyouts; Ruth Reichl was one of the last towering food critics, but her magazine, *Gourmet*, folded;[35] and Nathan Lee, one of *The Village Voice's* full-time film critics, was laid off.[36] More than one dozen longtime TV critics at major-market dailies—including the *Dallas Morning News*, *Seattle-Post Intelligencer*, New York's *Daily News*, and the *Houston Chronicle*—have been either let go or reassigned. Literary critics[37] and classical music critics fell by the wayside when McClatchy, the third-largest newspaper chain in the country, cut 10% of its workforce.[38] After 24 seasons on television, *At the Movies*—the nationally syndicated TV showcase for dueling thumbs up/thumbs down film critics Roger

Rating on a Curve, in profile

We may all be critics, as former *TV Guide* critic Jeff Jarvis suggests, but many sites such as Amazon, Netflix, and iTunes truncate consumer criticism to a user-generated "five-star review" rating. Unfortunately, according to *New York* magazine,[44] this democratization of reviewing tends to produce aggregate scores that reveal nothing much at all. The average rating in a five-star system, across the entire Internet, lingers at a 4.3, suggesting "a world of uniformly awesome products, services, and experiences[45] but reflecting the fact that few users bother to give poor reviews."

User-feedback experts Randy Farmer and Bryce Glass, authors of *Building Web Reputation Systems*,[46] called this pattern "the J-curve." This is where a chart with ratings along the x-axis and the number of users choosing that rating along the y-axis shows a few low ratings but then a sudden significant proliferation of high ratings.

The earliest known star ranking appeared in 1926, when Michelin published a guide to the Brittany region in France. Michelin began with a single-star system, and then went up to three. In 1958, Mobil put out its own travel guide and added two more stars. In the hands of professionals, the five-point scale meant something but, according to *New York* magazine, most online amateur reviewers are either "cranks or starry-eyed fanatics."[47]

Ebert and Gene Siskel (and, more recently, Michael Phillips of *The Chicago Tribune* and A. O. Scott of *The New York Times*)—was cancelled.

> *"Leaching critics of prestige will have the obvious effect of reducing the power of criticism to support good plays, guide audiences from less worthy ones and help magnify and interpret new voices. Producers of bad work may rejoice at this notion. Everyone else should be worried."*
> ~Adam Feldman, arts critic,[39] *Time Out New York*

These are merely the most high-profile casualties in an industry ravaged by them. "The fact that newspapers are giving up this role as navigators over this most pervasive of mediums," noted Dave Walker, a former president of the Television Critics Association, "it's totally weird to me."[40]

According to journalist and media critic Howard Kurtz, newspapers and magazines were built on the smorgasbord model, serving a little something for everyone. But in the age of Google and Bing, "growing hordes of people simply search for precisely what they need. That has pushed the pendulum toward a word-of-mouth arena in which anyone can play."[41] "The era of the experts, the informed cognoscenti whose judgments and tastes operated as a lodestar for the public," notes literary critic Ronan McDonald,[42] "has seemingly been swept aside by a public that has laid claim to its capacity to evaluate its own cultural consumption." The explosion of uncredentialed, unaccountable, and often anonymous online opinions—including amateur filmgoers on Rotten Tomatoes, typical readers on Amazon.com, pedestrian diners on Yelp, and casual theatergoers on Hotreviews—is astounding. "Now, we're all critics," says veteran editor and onetime *TV Guide* critic Jeff Jarvis.[43]

The Internet's speed is also making a difference. Reviews by Internet news sites' designated critics get posted the minute a show opens. Even these are being supplanted, for enthusiasts, by the instant reactions texted or tweeted, to chat boards and networking sites by those privileged to catch the workshop, the invited dress rehearsal, or the first 15 minutes of the first preview performance. "The multiplicity of opinions online can be refreshing, like a spring rain," notes former *Village Voice* critic Michael Feingold, "but their instant, unremitting inundation of all discourse seems more like the Johnstown Flood: The sane person instinctively retreats to higher ground."[48]

"With the newspaper industry shrinking," says Terry Teachout, drama critic for the *Wall Street Journal*, "I fear that a generation of critics is not going to be replaced. It's not enough to have a reporter who says the local museum has bought a new Picasso. It's also necessary to have someone on your staff who knows whether it's museum-quality and is worth $5 million."[49] Playwright Oscar Wilde once wrote that criticism "takes the cumbersome mass of creative work, and distils it into a finer essence," adding that "the duty of imposing form upon chaos does not grow less as the world advances." He warned that an age without criticism is "either an age in which art is immobile, hieratic" or "an age that possesses no art at all."[50]

Summary

In light of faltering arts attendance, the diminished role of national print media and the critical essays they carried, and the explosion of uncredentialed, uninformed, and undisciplined online opinions, it is more important now than ever to develop our own knowledge base, foster our own critical thinking skills, and apply them to the performing arts. We have become our own standard bearers and, perhaps, could be the next generation of arts journalists albeit on web pages, blogs, or what-

ever new social media or emerging mass media lay around the corner. "If the critic has to compete with every bright thing that flies to the surface of the iPhone," notes media scholar Katie Roiphe,[51] "that's all the more reason to write dramatically, vividly, beautifully. The critic could take all of this healthy competition…as a sign to be better, to be irreplaceable, to transcend."

The next chapter begins the process of us becoming arts critics by exploring the nature of being a critic. It examines the critic's role and function in the creative process and the distinction between a critic, a feature writer, and an entertainment reporter.

KEY CONCEPTS FROM THIS CHAPTER

Backstage musicals

Backyard musicals

Bibliomaniac

By appointment model of broadcasting

Critical thinking

Diffusion of innovations

Digital revolution

Disappearing professional critic

Dopamine squirt

Gay theater

J-curve

Smorgasbord model of print media

Staccato thinking

Vidiot

NOTES

1 Cited in Nadine Holdsworth, *Theater Nation* (London: Palgrave Macmillan, 2010), vii. Dan Rebellato is Professor of Contemporary Theatre at Royal Holloway University of London, and Jen Harvie is Professor of Contemporary Theatre and Performance at Queen Mary, University of London.

2 Nicholas Carr, "Is Google Making Us Stupid?" *The Atlantic Monthly*, July/August, 2008, www.theatlantic.com/doc/200807/google (accessed July 30, 2008).

3 Sven Birkerts, "Reading in the Digital Age," *The American Scholar*, Spring 2010, http://www.theamericanscholar.org/reading-in-a-digital-age/ (accessed January 5, 2010).

4 Steven Leigh Morris, "Why Theater Matters," *LA Weekly*, March 25, 2010, http://www.laweekly.com/2010-03-25/stage/why-theater-matters/ (accessed August 11, 2010).

5 Jonathan L. Fischer, "Should Theater Critics Be Allowed to Tweet an Opinion Before Writing a Review?" *Washington City Paper*, October 20, 2010, http://www.washingtoncitypaper.com/blogs/artsdesk/theater/2010/10/20/should-theater-critics-be-allowed-to-tweet-an-opinion-before-writing-a-review/ (accessed October 26, 2010).

6 See Deborah Netburn, "Theaters Set Aside Tweet Seats for Twitter Users," *The Los Angeles Times*, December 6, 2011, http://latimesblogs.latimes.com/technology/2011/12/theaters-tweet-seats-twitter.html (accessed December 14, 2011).

7 William Powers, *Hamlet's BlackBerry: A Practical Philosophy for Building a Good Life in the Digital Age* (New York: Harper/HarperCollins Publishers, 2010).

8 Neil Postman, *Amusing Ourselves to Death: Public Discourse in the Age of Show Business* (New York: Penguin, 1985).

9 Jerzy Kozinski, *Being There* (New York: Harcourt Brace Jovanovich, 1970).

10 Ralph Waldo Emerson, *The American Scholar* (New York: Laurentian Press, 1901).

11 Cited in Carr, "Is Google Making Us Stupid?"

12 Cited in Jonathan Kalb, *Play by Play: Theater Essays and Reviews, 1993–2002* (New York: Limelight Editions, 2003), 3. Kalb was the theater critic at the *Village Voice* and the *New York Post* until 2001.

13 Cited in Morris, "Why Theater Matters."

14 Patrick Healy, "New Gay Theater Has More Love Than Politics," *The New York Times*, February 22, 2010, http://www.nytimes.com/2010/02/23/theater/23gaytheater.html?pagewanted=all (accessed April 6, 2012).

15 Ibid.

16 See Evert M. Rogers, *Diffusion of Innovation* (Glencoe: Free Press, 1962).

17 Kalb, *Play by Play*, 3. See, also, Susan Harris Smith, *American Drama: The Bastard Art* (Cambridge: Cambridge University Press, 1997).

18 Richard Arum and Josipa Roksa, *Academically Adrift: Limited Learning on College Campuses* (Chicago: The University of Chicago Press, 2011).

19 From a radio interview posted on http://www.npr.org/2011/02/09/133310978/in-college-a-lack-of-rigor-leaves-students-adrift (accessed February 9, 2011).

20 Ibid.

21 See Bonnie Brennen and Hanno Hardt (Eds.), *The American Jouranlism History Reader* (New York: Taylor & Francis Group, 2011).

22 See, for example, Richard Gilman, *The Drama is Coming Now: The Theater Criticism of Richard Gilman* (New Haven, CT: Yale University Press, 2005); Jonathan Kalb, *Play By Play: Theater Essays and Reviews, 1993–2002* (New York: Limelight Editions, 2003); Stanley Kauffmann, *Persons of the Drama: Theater Criticism and Comment* (New York: Harper & Row, 1996); Frank Rich, *Hot Seat: Theater Criticism for The New York Times* (New York: Random House, 1998); John Simon, *John Simon on Theater: Criticism, 1974–2003* (New York: Applause Theater & Cinema Books, 2005); and Irving Wardle, *Theater Criticism* (New York: Routledge, Chapman and Hall Inc, 1992).

23 Address to New York Cultural League, May 6, 1969.

24 See Harold Fromm, *Bernard Shaw and the Theater in the Nineties* (Lawrence, KS: The University of Kansas Press, 1967).

25 See Alice Goldfarb Marquis, *Art Czar: The Rise and Fall of Clement Greenberg* (Boston: MFA Publications, 2006).

26 See David H.T.P. McCord, *Portrait of a Critic* (New York: Small, 1953).

27 See Edward Lueders, *Carl Van Vechten* (New York: Twayne, 1965).

28 See Kenneth Seib, *Critical Essays in Modern Literature* (Pittsburgh, PA: University of Pittsburgh Press, 1968).

29 See Herman Northrop Frye, *Anatomy of Criticism* (Princeton, NJ: Princeton University Press, 1957).

30 Robert Brustein, "Reinventing American Theater," *Plays, Movies and Critics,* (Ed.), Jody McAuliffe, (Durham, NC: Duke University Press, 1993), 13–14.

31 Marisa Guthrie, "The Disappearing Critic," *Broadcasting & Cable*, April 6, 2008, http://www.broadcastingcable.com/article/print/113181-COVER_STORY_The_Disappearing_TV_Critic. (accessed July 30, 2008).

32 Adam Feldman, "Theater Critic David Rooney is Out at *Variety*," *Upstaged*, March, 2010, http://www3.timeoutny.com/newyork/upstaged/2010/03/david-rooney-is-out-at-variety/ (accessed March 8, 2010). In 2013, Michael Feingold was released by the *Village Voice*.

33 Cited in http://latimesblogs.latimes.com/culturemonster/2009/01/theater-critics.html (accessed March 8, 2010).

34 Feldman, "Theater Critic David Rooney is Out at *Variety*."

35 Howard Kurtz, "Who Needs Critics, Anyway?" *The Washington Post*, April 12, 2010, http://www.washingtonpost.com/wp-dyn/content/article/2010/04/12/AR2010041201135_4.html (accessed 12 April, 2010).

36 David Carr, "Now On The Endangered Species List: Movie Critics in Print," *The New York Times*, April 2008, www.nytimes.com/2008/04/01/movies/01crit.html (accessed July 30, 2008).

37 See Stephen Burn, "Why Criticism Matters: Beyond the Critic as Cultural Arbiter," *The New York Times*, December 31, 2010, http://www.nytimes.com/2011/01/02/books/review/Burn-t-web.html (accessed January 5, 2010); Adam Kirsch, "Why Criticism Matters: The Will Not to Power, But to Self-Understanding," *The New York Times*, December 31, 2010, http://www.nytimes.com/2011/01/02/books/review/Kirsch-t-web.html (accessed January 5, 2010).

38 Susan Elliott, "Another Classical Critic's Job Bites the Dust," Musical America.com, June 20, 2008.

39 Feldman, "Theater Critic David Rooney is Out at *Variety*."

40 Guthrie, "The Disappearing Critic."

41 Kurtz, "Who Needs Critics, Anyway?"

42 Ronan McDonald, *The Death of the Critic* (London: Continuum, 2007), 4.

43 Ibid.

44 Sam Graham-Felsen, "Starstruck," *New York*, March 26, 2012, 12.

45 This finding was originally reported in *The Wall Street Journal* in 2009.

46 Randy Farmer and Bryce Glass, *Building Web Reputation Systems* (New York: Yahoo Books, 2010).

47 Graham-Felsen, "Starstruck."

48 Michael Feingold, "Theater Criticism Reconfigured," *The Village Voice*, August 11, 2009, http://www.villagevoice.com/2009-08-11/theater/theater-criticism-reconfigured/ (accessed August 11, 2010).

49 Ibid.

50 Cited in James Sims, "Death of a Theater Critic, Again," *The Huffington Post*, March 9, 2010, http://www.huffingtonpost.com/james-sims/death-of-a-theater-critic_b_490646.html (accessed December 20, 2010).

51 Katie Roiphe, "With Clarity and Beauty, the Weight of Authority," *The New York Times*, December 31, 2010, http://www.nytimes.com/2011/01/02/books/review/Roiphe-t-web.html (accessed January 5, 2010).

"Critics are like eunuchs in a harem; they know how it's done, they've seen it done every day, but they're unable to do it themselves."
~Brendan Behan, poet and playwright[1]

Chapter 3 Abstract

This chapter explores the nature of being an arts critic. It examines the critic's role and function in the creative process and the distinction between a critic, a feature writer, and an entertainment reporter. The critic as disruptor of audience autopilot, standard bearer for the audience and the arts, histoire morale, documentarian, and arts advocate will be examined.

The Critic

■■ First nights are special theater," notes *Sunday Times* entertainment critic A.A. Gill.[2] "These are moments when the creatives let go of the creation. There is nothing more to be done. Actors are the only artists who have to go on performing through a disaster, so there is a particular electricity, an atmosphere in the theater. Much depends on the first night." He continues:

> And, when it's over and the audience applaud and cheer and, more than likely these days, rise to their feet for a standing ovation, you may notice a little gang of hunted characters sidle out of the stalls and scuttle up the aisle. They seem to be escaping, running away.... They keep their heads down and don't look back, and they don't do applause. You might imagine they were rude, disrespectful philistines. But you couldn't be more wrong. These creeping things are the critics, keepers of the flame of theater, the referees of the muse.

Theater critics dashing out of playhouses is a long-standing tradition, although what they are running to and from has changed over the years. Back in the day, a critic would be returning to his (yes, *his*) newspaper workspace to write up his review in longhand on a legal pad, which would be handed to a copyboy (yes, *boy*) to take directly to the copy desk. Once checked for accuracy, the review would be forwarded to the composing room, where it would be set in type, proofed for typographical errors, and show up in the newspaper's late or morning edition.

Of course, fewer critics do "overnights" these days. In fact, fewer newspapers still have multiple editions. And there are fewer newspapers. Those heading for the doors at today's opening night productions are just as likely to be tweeters eager to be the first to post their 140-character observations and opinions, which will later appear on a blog or a paper's website and perhaps, eventually, in print.

Still, the appearance of critics on opening nights of theatrical events, art exhibits, dance recitals, and symphonic performances continues to be commonplace and the functions critics serve—despite their diminished numbers in major media outlets—continue to be an important, even instrumental part of the arts. And, despite the infusion of new technology in the process, the role of the critic has essentially remained the same.

So, what is a critic and what is that role?

As was pointed out in an earlier chapter, the etymological roots to the word *critic* are two-fold. *Critic* is believed to come from the Greek *kritikos*, which means "able to discuss," as well as the Greek *kritos*, which means "a judge." Indeed, the primary function and, perhaps, the greatest contribution of arts criticism is to incite or instigate discussion by passing judgment, thereby placing and keeping the arts center-most in public discourse. To do this, however, critics must be skilled in evaluating the qualities or merits of a creative work. They must also be eloquent and interesting in their presentation of that judgment, for their thoughts are shared works and a valuable commodity.

The terms "reviewer" and "critic" are often used synonymously, even by arts journalists themselves. There is, however, a clear distinction between an arts critic and an arts writer or entertainment reporter assigned to an arts beat. Both the critic and the writer/reporter serve to keep the arts a part of the local or national conversation, and their writing is grounded in observation and offers a response to a particular work of art. Often, today's arts journalists are asked to write reviews, previews, and feature stories. However, there are significant differences between the critic and the feature writer/reporter and the additional functions they serve.

The Arts Writer/Entertainment Reporter

Arts writers and entertainment reporters assigned to an arts beat tend to apply their craft *prior to* a cultural event, such as a play or exhibition. For the most part, the writer/reporter identifies and addresses the five-Ws—the who, what, when, where, and why—of a cultural event. Because the payoff of this enterprise is an awareness of, insight into, and, perhaps, a recommendation on whether or not others should attend that particular event, arts writers/reporters operate at times as consumer guides who have been given the license to offer their opinions about whether something is worthy of consumption. The arts writer typically writes preview features, while the reporter writes arts-oriented news stories.

In a preview piece, most opinion focuses on the more obvious or superficial aspects of that event, the "what" and the "who"—that is, for the performing arts, the nature of the story and the performances of the storytellers—and tends to treat the cultural event under examination as an isolated, singular, or stand-alone event. Most opinion in a preview is descriptive and simply passes judgment rather than serves to be interpretive or explanatory. The arts writer/reporter is expected to have standards no higher and no more demanding than the average member of the audience.

The target audience for previews and stories about an arts event is the potential audience for that event. Arts writers/reporters tend to treat this audience as a

passive market, requiring information, insight, and succinct recommendations to be consumed rather than perspective to be considered and acted upon. The value of a preview and news piece is to create an awareness of a particular event, generate a general understanding of the event, and provide a guide to the potential attendance at the event. Previews and feature stories are often published before the actual opening of a production or during a run of preview performances. As such, they serve several primary functions:

Public Relations and Promotions

Although independent from the theaters or galleries they serve, preview writers often operate as an extension of or in cooperation with a theater or gallery's own publicity departments. Indeed, press releases provided by theaters, which contain a description of the art and the artists, are often heavily relied upon to provide substance for previews and feature stories in small-market newspapers that have fewer resources of their own. These are often quoted on artists' websites, theater marquees, and subsequent press releases.

Back in the mid-20th century, when arts critics writing in intellectual periodicals like *The Saturday Review, The New Republic, Commentary, Commonweal, The Nation,* and *The Atlantic* cultivated a broad interest in theater as an intellectual subject and a platform for thoughtful cultural debate,[3] there was a huge divide between those who wrote critical reviews and those who wrote previews and light feature stories. It was suggested that the playbill or program should probably include the name of the entertainment reporter along with other members of the production staff. Previewers, noted famed theater critic Richard Gilman, "come close to being the most loyal and effective allies the commercial theater could possibly desire."[4] "Loyalty in a critic," wrote George Bernard Shaw, "is corruption."[5]

..

"[P]reviewers kill the theater with their kindness toward what is shoddy, pat, showy, cheap, pretentious and even false."
~Richard Gilman, theater critic, *The New York Times* [6]

..

Box Office Sales

Arts writers and entertainment reporters have been referred to as "cheap parasites"—those who make a living off the creative work of other people[7] and who form a class of cultural middlemen, distributing culture to society at a profit to

them while exploiting the artist and increasing the strain on his public.[8] Of course, it has also been suggested that every facet of the theater arts is parasitic.[9] That is, in the creative cycle of theater arts, playwrights feed off of life for their ideas, theaters feed off the playwright's work for their enterprise and identities, arts reporters and critics feed off the theaters for their subject matter, and audience members feed off of critics for guidance, which impacts on ticket sales.

Advertising Revenue

An additional element of the parasitic relationships between the various players in the arts is that arts previews and feature stories fill the entertainment sections of newspapers, magazines, and websites, which attract readers which, in turn, attract advertisers. Previews and entertainment feature stories make for light and interesting reading.

Status Conferral

Feature stories and preview pieces place artists and the places that house them in the limelight and, typically, in a positive light. Such exposure has the potential to impact professional profiles within the general community.

The Critic

The critic attends, reacts to, and—much like a reporter and feature writer—reports on a cultural event. However, the critic also reflects. A critic considers and attempts to explain the value of an event beyond the obvious or superficial, and does so by placing the event in a larger context and under greater scrutiny. A critic considers the event within a broader historical, cultural, political, or sociological perspective and comments on its merits accordingly. Critics address the story and the storytellers, as do arts writers and entertainment reporters, but critics place them and other significant aspects of the event within the framework of something bigger than the event itself: a reflection of the current state of the art or state of Humankind.

While reporters convey what a particular cultural event is and describe what it is about, critics are the equivalent of investigative journalists who contemplate what that particular cultural event could be or, perhaps, should be. Indeed, the best criticism is based on the notion that there is, perhaps, something more. Critics, like reporters, identify the who, what, when, where, and why of a cultural event, but they dig deeper. Their mission is not just to describe, but to explain, interpret, and analyze. As such, they also address the "so" (as in "So, what is particularly intrigu-

ing about this play and this production?"), the "how" (as in "How is this play and production able to accomplish what it did?") and, to make sense of the significance of the event at hand, the "so what" (as in "So what? What are we to take away from this play and this production of it?").

According to Bill Kovach and Tom Rosenstiel of the Nieman Foundation for Journalism at Harvard University,[10] it is the obligation of reporters to be absolutely objective in their writing, remain independent from those they cover, and seek verification of personal observations. A piece of criticism, however, offers a personal opinion, backed by interpretation and explanation, informed by insight and description, which leads to a subjective conclusion.

Critics, like reporters, target the potential audience of a cultural event, but they also address those responsible for creating, providing, and performing the event. Critic Leonard Jacobs suggests that "the critic's responsibility is to ricochet intelligently and conscientiously between three distinct yet interrelated constituents: practitioners, readers/browsers, and the critics' conscience."[11] Consumers of critical reviews are not just offered information about the event; they are given insight and personal judgment, and learn about the art on display as well as the singular event under scrutiny. Critical reviews are intended to be educative. They are a potential agent for change in how consumers view the arts as well as the very nature of the arts themselves. Critic and essayist H.L. Mencken suggested:

> A critic must consider a work of art by the clarity and sincerity of expression, the force and charm of its ideas, the technical virtuosity of the artist and their originality and artistic courage.... The best criticism is written by those with reflective and analytical faculties and the gusto of an artist.[12]

Similarly, theater critic Stanley Kauffmann suggested:

> Anyone can write a theater review. Any literate, intelligent person can tell you on paper what he or she thought of a play. What distinguishes the good, valuable theater critic, in my view, is that you sense that he's writing about a cause—about a theater in his or her mind. The criticism he is writing is possibly in some ways cloaked, but it is a crusade.[13]

As do previews and feature stories, critical reviews impact attendance and are employed by theaters and galleries for self-promotion. Criticism also attracts readers, which attracts advertisers. However, by tradition, critics attend productions when invited and hold the publication of their critiques until the morning after opening night. As such, critical reviews have the potential to serve additional and grander functions:

The Disruption of Audience Autopilot

Theater critic Jonathan Kalb noted that, for many, entertainment entails "renting a video and watching it on a private box inside a private box," which is an "unthinking envelopment" of an enterprise.[14] This has been referred to as the "cycle of self-hypnosis,"[15] suggesting that the suspension of disbelief that is an implicit and essential ingredient in all entertainment results in the audience's inability to effectively separate itself from the experience during consumption so that it can be dissected, explored, and discussed afterward. In fact, really good entertainment effectively removes us from our real world and facilitates our getting truly lost in a world of fabrication. It is a port of entry into another's life and another kind of living, and it is this vicarious and often cathartic experience that is the gift of the arts.[16]

The critic serves as the surrogate audience member who is also sucked into the vortex of entertainment, but has the wherewithal, discipline, and responsibility to remain partially removed from the experience. Critics are the designated drivers of the arts—the ones who remain sober enough to reflect on, describe, explain, and analyze the entertainment, the vortex, and the mechanics behind the suckage. This, in turn, facilitates the audience's subsequent reflection on its own.

Standard Bearer for the Audience

As a surrogate audience member, critics must understand and appreciate the tastes of the audience and what brings them to the arts. However, critics must also challenge the audience to be more perceptive consumers of the arts they attend, more receptive to the ambitious and innovative arts they do not attend, and more demanding of the arts in their community. Critics are experienced and informed consumers, who have taken the time to acquire the background to evaluate a specific event within established standards for the art, and to share those standards with others. "The purpose of a critic," wrote music critic Allan Rich,[17] is "not to lead his readers into blindly accepting his truths, but to stimulate them, delight them, even irritate them into formulating truths which are completely their own." It is up to the artists to meet, surpass, or miss audience expectations; it is up to the critic to manage expectations by helping to establish standards.

> "Without the consciousness that only a critical infrastructure can supply, [we] are doomed to talk at cross-purposes, or at random; it takes a corps of influential critics to unite individual reactions into a common discussion."
> ~Cynthia Ozick, essayist[18]

Seeing the Big Picture

It has been suggested that the performing arts are where human beings make human action worth watching.[19] Put another way, art reflects life and often provides insight and commentary about the current state of affairs in comparison to the ideal. As such, by showing us how art works, the critic shows us how life works—or isn't working—and calls attention to what literary critic Alfred Kazin noted as "important ideas being presented that are central to social policy and moral behavior."[20] Criticism finds and isolates the greater good or potential evil in a work of art and alerts us to possible implications, ramifications, or consequences, whereas the average consumer may simply see the work.

Providing Advocacy

While a critic must guard against too much personal involvement with the creators of the arts being critiqued, for fear of becoming corrupted and biased, the promotion of good art underlies the critical process. *New York Post* theater critic Clive Barnes[21] said it best when he described critics as "informed enthusiasts." *The New York Times* theater critic Frank Rich once noted that "Artists just happen; they are, if you will, God-given. Audiences, however, have to be created."[22]

Documentation

Art critics predate photography and vividly capture in omne tempus an exhibition, performance, or production. Because stage performances are not typically filmed or recorded, written criticism often constitutes the only surviving record of this intangible art form. Plays, symphonies, and choreography live on, but performances of them do not and written criticism gives permanence to something impermanent, and does so in a way that captures its flavor, value, and power at the time of its presentation. Some theater critics, noted playwright Ronald Harwood,[23] "have been able to quicken our imaginations with a felicitous and lucid phrase so that we may, for a fleeting moment, believe that we have seen the actor, or at least have an inkling of how he acted." Perhaps the most famous example of this was Samuel Taylor Coleridge's vivid reaction to actor Edmund Kean. "To see him act," said Coleridge, "is like reading Shakespeare by flashes of lightning."

Standard Bearer of the Arts

"Critics," noted media scholar Katie Roiphe,[24] "have always decried the decline of standards, the end of reading, the seductions of mediocrity, the abysmal shallowness and distractibility of the general public, the virtually apocalyptic state of

literature and culture…. There is, in this stance of the underdog defender of all that matters, a certain pleasing drama, an attractive nobility." Indeed, critics have long placed themselves in the position of standard bearers—those responsible for maintaining the integrity of and the audience's appreciation of the arts. In 1958, for example, poet and critic Randall Jarrell wrote, "By this time you must be thinking, as I am, of one of the more frightening things about our age: that much of the body of common knowledge that educated people (and many uneducated people) once had, has disappeared or is rapidly disappearing."[25] In 1865, poet and cultural critic Matthew Arnold lamented that "the world will soon be the philistines."[26] "The cave man who grinned disapprovingly at his wife as she flapped her arms to imitate a bird," noted scholar Charles Meister, "probably started it all."[27]

The reporter and the arts writer confer and contribute to an artist's status within the general community. The critic, however, has the potential to impact an artist's reputation within the arts community.

> *"For if the critic is not the maker of dramatic art, he is the person most able to say what it is and at the same time to establish the conditions under which it may flourish."*
> ~Richard Gilman, theater critic, *The New York Times*[28]

It should be noted that there is a difference between a theater critic and a drama critic. Whereas the drama critic concentrates on text—the play—and its literary and cultural-historical value, the theater critic is concerned with the text-in-performance; his/her jurisdiction is the play, the production, and the performance. The theater critic works under time constraints and pressure brought about by directly interacting with the performance, meeting deadlines, and, eventually, encountering feedback from the audience. The theater critic is, according to Stanley Kauffmann, a "front-line critic."[29] The drama critic is "sheltered by the aegis of literary criticism"[30] and runs into little animosity from theater companies, the theatergoing public, or impatient editors.

Critics in Conflict

Clearly, no one has more distain for the arts critic than the artists themselves. And, notes literary critic Ronan McDonald, "among all the arts, the theater is probably the one where the critic—because so traditionally powerful—evokes the strongest loathing and contempt."[31] While arts reporters and feature writers are authorized

to offer an opinion, theater critics offer their opinions with authority, which can and often does challenge the work and expertise of artists. In fact, many of the more prominent critics writing for the most powerful newspapers in the most theater-centric cities in the nation have firmly established themselves as "The Authorities" on theater. As standard bearers, they have made it their life's mission to challenge the arts community. They pushed artists with their well-informed commentary to raise the bar on the quality of their writing and push the envelope on risk-taking theater. And sometimes the artists pushed back (see *What Kind of Man*, in profile).

"If Attila the Hun were alive today, he'd be a drama critic."
~Edward Albee, playwright[32]

Before them, critics the likes of George Bernard Shaw—a brilliant playwright who wrote 151 weekly theater criticism pieces during his stint on *The Saturday Review* between 1895 and 1898—helped create the persona of critic as a smug, sycophantic elitist. Shaw had particular contempt for his contemporary rivals and brought a playwright's bias to his commentary on directing—which he usually referred to as merely "stage management"—producing, scenic design, and, especially, acting. "In an age when acting had declined in America almost to the level of mere behavior," noted John F. Matthews in his collection of Shaw's criticism, "Shaw offered vivid reports and analyses of what acting could and should be at its best, and equally vivid denunciations of what he thought was wrong with it at its worst."[33] Suggested historian Harold Fromm, "Shaw thought of the theater as a temple—not figuratively, but actually. It was a place where a man's highest instincts could and should be nourished."[34] And if what was being offered was perceived to be lacking in nourishment or if all the theatrical food groups were not well represented, Shaw would condemn the enterprise as offering, for example, a "dull routine of boom, bankruptcy and boredom" or chastise the performers for their "eternal clamor for ignominious collapse."[35]

Adding to the animosity between critic and artist, the history of arts journalism reveals a track record that is often out of synchrony with popular tastes. As was noted earlier, the feature writer and entertainment reporter have standards no more demanding than the average member of the audience, but the critic is a potential agent for change in how an audience views the arts as well as the very nature of the arts themselves.

Nothing fuels the divide between critic and artist more than when one of the parties is proven "wrong," such as when plays are condemned on all accounts but become smash hits. *The New York Times* theater critic Ben Brantley, for example,

What Kind of Man, in profile

Lyrics from the musical *Curtains* by John Kander and Fred Ebb

Critics!
Who'd make a living out of killing other people's dreams? I mean…
What kind of man would take a job like that
What kind of slob would take a job like that
Who could be mean enough
Base and obscene enough
To take a job like that
What kind of mom would raise her boy like that
Who'd want her baby to destroy like that
Who could be jerk enough
Hard up for work enough
To want a job like that.
Ohhhhhhhhhh what kind of low down dirty bum
Ohhhhhhhhhh what kind of swine-ish scurvy scum
Loathsome as they come, I wonder
What kind of man would want a job like that
What kind of putz would squeeze your nuts like that
Who could be prick enough
Mentally sick enough
Who'd want to grow to be
Everyone's enemy
Critics are hated and
So excoriated tell me
What kind of man
Would want a job like that

called the eventual mega-hit musical *Mamma Mia* "bland, hokey, corny, stilted, self-conscious and—let's not mince words—square"[36] while *New York* magazine theater critic John Simon noted: "The Italian exclamation 'Mamma mia!' usually expresses a not entirely pleasurable surprise…which is pretty much my reaction to the musical *Mamma Mia.*"[37] Samuel Beckett's *Waiting for Godot* had a similar fate (see *Waiting for Godot,* in profile).

More recently, the severely over-budgeted and accident-prone Broadway musical *Spider-Man: Turn Off the Dark* was ruthlessly and consistently panned by the

Waiting for Godot, in profile

In 1956, upon the New York premiere of Samuel Beckett's avant-garde play *Waiting for Godot, The New York Times* theater critic Brooks Atkinson had this to say:[38]

> Don't expect this column to explain Samuel Beckett's *Waiting for Godot*, which was acted at the John Golden last evening. It is a mystery wrapped in an enigma…. The point of view suggests Sartre—bleak, dark, disgusted. The style suggests Joyce—pungent and fabulous. Put the two together and you have some notion of Mr. Beckett's acrid cartoon of the story of mankind….*Waiting for Godot* is an uneventful, maundering, loquacious drama.

The play came to be considered an essential example of "Theater of the Absurd," which revolutionized theater in the 20th century. In fact, in his 2009 review of the Broadway revival of *Waiting for Godot, The New York Times* critic Ben Brantley noted that "this greatest of 20th century plays is also entertainment of a high order."[39]

As if he were anticipating adversity from the critics, Beckett makes that profession the most grievous insult among the many exchanged between the play's two main characters:

VLADIMIR: Moron! ESTRAGON: Vermin!
VLADIMIR: Abortion! ESTRAGON: Morphion!
VLADIMIR: Sewer Rat! ESTRAGON: Curate!
VLADIMIR: Cretin! ESTRAGON [with finality]: Crritic!

"A drama critic is a man who leaves no turn unstoned."
~George Bernard Shaw, playwright and critic[40]

critics[41] during its 2010 previews. Comments from critics included "a shrill, insipid mess" (*The Washington Post*), "under-baked, terrifying, confusing" (*New York* magazine), and "so grievously broken in every respect that it is beyond repair" (*The New York Times*).[42] According to *Bloomberg's* Jeremy Gerard, this is "a show still struggling to find its way."[43] Yet, the show opened to phenomenal box office success[44] (see *Spider-Man* Success by the Numbers, in profile).

Further lessening the credibility of critics in the eyes of the artists, many productions have received high praise, such as the Broadway drama *Journey's End* ("*Journey's End…*is that theatrical rarity, an uncompromising, clear-eyed play about war" (*The*

New York Times),[45] only to result in abysmal ticket sales and an eventual dishonorable discharge after only 125 performances. After the April 4, 1964 opening of Stephen Sondheim's *Anyone Can Whistle*, the critic at the *New York World Telegram & Sun* wrote: "Were I a less inhibited creature, I'd spend the next month hurling roses at the Majestic Theatre....You have no idea how many breath-taking surprises are in store for you in the musical." The show closed after nine performances. Sometimes high praise from the critics catches the marketing personnel at theaters off guard, which was the case with the staged version of the campy film-turned-musical *Xanadu*. After its opening weekend, the ads read: "The critics loved it. Seriously."[46]

Spider-Man's Success by the Numbers, in profile

The disastrous preview performance of Broadway's *Spider-Man: Turn Off the Dark* on November 28, 2010—which was stopped five times due to technical mishaps that included the actor playing Spider-Man left dangling over the stage—resulted in a flood of negative headlines, damning reviews and late-night television ridicule. One year later, the show set a new box office record and helped revive Broadway's economy.[47] Here is a look[48] at the show's surprising financial success:

$75 million—The record-setting amount it took to produce *Spider-Man*.

$5 million to $15 million—Typical production costs of most Broadway musicals.

$1.2 million—Operating expenses per week to keep *Spider-Man* running.

$100,000 to $300,000—Net income that *Spider-Man* was earning each week, prior to its surge in revenue one year after the first preview.

5–Years the show would have to run to recoup its initial investment if it continued netting $100,000 to $300,000 per week. Recent tourist-friendly musicals like *The Little Mermaid* and *Shrek: The Musical* ran for just over a year.

$2.07 million—*Spider-Man's* box office gross one year after the disastrous preview, a house record at the Foxwood Theatre.[49]

665,395—Tickets sold for the show since it first began previews in 2010.[50]

$314—Current top price for a *Spider-Man* ticket.

$138.37—Average ticket price for a performance the week of November 28, 2011.[51]

$97—Average ticket price for a performance a year earlier.[52]

"Any critic who is any good is going to write out of a pro-found inner struggle between what has been and what must be, the values he is used to and those which presently exist, between the past and the present out of which the future must be born."

~Alfred Kazin, literary critic[53]

Clearly, at the very heart of arts criticism is conflict, and not just between critic and artist. Criticism itself entails two dramatically conflicting impulses.[54] The first impulse is to embrace the known, firmly established, and consecrated foundations that define the art form under critical review, and to compare a current work accordingly. This impulse recognizes long, hard fought, but readily accepted standards and artistic conventions against which to evaluate new work. The conflicting impulse is to yearn for something new, something different, something innovative, something risky. This approach embraces art as a changing, evolving, and risk-taking enterprise where a new set of standards should be encouraged and rewarded. Often, in the practice of criticism, a choice emerges: to defend old standards and values against new ones or to defend the new against the old. Every critic has had this internal argument, as can be seen in poet Samuel Butler's 1678 treatise on this very subject (see *Upon Critics Who Judge of Modern Plays Precisely by the Rules of the Ancients*, in profile).

Critics as Privileged Communicators

By openly and often harshly criticizing artists and their works, it would seem as if the craft of criticism is a libelous enterprise, fraught with lawsuits. After all, libel is a legal claim for false statements of fact about a person that are printed, broadcast, spoken, or otherwise communicated to others. Libelous statements are defamatory, meaning that they actually harm the reputation of another person.

Actually, criticism is an aspect of free speech guaranteed by the Bill of Rights and has even been identified and protected as "privileged communication," a claim that has been specifically addressed and reinforced in the courts.[55] A precedent-making case occurred in 1904 (*Triggs v. Sun Printing and Publishing*), in which the court wrote: [56]

The single purpose of the rule permitting fair and honest criticism is that it promotes the public good, enables the people to discern right from wrong, encourages merit, and firmly condemns and exposes the charlatan and the cheat, and hence is based upon public policy. The distinction between criticism and defamation is that criticism deals only with such things as invite public attention or call for public comment, and does not follow a public man into his private life or pry into his domestic concerns…. A true critic never indulges

Upon Critics Who Judge of Modern Plays Precisely by the Rules of the Ancients, in profile

A Poem by Samuel Butler, 1678[57]

"Who ever will regard poetic fury
When it is once found idiot by a jury
And ev'ry pert and arbitrary fool
Can all poetic license over rule
Assume a barbarous tyranny to handle
The Muses worse than Ostrogoth and Vandal[a]
Make 'em submit to verdict and report
And stand or fall to th' orders of a court
Much less be sentenced by the arbitrary
Proceedings of a witless plagiary
That forges old records and ordinances
Against the right and property of fancies
More false and nice than weighing of the weather
To th' hundredth atom of the lightest feather
Or measuring of air upon Parnassus[b]
With cylinders of Torricellian glasses[c]
Reduce all Tragedy by rules of art
Back to its antique theater a cart
And make them henceforth keep the beaten roads
Of reverend choruses and episodes
Reform and regulate a puppet play
According to the true and ancient way
That not an actor shall presume to squeak
Unless he have a license for't in Greek"

a Six major German tribes, the Ostrogoths, the Vandals, the Visigoths, the Burgundians, the Lombards, and the Franks participated in the fragmentation and the eventual collapse of the Western Roman Empire.

b Mount Parnassus is located in central Greece. According to Greek mythology, the mountain was sacred to Apollo and the Corycian numphs, and the home of the Muses. This is believed to be the home of poetry, literature, and learning.

c Torricelli is the Italian philosopher and mathematician who discovered, in 1643, that the rise of a liquid in a tube, as in the barometer, is due to atmospheric pressure.

in personalities, but confines himself to the merits of the subject matter, and never takes advantage of the occasion to attain any other object beyond the fair discussion of matters of public interest and the judicious guidance of public taste.

In 1929, the case of *Hoeppner v. Dunkirk Printing Co.* spoke specifically to theater criticism:[58]

> Every one has a right to comment on matters of public interest and concern, provided he does so fairly and with an honest purpose. Such comments or criticisms are not libelous, however severe their terms, unless they are written maliciously. Thus…actors and exhibitors are all the legitimate subject of newspaper criticism, and such criticism fairly and honestly made is not libelous, however strong the terms of censure may be.

In 1964, the case of *The New York Times v. Sullivan* specifically laid out the major elements of the "fair comment and criticism" privilege afforded arts critics, further protecting them from lawsuits:[59]

1. The art form or subject matter being criticized must be one of public interest;
2. Critical comments or opinions about any popular art form must be based on facts or factual situations;
3. Critics may not overstep the line laid down by the law to comment on the private life of the individual whose work or qualifications are being considered;
4. The critic's comments are a fair and honest expression of opinion, regardless of what others may think of such views; and
5. Unless malice is proven—that is, the knowing desire to inflict injury, harm, or suffering on another—the right of critics to criticize is practically unlimited.[60]

While privileged and protected communication, criticism is not guaranteed communication. Theaters are free to "ban" critics from a performance or from their theaters. This precedent was set back in 1915 when the Shubert brothers, who owned several Broadway theaters, banned *The New York Times* critic Alexander Woollcott from their venues. It all started on March 17, 1915, when the Shuberts opened the show *Taking Chances*. Woollcott's critique appeared the next day and noted that the play was "not vastly amusing" and "not much energy and ingenuity was left for the reconstruction of a good play. It must be said that the resulting product is quite absurd and little more than that."[61] Woollcott was not the only critic to lambast *Taking Chances*. In fact, the play drew six mixed reviews and eight pans from the powerful New York press. On April 1, 1915, Woollcott presented his tickets to see another Shubert play but was denied admission, a decision that was ultimately held up in court. In response, the *Times* refused to run advertising for Shubert shows, and eventually, feeling the fiscal pinch, the Shuberts relented and Woollcott was back in his orchestra seat on the aisle.

This "banning" entailed refusal to provide Woollcott with the traditional pair of complimentary tickets to opening night performances; a tradition that still exists

today. However, if a critic, or any other person, holds a ticket to a show that was purchased, he or she cannot be ejected or excluded from the performance since he or she is attending as a citizen—a customer. This, too, was also upheld in court.[62] Does this mean that, as a customer, a critic is no longer a critic? This very issue surfaced recently regarding the maligned Broadway musical *Spider-Man: Turn Off the Dark* (see The Critic-Critic v. The Non-Critic Critic, in profile).

Critics as Creative Communicators

As privileged and protected communicators, critics have the additional burden of being effective communicators. More to the point, while previews make for a light and interesting read, criticism should be a thought-provoking and intriguing read. As such, critics write stylishly, concentrating on the perfect word, the excellent sentence, the fluid prose, and the graceful turn of a phrase, all in their distinctive and singular voices and from their definitive perspectives. "Critical authority," suggests arts journalism scholar Katie Roiphe,[63] "comes from the power of the critic's prose, the force and clarity of her language; it is in the art of writing itself that information and knowledge are carried…. If critics can fulfill this single function, if they can carry the mundane everyday business of arts criticism to the level of art, then they can be ambitious and brash." As referees of the muses, critics must tap into their own muses as well.

As is evident throughout this book, the most prominent and powerful arts critics of the past have been brilliant writers. However, the attainment of critical authority through good writing is particularly important today, with so many online reviewers and bloggers vying for attention and a readership. There is no shortage of enterprising critics on the Internet, but much of what is written consists of careless, woefully misspelled rages, grammatically unsound rants, and poorly phrased praises from someone who claims to love the arts yet fails to pay sufficient attention to his/her own craft: writing.

The best way for a critic to get attention and an audience is to write on a different level than the others. "The answer to the angry Amazon reviewer who mangles

> "*The instant thumbs-up or thumbs-down so beloved by the Internet is only the smallest part of a critic's job. The rest involves writing—exploring, simultaneously, the work under review and the critic's response to it. Oscar Wilde's definition of criticism applies: 'the record of a soul.'*"
> ~Michael Feingold, theater critic[64]

The Critic-Critic v. The Non-Critic Critic, in profile

In 2010, theater critics turned on *Spider-Man: Turn Off the Dark*, the Broadway musical that boasted a comic book storyline further popularized by several films, a musical score by U2's Bono and The Edge, and staging by Julie Taymor, who turned a Disney animated film, *The Lion King*, into one of the most successful Broadway musicals of all time.

At issue, according to the show's producers, is that these comments were not fair, since critics are expected not to post their comments until a performance is finalized. These criticisms were published while the production was still in previews. These critics broke a long-held trust that they attend productions when invited and to hold the publication of their reviews until opening night. In exchange, critics receive complimentary tickets, usually a pair.

Some critics say that the show's four delayed openings due to technical snafus that led to serious injuries to the cast and crew, and the lengthy preview period—being longer than some shows actually run on Broadway—was the cause for their early commentary. Plus, they paid for their own tickets (*Bloomberg*'s Jeremy Gerard's orchestra seat cost $292.50). Other critics, such as *The New York Times*' Charles Isherwood, noted that while the global media circus surrounding *Spider-Man*'s difficulties may explain critics "feeling like the last in line at the buffet," a work of art, "should be allowed to achieve the completed form its creators had envisioned before judgment is rendered."[65]

According to *Huffington Post* critic Leonard Jacob,[66] this protocol breach represents an important opportunity to review "how utterly outmoded the protocol really is. It offers us a chance to ask what constitutes a critic." He suggests:

> The whole idea that such critics still operate in some lofty, rarefied universe, with the unwashed masses breathlessly awaiting their verdict before deciding whether or not to buy tickets, is astonishingly 1970 (or earlier) in its thinking. In the real world, traditional-media critics and even some online critics compete constantly, unrelentingly, with the rest of the well-wired world for influence. Traditional-media critics can look askance all they like at twittery chit-chat websites...but the fact is, even the occasional tweet can be as informative as the scribblings of the reviewing gods. Those who carp over what Gerard and others did are clinging to the idea that they're gatekeepers. The gate is wide open.

Let's tie this back to the source of the upset within the community of critics: that Gerard and [others] did not wait for their complimentary tickets before publishing their *Spider-Man* reactions.... Surely Gerard and [others] are non-critic critics writing non-review reviews. A critic-critic is someone who accepts complimentary tickets and a non-critic critic is someone who buys his or her own.

sentences in an effort to berate or praise an author," notes Roiphe,[67] "is the perfectly constructed old-fashioned essay that holds within its well-formed sentences and graceful rhetoric the values it protects and projects."

Critics as New-Wave Communicators

The 21st century has brought many challenges to arts reporting and arts criticism. Downsizing throughout the traditional media has left fewer professional critics working at newspapers and magazines in the United States. The professional responsibilities of those remaining critics continue to expand. Today it is rare that a critic at a mid-size daily American newspaper is responsible for covering just one of the performing arts disciplines. The theater beat might be paired with the dance beat, dance with music, and music with theater. Or, in some cases, one critic does it all in the guise of the entertainment critic. The theater critic might be asked to cover not only professional productions but amateur and academic productions as well. In addition, critics are now taking on yet another role: that of reporter, by writing entertainment news and feature stories or promotional pieces for the very productions they will be critiquing in a separate article.

Add to the mix blogging, tweeting, and whatever new forms of social media come to fruition, for critics must now reach audiences wherever and whenever they can be found. Increasingly, theater critics work on many platforms—traditional print (newspapers and magazines) or on-air media (radio and television), online (websites and blogs) and with social media. All of these platforms have benefits. All speak to the changing media landscape, and how arts journalists must adapt this landscape in order to be heard above the noise of the crowd. All require expertise to operate effectively. There are a lot of voices out there yearning to be heard, and many channels of communication through which to hear them. If a critic wants to be the one in the crowd that the crowd listens to, s/he needs to become a 24/7 critic working in a 24/7/365 media landscape. "Backpack journalism"—a term typically applied to broadcast news reporters who carry their own equipment, are the writers, editors, and producers of their own stories, and oftentimes communicate their stories from remote locations using the latest in portable technologies—has become a way of life for many arts critics.

Summary

Arts journalists are no longer seen running from opening nights of theatrical events, art exhibits, dance recitals, or symphonic performances to make deadline for the morning editions. Times have changed. Yet, despite the infusion of new technology in the process of writing, reporting, and receiving information, the role of the critic has essentially remained the same.

...

*"I have two jobs, reporter and critic, and sometimes they
are in conflict."*
~Kerry Lengel, theater critic, *Arizona Republic*[68]

...

This chapter suggests that the critic serves as the sober observer of an intoxi-
cating experience, who possesses the wherewithal, discipline, and responsibility
to reflect on, creatively describe, thoughtfully explain, and critically analyze the
experience in the hope of facilitating the audience's own reflections and analysis.
In doing so, critics also challenge the audience to be more perceptive consumers of
the arts they attend, more receptive to the ambitious and innovative arts they do
not attend, and more demanding of the arts in their community. As such, critics
are arts advocates and informed enthusiasts but, also, standard bearers who push
the artists themselves to greater heights and greater risks.

In order to serve these functions, several key elements that define arts critics
and which separate them from arts writers and entertainment reporters were iden-
tified, including:

- Critics consider the value of an event beyond the obvious or superficial. They
 do so by placing the event in a larger context and under greater scrutiny.
- Critics address an event's potential. While arts writers and reporters con-
 vey what a particular cultural event is and describe what it is about, critics
 also contemplate what it could be or, perhaps, should be.
- Critics analyze. Rather than concentrating on the journalistic practices
 of synthesis and verification, critics add interpretation to the event being
 covered, and do so by asking and addressing "so?" (as in "So, what is par-
 ticularly intriguing about this play and this production?"), "how?" (as in
 "How is this play and production able to accomplish what it did?"), and
 "so what?" (as in "So what are we to take away from this play and this pro-
 duction of it?").
- Criticism's constituents are consumers, practitioners, and the critics'
 own consciences.
- Critics do not relinquish independence or personal opinion, while most
 arts journalists do. A piece of criticism leads to a subjective conclusion.

Serving the arts and the audience in this capacity is not without its own risks and
challenges. As privileged communicators, critics have the freedom to offer practically
unlimited value-laden opinion that is protected under the law, as long as it addresses
an art form or subject matter of public interest, and is fair, honest, and without mal-
ice. Still, such opinion has the potential to impact the reputation, finances, and enter-
prise of artists. The output of a critic carries significant weight and responsibility.

As professional communicators, critics need to write stylishly. They need to concentrate on the perfect word, the excellent sentence, the fluid prose, and the graceful turn of a phrase, all in their distinctive and singular voices and from their definitive perspectives. Most importantly, critics need to engage in critical thinking. Critical thinking is addressed in the next chapter.

KEY CONCEPTS FROM THIS CHAPTER

Arts writer	Front-line critic
Audience autopilot	*Hoeppner v. Dunkirk Printing Co.*
Backpack journalist	Manage expectations
Critic-critic	Non-critic critic
Critic defined	Preview performances
Critical authority	Previewers as parasites
Criticism as advocacy	Primary function of criticism
Criticism as documentation	Privileged communication
Criticism as histoire morale	Public relations and promotions
Criticism as a libelous enterprise	Suspension of disbelief
Criticism as standard bearer	The "5-Ws"
Criticism as the disruption of audience autopilot	The "how"
Cycle of self-hypnosis	The "so"
Drama critic	The "so what"
Entertainment reporter	*The New York Times v. Sullivan*
Fair comment and criticism	*Triggs v. Sun Printing and Publishing*

NOTES

1 As quoted in Jonathon Green, *The Cynic's Lexicon: A Dictionary of Amoral Advice* (London: Routledge & K. Paul, 1984), 20.

2 A.A. Gill, "It's Curtains for the Critics," *The Sunday Times*, June 24, 2007 http://entertainment .timesonline.co.uk/tol/arts_and_entertainment/stage/theater/article1961473.ece (accessed December 10, 2010).

3 Jonathan Kalb, *Play by Play* (New York: Limelight Editions, 2003), 24.

4 Richard Gilman, *Common and Uncommon Masks* (New York: Random House, 1971), 14.

5 Ibid.

6 Cited in Bert Cardullo, *American Drama/Critics: Writings and Readings* (London: Cambridge Scholars Publishing, 2007), 165.

7 Cited in Martin Gottfried, *Opening Nights: Theater Criticism of the Sixties* (New York: G.P. Putnam's Sons, 1960), 16.

8 Cited in Northrop Frye, *The Anatomy of Criticism* , http://northropfrye-theanatomyofcriticism. blogspot. com/2009/02/polemical-introduction.html (accessed December 10, 2010).

9 See Irving Wardle, *Theater Criticism* (New York: Routledge, 1992).

10 Cited in The Nieman Foundation For Journalism, "Essays About 'The Elements of Journalism,'" 55(2), 2001, http://www.nieman.harvard.edu/assets/pdf/Nieman%20Reports/ProfCorner/elements.pdf (accessed January 13, 2013).

11 Leonard Jacobs, "50 Thoughts on Theatrical Criticism," from http://www.clydefitchreport. com/2009/10/50-thoughts-on-theatrical-criticism-revisited-1-to-25/ (accessed November 27, 2012).

12 Cited in John W. English, *Criticizing the Critics* (New York: Hastings House Publishers, 1979), 18.

13 Cited in Bert Cardullo, "The Theater Critic as Thinker," *New Theater Quarterly*, 25, 2009, 316.

14 Kalb, *Play by Play*, 34.

15 Wardle, *Theater Criticism*, 7.

16 See Erin Hurley, *Theater & Feeling* (New York: Palgrave Macmillan, 2010).

17 Cited in Robert D. Thomas, "Obituary: Alan Rich," *Pasadena Star-News*, April 24, 2010, http:// classact.typepad.com/robert_d_thomasclass_act/2010/04/index.html (accessed April 24, 2010).

18 Cynthia Ozick, "Literary Entrails," *Harper's Magazine*, April 2007, 67.

19 Paul Woodruff, *The Necessity of Theater: The Art of Watching and Being Watched* (New York: Oxford University Press, 2008), 18.

20 See Alfred Kazin, "The Function of Criticism Today," *Commentary*, November 1960, 496, 498.

21 Cited in Palmer, *The Critics' Canon* (New York: Greenwood Press, 1988), 15.

22 Frank Rich, "Presentation," Americans for the Arts' 14th Annual Nancy Hanks Lecture on Arts and Public Policy, March 19, 2001, 13, http://www.americansforthearts.org/NAPD/files/ 10236/ Hanks%20Lecture,%20Frank%20Rich%20(May%20'01).pdf (accessed December 10, 2010).

23 Cited in Ronald Harwood, "Theater Critics are Like Eunuchs in a Harem," *The Independent*, December 19, 2000, http://www.independent.co.uk/opinion/commentators/ronald-harwood-theater-critics-are-like-eunuchs-in-a-harem-629271.html (accessed December 10, 2010).

24 Katie Roiphe, "With Clarity and Beauty, the Weight of Authority," *The New York Times*, December 31, 2010, http://www.nytimes.com/2011/01/02/books/review/Roiphe-t-web.html (accessed January 5, 2010).

25 Randall Jarrell, *Poetry and the Age* (New York: Vintage, 1959).

26 Cited in Roiphe, "With Clarity and Beauty."

27 Charles W. Meister, *Dramatic Criticism* (London: McFarland & Company, Inc, 1985), 3.

28 Cited in Cardullo, *American Drama/Critics*, 167.

29 Stanley Kauffman, *Persons of Drama: Theater Criticism and Comment* (New York: Harper, 1976), 377.

30 Ibid, 376.

31 Ronan McDonald, *The Death of the Critic* (London: Continuum, 2007), 9.

32 Cited in Leonard Jacobs, "50 Thoughts on Theatrical Criticism," *The Clyde Fitch Report*, October 28, 2009, http://www.clydefitchreport.com/2009/10/50-thoughts-on-theatrical-criticism-revisited-1-to-25/ (accessed October 26, 2010).

33 John F. Matthews, *Shaw's Dramatic Criticism* (New York: Hill and Wang, 1959), vi.

34 Harold Fromm, *Bernard Shaw and the Theater in the Nineties: A Study of Shaw's Dramatic Criticism* (Lawrence, KS: The University of Kansas Press, 1967), 203.

35 Cited in Cardullo, *American Drama/Critics*, 167.

36 Ben Brantley, "Mom Had a Trio (and a Band, Too)," *The New York Times*, October 19, 2001, http://www.didhelikeit.com/shows/mamma-mia-reviews.html (accessed October 26, 2010).

37 John Simon, "Greek to Me," *New York*, October 19, 2001, http://nymag.com/nymetro/ arts/theater/reviews/5312/ (accessed October 26, 2010).

38 Cited in http://www.nytimes.com/books/97/08/03/reviews/beckett-godot.html (accessed December 23, 2010).

39 Ben Brantley, "Eternal Tramps," *The New York Times*, May 1, 2009, http://theater.nytimes. com/2009/05/01/theater/reviews/01godo.html (accessed December 23, 2010).

40 Cited in McDonald, *The Death of the Critic*, 76.

41 See, for example, "Could the Musical 'Spider-Man' be the Biggest Disaster in Broadway History," *The Week*, January 12, 2011, http://theweek.com/article/index/206033/could-the-musical-spider-man-be-the-biggest-disaster-in-broadway-history (accessed January 12, 2011).

42 Cited in Michele Goncalves, "Another Bumpy Ride for Spider Man on Broadway," *Epoch Times*, February 14, 2011, http://www.theepochtimes.com/n2/arts-entertainment/spider-man-on-broadway-another-bumpy-ride-51357.html (accessed February 14, 2011).

43 Jeremy Gerard, "Spidey Flails in Taymor's Tale of Spider Woman," *Bloomberg*, December 26, 2010, http://www.bloomberg.com/news/2010-12-27/spidey-green-goblin-flail-in-taymor-s-tale-of-spider-woman-jeremy-gerard.html (accessed December 26, 2010).

44 See Mark Kennedy, "Strong 'Spider-Man' Demand Makes Producers Smile," *Associated Press*, June 28, 2011, http://beta.news.yahoo.com/strong-spider-man-demand-makes-producers-smile-195821473.html (accessed June 28, 2011).

45 Ben Brantley, "For Comrades in Arms, Waiting and Nothingness," *The New York Times*, February 23, 2007, http://theater.nytimes.com/2007/02/23/theater/reviews/23jour.html?pagewanted=1 (accessed June 28, 2011).

46 Cited in David Rooney, "The Perils of Giving Praise," *Variety*, October 12, 2007, http://www.variety. com/index.asp?layout=print_story&articleid=VR1117973975&categoryid=2524 (accessed June 28, 2011).

47 Cited in http://www.reuters.com/article/2011/01/04/us-stage-broadway-idUSTRE7030CB2011 0104 (accessed May 16, 2012).

48 Compiled and reported in "*Spider-Man*'s Surprise Broadway Success: By the Numbers," *The Week*, November 29, 2011, http://theweek.com/article/index/221906/spider-mans-surprise-broadway-success-by-the-numbers (accessed November 29, 2011).

49 Chris Michaud, "Broadway's Spidey Breaks Theatre Box Office Record, *Reuters*, November 28, 2011, http://www.reuters.com/article/2011/11/28/us-stage-spiderman-idUSTRE7AR1NV20111128 (accessed November 29, 2011).

50 Aubry D'Arminio, "Happy Birthday 'Spidey,'" *Entertainment Weekly*, November 28, 2011, http:// popwatch.ew.com/2011/11/28/happy-birthday-spider-man-turn-off-the-dark-hope-you-asked-for-cash/ (accessed November 29, 2011).

51 Cited in http://broadwayworld.com/grosses.cfm

52 Cited in Catherine Rampell, "'Spider-Man' Economics: Recouping That Initial Investment," *The New York Times*, December 14, 2010, http://economix.blogs.nytimes.com/2010/12/14/spider-man-economics-recouping-that-initial-investment/ (accessed November 29, 2011).

53 Cited in Stephen Burn, "Why Criticism Matters," *The New York Times*, January 2, 2011, http://www.nytimes.com/2011/01/02/books/review/Tanenhaus-t.html (accessed January 2, 2011).

54 Ibid.

55 See, for example, Kathy Roberts Forde, *Literary Journalism on Trial* (Amherst, MA: University of Massachusetts Press, 2008).

56 Cited in Philip Wittenberg, *Dangerous Words* (New York: Columbia University Press, 1974), 117.

57 J.E. Springarn, *Critical Essays of the Seventeenth Century, Vol. II, 1650–1685* (Oxford: Clarendon Press, 1908), 278-281. See, also, Samuel Butler, "Upon Critics Who Judge of Modern Plays Precisely by the Rules of the Ancients," in *Dramatic Theory and Criticism: Greeks to Grotowski*, (Ed.), Bernard F. Dukore (New York: Holt, Rinehart, and Winston, 1974), 339–341.

58 Ibid, 94.

59 Cited in John W. English, *Criticizing the Critics* (New York: Hastings House Publishers, 1979), 14.

60 In 2008, author Sarah Thornton took legal action against the Telegraph Media Group over a book review by Lynn Barber that was said to contain "malicious falsehood." In 2011, the court ordered The Telegraph Media Group to pay £65,000 in damages when it noted that the *Telegraph* columnist was "spiteful" and the review contained serious factual errors. Thornton hailed the ruling as a matter of "journalistic integrity." She added: "At a time when the ethics of the tabloids are under scrutiny, here is an example of a 'quality' journalist's abuse of power." The judge was careful to say in his summary that "a reviewer is entitled to be spiteful as long as she is honest." Cited from http://www.guardian.co.uk/stage/theatreblog/2011/jul/ 29/theatre-critics-review-giving-offence (accessed July 29, 2011).

61 Cited in Bennett Liebman, "Spider-Man Can't Turn Off the Critics," January 7, 2011, http://nysbar.com/blogs/EASL/ (accessed January 7, 2011).

62 Ibid. The Woollcott decision remained in place until 1941, when the legislature enacted a new addition to the Civil Rights Law (Ch. 893, L. 1941).

63 Cited in Roiphe, "With Clarity and Beauty."

64 Michael Feingold, "Theater Criticism Reconfigured," *The Village Voice*, August 11, 2009, retrieved from http://www.villagevoice.com/content/printVersion/1303580/ (accessed February 17, 2011).

65 Cited in Leonard Jacobs, "Ensnaring Theater Critics in the *Spider-Man* Web," *The Huffington Post*, February 17, 2011, http://www.huffingtonpost.com/leonard-jacobs/ensnaring-theater-critics_b_806101.html (accessed February 17, 2011).

66 Ibid.

67 Cited in Roiphe, "With Clarity and Beauty."

68 Kerry Lengel, personal interview with author, September 1, 2011.

"Although many of us may think of ourselves as thinking creators that feel, biologically we are feeling creators that think."

~Jill Bolte Taylor, author[1]

Chapter 4 Abstract

This chapter starts us on our way to becoming more thoughtful arts consumers and critics by examining the thought process associated with criticism itself. This chapter distinguishes between everyday thinking and the type of thinking in which a critic needs to engage—that is, critical thinking.

Critical Thinking

All of us think. That is, we use our intelligence and experience to consider something carefully. When something is important, we ponder, reflect, analyze, examine, and sort out information and evidence. We generate theories, which combine this information into a unified, comprehensive whole. We create hypotheses, which apply these theories to form tentative explanations. We form ideas or opinions, and we determine, resolve, and work things out. Rationality, common sense, and reasoning often guide our thinking. However, so too do emotions, instincts, bad habits, and superstition. We are all prone to over-react, rush to judgment, and leap to conclusions.

The thinking process usually passes through the following six stages, and does so quickly:[2]

- **Stage 1: Interest:** The thinker becomes aware of a problem, situation, or event and his/her interest is aroused;
- **Stage 2: Attention:** The problem, situation, or event becomes a priority, is put into focus, its nature is ascertained through observation and reflection, and relevant data from memory and experience are recalled and reviewed;
- **Stage 3: Suggestion:** Possible solutions to the problem, resolutions for the situation, or opinions regarding the event surface, based on memory and past experience;
- **Stage 4: Reasoning:** The possible consequences of each suggested solution, resolution, or opinion are briefly considered;
- **Stage 5: Conclusion:** The most satisfactory solution, resolution, or opinion is selected; and
- **Stage 6: Test:** The adopted suggestion is put to the test and into practice.

Feeling and thinking are integral outcomes of experiencing any art, of processing the images and stories being told by others from their unique perspective in their unique ways. To make sense of what is being told, to react to it emotionally, to take something away from the experience requires interest, attention, contem-

"I think, therefore I am."
~Rene Descartes, 16th–17th century philosopher[3]

plation, and the drawing of conclusions. When partaking in theater, for example, it is nearly impossible not to be a thinking, actively engaged individual, for this is a living, vibrant, real-time event where both the performers and audience members have purposefully gathered, breathe the same air, share the same space, and are fully aware of each other's immediate presence. Theater, as are other arts, is an occurrence that is fraught with purpose and intent, where an infinite number of creative choices are made for the purpose of engaging an audience. This includes the story being told, the formation of characters, the staging... even the establishment of the correct theatrically aesthetic distance—that is, the proper psychological and physical separation between the performers and the audience to facilitate a desired level of intimacy and involvement. Playwright Edward Albee suggested that theater "demanded the audience be involved" and went so far as to suggest that theater experience should be a "disturbing" one.[4]

Art consumers think, but arts critics engage in critical thinking, which is a more purposeful, elaborate, and time-consuming process. It is characterized by a watchful, exact, and repeated evaluation and judgment, the conducting of a serious search for information above and beyond one's own experience and memory, which is then contemplated and weighed before making a decision or forming an opinion. Engaging in critical thinking is lining up all of the essential critical elements of the subject matter in question and cautiously analyzing them before deliberating and rendering a decision or an opinion. Critical thinking is at the very heart of being a critic and, as we discovered in the previous chapter, is the principle factor that distinguishes a critic from a reviewer.

Unfortunately, being "critical" has negative connotations. It is often perceived as fault-finding, skeptical, captious, and severe. Critical thinkers are often characterized as those who are overly judgmental, unduly exacting, or perversely hard to please. Critical thinkers are thought of as serious, glass-half-empty types of people.

"[Critical thinking is a] desire to seek, patience to doubt, fondness to meditate, slowness to assert, readiness to consider, carefulness to dispose and set in order, and hatred for every kind of imposture."
~Francis Bacon, 16th–17th century philosopher[5]

Theater Critic Joke, in profile

Q: How many theater critics does it take to screw in a light bulb?

A: All of them. One to be highly critical of the design element, one to express contempt for the glow of the lamp, one to lambast the interpretation of wattage used, one to critique the performance of the bulb itself, one to recall superb light bulbs of past seasons and lament how this one fails to measure up, and all to join in the refrain, reflecting on how they could build a better light bulb in their sleep.

The Stages of Critical Thinking

Critical thinking is not implicitly negative. In fact, it is a very creative and constructive enterprise. Creativity entails the process of making or producing, while criticality is a process of assessing or judging. When engaged in high-quality critical thought, the mind must simultaneously produce and assess, both generate and judge the products it fabricates. In short, critical thinking requires imagination and creativity as well as intellectual standards.

Considering the stages of the thinking process previously identified, critical thinking, as presented by Sir Francis Bacon, would include additional stages (**in bold**):

- Stage 1: Interest: The thinker becomes aware of the problem, situation, or event and his/her interest is aroused;
- Stage 2: Attention: The problem, situation or event is put into focus, its nature is formulated, and relevant data from memory and experience is recalled and examined;
- **Stage 2a: Desire to seek:** Rather than relying solely on personal memory and past experience to serve as the data on which to contemplate when thinking about a problem or situation or event, the critical thinker seeks out additional information. The critical thinker is motivated to pursue supplementary, alternative, and potentially contradictory information from reliable secondary sources to flesh out the problem, situation, or event under consideration;
- **Stage 2b: Patience to doubt:** Rather than allowing personal memory and past experience to automatically trump reliable secondary information, the critical thinker will consider that personal memory is highly subjective, potentially distorted by time and circumstance and, thus, biased and

potentially clouding judgment. Critical thinking leads to judgment but begins with an open mind;

- Stage 3: Suggestion: Possible solutions to the problem, resolutions for the situation, or opinions surface;

- **Stage 3a: Fondness to mediate:** The critical thinker will contemplate and reconcile contradictions between personal perception and secondary information before generating viable solutions or rendering an opinion. Compared to standard thinking, critical thinking is a time-consuming enterprise;

- Stage 4: Reasoning: The consequences of each suggested solution, resolution, or opinion are worked out;

- **Stage 4a: Slowness to assert:** Before any singular solution, resolution, or opinion is adopted, each is evaluated, thoroughly thought through, and defended to see which hold up. Critical thinking is a highly purposeful enterprise;

- **Stage 4b: Readiness to consider:** An open-mindedness to possible alternative solutions, resolutions, or opinions exists, one that is informed by information other than memory and experience, and posed by others;

- Stage 5: Conclusion: The most satisfactory solution, resolution, or opinion is adopted;

- **Stage 5a: Careful to dispose and set in order:** Any expression of the most satisfactory solution or opinion is structured as the most rational, justified, and organized proposition. Critical thinking results in precise expression;

- Stage 6: Test: The adopted suggestion or opinion is submitted to trial and then put into practice; and

- **Stage 7: Hatred for every kind of imposture:** The proposed solution, resolution, or opinion is presented and defended passionately, eloquently, deliberately, and with the sense that any other proposition is incorrect, woefully misguided, and must be corrected. Critical thinking is authoritative.

So, how do Bacon's additional stages translate to the actual practice of arts criticism?

Desire to seek

Rare are the arts critics who know everything about every aspect of their designated art form. However, a working and well-rounded knowledge must be established to help generate an informed opinion and to share that knowledge with a reader. Rather than relying solely on personal memory, past experience, and an existing knowledge base, the arts critic seeks out additional information. As was noted in the previous chapter, the critic is an "informed advocate." The critic is motivated to pursue and research supplementary, alternative, and potentially contradictory information from reliable secondary sources to flesh out his/her own critical perspective.

Patience to doubt

Rather than allowing personal memory of a past performance or exhibition to automatically trump one's reactions to the performance or exhibition at hand, the critic will tap those memories but remain open to a change of position and perspective. Personal memory is sentimental, highly subjective, potentially distorted by time and circumstance, and, thus, biased. It can potentially cloud a critic's judgment.

Fondness to mediate

The critic will contemplate and reconcile contradictions between personal perception and secondary information before rendering a critical opinion. Although deadlines are a reality for the critic, opinions must be thoroughly formulated before they are put to paper, which is a time-consuming enterprise.

Slowness to assert

Before any one opinion is adopted, each is evaluated, thoroughly thought through, and defended to see which hold up. Arts criticism is impactful on audience perception and attendance, as well as on the state of the art itself. As such, it must be a highly purposeful enterprise.

Readiness to consider

A critic needs an open-mindedness to possible alternative opinions based on supplementary research, even if that information is potentially contradictory to memory or past opinion. Every performance of a play, for example, is a unique and potentially innovative experience that warrants careful deliberation.

Careful to dispose and set in order

Any expression of opinion is structured as the most rational, justified, and organized proposition. Arts journalists must also express themselves well, offering precise, intriguing, and thought-provoking expression.

Hatred for every kind of imposture

The resultant criticism—the outcome of careful observation, thoughtful deliberation and reflection, supplementary information, and purposeful expression—is presented and defended passionately, eloquently, deliberately, and with the sense that any other critical opinion is misguided. Writer T.S. Eliot referred to this as "a highly developed sense of fact" and noted that it is "not one which easily wins popular commendations."[6]

> "Critics are poets cut down, says someone—by way of
> jeer; but, in truth, they are men with the poetical tem-
> perament to apprehend, with the philosophical tendency
> to investigate."
>
> ~Margaret Fuller, 19th-century
> journalist and literary critic[7]

The Evolution of Critical Thinking

Thinking is a natural process but critical thinking is an acquired skill. According to the Foundation for Critical Thinking, a non-profit organization that seeks to promote essential change in education and society through the "cultivation of fair-minded critical thinking,"[8] the intellectual roots of critical thinking can be traced to Socrates 2,500 years ago. Socrates discovered by a method of probing questioning that most people could not rationally justify their confident claims to knowledge or learned opinion. Confused meanings, weak evidence, poor logic, or self-contradictory beliefs often lurked beneath smooth but largely empty rhetoric. In other words, ancient Greeks could not put their drachma where their mouth is.

Socrates realized that one cannot depend upon those in authority to have sound knowledge and insight, for assigned authority does not guarantee critical prowess. He demonstrated, at great personal and professional risk, that persons may have power and high position and yet be as deeply confused and irrational as everyone else. Socrates established the importance of questioning common beliefs and explanations by asking deep questions that probe profoundly into thinking before accepting ideas as worthy of belief. He found value in distinguishing the reasonable and logical beliefs from those that are not, seeking evidence, closely examining reasoning and assumptions, analyzing basic concepts, and tracing the source of implications. His method of questioning is now known as "Socratic Questioning," which highlights the need in thinking for clarity and logical consistency.

Socrates' practice was followed by the critical thinking of Plato (who recorded Socrates' work), Aristotle (who was Plato's student), and the Greek skeptics, all of whom emphasized that things are often very different from what they appear to be and that only the inquisitive and trained mind is prepared to see through the way things look on the surface to the way they really are. From this ancient Greek tradition emerged the need for anyone who aspired to understand the deeper realities to think systematically and to trace implications broadly and deeply. Only think-

ing that is comprehensive, well-reasoned, responsive to objections, and, well, critical can take us beyond the surface of understanding.

In the Middle Ages, the tradition of systematic critical thinking was embodied in the writings and teachings of Thomas Aquinas (1225–1274) who, to ensure his thinking met the test of critical thought, always systematically stated, considered, and answered all criticisms of his ideas as a necessary stage in developing them. Aquinas heightened our awareness not only of the potential power of reasoning but also of the need for reasoning to be systematically cultivated, subjected to criticism, and cross-examined.

"Comprehension without critical evaluation is impossible."
~Georg Wilhelm Friedrich Hegel,
18th/19th-century philosopher[9]

Aquinas lived at a critical juncture of western culture when the arrival of the Aristotelian's work questioned the relation between faith and reason—that is, the difference between philosophy and theology. Aquinas suggested[10] that the first and major formal difference between philosophy and theology is found in their starting points. The presuppositions of the philosopher, that to which his discussions and arguments are ultimately driven back, are in the public domain. They are things that everyone can know upon reflection and, perhaps, observation; they are where disagreement between us must come to an end. This is proportionately true of each of the sciences, where the most common principles are in the background and the proper principles or starting points of the particular science function as the common, agreed-upon principles.

By contrast, the discourse of the theologian is ultimately driven back to starting points or principles that are held to be true on the basis of faith—that is, the truths that are authoritatively conveyed and revealed by God. Theological discourse looks like any other discourse and is, needless to say, governed by the common principles of thought and being. However, it is characterized formally by the fact that its arguments and analyses are taken to be truth-bearing only for one who accepts what cannot necessarily be observed—faith.

In the Renaissance (15th and 16th centuries), a flood of scholars in Europe began to think critically about religion, art, society, human nature, law, and freedom. They proceeded with the assumption that most of the domains of human life were in need of searching, analysis, and critique. Among these scholars were John Colet, Desiderius Erasmus, Thomas More, and our friend Francis Bacon. They followed up on and refined the insights of the ancients, although the battle between philosophy

and theology continued to be hard fought. The life and times of Italian physicist, mathematician, astronomer, and philosopher Galileo Galilei, who was discredited and excommunicated by the Church, serves as the perfect example of this. Perhaps the most influential Renaissance critic was Ludovico Castelvetro (1505–1571), whose 1570 commentary on the *Poetics* elaborated on Aristotle's tightly structured rules of drama. According to Ronan McDonald in his text *The Death of the Critic*,[11] for the 200 years that followed Castelvetro's work, critics looked to ancient poems and plays for the permanent laws of art. They provided a standard against which artistic greatness could be gauged and critical thinking could be informed.

Francis Bacon (1561–1626), in England, was explicitly concerned with the way we misuse our minds in seeking knowledge. He recognized that the mind cannot safely be left to its natural, undisciplined tendencies, which tends to gravitate toward self-gratification and self-deception. He argued for the importance of studying the world empirically. He laid the foundation for modern science with his emphasis on the information-gathering processes. He also called attention to the fact that most people, if left to their own devices, develop bad habits of thought—which he called "idols"—that lead them to believe in what is false, misleading, or self-serving.[12] These idols illustrate the undesirability of placing complete reliance upon assumptions and principles which have not been verified by observation and experimentation. They stand in the way of critical thinking.

"Idols of the Tribe" are the ways our mind naturally tends to trick itself, suggesting that intellectual error can be derived from human nature in general and our limited intellectual faculties in particular. The "tribe" represents our most base and instinctive tendencies and human intellectual frailties. These tendencies include:

- **Common Sense.** The tendency to rely upon limited assumptions without verifying them as established truths;
- **Beliefs.** The tendency to stubbornly support personal beliefs over verified facts;
- **Wishful Thinking.** Wishful thinking is the tendency to believe what one wishes to believe, despite information to the contrary;
- **Overgeneralization.** The tendency to jump to conclusions on the basis of first impressions rather than contemplation and reflection; and
- **Ultimate Causes.** The tendency to describe the cause of a thing without verifying an actual relationship between an outcome (such as an opinion) and what created it.

"Idols of the Cave" are the tendencies toward intellectual error derived from our natural tendency to surround ourselves with predispositions or assumptions created by our peculiar, potentially limited, and singular worldview. The "cave" represents the limited confines of our worldly experience. These tendencies include:

- **Insularity.** The tendency to overemphasize the area of knowledge or the subject with which one is familiar. This is also the tendency to be ethnocentric, gender-driven, and such;
- **Conservatism.** The tendency to admire and prefer the past, and compare the current stage of things accordingly;
- **Novelty.** The tendency to admire and prefer anything new, despite its actual value;
- **Authority.** The tendency to accept authoritative propositions without critically evaluating the proposition, including our own; and
- **Inertia.** The tendency to bypass intellectually difficult problems or challenges, thereby dismissing or diminishing them.

"Idols of the Marketplace" are the ways we misuse words to express ourselves. The wrong words or the wrong use of words can lead to misunderstanding, confusion, controversy, and fallacy. The "marketplace" represents the social arena in which we engage in miscommunication with others and which foster certain tendencies. These tendencies include:

- **Meaningless Words.** The tendency to create words which are so general or to use words that are so overused and vague that they become meaningless to others;
- **Double-Meaning Words.** The tendency not to clarify the specific meaning in which a word is employed;
- **Personal Definitions.** The tendency to employ words whose meanings are entirely personal and, therefore, unknown to others or bear a different meaning;
- **Verbalisms.** The tendency to attribute significance to insignificant words or phrases; and
- **Jargon.** The tendency to accept slang that transcends understanding to the majority.

"Idols of the Theater" are our tendencies to become trapped in conventional systems of thought based on things one has learned in the past, which have created fictitious, dramatic, and "theatrical" worlds from where we operate. These tendencies include:

- **Experimentation.** The tendency which derives from the dogmatism and rigidity in one's learning that leads toward the acceptance of propositions that are not verifiable by the senses. This includes blind rules and poor instruction from our formal education; and
- **Superstition.** The tendency to interpret all of reality in terms of religious authoritative beliefs.

> *"A fool's brain digests philosophy into folly, science into superstition, and art into pedantry."*
> ~George Bernard Shaw,
> 19th–20th century playwright and critic[13]

Critical Approaches: Placing Art in Context

For arts critics, all this critical thinking takes the form of a critical approach to a particular work of art. That is, beyond simply describing the art and offering an opinion about it, the critic must also critically analyze the complexities, complications, and implications associated with a particular art form and place it into a proper critical context—perhaps by demonstrating its similarities and differences with other works by the same artist, or other works within the same genre, or other works of the time period in which it was created.

General classifications include Sociological Criticism, Genre Criticism, Auteur Criticism, and Anthropological Criticism. Each of these broad critical approaches represents the most common foci of critical thinking where the arts are concerned. In more academic forms of criticism, such as literary and dramatic criticism, any given piece of art is addressed with a singular focus. More popular or journalistic forms of criticism accommodate a range of critical contexts by touching on several within a single review, if warranted, rather than focusing on one. Which critical contexts are employed are primarily influenced by the art forms themselves. A new play written by a well-known and firmly established playwright, for example, cries out for Auteur Criticism, which would examine and analyze one piece of work by the artist as it relates to his/her other works. If a play has a political agenda or is intended to foster social change, it warrants Sociological Criticism. A revival of a classic play requires some exploration of the time in which the original work was conceived, which entails Anthropological Criticism.

The proper amount of critical context within a given review, as opposed to description and opinion, is a subjective decision that must be made by the critic. As Don McLeese, former music critic for the Chicago *Sun-Times* and *Austin American-Statesman*, suggests:[14] "A critic must gauge how much context he needs to provide a general readership without belaboring the obvious for readers who know a lot about the artist…. Too little might leave readers confused; too much will bore them." Each critical context is explained in detail.

"Discussing the Undiscussable" as Sociological Criticism, in profile[15]

In December 1994, the *New Yorker* published a startling piece of sociological criticism by arts critic Arlene Croce.[16] The essay, entitled "Discussing the Undiscussable," was in response to the premiere of a dance-infused piece of theater by the black, gay, and HIV-positive choreographer Bill T. Jones.

Croce's principal objection was that the work, *Still/Here*, integrated into the performance video and audiotapes of real people with cancer and AIDS intended to manipulate the audience into feeling sympathy, pity and intimidation. By the end of her essay, Croce lashed out at all forms of issue-oriented art and lamented the way "community outreach," "multiculturalism," "minority groups," and even the National Endowment for the Arts were turning high culture into banal "utilitarian art" that was nothing more than "socially useful." Croce's essay begins:

> I have not seen Bill T. Jones's *Still/Here* and have no plans to review it. In this piece, which was given locally at the Brooklyn Academy, Jones presents people (as he has in the past) who are terminally ill and talk about it. I understand that there is dancing going on during the talking, but of course no one goes to *Still/Here* for the dancing. People are asking whether Jones' type of theater is a new art form. Dying an art form? Why, yes, I suppose dying can be art in a screwily post-neo-Dada sense. (Dr. Kevorkian, now playing in Oregon). But this is not the sense intended by Bill T. Jones.... If I understand *Still/Here* correctly, and I think I do—the publicity has been deafening—it is a kind of messianic traveling medicine show, designed to do some good for sufferers of fatal illnesses, both those in the cast and those thousands more who may be in the audience. If we ask what a show does that no hospital, clinic, church, or other kind of relief agency has so far been able to do, I think the answer is obvious. If we consider that the experience, open to the public as it is, may also be intolerably voyeuristic, the remedy is also obvious: Don't go.

In response to this critical essay,[17] author Joyce Carol Oates offered her own piece of sociological criticism. She argued in the *The New York Times* that *Still/Here*, rather than pathetic "victim art," exemplified "the long, and honorable tradition of art that 'bears witness' to human suffering." She cited such masterpieces as Dostoyevsky's *House of the Dead*, the American slave narratives of Frederick Douglass and Harriet Jacobs, and *The Diary of Anne Frank* as examples.

Sociological Criticism

Sociological criticism is concerned with how various aspects of a play's text or performance (i.e., the depiction of social roles and relationships; the portrayal of conflict and conflict resolution; the interaction between player and audience)

reflect and impact the larger society in operation at the time the play is produced (see "Discussing the Undiscussable," in profile). Sociological criticism seeks to address whether and in what ways portrayals of cultural and ethnic stereotypes, violence, and sex influence people's behaviors and attitudes toward and perceptions of themselves and others. It also explores the potential impact of theater or a piece of theater on political behavior (e.g., voting), social activism, and awareness of what and who is important.

A related aspect of sociological criticism reflects on the audience itself, and its receptiveness to a particular play or playwright. Commentary on the state of the art can take the form of sociological criticism that addresses an audience's capacity to comprehend or appreciate a particular work or artist, or the appropriateness of a piece of work given the current state of the audience . For example, after the premiere of the 2009 revival of Samuel Beckett's *Waiting for Godot*, a play referenced in a previous chapter, *Variety* critic David Rooney noted that "Samuel Beckett's 1953 play has been absent from Broadway for more than 50 years, and the current climate of pervasive anxiety makes the timing ideal for a comedy of existential despair."[18] In a piece written by George Bernard Shaw for the *Saturday Review* in 1895,[19] the critic uses a production of Shakespeare's *All's Well That Ends Well* at St. George's Hall in London to spell out his greater concern that audiences and theater companies have lost their appreciation for the classics:

> Unhappily, though the nation still retains its ears, the players and playgoers of this generation are for the most part deaf as adders. Their appreciation of Shakespear is sheer hypocrisy, the proof being that where an early play of his is revived, they take the utmost pains to suppress as much of it as possible, and disguise the rest past recognition, relying for success on extraordinary scenic attractions; on very popular performers, including, if possible, a famously beautiful actress in the leading part; and above all, on Shakespear's reputation and the consequent submission of the British public to be mercilessly bored by each of his plays once in their lives, for the sake of being able to say they have seen it.

Genre Criticism

This form of criticism is concerned with identifying and describing the basic structural similarities among groups of theatrical presentations and other forms of artistic expression. As such, an organized constellation of recurring substantive and stylistic features—narrative structure, characters, plots, settings, staging, audio tracks—is used to characterize and classify plays. Subject matter and discrete formats or recognizable and generalizable styles can be used to classify other art forms.

The critical consumer can discover how a particular play is similar to or different from other members of the genre and how genres are similar or different from each other. Even a new format represents a hybrid of older formats, or subtle trans-

formations of a preexisting archetype. Aesthetic values can be attached to bodies of plays and used as measuring sticks to evaluate old and new representatives of the genre or new productions of old plays. By laying out the structural and aesthetic framework of plays, changes in genre can be mapped and the impact of institutional constraints and technological innovations on creativity can be monitored (see, for example, "In Defense of Disney," in profile").

Auteur Criticism

This form of criticism is also concerned with identifying and describing the basic structural similarities among expressions of art, but it focuses on products of a single artist or a specific production house. The stylistic traits and thematic motifs that serve as the signature of an individual creative force can be identified and analyzed across that individual's work (see, "Color Vision," in profile). The critic can

"In Defense of Disney" as Genre Criticism, in profile[20]

The Disney musical has become a genre in its own right, incorporating the firmly established components of musical theater but infusing them with elements uniquely Disney. This excerpt from a critical review from *Time* focuses on one of the latest installments of the Disney musical *The Little Mermaid*, and serves to identify some of the features that define the genre.

> Again, we face the Disney problem. Or rather, I face the Disney problem. With every new show that Disney has presented on Broadway since its acclaimed breakthrough hit *The Lion King*, I have to fight back the urge to review the reviewers instead of the show. The trouble, to oversimplify just a bit: I like most Disney shows; the critics hate 'em.
>
> The complaints have become as predictable as the patter for the villain's henchmen in a Disney cartoon: Disney shows are too big, too commercial, too over-marketed—not real theater so much as bloated 'theme park' extravaganzas that only children and undiscriminating tourists could love (though the criticism of Disney's last show, *Mary Poppins*, was somewhat different; the critics found it too heavy, not theme-parky enough). Disney's latest offering—*The Little Mermaid*, based on Disney's 1989 animated hit, which opened at Broadway's Lunt-Fontanne Theater last week—has received the usual fusillade. 'Washed Up on Broadway,' and 'Run for the Lifeboats,' ran the New York tabloid headlines. The *Times*' Ben Brantley, the Scar of the grump brigade, said he 'loathed' the whole wretched thing, including even the one aspect of Disney shows that usually wins a grudging cheer, its scenic design. 'The whole enterprise,' the *Times* critic sniffed, 'is soaked in that sparkly garishness that only a very young child—or possibly a tackiness-worshiping drag queen—might find pretty.'

"Color Vision" as Auteur Criticism, in profile

The following excerpt is from a *New Yorker* article from critic Hilton Als about Ntozake Shange and her play *for colored girls who have considered suicide/when the rainbow is enuf*.[21] The 1977 Broadway production was nominated for a Tony Award for best play and the play was turned into a film in 2010. The essay places the auteur center stage in its effort to best explain the play.

Shange was born Paulette Williams, in Trenton, New Jersey, in 1948, the eldest of four high-achieving children. Her father, Paul T. Williams, was a surgeon; her mother, Eloise, was a psychiatric social worker and an educator. When Shange was eight, the Williams clan relocated to St. Louis. A gifted, bookish child during the tumultuous days of Brown v. Board of Education, Shange was bused to a formerly all-white school in St. Louis, where she was harassed and attacked by the other students. The Williamses were what was then called 'race people.' 'Life was dedicated to the betterment of the race,' Shange said. In high school, Shange began to write. She enrolled at Barnard in 1966. At eighteen, she married an older law student, but the marriage unravelled while she was still an undergraduate. Shange unravelled with it. She attempted suicide several times. Shange threw herself into trying to understand how her sometimes painful and lonely past as a black girl had turned her into an alienated colored woman. In 1970, Shange enrolled at the University of Southern California. There she met artists, writers and performers, whose support helped usher her closer to self-expression. Shange was recording stories and dreams and observations that she would use in future work. After completing her master's in 1973, the twenty-four-year-old Shange moved to the Bay Area, where she taught humanities and women's studies at several colleges. Mentions her friendships with Jessica Hagedorn and Paula Moss.

Teaching during the day, Shange wrote and performed her pieces at night, slowly developing a multi-genre style that she thought represented the complexity of black American art. In the summer of 1974 Shange began writing a series of poems about seven nameless women, coping with the various trials that she saw black women dealing with. By the winter of 1974, *for colored girls who have considered suicide/when the rainbow is enuf* had taken off. Shange and Moss performed it in bits and pieces in coffeehouses and bars and at Minnie's Can-Do Club, in Fillmore. They took the show to Studio Rivbea in New York. Shortly after arriving, Shange met Oz Scott, a young stage manager for the Public Theater, who was itching to get started as a director. During the next year, working closely with Shange, Scott helped give *for colored girls...* a dramatic form. The play opened at the Public in June, 1976, and transferred to Broadway that December. For the past thirty years, black, female, and queer playwrights ranging from Suzan-Lori Parks to David Adjmi have borrowed from Shange's inventive forms. But in that time Shange herself has become less and less of a presence on the stage. Those who shun fame also sometimes shun posterity.

seek to discover the major similarities that exist in all or most of an auteur's productions or the stylistic and thematic differences that exist across several artists. The evolution of the auteur and, consequently, the evolution of genre and the art can be traced and evaluated.

Anthropological Criticism

This form of criticism is concerned with analyzing a piece of art within its historical real-world contexts. This approach assesses the roles that social, economic, political, technological, legal, and regulatory factors play in the creation, distribution, and reception of the work (see, *Assassins* and *Hair* as Anthropological Criticism, in profile). The critic uses the artistic expression as an anthropological barometer, a method of examining and better understanding the time in which the art was conceived and manufactured. The social and cultural trends, political ideologies, values, and ethical standards reflected in the work, for example, serve as a window to a different time. This approach suggests that artists are impacted by the world in which they live, which purposefully or unconsciously influences their art—what they are saying and the way they are saying it.

As was noted earlier, most pieces of theater criticism apply a variety of critical approaches in their analysis of a play rather than focus on one. A recent *New York* magazine review of the 2012 Broadway revival of Arthur Miller's watershed American drama *Death of a Salesman* is a fine example.[24] The 1949 play is about the hollowness of the American Dream by mid-20th century, as seen through the eyes of antiquated salesman Willy Loman, and how we have sadly come to define ourselves through ambition, success, appearance, and wealth. Here are brief excerpts from critic Scott Brown's essay:

Sociological Criticism: "*Salesman* is now in its early sixties, about as old as Willy himself, and attention has never ceased being paid, in classrooms and community theaters, even more than on Broadway. And why not? Our economy remains dream-based, delusion still flickers in every striver's eye, and past and present continue to smear together in a shimmery haze of nostalgia."

Auteur Criticism: "Leave it to [director Mike] Nichols, our greatest living anti-stylist—nobody avoids the briar patch of 'concept' like him—to point this up by resurrecting Elia Kazan's original mounting.... Nichols treats the script like the scripture it is, entrusting those mile-high-written-in-flame words to actors of size and skill and voice."

As a point of comparison, and to demonstrate that the play itself does not always dictate a critic's approach, here is an excerpt from a *New Yorker* review[25] offering a different take on the same production of the same play:

Assassins and *Hair* as Anthropological Criticism, in profile

One critical approach to a form of artistic expression is anthropological—that is, the work can be seen as an artifact of its time.

Frank Rich's *The New York Times* review of Stephen Sondheim's musical *Assassins* places the show in this critical context. [22] "No one in the American musical theater but Stephen Sondheim could have created the chorus line that greets—or should one say affronts?—the audience at the beginning and end of *Assassins*," begins the article. Dressed in motley garb ranging from Victorian finery (John Wilkes Booth) to worker's rags (Leon Czolgosz) to shopping-mall leisure wear (John Hinckley), this chorus line is entirely populated by "that not-so-exclusive club of men and women who have tried, with and without success, to kill the President of the United States." The article continues:

> The effect of this recurrent chorus line, a striking image in a diffuse evening, is totally disorienting, as if someone had removed a huge boulder from the picturesque landscape of American history to expose to light all the mutant creatures that had been hiding in the dankness underneath. In *Assassins*, a daring work even by his lights, Mr. Sondheim and his collaborator, the writer John Weidman, say the unthinkable, though they sometimes do so in a deceptively peppy musical-comedy tone. Without exactly asking that the audience sympathize with some of the nation's most notorious criminals, this show insists on reclaiming them as products, however defective, of the same values and traditions as the men they tried to murder.

"What is so likable about *Hair*," noted *The New York Times* critic Clive Barnes in his 1968 anthropological review of the then-controversial musical love-fest,[23] "is simply that it is so likable. So new. So fresh and so unassuming [with an] authentic voice of today." He continues:

> Frequent references—frequent approving references—are made to the expanding benefits of drugs. Homosexuality is not frowned upon—one boy announces that he is in love with Mick Jagger, in terms unusually frank. The American flag is not desecrated—that would be a Federal offense, wouldn't it?—but it is used in a manner that not everyone would call respectful. Christian ritual also comes in for a bad time, the authors approve enthusiastically of miscegenation, and one enterprising lyric catalogues somewhat arcane sexual practices more familiar to the pages of the *Kama Sutra* than *The New York Times*. So there—you have been warned. Oh yes, they also hand out flowers.

Genre Criticism: "What I found so disappointing wasn't the new production, however: it was the play itself. Like many people, I first encountered *Salesman* as a teenager, and—as with Steinbeck or Harper Lee—it was encouraging to discover that a supposed masterpiece of American literature could be so direct, comprehensible, and unmissably poignant. Miller's ironies—as when Willy, on the night he is to commit suicide, goes out into his back garden and plants a packet of seeds— are never so subtle that the reader is in any danger of missing them. 'Literature,' I remember thinking, 'I could get the hang of this.' Ten years later, at the Ethel Barrymore [Theatre], I found myself squirming in my seat from boredom and exasperation, amazed at how much glaringly conventional stagecraft *Salesman* was able to pack into its two acts. The rising action, the dramatic irony, the laborious, grandstanding speeches ('Spite, spite, is the word of your undoing.... When you're rotting somewhere beside the railroad tracks, remember, and don't you dare blame it on me')—I kept wanting to exclaim, 'It sounds like a *play!*'"

Summary

"More and more," noted theater critic Robert Brustein,[26] "I found myself subordinating the judgment that was so necessary to criticism, and that we're all looking for: Does he like it? Does she hate it? When I read criticism, I find that to be the least interesting part. I began to call that 'Himalayan criticism' after Danny Kaye—when he was asked whether he liked the Himalayas, he said, "Loved him, hated her." It's essentially what we've all been practicing—Himalayan criticism."

The point, of course, is that criticism is more than a simple passing judgment. It is not simple at all. As this chapter suggests, arts criticism is a highly purposeful, elaborate, and time-consuming process. It is characterized by a watchful, exact, and repeated evaluation and judgment, the conducting of a serious search for information above and beyond one's own experience and memory, which is then contemplated and weighed before making a decision or forming an opinion. Engaging in arts criticism is the lining up of all of the essential critical elements of the subject matter in question and cautiously analyzing them before deliberating and rendering a decision or an opinion. The average arts consumer knows whether or not she or he likes the art; the arts critic explains why.

The next chapter examines the history of theater criticism, which evolved from classical forms of literary and dramatic criticism. In doing so, it will identify and describe the contributions and unique styles of key critics during particularly pivotal times in theater history.

KEY CONCEPTS

Aesthetic distance

Anthropological criticism

Auteur criticism

Critical context

Critical thinking

Genre criticism

Himalayan criticism

Idols of the tribe

Idols of the market-place

Idols of the theater

Idols of the cave

Six-stage thinking process

Six-plus-stage critical thinking process

Sociological criticism

Socratic questioning

NOTES

1 Jill Bolte Taylor, *My Stroke of Insight* (New York: Viking Press, 2006), 19.

2 Cited from the Foundation for Critical Thinking website, http://www.criticalthinking.org/ (accessed July 30, 2009).

3 Cited in Forrest E. Baird and Walter Kaufmann, *From Plato to Derrida* (Upper Saddle River, NJ: Pearson Prentice Hall, 2008).

4 From Charles S. Kroan and Julian N. Wasserman, *Edward Albee: An Interview and Essays* (Houston, TX: The University of St. Thomas, 1983), 2.

5 Baird and Kaufmann, *From Plato to Derrida*.

6 Cited in Jennifer McDonald, "Masters of the Form," *The New York Times*, December 31, 2010, http://www.nytimes.com/2011/01/02/books/review/LitCritBackPage-t.html?_r=1 (accessed December 16, 2011).

7 Margaret Fuller, "A Short Essay on Critics," *The Dial*, Volume 1, 1840, http://www.vcu.edu/ engweb/transcendentalism/authors/fuller/essayoncritics.html (accessed December 16, 2011).

8 Cited in http://www.criticalthinking.org/

9 Cited in Peter Fuss, "Hegel: Reinterpretation, Texts, and Commentary (Review)," *Journal of the History of Philosophy*, 6(2), April, 1968, 189–193.

10 Cited in the *Stanford Encyclopedia of Philosophy*, http://plato.stanford.edu/entries/aquinas/#The (accessed December 22, 2009).

11 Ronan McDonald, *The Death of the Critic* (London: Continuum, 2007), 49.

12 Cited in Joseph Devey (Ed.), *The Physical and Metaphysical Works of Lord Bacon* (London: Bell and Sons., 1911), 19–20.

13 See http://www.quotationspage.com/quote/26153.html (accessed December 22, 2009).

14 Don McLeese, *The New York Times Reader: Arts & Culture* (Washington, DC: CQ Press, 2011), 10.

15 Cited in Maurice Berger, *The Crisis of Criticism* (New York: The New Press, 1998), 1–3.

16 Arlene Croce, "Discussing the Undiscussable," *The New Yorker*, December 26, 1994, 54.

17 Joyce Carol Oates, "Confronting Head on the Face of the Afflicted," *The New York Times*, February 19, 1995, http://www.nytimes.com/1995/02/19/arts/confronting-head-on-the-face-of-the-afflicted.html (accessed November 18, 2010).

18 David Rooney, "Waiting for Godot," *Variety*, April, 30 2009, http://www.variety.com/review/VE1117940162?refcatid=33 (accessed November 18, 2010).

19 George Bernard Shaw, "Poor Shakespear," *The Saturday Review*, February 2, 1895. Cited in John F. Matthews, *Shaw's Dramatic Criticism* (New York: Hill and Wang, 1959), 12–18.

20 Richard Zoglin, "The Little Mermaid: In Defense of Disney," *Time*, January 16, 2008, http://www.time.com/time/arts/article/0,8599,1703964,00.html#ixzz16UrLad2D (accessed November 18, 2010).

21 Hilton Als, "Color Vision," *New Yorker*, November 8, 2010, http://www.newyorker.com/reporting/2010/11/08/101108fa_fact_als#ixzz14isBB55Q (accessed November 8, 2010).

22 Frank Rich, "Sondheim and Those Who Would Kill," *The New York Times*, January 28, 1991, http://theater.nytimes.com/mem/theater/treview.html?res=9D0CE2DD1539F93BA15752C0A967958260 (accessed November 26, 2010).

23 Clive Barnes, "Hair ,"*The New York Times*, April 30, 1968, http://theater.nytimes.com/mem/theater/treview.html?html_title=&tols_title=HAIR%20(PLAY)&pdate=19680430&byline=By%20CLIVE%20BARNES&id=1077011430154 (accessed November 26, 2010).

24 Scott Brown, "The Originalist: A Staggering New *Salesman* Goes Back to the Source," *New York*, March 26, 2012, 57.

25 Giles Harvey, "*Death of a Salesman*: A Heartbreaking Work of Staggering Mediocrity," *New Yorker*, May 15, 2012. Cited in http://www.newyorker.com/online/blogs/books/2012/05/death-of-a-salesman.html#ixzz1v91DJIeZ (accessed May 17, 2012).

26 Cited in Bert Cardullo, "The Theater Critic as Thinker," *New Theater Quarterly*, 25, 2009, 315.

"Journalistic coverage of the London theater began in the eighteenth century, and one generalization that can be safely made is that there was no great call for it."
~Irving Wardle, theater critic[1]

Chapter 5 Abstract

This chapter will distinguish between and examine the evolution of dramatic and theater criticism. In doing so, it will identify and describe the contributions of the early Greeks and unique styles of key theater critics during particularly pivotal times in early American theater history. These critics include Stephen Cullen Carpenter, Henry Clapp, Jr., and Ada Clare.

The Evolution of Criticism
From Dramatic to Theater Criticism

The intellectual foundations for theater criticism can be found in classical literary and dramatic criticism, which, as with theater itself, originated in ancient Greece 2,500 years ago. In fact, the first recorded instances of arts criticism go back to dramatic festivals in ancient Athens—the Great Dionysia—which were organized as contests that required an official judgment as to which author had produced the best work.[2]

At these dramatic contests, which began around 500 B.C.E., prominent playwrights submitted three serious dramas and a satyr. Later, during the Lenaia—a winter festival that began around 442 B.C.E.—comedic works were considered in the competition. The conception, creation, form, and impact of dramatic poetry were contemplated and evaluated by judges, with significantly more attention given to the work itself than its theatrical performance. The social, political, and moral functions served by creative work at that time were of greater consequence and value than any particular artisan's interpretation or delivery of that work. Originally, an ensemble of singing and dancing chorus members presented the work with the intention of being viewed as an anonymous, collective whole rather than as separate and identifiable players. Over time, individual actors joined the chorus, wearing masks so they could play multiple parts without revealing themselves.

Their performances were looked upon as merely the vehicle required to make the work public and connect the author with an audience. It was the nature of language and imagery, the relationship between philosophy and rhetoric, and the underlying principles of literature that were far more pertinent, interesting, and rewarded during these contests. If the Tony Awards had been institutionalized back then, "Best Play" would have been the only category.

Actually, many contemporary playwrights also feel that the performance of their work is less significant than the work itself and, in some cases, performance

is perceived to be a necessary evil. In his recent book *Theatre*,[3] playwright David Mamet railed against method actors, theatrical theoreticians, arrogant directors, uppity designers, oppressive bureaucrats, and subscription audiences, suggesting that they simply get in the way of good writing. Directors should do little more than tell the actor "to fix his speech and posture, stand still, say the words, don't fidget and have a general idea of the nature of the scene…for further work is useless," he noted, adding that "one hundred years of actors have wasted their time in this pointless pursuit."[4] Regardless, while the dramatic criticism of ancient Greece tended to focus on the play, theater criticism has come to include the production and the performance of it as well.

The Birth of Dramatic Criticism

The earliest dramatic critics were the ancient Greek playwrights themselves. Parody of fellow playwrights was a rampant form of expression in the earliest of Greek plays and has been referred to as "criticism in the rough."[5] Sophocles and Euripides parodied and offered commentary on the style of contemporary writer Aeschylus[6] in their work. Euripides, in turn, was ridiculed in the satiric and farcical comedies of Aristophanes. In his *The Frogs* (ca. 405 B.C.E.), for example, Aristophanes has a pair of scales brought in to show that Aeschylus' verse is "weightier" than Euripides'[7] and, in *Thesmorphoiazusae* (ca. 411 B.C.E.), Aristophanes has the playwright condemned by the women for treating them so poorly in his own plays.[8] Antiphanes, a writer of Athenian comedy, went after the writers of tragedies, noting in his work that it is easier to write tragedy than comedy because the plots call for no imagination on the author's part. Just misery.

Plato—philosopher, mathematician, writer, and renowned party pooper—was a particularly stringent dramatic critic. In *The Republic*, Plato attacked tragedians, accusing them of stirring emotions that were not in accord with reason, although dramatic fiction was the primary target of his wrath. Because Plato believed that writers tell lies—that is, invent stories—and their stories are removed from true reality, he avidly encouraged the banishment of all playwrights and poets, along with their misguided works. They distracted citizens from their duties to the state, he noted, and neither improved nor enlightened them.[9] Plato depicted the physical world as merely a ghostly copy of perfect celestial ideas,[10] and the arts were one copy removed. In his *Apology*, which is a fictionalized version of a speech given by Socrates, Plato suggests that poetry is derived from inspiration rather than wisdom, and remarks on the pretensions of writers who claim knowledge that they do not and cannot possess.[11] This no doubt endeared him to the arts community of

the time and was, perhaps, the birth of the tradition of animosity between critic and artist described in an earlier chapter.

The body of Sociological Criticism discussed in the previous chapter is largely derived from Plato's critical orientation. Then, as now, literary and dramatic critics placed and explored literature and drama within the confines of their particular socio-political concerns, interests, and contemporary trends, and criticized the work accordingly. More contemporary Marxist, Thomist, secular-humanist, neo-Classical, feminist, Freudian, and existentialist approaches to literature and drama, among others, are all examples of critical approaches inspired by Plato's perspective of the dramatic arts.

Aristotle, a pupil of Plato's, followed in his mentor's footsteps as a dramatic critic. However, rather than condemn dramatic fiction, Aristotle wrote *Poetics*, which was intended to lay down his foundational principles for what constitutes the dramatic arts and how things ought to be done. This, in turn, established parameters with which to classify and critique storytelling.

Unlike his mentor and many of his contemporaries, Aristotle refused to subordinate his critical observations about the arts to their consequences based on externally derived socio-religio-political parameters. He believed that the axioms and postulates of criticism should grow out of the art itself, and went about the task of laying out the guiding principles of that pursuit. By doing so, he countered many of Plato's claims by espousing the benefits of the arts done well. Still, *Poetics* was a critical appraisal of the Greek dramatic achievement of his time, or the lack thereof.

Aristotle suggested, for example, that all fictional storytelling should include mimesis (a connection to reality or relationship with nature), praxis (a pretense or fictional story), and muthos (a plot, which gives the story direction, momentum, and a dramatic arc). Storytelling with mimesis, he believed, invites its audience to imagine its subject matter as real while acknowledging that it is, in fact, fiction. Because the audience is conscious of the praxis involved in art, it is detached enough that it can reflect on what it is experiencing and learn from it rather than merely observe and react to it. Witnessing or experiencing an act of betrayal in real life is emotionally scarring. Witnessing a staged or fictitious rendition of betrayal gives the audience, and the critic, a chance to reflect on the nature of human relationships, the parameters of trust, and the factors that could lead to betrayal so that they can lead a more reflective and informed life.

The body of Anthropological Criticism discussed in the previous chapter is largely derived from this Aristotelian critical orientation. This approach assesses the roles that social, economic, political, technological, legal, and regulatory factors play in the creation, distribution, and reception of the work. The critic uses

the artistic expression as an anthropological barometer, a method of examining and better understanding the time in which the art was conceived and manufactured.

Aristotle also noted that a story should consist of and typically center around a "somebody"—the hero of the story—doing "something." The something is what the hero does or fails to do in accordance with the level of the postulates made about him/her by the author and the consequent expectations placed upon him/her from the audience. In other words, what is the featured individual doing and is it exceeding what is expected of him? A well-formed plot traces that story from its beginning (protasis), which is not a necessary consequence of any previous action; its middle (epitasis), which follows logically from the beginning; and its end (catastrophe), which follows logically from the middle and from which no further action necessarily follows.

Despite this structural commonality in dramatic works, differences can be created by an emphasis of one plot stage over another, the different elevations of the characters in them, and the subsequent expectations by the audience. In some works, the hero is better than we are, in others worse, in still others the hero is on the same level as the audience. According to literary critic Northrop Frye,[12] works of literature and, subsequently, plays may be classified and criticized in accordance to Aristotle's notion of the hero's power of action, which may be greater than ours (creating myths, legends, folk tales, epic dramas and tragedies), roughly the same (creating romantic comedy and realistic fiction) or less (creating farce and broad comedy).

The body of Genre Criticism discussed in the previous chapter is derived from this Aristotelian critical orientation. Recall that this form of criticism is concerned with identifying and describing the basic structural similarities among groups of theatrical presentations and other forms of artistic expression. As such, an organized constellation of recurring substantive and stylistic features—narrative struc-

..

"The theatrical criticism has one difference from the literary, in that the theatrical critic becomes knowing and sensitive to different degrees of merit in performance. For instance, your ordinary newspaper commentator doesn't know the difference between a star and a great actor. But the real critic does. The so-called average critic doesn't know the difference between a good performance and a great performance, or an adequate performance and a superb performance."

~Eric Bentley, theater critic, *The New York Times*[13]

..

ture, characters, plots, settings, staging, audio tracks—is used to characterize and classify plays. Of course, dramatic criticism that has focused on the stylistic traits, thematic motifs, and employment of character types of an individual playwright has provided the foundations for Auteur Criticism.

What has been discussed thus far falls into the realm of scholarly or intellectual criticism—the academic exploration of the literary and dramatic arts. A journalistic form of criticism and the profession of the arts journalist/theater critic did not evolve until much later. While clearly informed and directly influenced by this heritage, arts journalism in general and theater criticism in particular is significantly different in form and function.

The Birth of Theater Criticism

Shakespeare, while alive, had no critics in the press. Oh, sure, he had supporters, detractors, and promoters in the late-1500s who would publicly compliment or admonish his work. However, the profession of theater critic was not codified in England, or in the United States, until well into the 18th century. The primary reason was that newspapers and a literate audience for them did not surface in earnest until the early 1700s. When it did, those who chose the theater as a profession were not deemed particularly newsworthy to warrant much attention in the press.

Another reason for the lack of news coverage was that most of the papers of the time concentrated on matters of politics, the church, and the conflict between the two. If the stage was mentioned, it was usually within the context of a controversy between the dramatists and the Puritanical element. In the American colonies and, particularly, in New England, the theater was a major target of Puritan prejudices. Church annals and records of colonial courts document that drama and the public theater had become issues of significant public concern as early as 1665,[14] with discussions surrounding not only whether theatrical entertainment should be tolerated but whether the establishment of a theater building should be legalized. As soon as magazines started to be published in the 1700s, debates about theater were common and almost all the arguments for the condemnation or toleration of theatrical performances used moral criteria. At issue was the perception that theater taught intemperance and lasciviousness, was a waste of valuable time and hard earned money, and offered fiction that depraved the human mind. As the American Revolution started to ferment, theater was also condemned for serving as a potential vehicle for partisan politics and propaganda—which, of course, it was.

These debates continued after the American Revolution, but the conception of morality pertinent to theater evolved from a religious to a social context, with theater being accepted as moral if it was useful and instructive by teaching acceptable

> *"Should I pretend to give a view of the wickedness of the theater, I should not know where to begin, or to what length the subject would carry me."*
> ~The American Magazine and Historical Chronicle, 1746[15]

American values and serving America's newfound and hard fought nationalism. In fact, theater gained favor as a vehicle to depict and spread the new revelations of thought and experience of a new nation, and as an instrument in the formation of national character and identity. Playwrights explored broad characterizations of British and American archetypes, gave form to interpretations of legends, and dramatically documented historical incidents. "American equality," noted drama historian Jurgen Wolter,[16] "would provide domestic tragedy with new heroes. As regards comedy and farce, the diversity of life in America and its multicultural society was thought to be a particularly rich mine" for the national theater. Anti-British sentiments were also popular in plays, with audiences more likely to be applauding a political perspective than the quality of the play or its performance. Political leaders and public representatives, including George Washington, patronized the theater and, when they did, theater made news (see "Dunlap's *Darby's Return*," in profile).

It was not long before newspapers and magazines were running feature articles about theater that advocated the performing arts or were offering thoughtful, intellectual forms of dramatic criticism. "A theater would not only provide a representative and decorative building for the recreation of the general public," noted one essay in *The Massachusetts Magazine* in 1792,[17] but it will attract visitors, reduce the contrast between town and city, create jobs, increase public revenue, and "offer destitute women a proper means of earning money." Many major cities began constructing theaters or dedicated buildings to theatrical performances, and dramatic entertainment became part of the staple of amusement for all classes of American society. In turn, the social position of actors improved and their handiwork became newsworthy.

The Paid Puff System

Newspaper items that did address the theater as entertainment at that time did little more than list a play's plot and its cast, and any rivalries that existed between theaters and their players. These pieces were often written by theater insiders themselves. They were expressly designed, notes theater critic and historian Irving Wardle, "to wound the object and bludgeon the reader into agreement. This is an inheritance we still have not shaken off." [18] In London in the late-1700s, suggests Wardle, "theater criticism was a thriving occupation variously pursued by managerial toadies, managers puffing their own wares, opportunistic knockers, unclassified

"Dunlap's *Darby's Return*," in profile

The *Gazette of the United States* was an early American partisan newspaper that was first issued on April 15, 1789. It was a biweekly publication friendly to the administration of George Washington and to the policies and members of the emerging Federalist Party.

What follows is a social item about the President, published on November 28, 1789, which also serves as an early theater review of William Dunlap's *Darby's Return:*[19]

> The Entertainment of the Theater [John Street], on Tuesday evening last, appeared, by the repeated plaudits, to give the fullest satisfaction to a very crouded house: The selections for the Evening were made with judgment—and animated by the presence of the illustrious personages, who honored the exhibition, the Players excited their best abilities. The Pieces performed, were the *Toy—The Critic*, and a new Comic Sketch, entitled *Darby's Return*. The latter piece is the production of the same ingenious hand, who hath already contributed so much to the entertainment of public by *The Father*, of *American Shandyism*. *Darby's Return* is replete with the happiest illusions to interesting events, and very delicately turned compliments. On the appearance of The President; the audience rose, and received him with the warmest acclamation—the genuine effusions of the hearts of Freemen.

eccentrics, and responsible writers whose seriousness covered the spectrum from detailed vivacity to stupefying dullness."[20] In the United States, the practice of publishing regular theater criticism in the late-1700s, according to former *Village Voice* critic Michael Feingold, began "with fly-by-night news-sheets and scurrilous pamphlets popping up everywhere, mingling blind-item theatrical gossip with detailed analysis, often willfully and malevolently inaccurate, of plays and performances."[21] Not an impressive beginning for theater criticism. Period author Samuel Taylor Coleridge thundered that:[22]

> Till reviews are conducted on far other principles, and with far other motives; till in the place of arbitrary dictation and petulant sneers, the reviewers support their decisions by reference to fixed canons of criticism, previously established and deduced from the nature of man; reflecting minds will pronounce it arrogance in them thus to announce themselves to men of letters, as the guides of their taste and judgment.

As theater grew in size and support, newspapers and magazines paid increasing attention to theatrical events, though few daily newspapers published regular reviews or assigned journalists to the beat. When newspapers did choose to cover a play, they usually sent untrained people to review an opening performance and

only on condition that the play's producer had purchased advertising in the paper and offered free admission to the reporter. This was called the "paid puff" system. To this day, soft, promotional previews of plays are referred to as "puff pieces."

Still, before 1800, many Americans outside of the big cities did not hold theater in high regard and even as late as 1854 theatrical entertainment was unlawful in Connecticut. The state of Massachusetts forbade dramatic performances on Saturdays and Sundays. Journalists addressing theater, therefore, looked upon themselves more as censors than critics, delivering critiques that commented on a play's import and impact ala Plato rather than its aesthetic qualities, dramatic values, or cultural significance ala Aristotle.[23] These critics were educated men of the professional classes. One of them, Stephen Cullen Carpenter, wrote in the *Charleston Courier* an essay that demonstrates both the moralist's mentality and the general distain for the theater of the time.[24] Here is an excerpt:

> Since it is the young, the idle, the thoughtless, and the ignorant, on whom the drama can be supposed to operate as a lesson for conduct, an aid to experience and a guide through life…it becomes a matter of great importance to the commonwealth that this very powerful engine [the theater]…should be kept under the control of a systematic, a vigilant and a severe, but a just criticism.

Carpenter was so intent on dictating the tastes of the public that, in 1810, he created his own short-lived monthly periodical in Philadelphia appropriately called *The Mirror of Taste and Dramatic Censor*.

Scalpers and Mountebanks

The first half of the 19th century saw some significant changes in the theater scene, not the least of which was a shift of influence from Philadelphia—which had been the nation's capital, a leading trade city, and reflected a heterogeneity that would become a major characteristic of the nation as a whole—to New York City. Philadelphia's population in 1820 was 63,802 and New York City's was 123,706. By 1840 it was 93,655 to 312,710, and by mid-century New York City was populated by nearly half a million people. While Philadelphia theaters were folding due to dwindling attendance, those in New York where thriving. They were bolstered by its growing population, the introduction of gas stage lighting, and, thanks to the copyright law of 1856, the ability for playwrights to actually make a living writing plays in a vibrant artistic community.[25]

A group of men facetiously calling themselves "scalpers and mountebanks" got together in New York City to write critiques of stage productions anonymously or with pseudonyms, such as "Mercutio" and "Personne," that disguised their identities. They were educated gentlemen and many were distinguished men of their day, but they loved literature and were regular frequenters of New York stage productions.

Although their work was published in the papers, it was often given major recognition by their peers only when republished under their actual names in contemporary theatrical magazines or in book form.[26] These men included Charles Adams, the son of John Adams (the second U.S. president) and brother of John Quincy Adams (the sixth U.S. president). An equivalent movement in critical writing was occurring in London. Its emergence was determined by a range of pragmatic factors including: the rise of opinionated essayists and the proliferation of journalism in general; the strength of Restoration acting (which is consciously lascivious in tone) and the presence of great actors worthy of attention; the need to protect the stage from moral censure; and the centrality of the stage in London life in the early 1800s.[27]

Washington Irving, the famous American author and essayist, made his literary debut in 1802 with a series of observational letters to the *Morning Chronicle* and, written under the pseudonym Jonathan Oldstyle, wrote theater criticism for several magazines including *The Salamagundi*, *Select Reviews*, and the *Analytic*. He boldly and aggressively admonished rude patrons for their lack of respect for the performing arts and called into question antiquated aesthetic standards in the performing arts. In a 1803 essay, Irving assumes the voice of an ignorant patron who fails to understand the value of the theater critic: "The critics, my dear Jonathan, are the very pests of society…they reduce our feelings to a state of miserable refinement, and destroy entirely all the enjoyments in which our coarser sensations delighted."[28]

Despite the best efforts of the so-called scalpers and mountebanks, puffery still dominated the profession of theater criticism in the newspapers well into the 1800s. Author Walt Whitman, in 1847, demanded reforms in theatrical reviewing. He wrote:[29]

> There is hardly anything more contemptible, and indeed, unprofitable in the long run, than this same plan of some paid personage writing laudatory notices of the establishment which pays him, and then sending them to the newspaper, to be printed as spontaneous opinions of the editors.

Whitman accused New York theaters of "keeping a puffer" and claimed that five-sixths of the criticism that appeared in the papers was written by puffers before the actual performance."[30]

Bacchanalianism

By the 1850s, the industrial revolution and the subsequent growth of cities, rail transportation, and leisure time by an increasingly large privileged class provided conditions that were favorable for theater and theater criticism in the U.S. The new rich sought out the arts as an outward demonstration of their wealth, and the arts

> *"How absolute is the necessity now daily growing, of rescuing our stage criticism from the control of illiterate mountebanks, and placing it in the hands of gentlemen and scholars."*
>
> ~Edgar Allan Poe, writer [31]

community responded. Prior to the 1850s, a theater bill might include several hours of various entertainments, such as farces, a "main piece," an "after piece," musical entertainment, and ballet. By the 1850s, the number of entertainments on a theater bill began to be reduced, first to two or three and, later, to one main feature only. Sophisticated French dramas, musical extravaganzas, and sensational melodramas achieved popularity in New York and displaced the traditional repertory.

As the East Coast's middle and working classes grew, so did the new public's desire for news, and at an affordable price. Penny papers, spearheaded by James Gordon Bennett's *New York Herald* and Benjamin Day's *The Sun*, emerged as a cheap news source with coverage of crime, gossip, and entertainment. Ambitious young writers streamed into New York and with them came a style of journalism that opposed traditional objective standards and valued creative subjectivity. Instead of writing in the elevated scholarly style of the period, which could be found in William Cullen Bryant's *New York Evening Post* and Horace Greeley's *The New York Tribune*, or in line with the promotional puffery that had previously filled the newspapers, many theater critics writing for the Penny Press newspapers and other publications offered personal opinion packaged in wit. Some launched personal crusades that attacked particular playwrights or expressed an impassioned dislike for particular types of plays.[32] Acting styles in the early 19th century were prone to exaggerated movement, gestures, grandiose effects, spectacular drama, physical comedy, and outlandish costumes. However, a more naturalistic acting style was coming into vogue, and actors were expected to present a more coherent expression of character. Many critics lambasted actors still stuck in the old mode of performance (see The Astor Place Riot, in profile).

The conservative *Round Table* magazine referred to these renegade critics as a "Bacchanalian mutual admiration society"[33] and, begrudgingly, acknowledged their power and influence on public opinion of the performing arts. It noted: "Managers despise them, yet dare not resist their suction. Actors despise them, yet dread their waspy stings in case they ignore them."

The Astor Place Riot, in profile

At its best, art inspires passion. At its worst, as was the case in New York City on May 10, 1849, art can incite a riot.

At the Astor Place Opera House in Manhattan, a simple spat over artistic differences between rival actors—fueled by remnant anti-British sentiment, political tensions in antebellum America, the increasing divide between the haves and have-nots, and cultural alienation among rival ethnic gangs in New York City—turned into an all-out riot. Twenty-two people died and 100 were injured during, appropriately enough, a production of *Macbeth*, the ultimate tale of rivalry and murder most foul.

The genesis of the riot was a dispute between fans of Edwin Forrest, one of the best-known American actors of that time who had cut his teeth at the working class Bowery Theater, and William Charles Macready, a notable British actor who was on stage that evening. In the early- to mid-19th century, the American theater was dominated by British actors and managers, so the rise of Edwin Forrest generated fervent support among native New Yorkers. The question of whether Forrest was the greater actor than Macready became a notorious bone of contention and was frequently debated in the newspapers.

Macready and Forrest had each toured each other's country twice before the riot broke out. On Macready's second visit to America, Forrest had taken to pursuing him around the country and appearing in the same plays to challenge him. On Forrest's second visit to London, in 1845, he went to a performance of *Hamlet* starring Macready and reportedly hissed at him from the audience.

Macready was on tour in New York in 1849, but not interested in engaging in this rivalry. Regardless, Forrest and his rowdy followers attended his performance of *Macbeth* two days before the riot and a well-orchestrated barrage of insults, coins, bottles, and rotten food met Macready. The actor left the stage but not, according to a report in the *New York Tribune*, until he "picked up one of the pennies and very coolly placed it in his bosom."[34]

He canceled his next performance and decided to end the engagement and leave New York immediately. The next day several petitioners met with the actor, persuaded him to continue, and then published the following letter in the *New York Herald*:[35]

> To W. C. Macready, Esq., Dear Sir:—The undersigned, having heard that the outrage at the Astor Place Opera House, on Monday Evening, is likely to have the effect of preventing you from continuing your performances, and from concluding your intended farewell engagement on the American Stage, take this public method of

requesting you to reconsider your decision, and of assuring you that the good sense and respect for order, prevailing in this community, will sustain you on the subsequent nights of your performances.

On May 10, the play went on without a hitch until an ugly mob of 20,000 lower- and working-class men, in response to inflammatory handbills that were circulated in the streets, descended on the Astor Place Opera House to break up Macready's performance.[36] The *New York Tribune* reported that "As one window after another cracked, the pieces of bricks and paving stones rattled in on the terraces and lobbies, the confusion increased, till the Opera House resembled a fortress besieged by an invading army rather than a place meant for the peaceful amusement of civilized community."[37] The mob was met by police and the local militia, who at first shot over the heads and then directly into the crowd.

Horace Greeley's *Tribune* interpreted the riot as the outgrowth of the class antagonisms resulting from rapid urbanization: "Is there no means," Greeley asked, "of preventing so many young men from rushing to the cities, of giving the less fortunate, the poor, a direct personal interest in the property and order of society, so that when it is attacked they shall feel that they are themselves attacked?" [38]

The *Herald* fulminated against Greeley's *Tribune* as an "organ of French socialism and kindred abominations" and meditated on how much mischief "may have been wrought amongst ourselves, by this continual harping upon the tyranny and oppression of the rich."[39]

The Astor Place Opera House is now gone, replaced by the Mercantile Library and a Starbucks.

In the mid-1800s, Charlie Pfaff's Restaurant and Lager Bier Saloon, on Broadway near Bleecker Street, claimed many of these Bacchanalian journalists among its eccentric clientele.

Many in the group wrote for *Saturday Press* and *Vanity Fair*. An unfinished poem by Walt Whitman memorialized the vault at Charlie Pfaff's, "where the drinkers and laughers meet to eat and drink and carouse."[40] Another 19th century observer called Pfaff's "the trysting-place of the most careless, witty, and jovial spirits of New York—journalists, artists, and poets"[41] who, like Whitman, helped to shape an emerging conception of New York City as the artistic, literary, and intellectual center of the United States.

A fellow Pfaff's patron was journalist and editor Henry Clapp, Jr. who, upon returning from France in 1850, set up a coterie of critics to rail against tradition and convention in the theater[42] and cultivate an American Bohemian arts culture in New York. Period journalist Junius H. Browne noted that "[Clapp] was nearly twice as old as most of his companions; was witty, skeptical, cynical, daring, and had a certain kind of magnetism that drew and held men, though he was neither person nor manner, what would be called attractive."[43] He was described as "a small, queer looking old fellow, with reddish gray whiskers, iron gray hair, a protruding forehead and a short, black clay pipe that he was forever smoking."[44] Pfaff's regular Elihu Vedder suggested that Clapp's verbal ability made up for his lack of physical attractiveness, which was "a living attestation of the truth of Darwin's theory."[45]

Clapp is best known as the tireless editor, instigator, and fundraiser for the *Saturday Press*, a short-lived but influential literary journal first published on October 23, 1858, which showcased fiction, poetry, and literary and dramatic criticism. It offered social commentary by many of Pfaff's bohemians that "embodied the new literary life of

PUBLISHER'S NOTICE.

THE SATURDAY PRESS,

A WEEKLY JOURNAL OF

Literary, Artistic, Dramatic, and Musical Intelligence,

IS PUBLISHED

Every Saturday Morning,

AT NO. 9 SPRUCE STREET, NEW YORK.

HENRY CLAPP, Jr., ⎱ Editors.
T. B. ALDRICH, ⎰

TERMS—$2 00 per year; Five Cents a single number.

ADVERTISEMENTS, Ten Cents a line for each insertion.

SPECIMEN COPIES will be sent to any part of the Union on the receipt of five cents in postage stamps.

the city."[46] The paper, according to historian Albert Parry, "did valuable spading of American life and spanking of the native arts."[47] It was believed that Clapp returned from France with "contempt for [America's] puritanism and a mania for shocking it."[48]

Clapp made efforts to include works by women writers like Ada Clare, who wrote the weekly column "Thoughts and Things" in which she discoursed upon a range of topics from women's rights to the status of the American theater.[49] She became known as the "Queen of Bohemia" at a time when critical writing was not considered to be a suitable occupation for women, or one they were capable of handling. Most female journalists in the mid-19th century, when given the opportunity to write, disguised their identities by assuming male pseudonyms or by signing their articles with initials only.[50] In fact, Ada Clare's real name was Jane McIlheny. It wasn't until 1890 that a female journalist named Dorothy Lundt was openly recognized as the drama critic for a major newspaper, the Boston *Commonweal*.

Clapp also advocated that the theater be judged on aesthetic rather than moral grounds, which was counter to the writing of the times. He wrote witty essays about the arts but was put out of business upon the onset of the Civil War and the journalistic focus on the battlefield. When he died, the *Daily Graphic* entitled his April 16, 1875 obituary "The Late Henry Clapp. A Bohemian's Checkered Life." While some argue that modern theater criticism was born in the salons and coffee houses of London in the early 18th century,[51] a case can be made that it was the saloons of America in the 19th century, and Charlie Pfaff's Restaurant and Lager Bier Saloon in particular.

Summary

It took nearly 2,500 years but, by the 19th-century, the theater critics' creativity and opinions were revered and often feared by their respective industries. They informed audience opinions, dictated box office sales, kept the arts the topic of discussion and, in some cases, shaped the arts themselves. As we shall see in the next chapter, it was not long before critics became a part of an elite corps of taste makers and culture shapers for the general public.

KEY CONCEPTS FROM THIS CHAPTER

Anthropological criticism	Literary criticism
Astor Place Riot	Mimesis
Auteur criticism	Muthos
Bacchanalianism	Paid Puff System
Catastrophe	Parody

Criticism in the rough

Dramatic criticism

Epistasis

Genre criticism

Hero's power of action

Penny Press

Praxis

Prostasis

Scalpers and Mountebanks

Sociological criticism

NOTES

1 Irving Wardle, *Theater Criticism* (London: Routledge, 1992), 16–17. The title page image is of 1850s theater critic and editor Henry Clapp, Jr., from William Winter, *Old Friends: Being Literary, Recollections of Other Days* (New York: Moffat, Yard, and Company, 1914).

2 M.A.R. Habib, *A History of Literary Criticism* (Malden, MA: Blackwell Publishing, 2005).

3 David Mamet, *Theater* (New York: Faber and Faber, 2010).

4 Cited in "Theater by David Mamet" review, *Times* Online, May 1, 2010, http://www.timesonline.co.uk/tol/money/article7111598.ece (accessed May 1, 2010).

5 Charles W. Meister, *Dramatic Criticism* (London: McFarland & Company, Inc, 1985), 5.

6 Aeschylus is credited with being the first dramatist to give serious consideration to production values. He designed special costumes for his actors, pioneered in the use of masks, enlarged the stage, and was the first dramatist to have any sort of setting for his plays.

7 Cited in Habib, *A History of Literary Criticism*, 14.

8 Cited in Bernard F. Dukore, *Dramatic Theory and Criticism* (New York: Holt, Rinehart and Winston, Inc., 1974).

9 See Gary Day, *Literary Criticism: A New History* (Edinburgh: Edinburgh University Press, 2008).

10 See Ronan McDonald, *The Death of the Critic* (New York: Continuum, 2007).

11 Cited in Habib, *A History of Literary Criticism*, 14.

12 Cited in Northrop Frye, *The Anatomy of Criticism*, http://northropfrye-theanatomyofcriticism.blogspot.com/2009/02/polemical-introduction.html (accessed May 1, 2010) .

13 Bert Cardullo, "The Theater Critic as Thinker," *New Theater Quarterly*, 25, 2009, 314–315.

14 Jurgen C. Wolter, *The Dawning of American Drama: American Dramatic Criticism* (Westport, CT: Greenwood Press, 1993).

15 Anonymous, "On Theatrical Entertainment," *The American Magazine and Historical Chronicle (Boston)*, August 3, 1746, 356–358.

16 Wolter, *The Dawning of American Drama*, 14–15.

17 Anonymous, "Effects of the State on the Manners of People, and the Propriety of Encouraging and Establishing a Virtuous Theater," *The Massachusetts Magazine*, October 4, 1792, 633–634, as cited in Wolter, *The Dawning of American Drama*, 15.

18 Wardle, *Theater Criticism*, 17.

19 Cited in Montrose J. Moses and John Mason Brown, *The American Theater: As Seen by its Critics, 1752–1934* (New York: Cooper Square Publishing, Inc., 1967), 26–27.

20 Ibid, 27.

21 Michael Feingold, "Theater Criticism Reconfigured," *Village Voice*, August 11, 2009, http://www.villagevoice. com/content/printVersion/1303580/ (accessed May 1, 2010).

22 A.O. Scott, "A Critic's Place, Thumb and All," *The New York Times*, March 4, 2010, http://www.nytimes.com/2010/04/04/movies/04scott.html?_r=1&pagewanted=2http://www.nytimes.com/2010/04/04/movies/04scott.html?_r=1&pagewanted=2 (accessed May 1, 2010).

23 Charles A. Weeks, "Theater and Performance Criticism," in *Encyclopedia of American Journalism*. Ed. Stephen L. Vaughn (London: Routledge, 2008), 531–533.

24 Cited in Tice L. Miller, *Bohemians and Critics* (Metuchen, NJ & London: The Scarecrow Press, 1981), 2.

25 Cited in Don B. Wilmeth (Ed.), *The Cambridge Guide to American Theater* (New York: Cambridge University Press, 2007), 7.

26 Cited in Gerald Bordman and Thomas S. Hischak, "Drama Criticism in America," *The Oxford Companion to American Theater* (New York: The Oxford University Press, 2004), http://www.encyclopedia.com/doc/1O149-DramaCriticisminAmerica.html (accessed May 1, 2010).

27 See Margaret Drabble and Jenny Stringer, *The Concise Oxford Companion to English Literature* (London: The Oxford University Press, 2003).

28 From a 1803 essay by Washington Irving, as part of an exchange between his pseudonym Jonathan Oldstyle and another invented persona, Andrew Quoz. Cited in http://schooltheater.org/sites/default/files/dramatics/2010/11/1110_york%20coppens_timeline2_0.pdf. (accessed May 1, 2010).

29 Cited in Miller, *Bohemians and Critics*, 8.

30 Ibid, 8.

31 Edgar Allan Poe, James Russell Lowell, and Nathaniel Parker Willis, *The Works of Edgar Allan Poe: Criticism* (New York: A.C. Armstrong & Sons, 1895), 140.

32 See Colin Chambers, *The Continuum Companion to Twentieth Century Theater* (London: Continuum Publishing, 2002), 183.

33 Cited in Miller, *Bohemians and Critics*, 1.

34 *New York Tribune*, May 8, 1849, 2, cited in Barbara Foley, "From Wall Street to Astor Place: Historicizing Melville's 'Bartleby'," *American Literature*. 72(1), 2000, 87–116.

35 *New York Herald*, May 9, 1849, 4, cited in Dennis Berthold, "Class Acts: The Astor Place Riots and Melville's 'The Two Temples'," *American Literature*, 71(3), 1999, 429–461.

36 See Robert W. Snyder in *The Encyclopedia of New York City* (New Haven, CT: Yale University Press, 1995).

37 *New York Tribune*, supplement, May 1, 1849, 1.

38 Cited in Foley, "From Wall Street to Astor Place," 114.

39 Ibid.

40 Cited in http://digital.lib.lehigh.edu/pfaffs/p14/

41 Ibid.

42 Cited in Wilmeth, *The Cambridge Guide to American Theater*, 189.

43 Junius Henri Browne, *The Great Metropolis; A Mirror of New York* (Hartford, CT: American Publishing, 1869), 152.

44 G.J.M., "Bohemianism: The American Authors Who Met in a Cellar," *Brooklyn Eagle*, May 25, 1884, 9.

45 Elihu Vedder, *The Digressions of V., Written for his Own Fun and that of His Friends* (Boston and New York: Houghton, Mifflin & Co., 1910), 232.

46 William Dean Howells, "First Impressions of Literary New York." *Harper's New Monthly Magazine*, June 1895, 62–74.

47 Albert Parry, *Garrets and Pretenders: A History of Bohemianism in America* (New York: Covici, Friede, 1933), 26.

48 Gay Wilson Allen, *The Solitary Singer: A Critical Biography of Walt Whitman* (New York: Macmillan, 1955), 229.

49 Cited in Wilmeth, *The Cambridge Guide to American Theater*, 189.

50 Alma J. Bennett, *American Women Theater Critics* (London: McFarland & Company, Inc., Publishers, 2010). The first female theater critic of record is Charlotte Ramsey Lennox, who wrote a three-volume set of Shakespearean criticism in 1753. Judith Sargent Murray wrote essays on theater in Boston for *Massachusetts Magazine* during the 1780s and 1790s.

51 McDonald, *The Death of the Critic*, 53.

> *"Criticism has only really had an effect on theater in the last 125 years. The reason theater criticism has its own power now is because there are so many forms of entertainment and the public has so many dollars to spend."*
> ~Stephen Sondheim, composer[1]

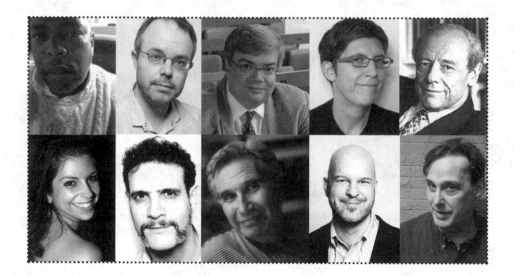

Chapter 6 Abstract

This chapter will identify and describe the contributions and unique styles of key theater critics from the 20th century. These critics include Bernard Shaw, Stark Young, Alexander Woollcott, Eric Bentley, George S. Kaufman, Harold Clurman, Kenneth Tynan, and Frank Rich. Today's leading theater critics will also be identified by name and reputation.

The Evolution of Theater Criticism
The Modern Era

As was noted in the previous chapter, it took nearly 2,500 years for theater criticism to eventually evolve into its own enterprise within the realm of print journalism. While some argue that modern theater criticism was born in the salons and coffee houses of London in the early 18th century,[2] a case was made that it was the saloons of America in the 19th century in the aftermath of the industrial revolution. The growth of cities, rail transportation, and leisure time by an increasingly large privileged class gave way to several subsequent changes in America which, in turn, gave way to changes in theater criticism.

A More Learned Press Corp

Conditions that had encouraged the Bohemian life had vanished during the Civil War and the chaos that followed prompted writers to seek refuge in tradition, not attack it. Moralists, conservatives, and puffers reasserted themselves in the press. Developments in Europe and increased travel after the Civil War, however, introduced theatergoing Americans to Henrik Ibsen, George Bernard Shaw (see Shaw as Critic, in profile), and other European dramatists who produced an intelligent and naturalistic form of theater, known as realism. Public demand brought those playwrights to America, which required that critics broaden their scope of interest and knowledge about theater.[3] Some critics, such as Harrison Grey Fiske of the New York Dramatic Mirror in the 1880s, encouraged a more professional American theater and ridiculed the shoddy business practices and productions of some playhouses. Improvements in city transportation and street lighting made for safer travel at night, and the number of patrons for the growing number of theaters in New York City increased enormously.

Shaw as Critic, in profile[4]

The playwright George Bernard Shaw wrote 151 weekly, 2,000–3,000 word theater criticism pieces during his stint at *The Saturday Review* between 1895 and 1898.

Before taking up his position as drama critic for *The Saturday Review*, Shaw had spent a few months in Dublin working in a clerical job in a land agency office, and another few months working in London for the Edison Telephone Company. It was through his mother that Shaw got his first job as a critic, as a ghost writer for her singing teacher doing music criticism for a periodical called *The Hornet*. In the early 1880s, while writing a series of unsuccessful novels, he did stints as art critic for *Our Corner*, literary critic for the *Pall Mall Gazette*, and music critic for *The Star* and *The World*, writing under the pseudonym "Corno di Basetto." While a theater critic he wrote numerous unsuccessful plays.[5]

Shaw was a theater critic at an especially interesting and volatile time in the history of British theater. Melodrama was the dominant genre, and actor-managers were prioritizing visual theater over text. Late Victorian theater was intellectually vacant and on the periphery of the vital social changes taking place at that time. Censorship was rampant and women playwrights who were addressing political and social issues were finding little success. All this gave Shaw much to lambast and, as he did with the works of Henrik Ibsen, to advocate.

At the core of Shaw's admiration for Ibsen—and really at the core of all of his critical writing on theater—is his deep-rooted sense of what theater, at its best, should be. He once wrote:[6]

> Only the ablest critics believe that the theater is really important: in my time none of them would claim for it, as I claimed for it, that it is as important as the Church was in the Middle Ages, and much more important than the Church was in London in the years under review. A theater to me is a place "where two or three are gathered together" [Matthew 18:20]. The apostolic succession from Aeschylus to myself is as serious and as continuously inspired as that younger institution, the apostolic succession of the Christian Church.

What did he think of the profession upon his retirement?

In his final piece for *The Saturday Review* on May 21, 1898, he grumbled about being "the slave of the theater…tethered to the mile radius of foul and sooty air which has its centre in the Strand, as a goat is tethered in the little circle of cropped and trampled grass that makes the meadow ashamed." Each

week, he said, the theater "clamors for its tale of written words, so that I am like a man fighting a windmill: I have hardly time to stagger to my feet from the knockdown blow of one sail, when the next strikes me down. Now, I ask," he said, "is it reasonable to expect me to spend my life in this way? For just consider my position. Do I receive any spontaneous recognition for the prodigies of skill and industry I lavish on an unworthy institution and a stupid public? Not a bit of it...."

A few years later, once his reputation as a playwright was firmly established, Shaw berated theater critics for their "gross ingratitude, their arrant Philistinism, their shameless intellectual laziness, their low tastes, their hatred of good work, their puerile romanticism, their disloyalty to dramatic literature, their stupendous ignorance, their susceptibility to cheap sentiment, their insensibility to honour, virtue, intellectual honesty, and anything that constitutes strength and dignity in human character."[7]

The Birth of Modern Criticism

Of course, there was plenty of low-brow theater in New York as well. The first of many vaudeville theater houses opened one block east of Union Square in 1881. Also, hundreds of musical comedies were staged on Times Square in the 1890s and early 1900s, comedic operas were imported to New York from England, and translations of popular late-19th century continental operettas were staged. After World War I, the newly formed Actors' Equity Association[8] demanded a standard contract for all professional productions. After a strike in 1919, which shut down all the theaters, the producers were forced to agree. All this contributed to the emergence of a more professional and vital theater culture in New York City and other major cities at the turn of the 20th century, and critics who championed this culture, such as Alexander Woollcott at *The New York Times*, grew in power.[9]

The Age of Instant Criticism

William Randolph Hearst had quite the opposite effect on theater journalism.[10] Hearst was an affluent American newspaper magnate and leading newspaper publisher who entered publishing in 1887 after taking control of *The San Francisco Examiner*. Moving to New York City, he acquired *The New York Journal* and other papers and engaged in an infamous circulation war with Joseph Pulitzer's *New York World* that emphasized sensationalism and undermined the standards of objective journalism. This was the era known as Yellow Journalism. What became known as "instant criticism" emerged about the turn of the 20th century, which treated

arts criticism as if it were news reporting. The highly competitive news operations were intent on "scooping" the other papers, so critics for morning newspapers were expected to rush back to their offices after an evening performance and kick out an article for the next edition. Less thoughtful, more reactive, and increasingly sensational criticism resulted.[11]

Pulitzer, haunted by the lack of professional integrity during the years of his rivalry with Hearst, returned the *World* to its crusading roots and, by the time of his death in 1911, made it a widely-respected publication. Hearst, however, continued to use his papers as playthings. This bled over to his papers' coverage of theater when Hearst, an avid theatergoer, met actress Marion Douras. At the peak of her stage career, she was a chorus girl in the Ziegfield Follies. When Hearst first saw the 16-year-old Douras dance in the chorus of *Stop! Look! Listen!*, he was 58 years old. Not very long after their relationship began, Hearst's newspapers began to run stories about Douras and promoted her stage exploits in the Sunday drama sections. In fact, he specifically issued instructions to his editors in 1915 not to engage in "old style dramatic criticism" but rather to provide "kindly" and "considerate" criticism of performances, eschewing the "perverse view of a blasé dramatic critic."[12]

Rebounding from Yellow Journalism

The pieces of theater criticism by Stark Young that began appearing regularly in the *New Republic* magazine from 1922 to 1924 and again from 1925 to 1947 (during the 1924–25 season he covered the theater for *The New York Times*) signaled a new era for the American theater and its criticism. According to theater educator Bert Cardullo, "here was a critic who thought the art of the theater worth taking seriously, and who, as luck would have it, appeared on the scene just as drama in America became worthy of being taken seriously."[13]

John Pilkington, who edited the two-volume edition of Young's correspondences, characterizes him as a modern humanist who believed in literature as a moral enterprise that forwards the welfare of society: "Fundamentally, Stark Young's drama criticism...developed from his philosophy of art. The more he understood the fine arts, the more convinced he became that the artist pointed out for society the ways to right living."[14]

Upon his retirement, theater critic Eric Bentley singled Young out and applauded his colleague for "his ready emotionality [that] is not divorced from his finer feeling or from his intellect."[15] Bentley praised Young for being "a critic in the fullest sense— one who judges by standards that are not imposed from without but prompted and checked by his own first-rate sensibility."[16] Cardullo noted that Young brought to his criticism an "intelligence that was acutely sensual, eyes and ears open in an unprecedented way to the nuance and texture of the theatrical moment, and an ability to record what he saw in a manner at once poetic and concrete."[17]

"The art of theater is not a mere combination of any particular things, settings, actors, recitation, literature," suggested Stark. "It is a distinct and separate art. It may be composed of many things, but it is none of them. Nothing that goes to compose this art remains as it was before coming part of it. But what that separate art of the theater is can be more easily illustrated than defined."[18] Here is an illustration, a 1926 critique of actress Ethel Barrymore's performance of the "Quality of Mercy" speech from Shakespeare's *The Merchant of Venice:*[19]

> The fundamental mistake here lay in the fact that the actress saw the speech not as art but as life. If she had left it as an arrangement in a work of art, the speech would have been lovely and rich. When she tried to make it plausible and natural she threw it out of focus and left us praising the actor but apologizing for Shakespeare.

Young also left his mark on in the field of criticism with his unique writing style. Being himself a theater practitioner, Young brought "an exhaustive knowledge of all the components required for an effective production of a play" according to Pilkington,[20] and a special ability to capture the visual stage effect through words. He continues:

> Whether he was writing about the inflections of an actor's voice in the delivery of a single word or line, the gestures of supporting characters, the design of a costume, the placement of furniture on the stage, or the lighting of the set, Young always had in mind a standard of excellence to which the particular component should conform.

An example can be found in Young's 1922 review of Eugene O'Neill's play *The Hairy Ape:*[21]

> And what a scene the last is, with that heavy, lost body stealing in there in the twilight; the darkness and the noises like those of the prison; and through the dim light the beast's figure looming up in the cage, more terrible and more beastly because half seen! The imagination behind the invention here is magnificent and unique; it exhibits a kind of dark and passionate warmth of life that is to be found nowhere else; it sums up and sweeps together into one grotesque and poignant moment all the life of that groping and wounded creature who comes there; his glimpses into thought; his impatient defeats and reticences, only half admitted and covered up with oaths; and the great inflexible hulk of this body, mind and soul that make such a tragic unity.

Or this more abstract description from Young's 1925 review of *The Fountain:*[22]

> The setting for the spring to which Ponce de Leon comes for the enchanted drink is an out-of-doors design that is most distinguished and splendid. In color it is all black and somber green. In form it is harsh and severe, clawing, hard edges, simple, strict forms. It is easily the pinnacle of the whole occasion.

When he was confined to fewer column inches, as he was with many of his pieces in *The New York Times* (which is one of the reasons he left), Young simply

employed more words per sentence. This excerpt from his 1924 review of *The Red Falcon* displays this:[23]

> *The Red Falcon* at present shows few signs of any sort of imagination. The best thing to do for it, then, would be to push what is there further on into pure theater, making it more frankly startling, more picturesque, more lurid, more villainous, daring and sentimental, playing it with more extravagance, polish and style, and not leaving it, as it is now, mildly wandering along, without the truth either of life or of romance.

T.S. Eliot proposed that a playwright should turn to poetry only in those instances when prose proved incapable of expressing the emotion felt by the character. Stark Young's writings suggest that the emotion of the dramatist which demands expression has, in and of itself, the capacity for turning prose into poetry. And it is precisely this quality that playwright Eugene O'Neill, in a 1929 letter to his critic/friend, praises Young for intuiting. The playwright thanks Young for his "real sympathy and understanding" and "sensitive comprehension," and then concludes, "Your opinion of my contribution to fundamentally poetic drama is the kind of reassurance I long for from someone whose opinion I respect."[24] A playwright thanking and respecting a critic. Therein lays Stark Young's greatest legacy.

The Roaring 20s

Broadway theaters were booming in the 1920s. During these post-World War I years, the number of productions increased from 126 in 1917 to 264 in 1928, which is still the all-time peak of production. Broadway was bursting with energy and enterprise. The theater was filled with hope, fresh ideas, and new styles of craftsmanship and showmanship. Florenz Ziegfeld produced spectacular song-and-dance revues featuring extravagant sets and elaborate costumes. The Theater Guild was formed during this time as well, which sought to produce non-commercial, original works by American and foreign playwrights, including Eugene O'Neill, which paved the way for other major dramatists like Elmer Rice, Tennessee Williams, and Arthur Miller, as well as writers of comedy like George S. Kaufman. In response to the increasingly popular film industry, which had just developed synchronized sound and was responsible for the conversion of many local playhouses to film, an increasing supply of large scale musicals took to the New York stage. Their books may have been forgettable, but the music was created by such geniuses as George Gershwin, Cole Porter, Jerome Kern, Vincent Youmans, and Rodgers and Hart.

Playwright George S. Kaufman was also the second-string drama critic at *The New York Times* from 1917 through 1930, with the renowned Alexander Woollcott serving as senior critic. Kaufman, a tall, bony, deeply unsentimental man with glasses and a shock of unruly hair, never used more words than were necessary while speaking or writing. What made him distinctive were the words he chose, which were

crisp and curt to the point of being sardonic. His first theater review was written when he was in his early 20s, while working for a small summer stock company in Troy, N.Y. He quit after one week, sending his father a telegram that said: "Last Supper and original cast wouldn't draw in this house."[25]

Kaufman was, according to critic Alvin Klein,[26] the "droll master of Broadway lingo, 1920s style." Of a particularly dismal comedy he wrote, "There was laughter in the back of the theater, leading to the belief that someone was telling jokes back there." Of another play, equally short-lived, he observed, "I saw the play at a disadvantage. The curtain was up."[27] During the performance of a very bad play, Kaufman leaned forward and politely asked the woman in front of him if she would mind putting on her hat.[28] *The New York Times* colleague Brooks Atkinson wrote that Kaufman's sarcasm and hard-boiled social commentary "managed to remove contentment from the face of this macadamized land."[29]

The other thing that made him distinctive was the other occupation he held while at *The New York Times*. Kaufman was a master comedic playwright with an expertise in a number of types of comic speech—blustery patter, desperate excuse making, unwitting foolishness, and the snide aside, to name a few[30]—and politics and theater were Kaufman's two principal subjects for satire. His debut as a playwright was in 1918 with the premiere of the melodrama *Someone in the House* that he coauthored with Walter C. Percival. The play opened on Broadway during that year's great flu epidemic, when people were being advised to avoid crowds. The play ran for only 32 performances, which prompted Kaufman to suggest in an ad for the show that the best way to avoid crowds in New York City was to attend his play.

Kaufman was really more of a play polisher and script doctor—a collaborator—than a playwright, for he wrote only one play alone, *The Butter and Egg Man* (1925). All his other plays were written in collaboration with other writers. "It must have been that he got lonely," noted *Times* critic Bruce Weber. "He didn't really need the help."[31] Kaufman made it a rule that whoever came up with the original idea for the play would be first-billed.[32]

With Marc Connelly he wrote *Merton of the Movies* (1922) and *Beggar on Horseback* (1924). With Ring Lardner he wrote *June Moon* (1929). With Edna Ferber he wrote *The Royal Family* (1927), *Dinner at Eight* (1932), and *Stage Door* (1936). With John P. Marquand he wrote a stage adaptation of Marquand's novel *The Late George Apley* (1944) and with Howard Teichmann he wrote *The Solid Gold Cadillac* (1953). Possibly his most successful collaboration was with Moss Hart, with whom he wrote several popular plays, including *Once in a Lifetime* (1930), *You Can't Take It with You* (1936), and *The Man Who Came to Dinner* (1939), whose lead character was based on senior critic Alexander Woollcott. Kaufman collaborated on several musicals as well, including *The Cocoanuts* (1925, with Irving Berlin) and *Animal Crackers* (1928, with Morrie Ryskind, Bert Kalmar, and Harry Ruby) for the Marx Brothers, who

were making the transition from vaudeville to the legitimate stage, and *Of Thee I Sing* (1931) and *Let 'Em Eat Cake* (1933) with Ryskind and George Gershwin. *Of Thee I Sing*, a political satire, was the first musical to win a Pulitzer Prize.

In every Broadway season from 1921 through 1958, there was a play written or directed by Kaufman, and there have been revivals of his work on Broadway in the 1970s, the 1980s, and in the 2000s. The reason has been succinctly stated by *Times* theater critic Charles Isherwood:[33]

> Setting aside the always vexing idea of greatness, Kaufman's writing retains its energy and force today because, aside from its clear virtues as expertly wrought comedy, much of it seems to prefigure, predict and lampoon cultural developments that have gained force in the decades since the years of his influence.

Even when he had success after success on Broadway, Kaufman stayed at the *Times* as its second string critic. *Times* drama critic Brooks Atkinson believed that Kaufman "trusted the *Times* more than he trusted the theater.... There was nobody less sure of himself as a theatrical genius.... He felt that if everything else blew up, he could always come back to the *Times*."[34] Plus, as a critic for the *Times*, he had access to every theatrical and literary celebrity in New York, who lunched with him at the Algonquin Hotel in the middle of the newspaper district. This group of New York literati became known as the Algonquin Round Table[35] (see The Aisle-Sitters of Gotham, in profile).

It was during the Great Depression that Kaufman decided to leave the *Times*. He realized that there were many editors and reporters out of work and he had sufficient theater royalty checks to fall back on. "Being a fair man," noted Broadway historian Ken Bloom, "he left room for someone else.[36] In fact, Kaufman refused the job of chief drama critic when Alexander Woollcott stepped down. The job went to Brooks Atkinson,[37] who Stark Young believed was more of a man of the people.

Atkinson was, according to critic Eric Bentley:[38]

> [W]ell-educated, dry, not too intellectual, very much on the level, extremely liberal, a big supporter of Roosevelt and the New Deal.... That was where the then-Broadway public was. They were all Brooks Atkinson's children.... Like he'd decide to say about a new Tennessee Williams or Arthur Miller, "tonight, the theater became an art again." That's line one. Then he tells the plot. Then at the end he said, 'The theater is an art again.' At ten o'clock the morning following, there's a line outside the theater. The play is a hit. No other critic has ever achieved that.

In truth, you could not have a hit on Broadway in the 1920s without having all seven of the major newspapers agree on the merits of a particular play. Still, Brooks Atkinson was the most important critic while George S. Kaufman was the most entertaining writer. Playwright Garson Kanin once said of Kaufman:

The Aisle-Sitters of Gotham, in profile[39]

The New York Drama Critics' Circle—a counterpart to the London Drama Critics' Circle—was formed in 1935 in part due to some prodding by the English critics who called the New York press "The aisle-sitters of Gotham," but largely due to widespread dissatisfaction with the annual winners of the Pulitzer Prize for drama.

In the 1933–1934 season, the Pulitzer board outraged New York critics by overruling the recommendation of its own drama jury for Maxwell Anderson's *Mary of Scotland* in favor of Sidney Kingsley's *Men in White*. The following year, the board chose Zoë Akins's melodrama *The Old Maid* over more impressive works by Anderson, Lillian Hellman, Robert Sherwood, George S. Kaufman, and Clifford Odets. Shortly thereafter, the need to establish a second major drama award, decided by New York critics, became a reality.

The first meeting of the New York Drama Critics' Circle, on September 22, 1935 at the Algonquin Hotel, consisted of nine critics that included Brooks Atkinson of *The New York Times*, Burns Mantle of the *New York Daily News*, John Mason Brown of the *New York Post*, and George Jean Nathan of *Vanity Fair* and *Life*. One month later, the Circle's second meeting had eight new members, including *The New Yorker*'s Robert Benchley, the *New York Herald Tribune*'s Percy Hammond, the *New York Mirror*'s Walter Winchell, and *The New Republic*'s Stark Young (who resigned his position on the Pulitzer play jury to join).

Needless to say, free liquor was provided.

Over the years the Circle joined with Actors' Equity Association, the Dramatists Guild, and other groups to fight censorship, protest the McCarthy-era blacklist, and raise money for war relief and other causes.

On March 25, 1936, the critics met to determine the winner of the Circle's first award. After five ballots, Maxwell Anderson's *Winterset* received the 14 votes required to win under the constitution's so-called "Popeye clause," which mandated a three-quarters majority. The three dissenting critics—John Anderson, Robert Garland, and Percy Hammond—held out for Robert Sherwood's *Idiot's Delight*.

In his awards ceremony acceptance speech, Anderson noted that "Except for the theater critics of New York no body of men in the country is qualified by training, education and professional experience to render judgment on a season's plays." In 1946, with his plays no longer in favor, Anderson noted that most critics bring to the theater "nothing but hopelessness, recklessness and

despair," and referred to them as "the Jukes family of journalism," after an infamous 19th-century crime clan.[40]

In keeping with its cantankerous origins, the Circle in 2010 spurned Broadway fare to find the winner of its best play award. The winner was the last work from the late Horton Foote, a three-part, nine-hour Off-Broadway opus dubbed *The Orphans' Home Cycle*.

"[He] ranks without peer as the wit of the American 20th century. George's comment, George's cool-off, George's swiftness to pick up the answer was breath-taking.... He was taciturn. He didn't say much, but what he did say was stringent, always to the point, cutting, acid, true or true enough. Which was his great trick. His trick of wit and his trick of criticism wasn't that he found what was true, but he would find what was true enough."[41]

"Shaw said once, 'The theater is always in a low estate.' If you look at an anthology of great plays from the Greeks to today, you think, 'My God, what a panorama of achievement.' Then you look at the dates and you see that hundreds of years elapsed between one play and the next. Sometimes we have the bad luck to be caught in between."
~Stanley Kauffmann, theater critic, *The New Republic*[42]

After the Lean Years

Theater survived the Great Depression in no small part due to federal funding through the Federal Theater Project. The FTP was a New Deal project to fund theater and other live artistic performances during the Depression. Its primary goal was employment for out-of-work artists, writers, and directors, with the secondary aim of entertaining poor families and creating relevant art. In addition, some playwrights joined together to consolidate their works under the auspices of one producing organization.

Interestingly, among the Wall Street financiers, commodity speculators, and foreclosing bankers held responsible for the Great Depression, William Sirovich, a U.S. Representative and chairman of the Patents, Trademarks, and Copyrights Committee, pointed the finger at theater critics as well. He charged[43] that the once-thriving theater business hit the skids due to "malicious criticism" by critics posing as "know-it-alls," and noted that "producers spend hundreds of thousands getting a play ready. When they get it to New York, the drama critics close it," putting stagehands, musicians, dressmakers, carpenters, mechanics, and actors out of work.

Sirovich called 18 well-known reviewers to attend a hearing in Washington. They all declined, and *New York Journal-American* drama critic John Anderson added that accusing critics of injuring the theater was as silly as "saying that newspapers were responsible for the Depression by quoting stock market reports." Brooks Atkinson of *The New York Times* invited Sirovich to meet with critics in New York, "so we can ask him some questions about the government." In the *New Yorker*, E.B. White suggested reducing Sirovich's salary to help balance the budget.[44]

After the Great Depression and during World War II, Broadway prospered as theater offered serious drama that melodramatically addressed the war and American idealism, and provided escapism from it through comedy and the musical. However, after WWII, high production costs on Broadway and efforts to establish professional theater outside of New York resulted in the Off-Broadway and regional theater movements which had both been operational but were far from universally successful. Away from the financial pressures and the commercial parameters of Broadway, alternative theaters surfaced. A new theatrical generation with priorities at odds with those of the establishment offered a voice for new playwrights and directors in the 1950s and 1960s.[45] Socially committed and aesthetically radical, these pioneers ventured into Bertolt Brecht's Epic Theater, Antonin Artaud's Theater of Cruelty, and the neo-Dada Happenings of the art world. This evolution required theater critics with a more diverse pallet and a wider range of expertise than previous generations of writers. Harold Clurman was one of them.

"In the history of every art form," noted actress Meryl Streep,[46] "there are certain key figures who might be called 'generators'—those who do not simply produce work but who by their presence, enthusiasm and passion cause important work to get done. In American popular theater, Harold Clurman was such a generator."

Harold Clurman was drama critic for *The New Republic* from 1948–1952 but spent 1953–1980 writing in the relative obscurity of *The Nation*. He was, nonetheless, one of the best critics of his time, as "good on theater," noted *Wall Street Journal* theater critic Terry Teachout,[47] "as Otis Ferguson was on film, Edwin Denby on dance, Fairfield Porter on art and Virgil Thomson on classical music."

What made him so good? For one thing, he was a man of wide-ranging taste and sensibility and adept at writing about any number of cultural subjects, including film, dance, art, and classical music. Because of the breadth of his cultural receptivity, he was interested in every kind of theater and open to the possibility that anything might be good in its own way. He was, for example, an early champion of playwrights Edward Albee and, particularly, Bertolt Brecht, whom he called a "kind of Gothic primitive, in whom a rude simplicity is coupled with a shrewd mentality."[48] In fact, according to his 12 commandments for critics that appears in an edited volume of his works (see Clurman's The Complete Critic's Qualifications, in profile), Clurman believed that any critic worth his salt should be as knowledge-

able, passionate, and receptive as him. Yet, he also believed that "deep thinkers of the theater who refuse to relate to its vulgar pleasures are off balance. They lack that essential ingredient of wisdom—the ordinary."[49]

Wisdom was another attribute that made him so good. Wherever Harold Clurman went, noted *The New York Times* theater critic Mel Gussow,[50] "he was accompanied by a sense of theatrical history, which was as endemic to his personality as his silver-tipped cane and black velour hat.... He would identify the Odetsian ancestry of a provocative drama by a black author, or reach back for a reference to Stanislavsky during a performance of a play by Chekhov." Clurman attended Columbia and later the University of Paris, where he wrote his thesis on the history of French drama from 1890 to 1914.

Clurman was a man who understood firsthand the difficulties that stand in the way of what novelist and essayist Wilfrid Sheed called "the simple miracle of

Clurman's "The Complete Critic's Qualifications," in profile[51]

I. The critic should know the greater part of classic and contemporary drama as written and played. Added to this, he must be conversant with general literature: novels, poetry, essays of wide scope.

II. He should know the history of the theater from its origins to the present.

III. He should have a long and broad play-going experience—of native and foreign productions.

IV. He should possess an interest in and a familiarity with the arts: painting, music, architecture and the dance.

V. He should have worked in the theater in some capacity (apart from criticism).

VI. He should know the history of his country and world history: the social thinking of past and present.

VII. He should have something like a philosophy, an attitude toward life.

VIII. He should write lucidly, and, if possible, gracefully.

IX. He should respect his readers by upholding high standards and encourage his readers to cultivate the same.

X. He should be aware of his prejudices and blind spots.

XI. He should err on the side of generosity rather than an opposite zeal.

XII. He should seek to enlighten rather than carp or puff.

getting the curtain up."[52] He was a successful director of more than 40 plays including Jean Giraudoux's *Tiger at the Gates* (1935), Eugene O'Neill's *Touch of the Poet* (1958), and Arthur Miller's *Incident at Vichy* (1964). During the 1930s, he was the passionate co-founder with Cheryl Crawford and Lee Strasberg of an experimental theater collective called Group Theater. The name came from the idea that, among its 31 members that included Stella Adler, Morris Carnovsky, Phoebe Brand, Elia Kazan, Clifford Odets, and Sanford Meisner, there would be no stars; the actors and everyone involved would be a true ensemble.[53] The benefits of a permanent acting company, Clurman believed, was that once actors knew and trusted each other they could truly work together to create great theater. The Group Theater, with its ensemble approach and emotional and realistic productions that expressed political and social views about contemporary issues, permanently altered American theater's previous emphasis on pure entertainment.

Some thought Clurman was too closely affiliated with the theater to be objective in his critical assessments of his colleagues. To that he responded: "The fact that I am engaged in active stage work does not render me timid and indulgent or resentful, malicious and vindictive. It makes me scrupulous and responsible."[54] It was precisely because Clurman had worked with people like William Inge, Clifford Odets, Eugene O'Neill, Arthur Miller, and Tennessee Williams, suggested Teachout, that he "was capable of writing with such lapidary insight about their virtues and flaws."[55]

A case in point is Clurman's 1948 review of the original production of Tennessee Williams's *A Streetcar Named Desire*. Teachout wrote: [56]

> Though he saw at once that Tennessee Williams's play ranked "very high among the creative contributions of the American theater since 1920," he was the only New York critic who also saw that Elia Kazan's staging suffered from "a lack of balance and perspective" arising from Marlon Brando's larger-than-life performance as Stanley Kowalski. "Brando's quality," Clurman wrote, "is one of acute sensitivity. None of the brutishness of his part is native to him.... When he beats his wife or throws the radio out the window there is, aside from the ugliness of these acts, an element of agony that falsifies their color in relation to their meaning in the play: they take on an almost Dostoyevskian aspect." That kind of sharp-eyed analytical insight comes naturally to a director—but not to a dilettante who knows nothing of the daunting realities of getting a play on stage.

British theater critic Kenneth Tynan (see Kenneth Tynan—The Notorious Critic, in profile), a contemporary of Clurman's, also found Clurman to be that rare critic who had no difficulty distinguishing between script and production, direction and performance. Here is his take on Clurman's piece on *A Streetcar Named Desire*: [57]

> What makes it such a brilliant review is that unlike his peers, he understood how Mr. Kazan's powerful production actually distorted the focus of the play. By tilting the drama in favor of Marlon Brando in the role of Stanley Kowalski, the director encouraged theatergoers to regard Blanche DuBois "as a deteriorated Southern belle" rather than "as the

Kenneth Tynan—The Notorious Critic, in profile

"No statue has ever been put up to a critic," noted Finnish composer Jean Sibelius. Perhaps not, but a play was written about British theater critic Kenneth Tynan. This would have pleased him for he once stated that "the true critic cares little for here and now. The last thing he bothers about is the man who will read him first. His real rendezvous is with posterity."[58]

Tynan is a 90-minute one-man play that premiered at the Royal Shakespeare Company in London in 2004 and made its U.S. debut in Los Angeles in 2010. The following excerpts from critical reviews of this play serve to profile Kenneth Tynan and his contributions as critic.

> Peter Brown, *London Theater:*[59] Kenneth Peacock Tynan was one of the foremost drama critics (if not the foremost critic) in the UK in the 1950s and 1960s. For some, his reviews were an art form, and there's no doubt that he was enormously influential. But he was much more than simply a critic. As his daughter Tracy says in her programme notes, he "was constantly re-inventing himself as stage director, bullfight aficionado, raconteur, essayist, screenwriter and TV personality." He's also renowned as being the first person to use the word f*** on British Television.

> From Nelson Pressley, *The Washington Post:*[60] "The critic's job—at least 9/10ths of it—is to make way for the good by demolishing the bad," Tynan wrote, a sentiment that makes its way into the fluid 90-minute stage adaptation by Richard Nelson and Colin Chambers. "I wish I were back at work bulldozing." Yet he was a splendid stylist, as this adaptation of the John Lahr-edited diaries reminds us. The most theatrical thing about *Tynan* is the gem-cut sentences within which Tynan performed; they are crafty, bravura events, detonations of deadly wit and mordancy.

> From Chris Klimek, *Washington City Paper:*[61] Kenneth Tynan was famous and successful by his mid-twenties, a London and later New York theater critic whose passionate, eloquent, lacerating judgments influenced the course of the form in the 1950s. In his 30s, he reinvented himself, taking a gig as literary manager of London's National Theater to which its director, Sir Laurence Olivier, personally invited him—to shut him up, some say. By his 40s, Tynan's life was a titillating wreck of ill health (emphysema didn't stop him from chain-smoking), debt, kinky extramarital dalliances, alcoholism, and occupational and existential malaise.

> Jayne Blanchard, DCtheaterscene:[62] Based on Tynan's diaries, the show reveals the man as at once deeply introspective and an enormous show-off. You relish the anecdotes about theater greats—who knew John Gielgud and Ralph Richardson were

so funny?—and the dizzying number of literary and stage luminaries, of whom he name-drops with deceptive casualness. Tynan demanded that you be dazzled, to consider him not only a great critic, but the creator of a scene enjoyed only by the privileged few.

Listen to him, read him—luscious. Have him in your life—no thanks. The irony of that is too delicious since *Tynan* reveals that one of literature's most astute observers and inciters of art is, himself, best viewed from a distance, safely tucked away on a stage where he can do no harm.

potential artist in all of us," as someone who is "defeated because everything in her environment conspires to degrade the meaning of her tragic situation."

"To serve as something beyond a privileged press agent with a fancy vocabulary," suggested Clurman,[63] "the theater critic must be an artist, a historian and a philosopher." Clurman was all three. He died in New York City in 1980. A Broadway theater bears his name.[64]

The Era of the Critic as Superstar

In the 1960s, President Lyndon B. Johnson spearheaded the approval of the National Endowment of the Arts. The NEA was conceived by President John F. Kennedy and found inspiration in a speech he gave on October 26, 1963 at Amherst College. President Kennedy made clear the need for a nation to represent itself not only through its strength but also through its art and in "full recognition of the place of the artist":[65]

Our national strength matters, but the spirit which informs and controls our strength matters just as much.... When power leads men towards arrogance, poetry reminds him of his limitations. When power narrows the areas of man's concern, poetry reminds him of the richness and diversity of his existence. When power corrupts, poetry cleanses. For art establishes the basic human truth which must serve as the touchstone of our judgment....

Coupled with funding from foundations, corporate sponsors, and individual donations, the NEA signaled a new-found acceptance of theater as a cultural resource as worthy of support as museums, symphony orchestras, and libraries. This placed theater critics in the position of dictators of cultural standards.

By the 1960s and with the demise of several New York papers—the result, in part, of the popularity of television as a news source—*The New York Times* became

the most powerful voice in theater criticism. It still is. Walter Kerr (see, Theater Criticism and the Pulitzer Prize, in profile) followed by Clive Barnes and Frank Rich, became dominant critics. In 1973, *Newsweek* ran a special issue on "The Arts in America" and writer Arthur Cooper heralded in "the era of the critic as superstar." He noted[66] that the influence of and interest in criticism increases as the quantity and quality of new art declines. Frank Rich so dominated the theater scene that if he disliked a play in London, producers would not bother to bring it to New York.

Frank Rich earned his first byline in *The New York Times* when he wrote a piece for the op-ed section while a student at Harvard. Following a short stint as film critic for the *New York Post* and film and TV critic for *Time* magazine, he joined *The New York Times* in 1980 and became the paper's chief theater critic. Once there he earned the moniker "The Butcher of Broadway" for the acidity of his reviews and their ability to kill shows. According to critic Charles Marowitz, "The theater community smarted under his acrimonious notices. When he walked into theater receptions, the actors, it is alleged, walked out en masse."[67] Case in point: He described the prom scene in the 1988 Stephen King musical flop *Carrie* as "the sort of cheesy foreign-language floor show one flips past in the nether reaches of cable television."[69] By his own admission, his most lethal review was for *Moose Murders*,

Theater Criticism and the Pulitzer Prize, in profile

Critic Walter Kerr wrote for *Commonweal* and the *New York Herald Tribune* before going to *The New York Times* in 1966. A highly educated man, Kerr's reviews were famous for their ability to reproduce in writing the sights and sounds of a live performance but infamous for digressing into drama theory. He allied this knowledge with an ability to write in an easily-comprehendible style, described by playwright Noel Coward as follows:[68]

> After a tortuous sentence fairly shimmering with emotion he suddenly introduces a vulgarism, a slang phrase, to prove that in spite of his impressive learning he is in fact just a regular guy like you or me.

Kerr's importance was such that he was awarded the Pulitzer Prize in Criticism, an award that was initiated in 1970. His award in 1978 was the only time the Pulitzer has gone to a theater critic. In 2011, the prize went to Sebastian Smee of the *Boston Globe* for his art criticism. Finalists were food critic Jonathan Gold of the *LA Weekly* and architecture critic Nicolai Ouroussoff of *The New York Times*. In 2012, the prize went to film critic Wesley Morris of the *Boston Globe*. Finalists were Tobi Tobias, artsjournal.com, for dance, and Philip Kenicott, *The Washington Post*, for cultural criticism.

a mystery farce that opened and closed on February 22, 1983. In it he wrote: [70] "The 10 actors trapped in this enterprise, a minority of them of professional caliber, will not be singled out here. I'm tempted to upbraid the author, director and producers of *Moose Murders*, but surely the American Society for the Prevention of Cruelty to Animals will be after them soon enough. Paging the A.S.P.C.A." Rich's review has become such a part of Broadway lore and so connected to this play that a recent minor league production of *Moose Murders* in Manila credited Rich as the playwright.[71]

It has been suggested that Rich was cut in the "Broadway mold"—that is, his blunt, acidulous, take-no-prisoners attitude was very much in keeping with the acrid climate of the city in which he worked. According to drama critic Charles Marowitz:[72]

> By and large, the New York critics are not noted for pulling their punches. The belief is that Broadway is a kind of theatrical Citadel and most critics view their job as keeping the barbarians from the gates. This often produces a harsh, unsentimental strain of criticism which yaps at mediocrity and tears great chunks out of flaccid or banal offerings.

This aggressive "New Yorker" approach to criticism dates back to the 1800s, which inspired actor Thomas Hamblin to maul the *New York Herald* editor after a particularly unflattering review and resulted in producer Abe Erlanger punching out *Dramatic Mirror* editor Harrison Grey Fiske.[73]

"In a sense," said Rich himself, "that reputation has always been the case with the *Times* drama critic. Alexander Woollcott was banned from the Shubert houses. Walter Kerr, my immediate predecessor, was physically thrown from the Public Theater by [theater producer and director] Joseph Papp."[74] "The purpose of the critic," wrote critic Alan Rich, is "not to lead his readers into blindly accepting his truths, but to stimulate them, delight them, even irritate them into formulating truths which are completely their own."[75] According to playwright August Wilson, Rich "agitated for a richer, fuller theater…he agitated for a theater committed to the belief that life is worthy of every moment of struggle to assert the authority of our common humanity."[76] The operative word when describing Rich is, clearly, "agitated."

To preserve the spontaneity of his response to a new show, Rich developed a practice of not reading about plays before seeing them. "This allowed me to still feel that rush of anticipation and surprise when the curtain went up," he wrote in a published collection of his works.[77] He aimed to write his reviews as stories that evoke the play's impact, rather than as report cards. "The lowest form of criticism— actually worthless, in my opinion—is, 'I give this an A or an F, or I give this four stars,'" he said in a magazine interview.[78] He continued:

> What matters is making the case for why Stephen Sondheim's *Sunday in the Park with George* is a visionary show. The easy part is having the opinion. The fun part is telling the story of how you got there. Anyone can say, 'I went to *King Lear* and I cried,' or 'I went to *The Odd Couple* and I laughed.' The creative aspect is looking at all the elements, all

the moving parts, to see how they fit together, and trying to crack the puzzle of how it produces that effect.

In 1993, Rich relinquished his theater critic gig to serve as an opinion columnist for the paper. "Theater was shrinking in New York," noted Rich, as "big-budget tourist musicals and the economics of the business made it prohibitive to produce new plays…. If you've reviewed five David Mamet plays, what are you going to say about the sixth one, other than it was a little better or worse than the last?"[79] Of course, it has also been suggested that Rich, himself, prevented a lot of very important playwrights and directors from being produced in New York. Rocco Landesman, president of Jujamcyn Theaters, estimated that Rich's negative reviews of such shows as *Big River* cost the producer $14 million over the years.[80] "I date the downfall and deterioration of the American theater," noted fellow critic Robert Brustein, "from Frank Rich's quite brilliant regime."[81]

Much like how he began in the business, Rich started writing longer-form essays for the op-ed page in 1999, and from 1999 to 2003 was also a senior writer for *The New York Times Magazine*, a dual title that was a first for *The Times*. "Welded to the position of influence these roles embody," noted August Wilson,[82] "is also responsibility, and it is a responsibility of proof, sometimes harsh and unforgiving, that requires its exponents a courage and a commitment that is self-defining. It is a responsibility Mr. Rich has shouldered with grace and a formidable presence."

Benjamin D. Brantley became chief theater critic of *The New York Times* in September 1996 after having served as its drama critic since joining the newspaper in August 1993, and still serves at this post. At the time of this writing, New York's leading theater critics—and current members of the New York Drama Critics' Circle—also include:[83]

Hilton Als, who began as staff writer at *The New Yorker* in November, 1996 and became a theater critic in 2002. Previously, he was a staff writer for the *Village Voice* and an editor-at-large at *Vibe* magazine; his work has also appeared in *The Nation*. He was awarded a Guggenheim in 2000 for Creative Writing and, in 2003, the George Jean Nathan Award for Dramatic Criticism.

Melissa Rose Bernardo, a contributor to *Entertainment Weekly*, where she reviews theater. She has worked for magazines including *Newsweek*, *Us*, *TheaterWeek*, and *InTheater (as one of the founding editors)*.

Scott Brown, *New York* magazine's theater critic since the fall of 2010. Before that, he was a columnist at *Wired* magazine and a senior writer for *Entertainment Weekly*.

David Cote, theater editor and chief drama critic for *Time Out New York*, who also appears as a contributing critic on NY1's *On Stage*. His writing has appeared in *The New York Times*, *Maxim*, *Opera News*, and the *Best Plays Theater Yearbook* series.

Plays and Films Featuring Critics, in profile

Earlier in this book it was noted that no one has more distain for the arts critic than the artists themselves. After all, critics offer their opinions in public and with authority, which can and often does challenge the work, expertise, and good intentions of artists. For many of the more prominent critics writing for the most powerful newspapers in the most arts-centric cities in the nation, the gloves often come off and comments can be cruel. Occasionally, artists strike back in the best way they know how: with their art. Here is a sampling of plays and films[84] that have featured the critic as a central character and, more often than not, depict them as pompous elites and provide them with the wittiest personalities and the nastiest dialogue:

- *The Critic* (1779) by Richard Brinsley Sheridan. The play is a clever, wordy, drawing room comedy. Two dilettantes, the easily charmed Lord Dangle and the jaded Sneer, though not professional critics or even writers, have somehow become important tastemakers in London theater circles. Playwrights, actors, and managers seek out their opinions. Much of the play centers on their clever sparring and barely-concealed insults with vain playwright Sir Fretful Plagiary.

- *The Man Who Came to Dinner* (1939) by George S. Kaufman and Moss Hart. In this play, the famously outlandish radio wit and critic Sheridan Whiteside of New York City is invited to dine at the house of rich factory owner Ernest W. Stanley and his family. Before Whiteside enters the house, he slips on a patch of ice, injures his hip, and must stay at the house. He makes life hell for the household.

- *All About Eve* (1950), a film written and direct by Joseph L. Mankiewicz. This is a backstage story revolving around aspiring actress Eve Harrington, who becomes the personal assistant to Broadway megastar Margo Channing. Before long, it becomes apparent that naïve Eve is a Machiavellian conniver who cold-bloodedly uses everyone, including waspish critic Addison DeWitt to rise to the top. DeWitt, in turn, uses his column and his eavesdropping skills to get what he wants.

- *The Real Inspector Hound* (1961), a one-act parody of "whodunit" plays by Tom Stoppard. The plot follows two theater critics named Moon and Birdboot who are watching a ludicrous setup of a country house murder mystery. By chance, they become involved in the action causing a series of events that parallel the play they are watching.

- *Waiting for Guffman* (1996) is a mock-documentary distributed by Warner Bros. and written by Christopher Guest and Eugene Levy. The town of Blaine, Missouri is preparing for celebrations of its 150th anniversary. Corky St. Clair, an off-off-off-off-off-Broadway director, is putting together an amateur theater show about the town's history, starring a local dentist, a couple of travel agents, a Dairy Queen waitress, and a car repairman. He invites a Broadway theater critic, Mr. Guffman, who never shows, to see the opening night performance. Guffman intimidates by the very thought of him.

- *St. Nicholas* (1997), by Conor McPherson, is a wry and ribald one person play about a self-hating, skirt-chasing, alcoholic Irish theater critic who falls hopelessly in love with a young actress. After following her to London, the critic is drawn into a world of big-city vampires and becomes their good-will ambassador and forager-food source.

- *Lady in the Water* (2006), distributed by Warner Bros., is writer and director M. Night Shyamalan's grown-up bedtime story about an apartment building superintendent who discovers a magical sea-nymph living in the building's swimming pool. One of the residents, Harry Farber, is a pompous ass and pessimistic film critic who causes serious problems and eventually gets eaten by evil forces.

- *Ratatouille* (2007) is a computer-animated film distributed by Buena Vista. A scrawny rat named Remy finds his dreams of culinary superstardom stirring up sizable controversy in the kitchen of a fine French restaurant. Food critic Anton Ego has reached the point where he won't even swallow food he doesn't like, and he appears to derive no joy at all from his job or any part of his life.

- *Character Assassination* (2010), a play by Charlie Schulman, explores what happens when a jaded theater critic with a pen as venomous as a cobra squares off with a playwright who has reached the end of his creative rope and is now bound for vengeance.

- *The Game's Afoot* (2011) is a murder mystery comedy by Ken Ludwig set in the 1930s, where Sherlock Holmes portrayer William Gillette employs the persona of the master detective to solve the murder of a much-hated theater critic in his Connecticut mansion.

Joe Dziemianowicz, the *Daily News* drama critic. In addition to Broadway and Off-Broadway reviews, he writes news stories, profiles and features. A journalist for nearly two decades, he joined the paper in 2000.

Michael Feingold, the former chief theater critic of the *Village Voice*. He has for many years sustained an ongoing second career in the theater as a playwright, lyricist, translator, director, and dramaturg.

Robert Feldberg, the theater critic and columnist for *The (Bergen) Record* since 1982. Before that, he reviewed movies and pop music for the paper.

Adam Feldman, who reviews theater and cabaret for *Time Out New York*. He is the contributing Broadway editor for *Theater World*, and has written for Canada's *Globe and Mail* and *National Post* as well as for *Time Out London*, Broadway.com, and *Show Business Weekly*, among others.

David Finkle, the chief drama critic at TheaterMania.com, who also contributes theater coverage to *The Village Voice, The Huffington Post, The New York Times, Vogue, American Theater,* and London's *Theatergoer*.

Elysa Gardner, who has been covering pop music and theater as a critic and reporter for *USA TODAY* since 2000. She has also been a contributor to the *Los Angeles Times, Rolling Stone, VH1, Entertainment Weekly,* and *The New Yorker*.

Eric Grode, chief theater critic for the *New York Sun* from 2005 through 2008. Prior to that, he reviewed for Broadway.com, *Back Stage,* and *Time Out New York*.

Erik Haagensen, *Back Stage*'s co-first-string theater critic, columns editor and New York reviews editor. He has also written for *Show Music* magazine, *The Seattle Review, The Kurt Weill Newsletter,* and *The Dramatists Guild Newsletter,* and is a Richard Rodgers Award-winning playwright-lyricist.

Mark Kennedy, drama critic and drama writer for The Associated Press. He spent 13 years on the AP's National and Supervisory desks.

Jesse Oxfeld, theater reviewer for *The New York Observer* and the executive editor of *Tablet Magazine*. He has previously worked as a writer and editor for *New York* magazine, *Gawker, Brill's Content, Editor & Publisher,* and elsewhere.

David Rooney, theater and film critic for *The Hollywood Reporter* and frequent arts contributor to *The New York Times*. He became chief theater critic and theater editor for *Variety* from 2004–2010. He has written about theater for *The Los Angeles Times, Rolling Stone,* and *Best Plays Yearbook,* among other publications.

Frank Scheck, theater critic for the *New York Post* and the *Hollywood Reporter*.

David Sheward, the executive editor and theater critic for *Back Stage East,* the actors' resource. He is contributing correspondent on NY-1 News' weekly theater show *On Stage*.

John Simon, who covers theater for the *Westchester Guardian* and the *Yonkers Tribune*. He has written theater, music, film, and book reviews for *New York, Esquire,*

the *Hudson Review, National Review, Opera News*, the *New Leader, Commonweal*, the *New Criterion*, and *The New York Times Book Review*. Simon has won the George Jean Nathan Award and the George Polk Award for Film Criticism.

Alexis Soloski, drama critic at *The Village Voice* since 1998. Her writing on theater, art, and literature has also appeared in *The New York Times, Modern Painters, The Believer, Salon*, and *Theater Magazine*.

Marilyn Stasio, drama critic for *Variety*, covering Broadway and Off-Broadway. Prior to that she reviewed theater for the *New York Post* and *Cue* magazine.

Steven Suskin, a theater and music critic for *Variety*. He also reviews CDs and DVDs for Playbill.com. He spent 25 years as a theatrical manager and producer.

Terry Teachout, the drama critic of *The Wall Street Journal*, the music critic of *Commentary*, and the author of "Sightings," a biweekly column for the *Saturday Journal* about the arts in America.

Elisabeth Vincentelli, chief drama critic at the *New York Post*. Over the years, she has contributed criticism, profiles, and essays to publications such as *The New York Times, The Los Angeles Times, Slate, Salon, The Believer* and *Entertainment Weekly*.

Linda Winer, chief theater critic of *Newsday*, which she joined in 1987. She was chief theater and dance critic of the *Chicago Tribune* from 1969–1980, a critic for the *New York Daily News* from 1980–1982 and *USA Today* from 1982–1987. Her criticism has won prizes from the American Society of Features Editors, New York Newswomen's Club Front Page Awards, and the New York Newspaper Guild's Page One Award.

Richard Zoglin has been theater critic for *Time* magazine since 1996. He joined the magazine in 1983 as a staff writer; for more than a decade he was *Time*'s television critic, and is currently a senior editor for the magazine.

In 2011 David Cote, theater editor and chief drama critic at *Time Out New York*, generated a list[85] for *American Theatre* magazine of the nation's 12 most influential theater critics outside of New York. The top three on the list include:

Don Aucoin, chief theater critic, *The Boston Globe:*

> Don Aucoin is the cub in this pack. Not that he lacks chops: He probably has more hard news experience than anyone else on this list. Since he arrived at the *Globe* in the late '80s, Aucoin worked the copy department, staffed the night news desk, wrote features and honed his critical voice while third-stringing on weekends. A true newspaperman, he has a little of everything in his résumé: covering gubernatorial elections, City Hall sessions and a stint as a TV critic. When theatre critic Louise Kennedy left the *Globe* last September, he was offered her position…. Aucoin displays Yankee restraint but unmistakable pride when describing his beat. In his reviews, one can see the classic journo, a seasoned deadliner who sticks to accessible, unstuffy prose with carefully reasoned aesthetic calls.

Misha Berson, theater critic, *The Seattle Times*:

Berson came to criticism through arts administration: In the early '80s she was executive director of the service organization Theatre Bay Area, and performing arts director of the Fort Mason Center, both in San Francisco. For a dozen years she reviewed for the *San Francisco Bay Guardian*, sharing the beat with playwright-critic Robert Chesley. Between her zest for arts journalism, her training as an actor and her experience as a producer, Berson believes she has a healthy appreciation for the actor's process and the challenges of running a company. Like many a critic in the cash-strapped media, she frequently has to switch between critic and feature-writer hats, a juggling act she doesn't mind. 'It's very helpful. I learn a lot from talking to artists,' Berson says. 'There are times when it is difficult: You might have a lovely conversation with someone, you know what they're trying to do, and if they fail, you have to point it out.'

Christine Dolen, theater critic and blogger, *The Miami Herald*:

It's hard to imagine the recent media contractions benefiting anyone, but longtime South Florida critic Christine Dolen finds that her influence has grown as a result of layoffs.... Dolen can appreciate the need to change. With more than three decades at the same publication, she is one of the few lifers on this list, but she speaks enthusiastically about blogging, an obligatory duty for most reviewers. 'It may have made me slightly looser, more casual at times,' Dolen muses. 'I can write about things that wouldn't make it into print or wouldn't be fodder for a full online article; it enhances what I do.'

Summary

Professional criticism in the nation's leading daily newspapers and magazines was once a thriving enterprise. In the early 20th century, in particular, the professional arts critics' opinions were revered and often feared by their respective industries. They helped inform audience opinions, dictated box office sales, kept the arts the topic of discussion, and—for critics the likes of George Bernard Shaw (theater), Clement Greenberg (art), H.T. Parker (music), Carl Van Vechten (dance), James Agee (film), and Northrop Frye (literature)—shaped the arts themselves. A few short decades ago, critics were part of an elite corps of taste makers and culture shapers for the general public.

The disintegration of professional theater criticism began in earnest in the 1990s, as arts journalists became collateral damage in the digital revolution that has sent the newspaper business into financial turmoil. "The era of the experts, the informed cognoscenti whose judgments and tastes operated as a lodestar for the public," notes literary critic Ronan McDonald,[86] "has seemingly been swept aside by a public that has laid claim to its capacity to evaluate its own cultural consumption." Although

prominent and powerful critics are still practicing their craft, they are fewer and growing less impactful amidst what media critic Howard Kurtz called the "growing hordes of people [who] simply search for precisely what they need. That has pushed the pendulum toward a word-of-mouth arena in which anyone can play."[87]

Playwright Oscar Wilde once warned that an age without criticism is "either an age in which art is immobile, hieratic" or "an age that possesses no art at all."[88] Put a tad less poetically, critic David Cote noted: "We critics...are the dung beetles of culture. We consume excrement, enriching the soil and protecting livestock from bacterial infection in the process. We are intrinsic to the theater ecology. Eliminate us at your peril."[89]

The next chapter begins our effort to build the next generation of theater critics. It focuses on the art of theater and the fundamental conventions it employs to generate effective storytelling—the stuff of theater appreciation. These conventions must be understood and mastered in order to engage in theater criticism.

KEY CONCEPTS FROM THIS CHAPTER

Actors' Equity Association	Instant criticism
Aisle-sitters of Gotham	National Endowment for the Arts
Algonquin Round Table	New York Drama Critics' Circle
Butcher of Broadway	Pulitzer Prize
Critic as superstar	Realism
Critic's qualifications	The Theater Guild
Federal Theater Project	Yellow journalism
Group Theater	

NOTES

1 Kalina Stefanova-Peteva, *Who Calls the Shots on the New York Stages?* (Switzerland: Harwood Academic Publishers, 1993), 137. The title page photograph is of representative members of the New York Drama Critics' Circle: (from left to right) Hilton Als (*The New Yorker*), Scott Brown (*New York*), Terry Teachout (*Wall Street Journal*), Elisabeth Vincentelli (*New York Post*), John Simon (*Westchester Guardian*), Melissa Rose Bernardo (*Entertainment Weekly*), Adam Feldman (*Time Out New York*), David Finkle (TheaterMania.com), Eric Grode (*New York Sun*), Michael Feingold (*Village Voice*).

2 Ronan McDonald, *The Death of the Critic* (New York: Continuum, 2007), 53.

3 Cited in Gerald Bordman and Thomas S. Hischak, "Drama Criticism in America," *The Oxford Companion to American Theater* (New York: The Oxford University Press, 2004), http://www.encyclopedia.com/doc/1O149-DramaCriticisminAmerica.html (accessed May 1, 2010).

4 Much of this "in profile" was extracted, with permission, from Leonard Conolly, from http://
 www.post-gazette.com/pg/06201/707270-325.stm#ixzz1MeHbevId, based on Conolly's paper
 for the American Theater Critics Association meeting June 15, 2006.

5 By the time Shaw retired from the *Saturday Review* he had written *Widowers' Houses*, *The
 Philanderer*, *Mrs Warren's Profession*, *Arms and the Man*, *Candida*, *The Man of Destiny*, *You Never
 Can Tell*, and *The Devil's Disciple*. Only *Arms and the Man* had achieved a commercial run.

6 Bernard Dukore (Ed.), *Bernard Shaw: The Drama Observed* (University Park, PA: The
 Pennsylvania State University Press, 1993), 1133–1134.

7 Cited in Colin Chambers, *The Continuum Companion to Twentieth Century Theater* (London:
 Continuum Publishing, 2002), 183.

8 Stagehands had first organized themselves into a union in 1886 and Actors' Equity was formed
 in 1913, despite efforts by many producers and actors who considered themselves artists and
 not laborers.

9 Cited in Stephen L. Vaughn, *Encyclopedia of American Journalism* (New York: Routledge, 2008),
 531

10 Cited in http://www.americanpopularculture.com/archive/film/hearst_davies_1.htm (accessed
 May 11, 2011).

11 See John W. English, *Criticizing the Critics* (NY: Hastings House, Publishers, 1979).

12 Cited in http://www.americanpopularculture.com/archive/film/hearst_davies_1.htm (accessed
 May 11, 2011).

13 Bert Cardullo, *American Drama/Critics: Writings and Readings* (New Castle: Cambridge
 Scholars Publishing, 2007).

14 John Pilkington (Ed.), *Stark Young: A Life in the Arts: Letters, 1900–1962*, 2 vols. (Baton Rouge:
 Louisiana State University Press, 1975), xix.

15 Eric Bentley, *In Search of Theater* (New York: Atheneum, 1975), 275.

16 Ibid, 269.

17 Bert Cardullo, "Images in a Vast World: Homage to Stark Young (1861–1963)," *Sewanee Review*,
 117(1), 2009, 151.

18 Ibid, 153.

19 Stark Young, "Footnotes on Acting," *Theater Arts Monthly*, 1926, 667.

20 Pilkington, *Stark Young: A Life in the Arts*, xviii.

21 From Stark Young, "Review of the 'Hairy Ape,'" *The New Republic* 30, March 22, 1922, 112–113.

22 Cited in Thomas Adler, "The Legacy of Eugene O'Neill According to Stark Young," *The Eugene
 O'Neill Review*, 29 (1 & 2), 1996, http://www.eoneill.com/library/review/20/20g.htm (accessed
 May 11, 2011).

23 Stark Young, "The Play: Relapsing a Generation," *The New York Times*, October 8, 1924, 22.

24 Adler, "The Legacy of Eugene O'Neill."

25 Cited in Mel Gussow, "The Season's Hot Playwright: George S. Kaufman in Revival," *The New
 York Times*, February 19, 1990, http://www.nytimes.com/1990/02/19/theater/critic-s-notebook-
 the-season-s-hot-playwright-george-s-kaufman-in-revival.html?ref=georgeskaufman (accessed
 May 11, 2011).

26 Cited in Alvin Klein, "When a Mere $20,000 Made You a Producer," *The New York Times*, January 31, 1999, http://www.nytimes.com/1999/01/31/nyregion/theater-review-when-a-mere-20000-made-you-a-producer.html?ref=georgeskaufman (accessed May 11, 2011).

27 Ken Bloom, *Broadway: It's History, People and Places* (New York: Routledge, 2004), 271.

28 Cited in Jon Winokur, *The Big Curmudgeon* (New York: Black Dog & Leventhal Publishers, 2007), 162.

29 Cited in Ben Brantley, "Setting the Table for Indigestion," *The New York Times*, December 20, 2002, from http://www.nytimes.com/2002/12/20/movies/theater-review-setting-the-table-for-indigestion.html?ref=georgeskaufman (accessed May 11, 2011).

30 Bruce Weber, "George S. Kaufman's Jet-Paced Solo Flight," *The New York Times*, October 4, 2002, http://theater.nytimes.com/mem/theater/treview.html?res=9e06e1df1f38f937a35753c1a9649c8b63 (accessed May 11, 2011).

31 Ibid.

32 Cited in Woody Allen, "I Appreciate George S. Kaufman," *The New York Times*, October 24 2004, http://www.nytimes.com/2004/10/24/books/review/24COVERAL.html?pagewanted=3&ref=theater (accessed May 11, 2011).

33 Charles Isherwood, "No, Mr. Kaufman, Satire Lives on, if It's Yours," *The New York Times*, September 24, 2009, retrieved from http://www.nytimes.com/2009/09/27/theater/27ishe.html?_r=1&ref=theater (accessed May 11, 2011).

34 From Howard Teichmann, *George S. Kaufman: An Intimate Portrait* (New York: Atheneum, 1972), cited in http://www.nytimes.com/2009/09/27/theater/27ishe.html?_r=1&ref=theater (accessed May 11, 2011).

35 See http://www.georgeskaufman.com/pages/internas.php?SECCIONPAS=Biography.

36 Cited in Bloom, *Broadway*, 271.

37 Ibid.

38 Cardullo, "The Theater Critic as Thinker," 311.

39 Cited largely from http://www.dramacritics.org/dc_history.html.

40 Ibid.

41 Cited in http://www.imdb.com/name/nm0442151/bio.

42 Cardullo, "The Theater Critic as Thinker," 311.

43 Philip Scranton, "Did Theater Critics Deepen the Great Depression?" *Bloomberg*, March 5, 2012, http://www.bloomberg.com/news/2012-03-05/did-theater-critics-deepen-the-great-depression-echoes.html (accessed June 6, 2012).

44 Ibid.

45 Cited in Wilmeth, *The Cambridge Guide to American Theater*, 24.

46 Cited in the TV documentary "Harold Clurman: A Life in Theater," http://www.classicaltv.com/about-us.html (accessed May 11, 2011).

47 Terry Teachout, "Opinion Born of Experience: Harold Clurman, great critic and director, was no amateur," *The Wall Street Journal*, April 4, 2009, retrieved from http://online.wsj.com/article/SB123879644745588081.html (accessed May 11, 2011).

48 From Marjorie Loggia and Glenn Young (Eds.), *The Collected Works of Harold Clurman* (New York: Applause Books, 1994), 161.

49 Cited in Teachout, "Opinion Born of Experience."

50 Cited in Mel Gussow, "Clurman on the Theater, With Sweep and Passion," *The New York Times*, April 6, 1994, http://www.nytimes.com/1994/04/06/theater/critic-s-notebook-clurman-on-the-theater-with-sweep-and-passion.html?pagewanted=print&src=pm (accessed May 11, 2011).

51 From Loggia and Young, *The Collected Works of Harold Clurman*, vi.

52 Cited in Teachout, "Opinion Born of Experience."

53 Harold Clurman, *The Fervent Years: The Group Theater and the Thirties* (New York: Da Capo Paperbacks, 1983).

54 Cited in Gussow, "Clurman on the Theater."

55 Cited in Teachout, "Opinion Born of Experience."

56 Ibid.

57 Cited in Gussow, "Clurman on the Theater."

58 Susan Davidson, "Tynan." *Curtain Up*, January 23, 2011 http://www.curtainup.com/tynandc.html, (accessed January 23, 2011).

59 Peter Brown, "Tynan," *London Theater*, February 21, 2005, http://www.londontheater.co.uk/londontheater/reviews/tynan05.htm (accessed May 11, 2011).

60 Nelson Pressley, "'Tynan': A Show to Please The Critic," *The Washington Post*, January 27, 2011, http://www.studiotheater.org/calendar/view.aspx?id=1601 (accessed January 27, 2011).

61 From Chris Klimek, "Monologues from a Bawdy Reviewer," *Washington City Paper*, January 28, 2011, http://www.washingtoncitypaper.com/articles/40322/tynan-and-beyond-the-horizon-reviewed-monologues-from-a-bawdy/ (accessed January 28, 2011).

62 Jayne Blanchard, "Tynan," *DCtheaterscene*, January 25, 2011, http://dctheaterscene.com/2011/01/25/tynan/ (accessed January 25, 2011).

63 Ibid.

64 Cited in the PBS documentary "Harold Clurman: About Harold Clurman," December 2, 2003), http://www.pbs.org/wnet/americanmasters/episodes/harold-clurman/about-harold-clurman/557/ (accessed May 11, 2011).

65 Cited in http://arts.endow.gov/about/Kennedy.html.

66 Cited in John English, *Criticizing the Critics* (New York: Hastings House Publishing, 1979), xiv.

67 Charles Marowitz, "English vs. American Theater Criticism," http://www.swans.com/library/art11/cmarow13.html, (accessed May 11, 2011).

68 Cited in http://www.walterkerrtheatre.com/biography.php.

69 Frank Rich, "The Telekinetic 'Carrie,' with Music," *The New York Times*, May 13, 1988, http://theater.nytimes.com/mem/theater/treview.html?pagewanted=print&res=940DE7DA133FF930A25756C0A96E948260 (accessed May 11, 2011).

70 Frank Rich, "'Moose Murders': A Brand of Whodunit," *The New York Times*, February 23, 1983, retrieved from http://theater.nytimes.com/mem/theater/treview.html?html_title=&tols_title=MOOSE%20MURDERS%20(PLAY)&pdate=19830223&byline=By%20FRANK%20RICH&id=1077011430808 (accessed May 11, 2011).

71 Campbell Robertson, " A Broadway Flop Again Raises Its Antlers," *The New York Times*, April 21, 2008, http://www.nytimes.com/2008/04/21/theater/21moos.html?pagewanted=1&_r=1 (accessed May 11, 2011).

72 Marowitz, "English vs. American Theater Criticism."

73 Cited in Tice L. Miller, *Bohemians and Critics: American Theater Criticism in the Nineteenth Century* (London: The Scarecrow Press, Inc., 1981).

74 Cited in James Ireland Baker, "Frank Rich: The Op-ed Firebrand," *Time Out New York*, September 20, 2006, http://newyork.timeout.com/arts-culture/7649/frank-rich (accessed May 11, 2011).

75 Cited in Robert D. Thomas," Obituary: Alan Rich," *Pasadena Star-News*, April 24, 2010, http://classact.typepad.com/robert_d_thomasclass_act/2010/04/obituary-alan-rich-19242010.html (accessed May 11, 2011).

76 August Wilson, "Introduction of Frank Rich," Americans for the Arts' 14th Annual Nancy Hanks Lecture on Arts and Public Policy, March 19, 2001, 4–5, cited in http://www.americansforthearts.org/NAPD/files/10236/Hanks%20Lecture,%20Frank%20Rich%20(May%20'01).pdf (accessed May 11, 2011).

77 Frank Rich, *Hot Seat: Theater Criticism for The New York Times* (New York: Random House, 1988).

78 Craig Lambert, "Reviewing 'Reality.' *Harvard Magazine*, March–April 2007, http://harvardmagazine.com/2007/03/reviewing-reality.html (accessed May 11, 2011).

79 Ibid.

80 Kenneth Jones, "Former *New York Times* Critic Frank Rich Sits in Q&A Hotseat," *Playbill.com*, October 26, 1998, http://www.playbill.com/features/article/64828-Former-New-York-Times-Critic-Frank-Rich-Sits-in-QA-Hot-Seat-With-Producer-Landesman (accessed May 11, 2011).

81 Cited in Bert Cardullo, "The Theater Critic as Thinker," 319.

82 Wilson, "Introduction of Frank Rich," 5.

83 Retrieved from http://www.dramacritics.org/dc_current.html.

84 Cited in http://blog.moviefone.com/2010/03/25/cinematical-seven-critics-as-movie-characters/ (accessed April 18, 2012).

85 David Cote, "Critical Juncture," *American Theatre*, November 2011, http://www.tcg.org/publications/ at/nov11/critical_juncture.cfm (accessed May 11, 2011).

86 McDonald, *The Death of the Critic*, 4.

87 Howard Kurtz, "Who Needs Critics, Anyway?" *The Washington Post*, April 12, 2010, http://www.washingtonpost.com/wp-dyn/content/article/2010/04/12/AR2010041201135_4.html (accessed April 12, 2010).

88 Cited in James Sims, "Death of a Theater Critic, Again," *The Huffington Post*, March 9, 2010, http://www.huffingtonpost.com/james-sims/death-of-a-theater-critic_b_490646.html (accessed December 20, 2010).

89 Julie York Coppens, "Tough Times on the Theater Beat," *Dramatics Magazine*, November 2010, http://schooltheater.org/publications/dramatics/2010/11/tough-times-beat (accessed December 20, 2010).

"All the world's a stage,
And all the men and women merely players;
They have their exits and their entrances;
And one man in his time plays many parts."
~William Shakespeare, *As You Like It* (Act II, Scene 7)

Chapter 7 Abstract

This chapter explores the fundamental characteristics of storytelling that constitute theater. Storytelling involves an unspoken agreement between the audience and the storyteller, where the artists are free to create whatever world they wish to tell their story, populate it accordingly, and stay true to the vision of that fabrication. In turn, the audience is expected to buy into that world, its characters, and its conventions. This chapter explores that agreement and identifies the range of conventions that makes theater theatrical. It explains how audience members and critics learn these conventions, which then becomes the stuff of theater appreciation and criticism.

Storytelling Conventions

I n the previous chapters it was established that theatergoers think, critics engage in critical thinking, and the evolution of critical thinking in the form of literary and dramatic criticism has been long and varied. What has yet to be addressed is what, exactly, it is that those who participate in theater—on both sides of the proscenium arch—think about. What is the focus of their attention and enterprise? The answer is stories and storytelling.

Theater is, essentially, storytelling,[1] where a playwright has experienced something, witnessed something, or survived something worthy of sharing and theater companies do the sharing. Plays and their presentation use language, image, movement, gesture, and/or sound to recall, recount, and relay factual or fabricated events to an audience. The act of storytelling:

- passes on accumulated experience, wisdom, beliefs, and values from one generation to the next;
- passes on shared experience, wisdom, beliefs, and values from one culture to another;
- creates the foundation of memory, which serves as the building blocks of knowledge and the pathways for learning;
- questions, changes, and overthrows the status quo; and
- provides entertainment.

As a creative enterprise, storytelling allows:

- events that are unrelated, disconnected, or random in reality to be given a sense of continuity, sequence, and meaning;
- events that are conjoined or sequential in reality to be isolated, reconfigured, and dissected;
- events that transpired in the past to be reenacted in the present;
- some aspects of events to be purposefully embellished while others can be intentionally obscured; and

- fabrications to be imbued with a sense of reality and relayed with authority and an air of authenticity.

Storytelling is a very creative activity engaged only by humans. Though primates share many of our behaviors, and we theirs, only humans possess imagination, the capacity for abstract thinking, and the desire and the need for stories. Humans have been storytellers for quite some time. In the 1940s, some French children discovered drawings of extinct animals in the Lascaux Caves in the Pyrenees Mountains. The 17,000-year-old paintings on the walls are our earliest recorded evidence of storytelling, and since Lascaux other ancient examples of visual storytelling have been found.

> *"The shortest distance between truth and a human being is a story."*
>
> ~Anthony de Mello, storyteller[2]

Storytelling has several defining characteristics—referred to as core conventions—that separate it from other forms of human communication and, consequently, offer insight into the very nature of theater. These core conventions are the guiding principles and practices on which theater is based and serve as the fundamental criteria for theater appreciation by audience members as well as theater criticism by arts journalists. In other words, our ability to understand, appreciate, think about, and judge theater—or any art—is based largely on our understanding, appreciation, contemplation, and eventual judgment of these core storytelling conventions and the creative community's handling of them.

Johann Wolfgang von Goethe, a 19th-century author, philosopher, and intellectual, identified three general criteria with which to evaluate the core conventions of artistic enterprise. They take the form of questions, which will be asked throughout this chapter as they are typically asked by the average theatergoer. And, of course, these are the questions answered by critics when they attempt to make sense of a theatrical event—that is, when they address the "so what" of critical analysis discussed in previous chapters (as in "so what are we to take away from this play and this production of it?"). They are:

- What is the artist trying to say?
- Did the artist succeed?
- Was it worth the effort?

Theater's Core Conventions

Theater is an Art Form

Storytelling—in all its forms—is a purposeful, artistic enterprise. It entails creativity, imagination, the acquisition of knowledge and experience to constitute a story, elegance of presentation, and a sense of aesthetics that offers harmony and consistency throughout the storytelling. Art is artificial in that it needs to be created, even if it is a piece of storytelling that recalls, recounts, and relays factual events or tells the story of real people. Art is an artifact; it is a product of a particular place of a particular time, revealing what is important by the fact of its very creation.

Theater is a form of performance art. As such, it employs:

- **pretense** (the sophisticated expression of the basic human need/instinct to pretend and to create meaning through narrative and metaphor);
- **impersonation** (the imitation of another); and
- **heightened vision** (the creation of worlds more intense, concentrated, and intriguing than the world in which we live) as fundamental storytelling methodologies.

Playwrights create characters based on real or fictitious persons and place them in an intriguing and sustainable environment, and actors portray these creations with an understanding of the environment in which they exist. In ancient days, masks were employed to aid in the literal-minded audience's belief in the playwright's pretense and an actor's impersonation. Of course, costuming, makeup, and, in some cases, masks, are still employed in most forms of performance art.

One of the fundamental aspects of the art of pretense and impersonation in theatrical storytelling is that storytellers vanish and "simulated others" take their place. In theater, this has been called the "paradox of the actor" by 18th-century dramatist Denis Diderot. During a theatrical performance, an actor *is* this character. At the end of a theatrical presentation, the pretense comes to a close and the audience applauds the actor's craft and not the character's behavior. Other aspects of this pretense are that: the entire performance attempts to appear real but is, in fact, simulated; it seems spontaneous but is, in fact, rehearsed; and each performance comes across as a unique event but has been or will be replicated and repeated at other times. During a theatrical performance, the art of storytelling and the application of pretense, impersonation, and heighted reality are in full effect.

It is the pretense, impersonation, and heighted reality of theater that separates theater from many other forms of performance art, such as stand-up comedy or a concert. Stand-up comedy and concerts are examples of performance art that employ presentational performance—that is, the offering of staged activity that gives into the performance nature of its enterprise, acknowledges the existence of

an audience, and allows for—even encourages—interaction between the audience and the performers.

Clearly, some comedians employ impersonation in their acts, some bands incorporate heightened theatrics into their performances, and some forms of theater (see Juke Box Musicals, in profile) incorporate concert presentation as part of their enterprise.[3] However, the focus of theatrical storytelling is the representational performance—that is, the presentation of staged activity that does not appear to be staged at all. In many if not most forms of theatrical storytelling, the audience walks into a manufactured world and witnesses the activities of its inhabitants as if through an imaginary "fourth wall." In turn, the performers do not typically acknowledge an audience's existence.[4] Theatrical performance serves to represent reality, whatever particular reality has been chosen by the playwright and embellished by those who stage the work.

Of course, some plays are more representational than others. Different movements throughout the history of the theater arts have occurred and can be largely defined by their varying degrees of representation of reality, or verisimilitude—the appearance of being real. Most movements in modern theater have been toward the more natural or real presentations. In fact, in just the last century or two there have been radical changes in this regard:

ROMANTICISM. At the turn of the 19th century, Romanticism came into fashion amidst extremely turbulent times, including major political revolutions in the Americas and France, the industrial revolution, and unprecedented migrations from country to city and from one country to the next. Simultaneously, an intellectual revolution was occurring with significant advancements in science and mathematics, and shifting perceptions of philosophy and religion. The social classicism of the day was modeled after strict rules of etiquette and decorum, which were increasingly out of step with rapidly evolving views of life and art. Previously, theater reflected frivolity. Romanticism gave creative license to the playwright to address rebellion, liberty, individualism, and the beauty and power of nature, and encouraged productions to employ on-stage action and the latest technologies to help foster a strong emotional response to the plays. So many 19th-centry playwrights penned scripts that pushed the boundaries of new-found creativity that they were impossible to produce. Victor Hugo's *Hernani* (1830), however, with its employment of grandiose themes but lyrical presentation, was an exception.[5] It has been suggested[6] that the play's controversial, catastrophic climax—where the characters take a swift and overly dramatic plunge from marital bliss and security to death and dishonor—opened doors for other Romantic dramatists.

REALISM. By the 1850s, problems of inequality, industrialization, and urbanization were the subjects of discussion and scientific discoveries and theories by Charles

Jukebox Musicals, in profile

A jukebox musical is a form of theater that employs previously released popular songs as its musical score and blends representational performance with presentational performance. Typically, the songs are contextualized into the storytelling in some way—often as actual concert presentation. However, the range of representational and presentational performance in these musicals results in a very different dramatic effect.

Biographical Musical Theater: In these jukebox musicals, the story is about the actual performer or creator of the featured music—for example, The Four Seasons (*Jersey Boys*), Peter Allen (*The Boy From Oz*), John Lennon (*Lennon*), and Mahalia Jackson (*Mahalia: A Gospel Musical*)—and an actor as imitator performs the songs in concert as narrative accompaniment to the particular life stories.

The popularity of the featured performer is no guarantee of success. *Jersey Boys* won four Tony Awards in 2006, including Best Musical. *The Boy From Oz*, however, obtained moderate success. *Lennon* closed after 49 performances.

An interesting off-shoot is the **Pseudo-Biographical** jukebox musical, such as *Dreamgirls*. This musical features the rise and fall of a fictitious 1960s girl's group ala The Supremes, and many of its "hit" songs (which are original creations) are presented in concert as part of the show's narrative.

The Musical Revue: These are merely showcases of the works of particular songsters in a cabaret or staged setting, such as Stephen Sondheim (*Side by Side By Sondheim, Sondheim on Sondheim*). *Smokey Joe's Café*, which opened on Broadway in 1995, featured the songs of Jerry Leiber and Mike Stoller and ran for five years, making it the longest running musical revue. Although Richard Maltby and David Shire wrote many Broadway hits, the 1977 musical revue of their collaborative efforts, *Starting Here, Starting Now*, was not one of them.

Narrative Form: The most prolific type of jukebox musical is the narrative form. It includes shows like *Good Vibrations* and *All Shook Up*, which recycle the chart toppers of the Beach Boys and Elvis Presley, respectively, and interweave them with a thin storyline that is inspired by the music but has nothing to do with the original artist. Many, like these two, fail.

Others, like the Billy Joel-based *Movin' Out*, are quite triumphant. *Mamma Mia*, which opened in London in 1999 and features the music of Swedish pop group ABBA, is the mother of all narrative jukebox musicals. It was one of the longest running shows in Broadway history and was turned into a successful film.

At the bottom of the jukebox musical food chain is the **Remix Narrative**, such as *The Marvelous Wonderettes* and *Priscilla Queen of the Desert: The Musical*. Shows like this recycle a mixture of popular tunes from the 1960s and wrap them around a rice paper thin storyline. The appeal of a remix narrative is the nostalgia they generate, for the storyline is merely a hook on which to hang songs that otherwise have no unifying themes or connective tissue.

Darwin and others were threatening people's worldview. So, too, were the work of Sigmund Freud and the political writings of Karl Marx. Life became more real. Realism and the more extreme Naturalism surfaced in the theater, spearheaded by the works of Henrik Ibsen, who turned from writing verse plays to creating serious plays such as *A Doll's House* (1879) in everyday language dealing with important, everyday social and moral issues. In his plays, unlike those that came before him, actors are expected to behave as real people do in life and to do so on a stage that is intended to be an accurate representation of their real-world equivalent. It has been suggested that the works of Ibsen gave prominence to this movement, but the works of Anton Chekhov reflected the high point of its melancholic, foreboding style, best found in *The Seagull* (1896),[7] *The Three Sisters* (1901), and *The Cherry Orchard* (1904). In all of them, Chekhov employs a method of "indirect action," where characters confront changes that result from offstage occurrences, and seem destined either to wallow in self-pity or indifference or consume themselves in frustrated passion.

More contemporary realists, and examples of their work, include Arthur Miller's *Death of a Salesman* (1949), Tennessee Williams' *A Streetcar Named Desire* (1948), and William Inge's *Picnic* (1953). Playwright David Mamet chose to temper the naturalistic approach, where the illusion of reality rather than the actual imitation of reality is presented. In his *Oleanna* (1992), for example, which centers on a violent confrontation between a college professor and a student, Mamet employs fragments of intensely realistic writing—the tortured syntax of everyday speech, such as stammerings, grunts, curses, repetitions, and sentences that trail off into nothing or abruptly interrupt others—rather than the turned phrases of eloquent discourse.[8]

OTHER "ISMS." Some playwrights were uncomfortable with Naturalism, finding this "slice of life" depiction of reality to be too dull and untheatrical. This resulted in a range of artistic approaches—or "isms"—that sought to re-theatricalize the stage through innovation. Included were:

- **Symbolism** (also referred to as idealism and impressionism), which dramatized life in a very metaphorical and suggestive manner, endowing particular images or objects with symbolic meaning and denouncing plain

meanings and matter-of-fact description. Maurice Maeterlinck's *Pelleas and Melisande* (1892)[9] is an example;

- **Expressionism**, which attempted to express the underlying reality of human experience rather than its mere surface reality or appearance. Eugene O'Neill's dramatic exploration of the dehumanizing effects of industrialization in *The Hairy Ape* (1922)[10] is an example; and

- **Absurdism**, which explores reality by placing its characters in a meaningless present that exists between a guilt-ridden past and an unknowable future. See, for instance, Jean-Paul Sartre's *No Exit* (1944),[11] Samuel Beckett's *Waiting for Godot* (1958), and Eugene Ionesco's *The Bald Soprano* (1950).

EPIC THEATER. In response to worldwide political and social upheaval in the early- to mid-20th century, some theater was aimed at advocating social action. Epic Theater, typically associated with the works of playwright-director Bertolt Brecht, sought to shift the role of the audience member from passive spectator into someone engaged in the play through alienation, confrontation, and the removing of historical events from their actual real-world context and making it seem recognizable yet unfamiliar. His *Resistible Rise of Arturo Ui* (1941), for example, is a parable about Hitler's rise to power, but it abstracts, exaggerates, and distances the story from its realistic context by setting it among Chicago gangsters, turning it into a semi-farce,[12] and employing a scenic design meant to illustrate the plot and the issues at hand rather than to establish a specific location or setting. Brecht's *The Good Woman of Setzuan* (1940) and *The Threepenny Opera* (1928) are other important examples of this theatrical approach.

> *"Because we do not [physically] participate...we can view [moral values reflected on stage] clearly, within the limits of our emotional equipment. These people on stage do not return our looks. We do not have to answer their questions nor make any sign of being in company with them, nor do we have to compete their virtues nor resist their offenses. All at once, for this reason, we are able to see them. Our hearts are wrung by recognition and pity, so that the dusky shell of the auditorium where we are gathered anonymously together is flooded with an almost liquid warmth of unchecked human sympathies, relieved of self-consciousness, allowed to function."*
> ~Tennessee Williams, playwright[13]

The range of "isms" that has been embraced throughout the history of theater is a part of a playwright's and director's repertoire. They are well aware of the pretense of storytelling and are well schooled or experienced in the range of historical theatrical approaches at their disposal. Some apply traditional, familiar, established modes of presentation, while others push the envelope on how best to represent reality and express an idea. Some restage classic productions created during one theatrical movement in a more modern style of representation. These choices impact on the storytelling.

Regarding the convention of theater as art, the theatergoer asks: What was the playwright and production company trying to say by employing pretense, impersonation, and heightened vision, and the chosen degree of realism projected in their usage? Did these artists succeed? Was it worth the effort? The critic helps answer these inquiries and explains him/herself accordingly.

Theater is Grounded in the Human Condition

As was noted in a previous chapter, when Aristotle wrote about drama in *Poetics*, he began by explaining it as the imitation of a natural action, or mimesis. Drama imitates life—the human condition—regardless of how realistic or representative its artistic approach. For example, although the drama of Aristotle's time and place possessed intense mythic structure, formidable and endless speeches, depictions of the gods, and profoundly exaggerated activity, the Greeks of that time were still able to recognize themselves in the larger-than-life characters. They could recognize the human condition in these larger-than-life scenarios. They could realize that those characters are saying things that they and their neighbors are capable of saying and doing things that they and their neighbors might or should be doing. The lessons to be learned from this pretense are pertinent and applicable to real life.

In *Oedipus Rex* (ca. 429 B.C.E.) and *Antigone* (ca. 442 B.C.E.), for example, Sophocles emphasized the interaction between the will of the gods and the will of humans, often pitting the truths of men and women against the truths of the gods, resulting in dramatic consequences. These were literary mirrors that helped the ancient Greeks participate in and relate to the myths of their time, understand them, and apply their values to their daily lives.[14] Of course, it is often difficult for today's audiences to understand Greek tragedy because the specific vision of life reflected in those plays—the paradigm of the time—is not one we subscribe to today.

As a point of comparison, in Shakespeare's *A Midsummer Night's Dream* (ca. 1590), the Elizabethan age audience is introduced to a fanciful world full of fairies and enchantment, and it is expected to buy into it completely. Amidst all the fantasy and pretense is a very human story where Egeus, an Athenian nobleman, wants his daughter Hermia to marry Demetrius (who loves Hermia), but Hermia

> *"So why has* **Waiting for Godot** *proved so durable? How has Beckett's work outlasted the other iconoclasts and angry young writers of the 1950s and 1960s? It asks all the big philosophical questions—about life and death and the uncertain purpose of what goes on in between—but in a way that isn't limited to a particular place or era....*
> *It was performed in Sarajevo under siege in the 1990s, in South Africa it was seen as a critique of apartheid, and in the wake of Hurricane Katrina a performance in New Orleans was seen as an emblem of the city's wait for recovery. Inmates in San Quentin prison in California saw it as their own story in a famous production in the late 1950s."*
> ~Sean Coughlan, BBC News correspondent[15]

is in love with Lysander and refuses to comply. In short, all this fanciful storytelling is grounded in the human condition. Thus, a core convention of theater is that it must have relevance or it will not resonate with its audience.

What is particularly intriguing about theatrical storytelling and its grounding in the human condition is that the private sphere is made overtly public. Intimate relations, personal problems, illicit and illegal acts, embarrassing behavior, and confidential activities are exposed to the audience but yet remain magically protected under the guise of pretense. Whereas in real life a defined barrier (and a few laws) separate private and public experiences, in storytelling the barrier is breached by the pretense of the storyteller and the omnipresence of the audience this creates. Theatergoers are able to see behind closed doors, sit in the courtroom or at bedside, listen to private conversations, and enter the thoughts, hidden feelings, and personal disclosures of fictional characters. In fact, public exposure to private feelings and experiences is the ruling dynamic in theater. Playwrights simply do not understand the meaning of "It's none of your business." In the world of theater, everything is everyone's business and the audience serves as a curious, invisible, silent, third party voyeur.

Some aspects of the human condition embraced by theater are evergreen—that is, they are innate, intuitive, or instinctual in the human animal and, thus, uninfluenced by time, place, or culture. This includes our fundamental needs to survive, to reproduce, to nurture, and to be social. It incorporates the range of human emotions and drives that all of us share and which are seemingly universal. To borrow from previous examples, Shakespeare's *A Midsummer Night's Dream* is, fundamentally, about the evergreen emotion of love. Sophocles' *Antigone* is very much

a story about survival and is an enduring morality play. One of Antigone's brothers is killed in battle against the state and it is deemed that, as punishment, his body must be left on the plain outside the city to rot and be eaten by animals instead of being buried as tradition warrants. Antigone determines this to be fundamentally unjust and immoral, and determines to bury her brother regardless of the law. She is punished accordingly.

Other aspects of the human condition are more transitory and time-sensitive, and address changing social and cultural norms and values. They reflect conditions specific to a particular time and place. They tap into socio-politico-religious realities, such as social movements, political issues and conflicts, economic circumstances, and religious ideologies. They question or call attention to passing fads, such the celebration of celebrity, and put into perspective contemporary priorities, such as personal initiative in the face of bureaucratic control. Theater can explore the range of social ills and prevailing concerns that place the evergreen aspects of the human condition—such as survival—at risk. Characters become metaphors for what is or should be relevant and important in contemporary times. The naturalism of Ibsen's *A Doll's House*, discussed earlier, lends itself to tell the tale of personal freedom, which is a contemporary concern. At its core, this play is about the need for every individual to find out the kind of person he or she really is and to strive to become that person. The realism of Mamet's *Oleanna* provides an appropriate vehicle for commentary on the consequences of miscommunication, excessive political correctness, and sexual harassment, which are contemporary concerns. Sophocles' *Oedipus Rex* explores the destructive powers of politics on the dynamics of family relations. Brecht's *Resistible Rise of Arturo Ui* is all about absolute power corrupting absolutely.

Regarding the convention that theater is grounded in the human condition, the theatergoer asks: What is the playwright trying to say by focusing on and addressing a particular aspect of the human condition? Did the artist succeed? Was it worth the effort? The critic helps answer these inquiries and explains him/herself accordingly.

Theater's Structural Parameters

NARRATIVE STRUCTURE. Aristotle was the first to point out the seemingly basic but vital fact that the plots of all storytelling have a beginning, a middle, and an end, and that these stages neither begin nor end haphazardly. That is, narrative storytelling has a purposeful structure. This observation was eventually refined by a 4th-century grammarian, Evanthius, who noted that a narrative should consist of a: protasis or exposition, which lays out the state of normalcy in the story being told; an epitasis or complication, where some conflict occurs to disrupt the normalcy; and a catastrophe or resolution to the conflict.[16]

Over a century ago, German playwright and novelist Gustav Freytag elaborated on this insight by describing the typical dramatic triangle of a well-made story, which has been embellished by others.[17] A well-made story:

- begins with an expository sequence that introduces the audience to the principal characters, their relationships with each other, and the space or environment the characters exhibit during the course of the story. The state of normalcy, also referred to as a status quo or equilibrium, is revealed;
- rises through various twists and turns of complicating actions, called narrative enigmas, conflicts, or pollutions, that entail changes from one state of affairs to another that take the characters from equilibrium through disequilibrium to the height of disequilibrium, or a climax or dramatic arc; and
- falls off in intensity to a coda that delineates the resolution of the conflict, and the new state of affairs—a new status quo—is created, as dictated by the nature of the story.[18]

SPATIAL STRUCTURE. A play's structure is not only defined by its narrative structure. It is also structured in space. The audience is required to imagine that the physical space where the play takes place is somewhere else, as dictated by the playwright, envisioned by the director, and embraced by the performers. The audience must allow for the fantasy that when performers enter or exit the stage through doors or other means of access, they are arriving from or departing to another, unseen part of the imaginary world. They must allow for the pretense of other characters not being able to hear a character breaking the "4th wall" and directly addressing the audience, even if those other characters are sharing the same stage and are within earshot.

"When an actor makes a strong move to the right, somebody else onstage moves slightly to the left; the spectator's eye gets a sense of pictorial balance. It's a compositional tactic directors used to be taught to use—the challenge is to use it subtly and inventively. It doesn't exist in film or television, where the camera does most of the moving, and the editor chooses which actor to focus on. The stage demands an overall image all the time. Unlike the sequence of shots in a movie, it's a representation of life that's being shaped right there, before our eyes and with our connivance."

~Michael Feingold, theater critic, *The Village Voice*[19]

Plays starting with the Realist movement incorporated the fourth wall into the performance space, which makes a unique demand on the audience. Here, action is unfolding in a performance space before an audience with the assumption that there is a fourth wall separating the actors from the audience, but the wall is transparent for the public and opaque for the player. Many plays, however, extend the performance space into the audience and ignore any pretense of a fourth wall. It is up to the audience to make whatever spatial accommodations are demanded by the playwright, envisioned by the director, and embraced by the performers.

TEMPORAL STRUCTURE. Plays are also structured in time. The audience must accept the time when the play takes place, as dictated by the playwright, envisioned by the director, and embraced by the performers. Plays have the freedom to proceed through real time, freeze time, or leap forward and back in time at will. For example, playwright Mark Brown's stage adaptation of Jules Verne's massive novel *Around the World in 80 Days* does not take 80 days to tell. In most plays, the audience is expected to assume that, during intermission, the play is not progressing and will pick up where it left off. That is, unless there is an indication to the contrary. In Thornton Wilder's classic *Our Town*, the second act transpires three years after the end of the first act and, during the third act, one of the characters has a posthumous visit to the past. *Merrily We Roll Along*, by George Furth and Stephen Sondheim, proceeds backwards while Jason Robert Brown's musical about a failed marriage, "The Last Five Years," begins with one character at the very start of their relationship, the other character at the very end, and works its way toward the middle.

LINGUISTIC STRUCTURE. Plays are also given form and structure by their use of language. The audience must imagine that the language being employed to tell the story, whatever that language might be, is normal for the world manufactured for this play. Some plays are written in verse, some have characters conversing in rhyming couplets, and some use heightened, unrealistic language, street slang, or gibberish. For example, *Wings* (1978), a radio drama turned play by Arthur Kopit, features an elderly woman who has a massive stroke and the vast majority of the play is presented in seemingly random, undecipherable "stroke-speak." Some plays begin in a foreign language and then ease into the language of the audience, with the understanding being that the characters are still speaking the foreign language. Some plays move from dialogue to monologue and back again. Musicals lapse into song as an acceptable mode of expression. These are all creative leaps that the audience is expected to take along with the storytellers.

Having a working knowledge of these structural parameters gives an audience member a set of expectations and guidelines with which to approach a particular play and production. It provides a set of standards with which to compare different types of plays and different productions of the same play. The theatergoer asks:

What is the artist trying to say through the many choices associated with staging this play—its choice and manipulation of order, time, space, and language? Did the artist succeed? Was it worth the effort? The critic helps answer these inquiries and explains him/herself accordingly.

Theater Can Be Classified by Genre

Aristotle noted that a story consists of and typically centers around a "somebody"—the hero of the story—doing "something," and that the nature of this character and the something s/he does defines the nature of the story. Indeed, all theatrical productions can be classified based on the commonality of the behavior of the central character and its outcome. This, in turn, influences other aspects of the storytelling and creates an organized constellation of recurring substantive and stylistic features. This is most apparent in the broad genre classifications of Tragedy, Drama, Comedy, and Musical.

TRAGEDY. The great Greek tragedians of the 5th century B.C., including Aeschylus' *Prometheus Bound* (ca. 415 B.C.E.), Sophocles' *Oedipus Rex* (ca. 429 B.C.E.), and Euripides' *Medea* (ca. 431 B.C.E.), gave the tragedy its defining characteristics. These include:

- a central protagonist with much to lose, such as high rank, social stature, immense wealth, or perfect love;
- a fatal flaw, or "hamartia," that makes it immediately apparent that significant loss is forthcoming, unavoidable, and will come in dramatic fashion;
- a moment of self-recognition, where this central character discovers and recognizes his/her flaw and comes to terms with his/her fate;
- self-sacrifice, where the loss of life, love, or livelihood serves a greater good; and
- an anticipated unhappy ending for that central character.

Tragic characters tend to be heroes, not victims, for their flaws are human and insurmountable for most mortals. In *Poetics*, Aristotle notes that these characters' misfortunes are "brought about not by vice or depravity, but by some error or frailty." In fact, classic frailties and flaws are forever linked to their theatrical namesakes, such as an Oedipus complex (the unconscious and repressed desire of a boy wanting to sexually possess his mother and kill his father), an Electra complex (a girl's psychosexual competition with her mother for possession of her father), an Achilles' heel (a deadly weakness in spite of overall strength), and a Promethean struggle (the human will's potential for heroic defiance against arbitrary authority, despite its costs and risks). Also, these characters' sacrifices are made with full realization of the looming doom, thereby ennobling these characters and resulting

Genre, in profile

In *Hamlet* (Act II, Scene II), one of Shakespeare's greatest (and longest) tragedies, the playwright parodied the division of plays into assorted genres which, by his time, had become excessive.

In the play, Polonius, the king's chief counsel, announces the arrival of a traveling troupe of theatrical players. He describes the acting company as "the best actors in the world, either for tragedy, comedy, history, pastoral, pastoral-comical, historical-pastoral, tragical-historical, tragical-comical-historical-pastoral, scene individable, or poem unlimited."

This bit of playfulness helps set up Hamlet's attempt to avenge his father's "murder most foul."

Hamlet builds tension by asking the actors to give a speech about the fall of Troy and the death of the Trojan king and queen. He announces that the next night *The Murder of Gonzago* will be performed. Later, Hamlet resolves to devise a trap that forces the king to watch a play whose plot closely resembles the murder of Hamlet's father. If the king is guilty, he reasons, Claudius will surely show some visible sign of guilt when he sees his sin reenacted on stage. "The play's the thing," Hamlet declares, "wherein I'll catch the conscience of the king."

in valuable insight into the human condition. Their struggles and loss help us find meaning in the pain of our own existence. Shakespeare's *Hamlet* (ca. 1600), *King Lear* (ca. 1601), *Othello* (ca. 1603), and *Macbeth* (ca. 1603) have become classic examples of this. Tragedies are serious, sobering affairs.

The general classification of Tragedy remained a mainstay of theatrical genres through the 17th century, until neoclassic dramatic critics in Europe attempted to formalize theatrical presentations into more specific, identifiable, and increasingly rigid classifications. The central character remained important in these genre classifications. In fact, according to literary critic Northrop Frye, works of literature and theater are best classified and criticized in accordance to the hero's power of action, which may be greater than, less than, or roughly the same as the audience's.[20] Noted Frye:

- If superior in kind both to other people and to the environment of other people, the hero is a divine being, and the story about him/her will be a **myth** in the common sense of a story about a god or gods;

- If superior in degree to other people and to their environment, the hero is the typical hero of romance, whose actions are marvelous but who is him/herself identified as a human being. The hero of romance moves in a world in which the ordinary laws of nature are slightly suspended: prodigies of courage and endurance, unnatural to us, are natural to the hero, and enchanted weapons, talking animals, terrifying ogres and witches, and talismans of miraculous power violate no rule of probability once the postulates of romance have been established. Here we have moved from myth into **legend** and **folk tale**;

- If superior in degree to other people, the hero is a leader but subject to human frailty. The hero has authority, passions, and powers of expression far greater than ours, but what s/he does occurs in the natural order of things. This is the hero of the *high mimetic* mode, found in most epic **dramas** and tragedies; and

- If superior neither to other people nor to their environment, the hero is one of us: we respond to a sense of his/her common humanity. This gives us the hero of the *low mimetic* mode, of realistic fiction. On this level, it is difficult to retain the word "hero" to the main character, since that individual is an ordinary Everyman.

DRAMA. Frye's classifications basically suggest that tragedies without tragic heroes, without foreknowledge of the protagonist's impending doom, without the element of self-sacrifice, and with the protagonist's flaw being associated with vice or depravity rather than something of a higher order results in plays generally classified as "dramas." There are, of course, several distinctive types of dramas based on the central action of the play:

- Dramatic works that exaggerate plot and character portrayals in order to appeal to the emotions, and where much of the dramatic dialogue and overly dramatic action revolves around the story's narrative enigmas are best clas-

> "In a biographical solo play about a celebrity, you can usually count on a few things. The conceit designed to get the famous person to narrate a highlights reel of a lifetime is going to be strained. The performance will be theatrical. And at some point the actor will pause dramatically, holding back something that the author has no intention of keeping hidden."
>
> ~Jason Zinoman, critic, *The New York Times*[21]

sified as **melodramas.** Melodramas, which became popular in the 18th century, typically depict good triumphing over evil enveloped in sentimentality;

- **Historical dramas** use history as the source material for their fiction and the exploits of historical figures as their central focus of attention. These types of plays were particularly popular during the Elizabethan era, when Shakespeare—often credited with inventing the genre—wrote many historical plays that centered on the reign of English Kings, such as Henry IV, Henry V, Henry VI, Henry VIII, Richard II, Richard III, as well as Julius Caesar. Historical plays have been popular since, with the 1945 play *The Life of Galileo* by playwright Bertolt Brecht and the escapades of American president Richard Nixon in Peter Morgan's *Frost/Nixon* (2006) serving as contemporary examples;

- In **mysteries**, or "who-dun-its," most of the activity revolves around conflict resolution rather than merely leading to it. Several of novelist Agatha Christie's murder mysteries have been made for the stage, with her *The Mousetrap* holding the record for the longest initial run; it opened at the Ambassadors Theatre in London in November 1952 and has been running ever since; and

- An intriguing sub-genre of historical plays exists, called the **bio-drama**, which are typically one-man or one-woman productions that focus on the life and times of a celebrity but take less creative liberties with the historical content. Examples include David Rambo's *The Lady With All the Answers* (2009) about newspaper columnist Ann Landers, and Tom Lysaght's *Nobody Don't like Yogi* (2003), a one-act treatment about baseball great Yogi Berra.

COMEDY. The first known comedies were improvised entertainments in ancient Greece that combined satirical skits, bawdy jokes, and uninhibited revelry. Aristophanes' *The Birds* (ca. 414 B.C.E.) and *Lysistrata* (ca. 410 B.C.E.) established the general recipe for this genre,[22] which includes:

- a celebration of the eternal ironies of human existence and human frailty;
- interpersonal conflicts resulting in playful, witty, and often sexually charged dialogue that addresses topical issues;
- physical antics of some nature;
- a central hero—in this case, an ironic hero—whose fatal flaw is as grounded in the character's humanity as that of a tragic hero, but is more superficial, highly exaggerated, and results in hilarity; and
- the ironic hero's fate in a comedy is just as predictable as the tragic hero, but all ends happily.

Who Doth Inhabit the Primary Position, in profile

"Who's on First?" is a vaudeville comedy routine made famous by Bud Abbott and Lou Costello. The premise of the routine is that Abbott is identifying the players on a baseball team to Costello, but the players' nicknames can be interpreted as non-responsive answers to Costello's questions. A brilliant parody of this routine was created by Shakespearian actors David Foubert, and Jay Liebowitz and director Jason King Jones that places the performers in Elizabethan England. Here is an edited excerpt from the original sketch[23] and then a parallel excerpt from the parody. [24] As with all arts, the more you know about the original the more you understand and appreciate the parody.

Lou: I love baseball. When we get to St. Louis, will you tell me the guys' names on the team so when I go to see them in that St. Louis ballpark, I'll be able to know those fellas?

Bud: They give ballplayers nowadays very peculiar names—nicknames, pet names…. On the St. Louis team, we have "Who" on first, "What" on second, "I Don't Know" on third….

Lou: That's what I want to find out. I want you to tell me the names of the fellas on the St. Louis team.

Bud: I'm telling you. "Who's" on first, "What's" on second, "I Don't Know's" on third.

Lou: You know the fellas' names?

Bud: Yes.

Lou: Well then, who's playing first?

Bud: Yes.

Lou: I mean the fella's name on first base.

Bud: Who.

Lou: The fella playing first base for St. Louis.

Bud: Who.

Lou: The guy on first base.

Bud: Who is on first.

Lou: What are you asking me for?

Actor 2: And many a man makes sport with baseballs. I charge thee, tender well the huntsman's hounds, bid the archer loose his golden shaft, and like brave Apollo who ran Olympus, crouch we here a while and let us speak of

every man's name which is thought fit to play this raucous sport before the King. Come sir, know you names?

Actor 1: Ere I name them, sir, I shall have you err. Know you, sir, of the wayward wanderers, Whose names doth shift as breezily as the wind…. Hark! I here shall name the King's base ballers: "Who" doth inhabit the primary position. "What" doth inhabit the secondary. And "I Cannot Tell," the tertiary.

Actor 2: Nor can I tell and this is the matter I come to discuss.

Actor 1: And I tell you sir: "Who" doth inhabit the primary position. "What" doth inhabit the secondary. And "I Cannot Tell," the tertiary.

Actor 2: Names, villain! Know you names?

Actor 1: Indeed, sir.

Actor 2: Who is he, then, that doth inhabit the primary position?

Actor 1: Yea.

Actor 2: Come sir, the fellow's name.

Actor 1: Who.

Actor 2: The man in the primary position.

Actor 1: Who.

Actor 2: The primary gentleman.

Actor 1: Who is primary.

Actor 2: Why ask you me?

Most of the humor generated in a comedy is the result of a character attempting to reach conflict resolution; an attempt that is typically flawed, extended and exaggerated to comedic proportions. There is, however, a range of comedic plays that takes liberties with the nature of the conflict and just how that conflict is resolved:

- There are the *high comedies*, best reflected in the **comedy of manners** comedies popular in the 17th century, which are dialogue-heavy enterprises characterized by clever writing and intellectual wit. Conflict resolution is typically revealed through discussion, which is certainly the case in Oscar Wilde's *The Importance of Being Earnest* (1895);

- There are the *low comedies*, best reflected in **farce**, which are wildly active enterprises characterized by exaggerated physical action, mistaken identity, and trivial situations that result in outcomes of little consequence. Classic examples are William Shakespeare's *The Comedy of Errors* (ca. 1592) and Noel Coward's *Hay Fever* (1925). Conflict resolution is typically revealed through crazed antics;

- A distant cousin of farce is **parody**, which is an imitative work created to mock, comment on, trivialize, or just have fun with an original work (see "Who Doth Inhabit the Primary Position," in profile);
- In between high and low comedies are comedies that incorporate stinging social commentary, referred to as **satires** such as the dramatization of George Orwell's *Animal Farm* (1984), or those that infuse the comedy with romance, such as George S. Kaufman and Moss Hart's *You Can't Take it With You* (1936), which are classified as **romantic comedies**;
- Although all comedies end happily, they do not all end with humor. Those that end with poignancy or irony, leaving the impression of an unresolved or unkind universe, have been called black or **dark comedies**. A contemporary example is the 2011 play by Stephen Adly Guirgis called *The Motherf**ker With the Hat*;
- The **backstage comedy** is a unique subgenre that depicts the lives of actors and other theater folk from both sides of the proscenium arch, such as Ken Ludwig's *Moon Over Buffalo* (1995). Some fictionalize the lives of real-life celebrities, such as Jeffrey Hatcher's *Ten Chimneys* (2011), about the renowned actors Alfred Lunt and Lynn Fontanne; and
- There also exists a genre that borrows from both comedy and tragedy, called the **tragicomedy**, and is best characterized as dramatic action that ends happily or, at least, catastrophe is avoided and things do not end tragically. Often these types of plays offer a wide variety of characters from highly divergent social strata, and who experience a reversal in fortune. In some, characters are trapped in an unfulfilling existence from which there is no escape, and while witnessing their struggles often results in dark comedy, their endurance and survival is dramatic. An example is *Communicating Doors* (1994) by Alan Ayckbourn, where we find three women on urgent business in a hotel suite. One has narrowly escaped being murdered, one is about to be murdered, and the other was murdered two decades before.

THE MUSICAL. Yet another hybrid form, but one that has become its own distinctive genre, is the musical. Originating as musical revues and broadly drawn parodies of European opera in American vaudeville and burlesque theaters of the 1820s, the musical evolved into the minstrel show in the 1840s, which lacked characterizations or particular settings, but incorporated the exploitation of the humor, dance, and song of the American "Negro," and original operettas, which were shorter, lighter works in contrast to the full-length, serious operas. This gave birth to the extravaganza in the 1860s, which entailed ornate musical production numbers that introduced some of the elements subsequently identified in the American musical comedy: chorus girls, elaborate costuming, songs provocative

with sexual innuendos, and large dance numbers. By the turn of the century, these music-heavy productions incorporated plot and dialogue between songs.

If there is one man who can be singled out as the father of musical comedy as we know it today he is librettist, lyricist, composer, and performer George M. Cohan. Musicals like *Little Johnny Jones* (1904) and *Forty-Five Minutes from Broadway* (1906) were neither parody, extravaganza, nor burlesque, nor were they operettas or revues, but combined elements of all of them. Plus, they incorporated an ingredient called "willful nonsense," which meant that the story revolved around a central character, but the central character was given license to engage in business that was irrelevant to the story, such as singing and dancing. In the 1920s, in the place of big production numbers, humorous skits, and chorus-girl lines, musicals concentrated on sophistication, witty dialogue, amusing incidents that rose naturally from the context of the play, charming music, and a distinctly American personality of plot and characters. The greatest revolution in the American musical occurred in 1927, when composer Jerome Kern, lyricist and librettist Oscar Hammerstein II, and producer Florenz Ziegfeld created *Show Boat. Show Boat* offered a complicated narrative that was facilitated by the music and the musical numbers, with challenging themes and multiple storylines.[25] This was the birth of the musical drama, simply referred to as the "musical."

The incorporation of songs into the storyline, which is a mainstay in the modern musical, allows musical numbers to serve the following key narrative functions:

- **Reveal the playwright's artistic vision.** Songs serve to introduce the audience to the essential cast of characters as well as the world in which they live. The play's tone, location, and point of view are typically revealed in the opening musical number of every musical. The 2001 musical *Urinetown: The Musical*,[26] for example, is a musical comedy that parodies other musicals. Its opening number, "Too Much Exposition," purposefully makes fun of its own art form and sets the tone for the rest of the production;

- **Present the drama that drives the play.** Songs in musicals are often the only or best way a character can express his or her heightened emotions. No matter whether the musical is a comedy, drama, or tragedy, the play's protagonists are eager to get something important, but something else is standing in their way—some force, person, character flaw, or circumstance. Music has the ability to find an audience and move it emotionally in ways

..

"The great musicals had to be musicals."
~Scott Rudin, Broadway producer[27]

..

Broadway Musical Flops, in profile

The longest running shows in the history of Broadway have been musicals. Topping the list is *The Phantom of the Opera*, which has been running since 1988, followed by *Cats*, which premiered in 1982 and ran for 7,485 performances until it closed in 2000, and *Les Miserables*, which ran from 1987 until 2003 after 6,680 performances.

Of course, musicals have also been Broadway's most legendary, expensive, and high-profile flops, most of which have been chronicled in Ken Mandelbaum's book *40 Years of Broadway Musical Flops*.[28] He argues that the worst flop ever was *Portofino* which, in 1958, offered a convoluted plot about an Italian autoracer and his look-alike, Guido, who was an emissary of Satan's. It ran for three performances but not before *Herald Tribune* critic Walter Kerr noted that it may not be the worst ever since he has "only been seeing musicals since 1919" and there were many more before then.[29]

In a recent *New Yorker* article,[30] author Michael Schulman suggested that *Carrie*, the musical based on the Stephen King horror novel, was the low-water mark when, in 1988, it closed after three performances. Frank Rich, then the chief critic for *The New York Times*, compared it to the Hindenburg disaster. In his article, Schulman polled prominent New York theatergoers and provided their best of the worst:

Paul Rudnick, playwright and humorist: "*Into the Light*, from 1986, had the distinction of being both terrible and transcendently unlikely, because it was a musical about the Shroud of Turin…. A laser show erupted, proving I'm not sure exactly what. Maybe that God is, in fact, a really chintzy special effect."

John Lahr, *New Yorker* critic: "In my nearly fifty years of theatre-going, *Ari* (1971), the adaptation of Leon Uris's novel, which featured Holocaust survivors dancing over barbed wire, was the absolute worst." It ran 19 performances.

Frank Rich, former *The New York Times* critic: "The musical version of *Breakfast at Tiffany's* (1966), which starred Richard Chamberlain and Mary Tyler Moore at the height of their fame. [Producer] David Merrick folded it in previews and announced that…he didn't want to bore audiences to death."

Michael Riedel, *New York Post* theater columnist: "I'm one of the very few people who saw this unbelievably ghastly musical called *Senator Joe* (1989), which was a musical about Joe McCarthy. It ran exactly a performance and a half—they closed it at intermission…. I'll never forget this number that was a musical tour of Joe McCarthy's liver. They had alcohol-affected blood cells dancing around the stage."

Michael Schulman, actor and author: "*In My Life*, the 2005 musical by Joseph Brooks…. The show concerned a man with Tourette's syndrome *and* a brain tumor, who is watched over by the scooter-riding ghost of his little sister and a foppish cross-dressing angel. The angel sang the first-act finale—about how we all have skeletons in our closets—with a chorus line of dancing skeletons. Sample lyric: 'Here's a little rumor. / Someone's got a tumor.' The finale featured a giant lemon."

that literal meaning through spoken word can't, thereby allowing the characters' needs to be felt as well as understood. This takes place in a musical number that appears early in the production and is typically referred to as the "I want song." The 1977 musical *Annie* takes place during the Great Depression in the 1930s. Annie is a fiery orphan girl whose hopeless situation changes dramatically when she is selected to spend a short time at the residence of the wealthy industrialist Oliver Warbucks. The show's opening number is "It's a Hard Knock Life," followed by "Maybe," which reveals Annie's needs and desires;

- **Plot Progression.** A song can be used as a narrative device that complements the script and moves a character from one place—physically, temporally, or emotionally—faster, more expediently, and, often, more entertainingly than excessive amounts of monologue or dialogue. A song allows a character to be in one physical, temporal, or emotional place at its start, only to end up in a different place at its completion. In "I Only Want to Say," from the 1971 musical *Jesus Christ Superstar*,[31] Jesus is found questioning his fate and weighing his options at the beginning and has come to terms with his destiny at the end. Most of these types of songs typically take place late in Act 1 or early in Act 2; and

- **Story Summary.** After approximately two hours of storytelling, a musical number at the end of the production, referred to as the "11 o'clock Number," summarizes all that has transpired in grand fashion. It is called the "11 o'clock Number" because back in the day when musicals often lasted over three hours, this last-scene song often occurred at 11 p.m. "The Song of Purple Summer," from the 2007 musical *Spring Awakening*, is an example. The rock musical is set in late-19th century and is a coming-of-age story concerning sexually repressed teenagers. The song is about bridging the gap between adolescence and adulthood. The Purple Summer is a late-blooming flower.

The lineage of more contemporary forms of storytelling, such as commercial television programming, can also be traced to classic, character-based genres of literature and theater.[32] The sitcom, which centers around an ironic hero, has its most immediate roots in radio, film, and vaudeville but can be traced[33] to the time of Aristophanes in the 4th century and its evolution has been mapped through the Italian commedia dell'arte of the early 16th century, the Renaissance comedy of the early 17th century, and the Victorian comedy of the late-19th century. The issue-driven movie-of-the-week and miniseries can be said to derive comfortably from the worldview of antiquity, from Ovid or Sophocles.[34] The police drama (e.g., CBS' *CSI*) descends from another 19th-century genre, the crime-solving puzzles of Edgar Allan Poe and others.[35] Daytime and primetime soap operas (e.g., ABC's *All My Children*; FOX's *Melrose Place*) and telenovelas (e.g., Telemundo's *Sacrifice of a Woman*) are rooted in the very beginnings of the Anglo-European novel in the late-18th century and the melodrama. Earlier serial forms of storytelling can be traced back to the *Iliad*, the *Arabian Nights*, Daniel DeFoe, and Charles Dickens.[36]

Regarding the convention of genre, the theatergoer asks: What is the artist trying to say by placing characters and conflicts within the known parameters of a specific genre classification? Did the artist succeed? Was it worth the effort? The critic helps answer these inquiries and explains him/herself accordingly.

Theater is Collaborative

Another core convention of storytelling is that it is a collaboration between the storyteller and an audience. In fact, there is a co-dependency between the two. The storyteller's role is to efficiently create and communicate the images of a story. An audience member's role is to actively recreate the vivid "reality" of the story in his/her mind based on his/her past experiences, beliefs and understandings, and the performance by the storyteller. The completed story happens in the mind of the audience.

In order for this to happen, there is a sort of unspoken agreement between the storyteller and the audience. By showing up, audience members implicitly agree to be active, engaged participants in the process—not passive witnesses, casual observers, or innocent by-standers—by giving their undivided attention, employing their imagination, thinking, and accepting the established conventions of theater and the specific parameters created by the playwright and the creative team coordinating the theatrical performance. In turn, the storytellers implicitly agree to employ their imagination, expertise and the established conventions of theater to create and convey an interesting, engaging piece of performance art.

There are, of course, challenges specific to the performing arts in general and theater in particular that make this collaboration between storyteller and the audience (including the critic) extremely difficult to achieve. As part of the collaboration

between storyteller and audience, it is the responsibility of the storytellers to help overcome these challenges to the best of their abilities. For instance:

- **The audience is physically segregated from the performers.** For most traditional theatrical productions, the audience is expected to remain in their designated seats and watch the performance from a specified distance. This distance can be expansive in an amphitheater, the cheap seats of a large playhouse, or in an outdoor setting. Physical detachment can inspire disassociation and disinterest, particularly over the course of a two-hour production. To compensate, storytellers are typically aware of aesthetic distance—that is, the proper physical separation that allows for the audience to be engaged in the storytelling at a level appropriate for the play and production. Plays are often chosen to match the size and configuration of an available physical space for a production. Technology to enhance sound and sight can be employed. Staging can be modified to accommodate slight lines, create higher elevations for performers, and, perhaps, to actually bring certain aspects of the production into the audience;

- **The audience is psychologically separated from the performance.** In most forms of theatrical presentation, there is no actual physical or verbal interaction between the audience and the performers. Theater is also a public experience, with audience members surrounded by strangers partaking in the same theatrical performance with clear rules of engagement (or the lack thereof) with each other. The communal nature of theater can potentially hinder the desired degree of verisimilitude or the intimate relationship between the audience and the performers that is often sought by the storytellers. A large part of the art and craft of theater is narrowing or bridging this psychological distance by drawing an audience into the action and engaging them emotionally. This is referred to as kinesthetic appeal. An open curtain before a production begins, for example, can bring the audience into the fabricated world of the storyteller from the get-go, as can era- or mood-appropriate music. Performers breaking the fourth wall dur-

"*Acting has a powerful kinesthetic appeal. As we sit in the Theater, we follow the action by internally copying or re-enacting what we see. Here we are not only responding to what the characters do; we are re-enacting the actions by which the actors possess and project their parts.*"
~Michael Goldman, Princeton University scholar[37]

ing a production and directly addressing the audience as part of the language of the production can have the same kinesthetic effect;

- **Theater is an ephemeral art;** that is, a performance of a production is happening live, in the moment, and then is over. Miss something through a lapse of attention, distraction, or disengagement and it is gone. It is up to the storytellers to offer a product that is absorbing, engaging, and memorable by employing vivid, poignant, impressionable stories, performances, and production values; and

- **Disproportionate resources.** Some theater troupes are more endowed than others when it comes to financial resources, physical space, and artistic expertise. This may be the result of their particular artistic mission (i.e., professional, amateur), funding (commercial, non-profit), or market. This, in turn, impacts on the type, size, and scope of productions a theater is interested in and capable of offering and the creative risks its creative team is willing to take. Theaters must do the best they can with what they have to overcome whatever resource challenges they possess. Nonetheless, available resources often impact on the quality of the production and performances.

Regarding the convention that theater is collaborative, the theatergoer asks: What choices were made by the artists to help bring the audience into the action and hold it there for the duration of the performance? Did the artists succeed? Was it worth the effort? The critic helps answer these inquiries and explains him/herself accordingly.

Becoming Theater Literate

For the theatergoer, developing an appreciation for theater by recognizing and understanding its core conventions—that is, its sense of pretense, its employment of storylines grounded in the human condition, the mandatory collaboration between the storytellers and an audience, its genre classifications, and its narrative parameters—is a learned enterprise. We have to acquire an ability to recognize, comprehend, and then integrate the artistry behind the storytelling. Live theater involves storytelling methods that can be foreign to how we encounter real world experience and are unique to other forms of storytelling. This is particularly true when we encounter archaic forms of theater, such as the ancient Greek tragedies, or forms of theatrical presentation specific to a culture, such as Japanese Noh theater that reflects a model of reality based on Buddhist teachings.

Understanding theater, or any other form of storytelling, requires:

- **Exposure to these conventions through experience.** Being exposed to these conventions generates an initial awareness that these conventions exist,

that they exist in great variety, and that they exist for a reason. Exposure establishes the realization that these conventions are not random or haphazard, but must somehow contribute to the storytelling;

- **Repeated exposure to these conventions,** which eventually facilitates understanding and establishes shared meaning with the playwright and production regarding their contribution to the storytelling. Repeated exposure reinforces the notion that these conventions are not anomalies to one playwright, one play, or one production but, rather, recognizable and repeatable practices in the performing arts;

- **Assimilation of these conventions,** which creates a general, holistic understanding of theater as a form of storytelling and what plays and performances consist of. This includes the realization that different types of stories incorporate different elements within these conventions for storytelling. It has been suggested[38] that, during assimilation, audience members are in a self-reflective state—that is, they are hyperaware of all these conventions and their contributions, and quite conscious of the art and artificiality of the theatrical experience;

- **Suspension of disbelief** that the staged activity in a play is staged and artificial. At this point in an audience member's theater experience, this individual buys into the pretense of theater, which allows him/her to see and relate to the characters (not actors) and give into the story being told. Here audience members are in a transportive state,[39] where they are swept away with the story and the storytelling and lost in the experience; and finally

- **Cognitive complacency,** which allows these storytelling conventions to become seamless and invisible parts of the play's narrative and the theater-going experience. They no longer call attention to themselves or require conscientious effort to comprehend, for the audience members by this stage are experienced, fully on board, totally invested, and engaged.

Only after we go through this process of experience and learning—which we have all done upon our first exposures to theater—does exposure to this form of storytelling become seemingly effortless and appears as if it is a natural extension of our communication repertoire. Just like learning our native language, we have to learn the language of theater before we are comfortable with it and fluent in it. Once we are fluent, we are conversant. This is true for any art form.

Summary

This chapter pointed out that theater is, essentially, storytelling. It uses language, image, movement, gesture, and/or sound to recall, recount, and relay factual or fabricated events to an audience. By doing so, events that are disconnected or random in reality are given a sense of continuity, sequence, and meaning within the context of a story. Events that are conjoined in reality can be isolated, frozen in time, and dissected for the stage. Aspects of events are purposefully embellished by storytellers while others are intentionally obscured.

This chapter also made reference to Johann Wolfgang von Goethe, a 19th century author, philosopher, and intellectual, and his three-step approach that centers on how we go about judging an art work's storytelling function and effectiveness. It asks: What is the artist trying to say? Did the artist succeed? Was it worth the effort?

In order to answer these questions it is important for a critic to have, at the very least, a basic understanding of the artists behind the storytelling and the specific functions they serve in the collaboration that is theater. The next chapter provides that information.

KEY CONCEPTS FROM THIS CHAPTER

Absurdism	Jukebox musical
Aesthetic distance	Kinesthetic appeal
Assimilation	Linguistic structure
Backstage comedy	Low comedies
Bio-drama	Melodrama
Catastrophe	Mimesis
Climax	Musical comedy
Cognitive complacency	Musical drama
Collaboration	Mysteries
Comedy	Narrative enigmas
Comedy of manners	Narrative structure
Core conventions	Naturalism
Cultural values	Paradox of the actor
Dark comedy	Parody
Drama	Performance art
Dramatic triangle	Presentational performance
"11 o'clock Number"	Pretense

Ephemeral art

Epic theater

Epitasis

Equilibrium/disequilibrium

Expository sequence

Exposure

Expressionism

Farce

Fatal flaw

Fourth wall

Genre

Hamartia

Heightened vision

Hero's power of action

High comedies

Historical plays

Human condition

"I Want" song

Impersonation

Private sphere

Protasis

Realism

Redemption

Repeated exposure

Representational performance

Romantic comedies

Romanticism

Social norms

Spatial structure

Status quo

Storytelling

Suspension of disbelief

Symbolism

Temporal structure

Theater literate

Tragedy

Tragicomedy

Verisimilitude

Willful nonsense

NOTES

1 See Michael Wilson, *Storytelling and Theater* (London: Palgrave Macmillan, 2006).

2 Cited in http://www.aaronshep.com/storytelling/quotes.html

3 The 2012 Broadway musical *Once*, which was nominated for 11 Tony Awards and captured eight, including Best Direction of a Musical, Best Lead Actor in a Musical, and the top musical prize itself, merges presentational and representational performance. In the show, cast members play their own instruments and are their own orchestra.

4 The establishment of an imaginary fourth wall as a theatrical pretense, where the characters are unaware of the facts that they are fictional characters in a play and that there is an the audience observing them, gave rise to the "breaking of the fourth wall." Here, a character acknowledges the fact that s/he is fictional by directly addressing the audience for a dramatic or comical purpose. This narrative device dates as far back as 17th century Baroque period paintings, where a figure in a devotional or allegorical scene can be found playfully or dramatically looking directly at the viewer. It has been suggested that the figure typically represents the painter.

5 Summary of Victor Hugo's *Hernani* (1830): Three men—two noble and one a mysterious bandit named Hernani who is being pursued by the King—are all in love with Doña Sol, a young noblewoman of the court of the fictional Don Carlos, King of Spain. At Doña Sol's wedding to one of the noblemen, Don Ruy Gomez de Silva, Hernani interrupts the affair. Alone with Hernani, she reveals that she plans to commit suicide before her marriage can be consummated. In the end, the King pardons Hernani and gives him Doña Sol. The two are married, but as they enjoy their wedding feast, Hernani hears the distant call of the horn blown by Silva, and kills himself by drinking poison to retain the honour. Doña Sol drinks his poison as well and they die together.

6 Alfred Bates (Ed.), *The Drama: Its History, Literature and Influence on Civilization*, vol. 9 (London: Historical Publishing Company, 1906), 23.

7 Summary of Anton Chekhov's *The Seagull* (1896): This play is about a very human tendency to reject love that is freely given and seek it where it is withheld. Many of its characters are caught in a destructive, triangular relationship that evokes both pathos and humor. What the characters cannot successfully parry is the destructive force of time, the passage of which robs some, like the faded actress Madame Arkadina, of beauty, and others, like her son Konstantin, of hope.

8 Wilson, *Storytelling and Theater*, 106.

9 Summary of Maurice Maeterlinck's *Pelleas and Melisande* (1892): The play is about forbidden, doomed love. While hunting, Golaud discovers Mélisande by a stream in the woods. She has lost her golden crown in the water but does not wish to retrieve it. They marry, and she instantly wins the favor of Arkël, Golaud's grandfather and King of Allemonde, who is ill. She falls in love with Pelléas, Golaud's brother. They meet by the fountain, where Mélisande loses her wedding ring. Golaud grows suspicious of the lovers, has his son Yniold spy on them, and discovers them caressing, whereupon he kills Pelléas and wounds Mélisande. She later dies after giving birth to an abnormally small girl.

10 Summary of Eugene O'Neill's *The Hairy Ape* (1922): The play is written in eight short, abrupt scenes, and has been called an expressionistic tragic-comedy of modern industrial unrest. The play tells the story of a brutish, unthinking laborer known as Yank, as he searches for a sense of belonging in a world controlled by the rich. *The Hairy Ape's* strong condemnation of the dehumanizing effects of industrialization made it appealing to many labor groups and unions, who seized upon its concepts to further their cause for better working conditions.

11 Summary of Jean-Paul Sartre's *No Exit* (1944): Three damned souls—Garcin, Inez, and Estelle— are brought to the same room in hell by a mysterious Valet. They had all expected medieval torture devices to punish them for eternity, but instead find themselves in a plain room. None of them will admit the reason for their damnation: Garcin says that he was executed for being a pacifist, while Estelle insists that a mistake has been made. Inez, however, demands that they all stop lying to themselves and confess to their crimes. Forgetting that they are all dead, Estelle unsuccessfully tries to kill Inez, stabbing her repeatedly. Shocked at the absurdity of his fate, Garcin concludes, "hell is other people."

12 Wilson, *Storytelling and Theater*, 23–24.

13 Tennessee Williams, *The Rose Tatoo* (New York: New Directions, 1951) cited in Dennis J. Sporre, *The Art of Theater* (Englewood, NJ: Prentice Hall, 1993), 45.

14 Noted in Lee A. Jacobus, *The Bedford Introduction to Drama* (New York: St. Martin's Press, 2009).

15 Sean Coughlan, "Why Are We Still Waiting For Godot," BBC News, January 4, 2013, http://www.bbc.co.uk/news education-20889073 (accessed January 7, 2013).

16 Cited in Steve Neale and Frank Krutnik, *Popular Film and Television Comedy* (New York: Routledge, 1990), 27.

17 Kenneth Burke, *A Grammar of Motives* and *a Rhetoric of Motives* (Berkeley, CA: University of California Press, 1970).

18 Gustav Freytag, *Freytag's Technique of the Drama: An Exposition of Dramatic Composition and Art*, trans. Elias MacEwan (New York: Benjamin Blom, 1970), 19–20.

19 Michael Feingold, "A Case for the Return of Some Vanishing Stage Customs," *The Village Voice*, January 2, 2013, http://www.villagevoice.com/2013-01-02/theater/let-s-cheat-this-year/2/ (accessed January 4, 2013).

20 Cited in Northrop Frye, *The Anatomy of Criticism*, http://northropfrye-theanatomyofcriticism.blogspot.com/2009/02/polemical-introduction.html (accessed January 30, 2012).

21 Jason Zinoman, "That Bellow, That Beard: An Actor's Life and Hair," *The New York Times*, November 30, 2009, http://theater.nytimes.com/2009/11/30/theater/reviews/30zero.html?scp=19&sq=1977&st=cse (accessed January 30, 2012).

22 Cited in Robert Cohen, *Theatre* (New York: McGraw-Hill, 2003), 34–35.

23 The transcription was based on a video retrieved from http://www.youtube.com/watch?v=sShMA85pv8M, which depicts Abbott and Costello performing the classic sketch in their 1945 film *The Naughty Nineties* (accessed January 30, 2012).

24 "Who Doth Inhabit the Primary Position" was originally performed in its entirety at First Night Morristown, December 31, 2005, by co-authors Jay Leibowitz and David Foubert, and directed by co-author Jason King Jones. It is based on an idea by Bonnie J. Monte, artistic director of Shakespeare Theatre of New Jersey. The transcription was based on a video retrieved from http://www.youtube.com/watch?v=BaGHVWKrcpQ&feature=share (accessed January 30, 2012).

25 Cited in www.pbs.org/wnet/broadway/print/p-showboat.html (accessed January 30, 2012).

26 *Urinetown: The Musical* is set in a grim Gotham-like city of the future, where a 20-year drought has occurred. The government has banned private toiletries and the citizens must use pay toilets regulated by a monopolistic company, the Urine Good Company, which charges exorbitant prices. Bobby Strong, the assistant custodian at the poorest urinal in town, decides enough is enough. With the help of the daughter of the CEO of the Urine Good Company, Hope Cladwell, Bobby leads a rebellion.

27 Cited in Scott Brown, "Broadway Songwriting: Is in Critical Condition. Again." *New York*, May 20, 2012, http://nymag.com/arts/theater/features/broadway-songwriting-2012–5/ (accessed May 21, 2012).

28 Ken Mendelbaum, *40 Years of Broadway Musical Flops* (New York: St. Martin's Press, 1991).

29 Ibid, p. 2.

30 Michael Schulman, "Is *Carrie* the Worst Musical of All Time?" *The New Yorker*, January 30, 2012, http://www.newyorker.com/online/blogs/culture/2012/01/the-discrete-pleasures-of-a-broadway-flop.html (accessed January 30, 2012).

31 The musical is based very loosely on the Gospels' account of the last week of Jesus' life, beginning with the preparation for the arrival of Jesus and his disciples in Jerusalem, and ending with the crucifixion.

32 See Robert Abelman and David Atkin, *The Televiewing Audience: The Art and Science of Watching TV, 2nd edition* (New York: Peter Lang Publishing, 2011).

33 Hal Himmelstein, *Television Myth and the American Mind* (Westport, CT: Praeger, 1994), 113–162.

34 John Leonard, *Smoke and Mirrors* (New York: The New Press, 1997), 9.

35 Todd Gitlin, *Inside Prime Time* (New York: Pantheon Books, 1985), 27.

36 Jib Fowles, *Why Viewers Watch* (Newbury Park, CA: Sage, 1992), 159.

37 Michael Goldman, *Acting and Action in Shakespearean Tragedy* (Princeton, NJ: Princeton University Press, 1985), 10.

38 See W. James Potter, *Media Literacy,* (4th ed.) (Los Angeles, CA: Sage, 2008), 38–39.

39 Ibid, 38.

"Human imagination has given mankind the unique ability to communicate abstract concepts and ideas among its people. It has given its storytellers the power to emotionally enter people's minds."
~Donald L. Hamilton, professional storyteller[1]

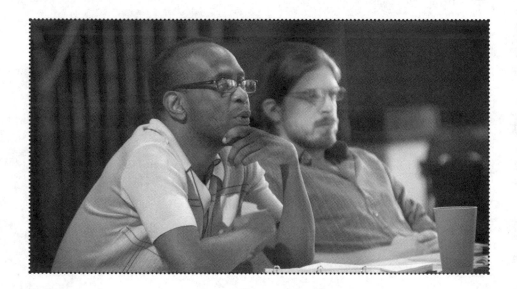

Chapter 8 Abstract

This chapter identifies the variety of artists who contribute to a theatrical production. Their independent functions, the nature of their specific contributions, and the interdependency of their creative collaboration will be explored. This chapter will help direct criticism to its most appropriate and deserving targets.

The Storytellers

A s was discussed in the previous chapter, theater is art—a purposeful enterprise that employs creativity and imagination. More specifically, theater is a performance art that incorporates pretense, impersonation, and heightened vision in its endeavor to tell stories, and the storytelling is a collaborative co-dependency between a storyteller and an audience. The teller is responsible for efficiently communicating the images of a story, generating an elegance of presentation and a sense of aesthetics that offers an overriding harmony and consistency throughout the storytelling, all the while attempting to overcome barriers that might keep this collaboration from happening. In turn, an audience member offers attention and invests imagination in actively recreating the vivid "reality" of the story in his/her mind and, through experience, learns to appreciate the conventions, elegance, and aesthetics of the storytelling.

Theater relies upon another form of collaboration besides the one that exists between the storyteller and the audience. Theater is also dependent on the collaboration between all the members of the team of storytellers. This includes the playwright, a theater's artistic director, the play's director and designers, the actors, and other members of the creative and technical staff. Although each of these individuals serves significant, specific, and identifiable functions, most forms of theater work hard at obscuring the labor and specificity of these activities so that they merge into a collective, unified whole. One of the key conventions of theater is that the art and craft of storytelling appear seamless and invisible to the audience[2] so it can suspend disbelief and watch in a state of cognitive complacency.

It's a different story for critics, however, who must acquire a sixth sense and critical third eye through which to see theater. While allowing ourselves to venture into a state of cognitive complacency, which is fundamental in enjoying a theatrical production, critics must also remain partially removed from the experience and overtly aware of the mechanics involved in its creation. This includes being able to identify and critique the specific contributions of the various members of the pro-

duction team when witnessing the finished staged product. A critic needs to know where to cast blame and lay accolades in his or her review of a play and a production. The task of separating the play from the production, as well as knowing where the contribution of the director ends and that of the actors begins, is intrinsic in critical assessment.

What follows are brief descriptions of the various storytellers associated with a theatrical production and what each storyteller brings to the table.

The Playwright

The playwright provides the point of origin for theater. No playwright, no play. No play, no production. No production, no performance. The playwright's handiwork is the script. There have been various times throughout history when theater was scriptless, such as the improvisational performances of commedia dell'arte during the Italian Renaissance of the 1500s. There are also various forms of contemporary improvisational and devised theater. However, most theater revolves around and is dependent upon the written product generated by the playwright.

The majority of theaters across the country offer re-productions of plays—that is, the scripts being staged and given life are existing works that have been previously staged elsewhere. There are some theaters that produce only original, world-premiere work that is obtained or commissioned directly from a playwright, and some other theaters have a playwright or two in residence whose work is initially produced exclusively by that theater's company. However, most theaters choose their seasons from the vast array of existing works by playwrights living or dead. They pay a royalty for the right to re-produce a play, which is typically based on the number of performances and the size of the potential audience, and which goes to the playwright after being filtered through whatever agents, agencies, or publishers that serve as go-betweens.

Since the 19th century, the playwright has been increasingly removed from the actual production of his or her play. The Greek playwrights typically staged their own works. Shakespeare and Molière both wrote for and acted in their own theater companies. However, contemporary playwrights tend to provide the words and then a theater company's production team provides their enactment. It has become common practice that few of those scripted words serve to actually facilitate the production of the play, allowing the production team to figure things out for themselves.

Only a minimum amount of description at the start of a script is provided to create the playwright's theatrical vision for how the work is to be staged. Only occasional stage directions are peppered throughout the body of a script to guide specific actions. Modern playwrights must use only their ability to write dialogue to trans-

mit a statement about human experience and how it is to be enacted on the stage. They do not have the luxury of the descriptive running narrative of the novelist to accomplish this.[3] Nor are they able to manipulate audience positioning and perspective in the same way TV scriptwriters or film screenwriters are able to recommend camera position, angle, and movement throughout their dialogue.

In fact, most playwrights look at their work as a piece of literature and give little thought to the eventual production of their play when it is being written.[4] They create a vibrant world, populate it with interesting characters, place it in a particular time and space, and make it live and breathe in their imagination. Most playwrights do not people their work with actors they imagine playing the roles or envision a specific theatrical space or design for its staging. Nor do they have a game plan for the play's production, finding that any attempt to specifically write a giant commercial hit that will play on Broadway, or thrive in regional theater, or endure in community theater will get in the way of the actual writing.

Realizing that they will have little if anything to do with the initial or subsequent productions of their work, and that these productions may or may not correspond with their vision, playwrights devote themselves to what they can actually control. What they can control is the intrinsic value of and vision for the play, the integrity of the story being told, the nature of the characters that populate their story, and the emotions and desires in the words their characters speak. Of course, playwrights realize full well that their work will appear before an audience and, while they do not cast the play with actors, they are, in fact, casting the audience. They often ask "for whom am I writing this play?" and proceed accordingly with audience comprehension and response in mind. There tends to be the general belief that, if the playwright does his or her job of creating an interesting story and telling it well, a capable production team will do its job of envisioning it and putting the play into practice. The play is the blueprint for production.

Although it was just stated that, historically, the playwright has been increasingly removed from the actual production of his or her play, there are several exceptions. One exception is when a new play is being workshopped—that is, when it is read or staged before a typically non-paying audience as a work-in-progress to help further develop the work. Here, a playwright leaves the self-imposed seclusion of writing and is afforded a reality check on whether his or her ideas and dialogue work on the stage. In many cases, a work-in-progress goes through various readings, revisions, and rewrites as the play is filtered through a creative team and tested on audiences. A director may push the playwright to explore new ideas. Actors give voice and depth to characters and may help identify what works and what is missing. Workshopping a play can be both nurturing and absolutely frustrating to a playwright.

> *"Life as a playwright exists as a double helix of intense solitude coupled with intense collaboration. I actually love both, but it is the collaboration that ultimately makes a production sing. The life of a play will ultimately, hopefully transcend any particular production, but when I see other creative people take my work to unexpected and thrilling places, it is extremely fulfilling."*
> ~Rajiv Joseph, playwright[5]

Another exception is during a world premiere production of a playwright's finished work, where the playwright is often included as part of the production team and involved in the collaboration. How much is typically up to the play's director. At the very least and as a courtesy, the playwright is available as an on-looker during rehearsals and during the preview performances. Often s/he is a consultant and will rewrite the work if something unexpected or interesting occurs, in preparation for the play's actual premiere. Upon occasion, the playwright is asked to direct his/her own work.

Since playwrights typically have little to do with the initial production of their work and usually nothing to do with subsequent productions, concerns and complements generated by the critic that can be targeted at the playwright have only to do with the play itself. Even this needs to be tempered in accordance with the play's track record. For example, a contemporary critic would be hard pressed to criticize the writing in Shakespeare's *Hamlet,* which has done pretty well for itself for more than 400 years, or the quality of the Pulitzer Prize-winning play *Next to Normal.* Of course, criticism about a production of these works is certainly fair game. New, less produced, as well as less familiar plays certainly warrant critical scrutiny, particularly in terms of their embracement of or departure from theater's core conventions.

The Critic and the Playwright

Consequently, it is essential that a critic learn to separate a good play from a good performance of a bad play—that is, to distinguish between the story and the storytelling. When a review of a performance of the play addresses the play itself, it is here that the questions raised in the previous chapter regarding theater's core conventions come into play and, if relevant, can be answered:

- What is the playwright trying to say by employing pretense, impersonation, heightened vision, and the degree of realism reflected in these elements? Did s/he succeed? Was it worth the effort?

- What is the playwright trying to say by focusing on and addressing a particular aspect of the human condition? Did s/he succeed? Was it worth the effort?
- What choices are made by the playwright to help bring the audience into the action and hold it there for the duration of the production? Did s/he succeed? Was it worth the effort?
- What is the playwright trying to say by incorporating characters, situations, and other known parameters of a specific genre? Did s/he succeed? Was it worth the effort?
- What is the playwright trying to say through his or her choice and manipulation of order, time, space, and language? Did s/he succeed? Was it worth the effort?

Musicals not only have playwrights, referred to as librettists, but also composers who write the music and lyricists who write the words to accompany the music. Early American musicals offered stories that were little more than the substance that linked one musical extravaganza to the next but, in the early 20th century, more serious social content in the plays brought more narrative function to the music.

As was noted in the previous chapter, songs in musicals are often the only or best way a character can express his or her heightened emotions. As a storytelling mechanism, music has the ability to find an audience and move it emotionally in ways that literal meaning through spoken word can't. More pragmatically, a song can be used as a narrative device that complements the script and moves a character from one place—physically, temporally, or emotionally—faster, more expediently and, often, more entertainingly than excessive amounts of monologue or dialogue. Consequently, criticism of musicals should ask and answer an additional question:

- What are the librettist, composer, and lyricist contributing to the story and storytelling? Did they succeed? Was it worth the effort?

From a playwright's perspective, reviews of his/her work serve three primary functions:

- **Status conferral.** Critics with authority have the potential to make a playwright, confirm his/her current standing in the arts community, or break a playwright based on the critique of his/her new works;
- **Promotion.** Reviews of world premiere and regional premiere productions of plays can impact on the shelf-life of the play itself. Positive reviews can serve to promote the play and influence other theaters' decisions about incorporating the play into their upcoming season; and
- **Serving as standard bearer of the arts.** Well-informed criticism has the potential to push artists to raise the bar on the quality of their writing and push the envelope on risk-taking storytelling.

Timing and the Cruel Review, in profile

In a wonderful blog entry[6] by Jason Robert Brown (*The Last Five Years, Parade, Songs For A New World, 13*), the playwright and composer argues that it isn't so much the tone of a review but its timing that can be particularly problematic for artists. He tells a story of when he was a younger man and invited by the great Stephen Sondheim to go to the opening night of a new Sondheim production on Broadway.

After the show ended, Sondheim asked Brown what he thought of the work. Here is Brown's account of Sondheim's response to receiving criticism a tad too soon:

> Say only this: "I loved it." It doesn't matter if that's what you really felt. What I need at that moment is to know that you care enough about me and the work I do to tell me that you loved it, not "in spite of its flaws," not "even though everyone else seems to have a problem with it," but simply, plainly, "I loved it." If you can't say that, don't come backstage, don't find me in the lobby, don't lean over the pit to see me. Just go home, and either write me a nice email or don't. Say all the catty, bitchy things you want to your friend, your neighbor, the Internet.

> Maybe next week, maybe next year, maybe someday down the line, I'll be ready to hear what you have to say, but that moment, that face-to-face moment after I have unveiled some part of my soul, however small, to you; that is the most vulnerable moment in any artist's life. If I beg you, plead with you to tell me what you *really* thought, what you actually, honestly, totally believed, then you must tell me, "I loved it."

> That moment must be respected.

The Artistic Director

Different types of theater companies provide different modes of storytelling, as defined by their particular creative mission and adopted business model. Some theaters are more endowed than others when it comes to financial resources, physical space, and artistic expertise. This, in turn, impacts on the types of plays and playwrights they embrace, the size and scope of productions they are capable of staging, the creative risks their team is willing to take, and the subsequent ticket price for their productions. Audience expectations are often influenced accordingly. So, too, are the critics'. The different categories of theaters include the following:

- **Community theaters,** which cater to the specific community in which they are housed and are operated by members of that community. Their

productions are largely dependent on non-paid amateur performers and volunteer or minimally paid members of the production team and staff. They typically operate a small budget bolstered by local resources such as ticket sales, season subscriptions, playbill advertising, gifts and donations, and community- and state-wide arts association grants. Of course, some community theaters have greater financial resources than others and reputations that attract former professional performers. The nature of the plays produced and the amount of risk being taken in their productions are largely a reflection of the community being served;

- **Collegiate theaters,** which are on-campus training grounds for college students considering theater as a profession. Their budgets are determined by academic administrators and filtered through the drama program, school, or conservatory. The nature of the plays produced and the amount of risk being taken in their productions are determined by the school or program's areas of specialty, national reputation and artists in residence, as well as the mission to stretch students' knowledge base and expertise in preparation for a career in the arts;

- **Professional theaters** are able to pay all performers and members of the production team, but have no money to support Actors' Equity performers. They are dependent on some mix of local, state, and national grants and endowments, national foundation or corporate support, and private donations as a means of financial stability in order to sustain a season's productions. Local professional theaters tend to attract and cater to an audience larger than the immediate community in which it is housed, which puts them in competition with community and other professional theaters in the region. This is reflected in the types of plays they select and the creative risks they take. Most professional theaters are non-profit;

- **Hybrid theaters** are professional theaters with enough financial support to sustain a troupe of paid actors and some Actors' Equity performers, who are paid based on the union scale. Typically, these theaters can afford under three Equity contracts; having more requires the hiring of a union stage manager; and

- **Equity theaters** are perceived as top-tier institutions, with a greater share of budget, facilities, and talent (three or more Actors' Equity performers) to produce more elaborate and expensive performances. Many are for-profit, commercial enterprises that include Broadway and Broadway touring companies, although some touring companies are strictly professional. Others are not-for-profit institutions and typically referred to as Regional theaters. Supported largely by National Endowment for the Arts grants and

typically housing a recurring company of players, regional theaters often produce new plays and challenging works that do not necessarily have the commercial appeal required of a Broadway production. Their wide-ranging repertoire includes classics; modern plays and musicals; adaptations and translations by American and international writers; plays for culturally specific and young audiences; and experimental, multimedia, and performance-art works. Many devote themselves to one particular type of work, such as classics, or original work, or American plays.

Embracing a theater's mission, business model, and the specific capabilities of its performance space—and making financial and creative decisions accordingly—is the artistic leader and chief executive officer of that theater. This individual is referred to as the Artistic Director, or AD. The AD has over-arching control of the vision, direction, and risk-taking of the theater; maintains quality control of its productions; and is responsible for recognizing, reaching, and appeasing the theater's target audiences. As such, s/he attends all shows and public functions as the "face" of the theater, and his/her vision for the theater is often identified in the playbills distributed at each performance. In short, the buck and the theater's specific identity and stature in the arts community stops with the AD.

In addition to providing the vision for the company's present and future, this individual articulates that vision both within the organization and in the community, and

> *"I am interested in the future of theater that is pulled by two forces—practicality and spirituality. Practicality drives us to issues of craft. It forces us to live within our means, organizationally and artistically. Practicality insists on relevance…. Practicality keeps us honest and grounded. Spirituality keeps the spark of life at the center of our work and reminds us that theater is deeply personal. Spirituality places high value on truth, even if that truth cannot be easily packaged or explained. Spirituality trusts the audience and invites them to play with us. It reminds us that if we are to transform others, we first must seek our own transformation…. Spirituality demands that, no matter how uncool it may be, we cannot shy away from the deepest questions and the search for meaning in life."*
> ~Raymond Bobgan, executive artistic director, Cleveland Public Theatre[7]

presides over the execution of that vision. In particular, the AD's duties include the selection of the season—that is, the plays and projects for the theater to produce—as well as the conception and implementation of various other artistic initiatives. These initiatives could include the production of a new play or a one-act festival, collaborations and partnerships with playwrights or other theater troupes, and any artistic initiatives outside the theater's current repertoire. The AD also has producing duties associated with bringing these various projects to life. As the producer, the AD hires and engages in performance reviews of artistic personnel, including the directors of plays, presides over casting and the technical hiring of each project, and then supervises the entire creative process of each project. Often, particularly at professional, hybrid, and equity theaters, an AD is a theater artist who also directs plays or perhaps acts in them or writes them.

Generating new revenue streams is also a priority. The AD reports to the theater's Board of Directors, a group of volunteers who are most often community and business leaders who have fiduciary responsibility for the theater. Ideally, the Board of Directors has a strong supervisory and advocacy role with the theater, but not a creative one. Typically, the AD is responsible for recruiting and cultivating an effective Board. In Equity theaters, the AD also concerns him/herself with contracts, developing relationships with talent agents, and making sure union requirements are firmly adhered to throughout the rehearsal and production process. The Artistic Director also coordinates strategic planning, fundraising, community outreach, educational, and promotional and marketing efforts, often in coordination with a Managing Director.

It should be noted that some theaters have several ADs; one is called an Executive Artistic Director and is just concerned with the creative activities of the theater, and another called a Producing Artistic Director, who handles all the financial responsibilities.

The Critic and the Artist Director

All "big picture" concerns and complements generated by the critic in a review of a production fall under the jurisdiction of the AD. These include:

- issues associated with the appropriateness of the season's shows as it pertains to the particular creative mission, adopted business model, target audience, and capabilities of the theater. Is the theater biting off more than it can chew? Is the theater not stepping up to the plate by producing more challenging plays;
- hiring decisions as reflected in the overall quality of a production; and
- the creative direction of the theater, as reflected in its individual productions.

As was noted earlier, an audience's "big picture" expectations for a production are often influenced by the type of theater it is attending. The same is true for

Job Description at East West Players (Los Angeles, CA), in profile[8]

Program/Department:	Artistic Programming/Administration
Direct Report:	Board of Directors
Position:	Producing Artistic Director
Classification:	Full-Time/Salaried/Exempt/Benefits Eligible

The primary responsibility of this position is to currently oversee and implement all artistic programming of the organization as well as oversee the day to day operations and administrative aspects of the organization. It is currently producing artistic director and managing director responsibilities combined.

Responsibilities include, but are not limited to the following:

Artistic

- Interprets and creates the artistic vision of the theater based on the mission
- Selects the mainstage season of works and special mainstage programs; oversees the development of new works or adaptations of works
- Positions EWP as a(n) (inter)national arts entity (i.e. with Coalition of Asian American Theaters and Artists (CAATA), Theater Communications Group (TCG), LA Stage Alliance (LASA), Arts for LA, Culturally Specific Capacity Building Program at the Kennedy Center) by participating in artistic and planning meetings at the community, local and national level
- Oversees and advises the arts education programs of the organization such as the David Henry Hwang Writers Institute, Actors Conservatory, Alliance of Creative Talent Services, PEAC and Theatre for Youth including development and workshop of literary works

Management

- Helps create and implement the organizational vision for EWP. Ensures that assessment findings and strategic plan goals are addressed.
- Develops and plans organizational infrastructure needed for the "next stage of development" for EWP and acquires the strategic resources/partners needed.
- Oversees contract negotiations and agreements with contract staff, writers or their representatives and other contractual agreements of theater rental (to be given to Business Administrator)
- Oversees/facilitates business development and coordination of all functional areas and reports operational activities to the Board of Directors (to be assisted by Business Administrator)
- Attends weekly staff meetings

- Approves all final artwork and press releases before printing
- Oversees and supervises artistic aspects of contract staff performance
- Oversees updates on job descriptions for direct reports
- Meets regularly with direct reports to set goals and monitor progress toward goals
- Gives ongoing feedback and conducts formal performance evaluations in timely manner
- Solicits feedback from direct reports on management style and techniques

Finance
- Oversees development of annual budget and monitors monthly financial reports to ensure organization stays on budget. Revises budget at mid-year point or as necessary
- Manages merchant banking accounts, investments, credit card processing vendor. Research/negotiate discounts, financial incentive packages
- Analyzes/interprets/reports financial status and projections to Board of Directors

Fundraising
- Oversees creation and implementation of fundraising plans and budgets with Development Manager, and Business Administrator, where necessary.
- Oversees fundraising events and donor cultivation events
- Works with Board of Directors, Business Administrator, and resource committees in planning all aspects of fundraising
- Directly involved with Major Donor cultivation (Contributions of $1,000 or more)
- Provides direction of all grant and program proposals
- Serves as executive producer of all special event such as One Night Only and the Visionary Awards

PR/Marketing
- Oversees creation and implementation of marketing plans and budgets with PR/Marketing Manager and Arts Education Director, where necessary
- Edits/approves all final text and artwork for marketing and other public materials before printing or dissemination

Community
- Works with senior staff in planning outside community events in which the organization is participating in such as festivals and fundraisers
- Reviews requests and approves or declines participation in community events

Board of Directors
- Attends all monthly board meetings
- Reports activities of the organization to the Board of Directors

> *"I find that the more theater education and experience a writer has, the more balanced his or her criticism tends to be. It's not that these critics are less discerning; rather, they are capable of spending more time discussing the merits of the play on drama-turgical grounds than complaining about the performances."*
>
> ~Chris Coleman,
> artistic director, Portland Center Stage[9]

critics. "Big picture" critical concerns and complements are typically tempered by whether productions are created by community, collegiate, professional, hybrid, and equity theaters, for each type of theater has a disproportionate allocation of financial resources, physical space, and artistic expertise based on its particular creative mission and adopted business model. This is often apparent in the productions. For many critics who cover this range of theaters, there exists a sliding scale of expectations that impacts what they say about a production that reflects the AD and his/her decisions, as well as how they go about saying it. It is fair to say that this sliding scale (discussed at greater length in a later chapter) also applies to the decisions made by other members of the creative team.

From an AD's perspective, a piece of criticism serves several significant functions:

- **Public relations and promotion.** Previews and, to a lesser degree, reviews operate as an independent extension of a theater's own publicity department. They provide exposure for the theater and the production, and are quoted on theater websites, marquees, and subsequent press releases;
- **Providing advocacy.** While a critic must guard against too much personal involvement with the creators of the arts being reviewed, for fear of becoming corrupted and biased, the promotion of good art underlies the critical process. ADs realize and appreciate the power of criticism to keep art, theater in general, and their theater company in particular an active part of the dialogue in the community; and
- **Serving as standard bearer of the arts.** This is particularly true in major markets, where new plays and new forms of theater are being created and staged. Critics have long placed themselves in the position of standard bearer—those responsible for maintaining the integrity of the arts. Former *Times* theater critic Frank Rich so dominated the theater scene that if he disliked a play in London, producers would not bother to bring it to New York.

"The ephemeral nature of our work has sponsored a perennially neurotic relationship between the theater and a press that is far more durable and easily disseminated than the actual performances. What appears in print about us necessarily means a great deal to the company. Press coverage gilds our image for our audience, funders, and board of directors, all of whom feel a warm thrill of legitimacy…and that thrill translates into real numbers at the box office and the bank. I care about criticism, but I wish I cared differently. The fact is…press helps us simply because it exists. That picture in **The New York Times** *could be attached to nearly any copy; we'd still bounce."*

~David Herskovits, artistic director,
Target Margin Theater, Brooklyn, NY[10]

Director and Designers

The individual who oversees, orchestrates, and unifies all the activities associated with taking a play from page to stage and mounting a specific theatrical production is the director. In some cases, the director has a say on play selection; in most cases, the director is assigned to a play shortly upon the announcement of the season's offerings.

The director's primary function is to ensure the quality and completeness of a production, and to lead the artistic personnel associated with that production into realizing the playwright's vision and the director's own interpretation of it. The responsibility of the director is to serve the playwright by carefully analyzing the meaning and intent of the play and then coming up with a creative and vibrant production plan that will tell the story in a compelling way and from an interesting point of view, and within the theater's financial and logistical parameters. This typically entails multiple readings of the script and careful study of the world in which the play takes place. Some directors surgically dissect a script in search of new or hidden meaning. If the play is an original work, directors often confer with the playwright. In fact, the director's knowledge of and insight into the play should be on par with that of the playwright's.

It is an unwritten rule—and one that can potentially metastasize into a legal suit if undermined—that a playwright's dialogue and, for a musical, a composer's music and a lyricist's words, will not be tampered with, altered, or eliminated without consent. After all, they have been purposefully chosen and are copyrighted. With

The New York Times Critic Watch, in profile[11]

The Critic Watch is an experimental, online, reader-fueled blog that analyzes the tone, temper, and trends in theater reviews of new work from the field's top cultural print outlets. Here is a laundry list of what they discovered that professional theater producers and practitioners want most from professional critics:

More publicity for their production. A picture in the paper. A headline. Something that they can excerpt for their e-blasts, websites, or postcards. A review that takes their hard work, experience, and specific artistic goals for the production into consideration. They want to help audiences prepare for the show. They want the show's surprises to be kept surprises. They want biases to be fairly aired. They want individual achievements to be noted. They want to keep their jobs and their theaters open. They want to grow their patronage. They want to grow as artists.

that said, it is the director's job to create a theatrical event out of a written text and creative liberties are often taken.

Indeed, it has been suggested[12] that directors fall into two general categories in this regard. There are the worshipful directors, who venerate the written text as the only original and permanent art object in a production and in each performance of it. At its most extreme, this breed of director embraces the belief that the playwright's work is the foundation of theatrical art, and the director's job is to mount the play as faithful to the original and as true to the original production of it as possible. From this perspective, the director's job is not to create theater, but to allow the play to speak for itself and do the heavy lifting.

At the other end of the directing spectrum are the heretical directors, who believe that there is no single or correct interpretation of a play. Fidelity to some authorized or time-honored view of a play or a production is neither in the play's nor audience's best interest, nor does it result in particularly interesting theater. There are some theaters, such as Chicago's Hypocrites, that are known specifically for their modernized, condensed adaptations of classics. The extremes of the heretical director's creative interpretations of a work can lead to audiences being baffled, insulted, or enlightened.

After envisioning an aesthetic for the play in terms of its voice and look, the director selects and works with various designers to come up with a cohesive plan that will elucidate this aesthetic. Most directors believe that the most essential talent associated with direction is the ability to assemble the best artistic staff possible. The director is the point person for all these designers, who all have their specific

"In my view, the playwright is God. I am an interpreter of the text. Whether the playwright is living or dead, it is my job with the creative team to dig deep and try to discover what the playwright intended to say; what story does she or he want to tell? A great artistic team can bring out the strengths of a weak play—perhaps even cover up those weaknesses. Conversely, a weak directoral/design team can ruin a good play. When you have an excellent play and an excellent team, that is an unstoppable combination for success."

~Risa Brainin, freelance director and Director of Performance, University of California, Santa Barbara[13]

design functions but who must operate in coordination with one another. They include the set designer, lighting designer, sound designer, and costume designer.

The scenic designer is responsible for creating an environment for the production that complements the playwright's vision and coincides with the director's interpretation. Famed American scenic designer Robert Edmond Jones is credited with first integrating scenic elements into the storytelling instead of having them stand separate and indifferent from the play's action. In the 1930s, at the height of his innovation, Jones noted that:

A stage setting has no independent life of its own. In the absence of an actor it does not exist. A scene on a stage is...like a mixture of chemical elements held in solution. The actor adds the one element that releases the hidden energy of the whole. Meanwhile, wanting the actor, the various elements which go into the setting remain suspended, as it were, in an indefinable tension. To create this suspense, this tension, is the essence of... stage designing.[14]

Scenic designers often create scale construction drawings, creative renderings, or models of the scenery and set pieces, which serve to communicate their vision with the director and allow the other designers to follow suit.

The primary functions of the lighting designer is to allow the audience to see the scenic design and all the staged activity, to help focus the audience's attention in relation to the playwright's vision and the director's concept, to establish mood in accordance with the script, and to reveal the performer's three dimensional form, which is often obscured in a staged production. All this is done through a combination of lighting intensity, direction, distribution, movement, and color.

The first person to receive a Broadway credit as sound designer was Jack Mann, for the 1961 production of the musical *Show Girl*, even though music and sound

effects have been used in the theater since ancient times and electrical sound rein-forcement and reproduction had been used in the theater since the 1940s. Augmented sound is used routinely in theatrical performances to reinforce an actor's voice, to establish locale, time of day, time of year, weather conditions, assorted ambient noises specific to a location, and to evoke a mood, support an emotion, intensify an action, and to provide segues from one scene to another. Sound design has rapidly escalated in importance over the past decades, as playwrights and directors avidly incorporate new technologies that can more easily and effectively replicate, inte-grate, and synchronize sound.

The notion that costuming can serve to define a character came about gradu-ally in theater's history, evolving from ceremonial vestments, to mere wardrobe, to purposeful art form. Shakespeare often combined contemporary clothing with cos-tumes reflective of the period of the play for dramatic effect. In Renaissance Italy, commedia dell'arte dressed actors in costuming that signified their characters' age, intelligence, and disposition. Today, the costume designer's task is to balance an imaginative aesthetic creativity with dramatic suitability that complements the play and the director's interpretation. It must help establish a theatrical time and place in accordance with the script. It must shed light into the customs and practices of that time and place. Costumes must also express the specific individuality of each character's role—that is, they reveal the nature of that character and his/her rela-tionship with others. The same can be said for makeup and the complementary function of makeup artists.

The director also collaborates with and coordinates the activities of other creative individuals responsible for other aspects of stagecraft, such as props and, if necessary, stage fighting. If the play is a period piece or reflects a foreign culture, the director might consult with a researcher or dramaturg, who is an expert on the physical, social, political, and economic contexts in which a play takes place. This will bet-ter guarantee a production's authenticity and historical accuracy. If the production is a musical, the collaboration includes the music director and the choreographer.

The responsibility of the music director and his or her approach to the music is much the same as a director and his or her approach to the script. The goal is to serve the playwright and the song writers by carefully analyzing the meaning and intent of the lyrics and music and then coming up with a creative and vibrant musi-cal production plan that will tell the story in a compelling way and within the the-ater's financial and logistical parameters. These choices must be in synchrony with the director's overall vision for the production—in truth, a music director's sensi-tivity to what the composer is communicating through music often contributes to the director's overall vision—and be effectively communicated with the perform-ers and choreographer.

The key responsibility for a choreographer is to enhance a musical by adding another visual element to the production—dance. Depending on the nature of the play, choreography can merely assist in the storytelling by complementing the movement created by the director during musical interludes, it can accentuate activity by bringing life and creative interpretation to the story during musical production numbers, or it can act as a momentary diversion from the dialogue by offering something different through choreographed movement. As with all the other visual elements of a production, choreography can help define a play's style, establish a time and place, and communicate a character's personality or mood state. Often a choreographer will work with a director to help create a physical flow between scenes and other dramatic transitions. Just as a director is guided in his/her vision by the script, the choreographer is inspired and, in some cases, constrained, by the libretto and score. Similarly, the choreography is both inspired and constrained by the talent available in a particular production. A choreographer works closely with the musical director since tempo changes, modifications, and difficult passages that make singing difficult also impact on the choreography.

Of course, the director also collaborates with the actors and helps orchestrate their on-stage movements—or blocking—as well as guides their interpretation of their characters and the dialogue they are given.

Different directors assume divergent degrees of authority over their creative team and allocate responsibility based on their personal philosophy and personality, the mission of the theater companies, or the size and scope of the production.

"How do I go about my business? The script. The music. What is the objective of the piece? Research the time period and the dances of the time, and see how those dances shaped that era and effected society. Then I get in the studio space and shape small riffs of movement that will be notated and brought in to rehearsal as the foundation of the overall choreography. I also collect images of that time period—dances, dress, and even politics—it all affects the style of movement I employ. The script fleshes the world I have to live in; the score is the pulse that drives moment to moment. Even the underscoring is cinematic in a choreographer's world."

~Martín Céspedes, freelance choreographer[15]

Regardless of directorial style, the goal is to create a creative environment and collaborative atmosphere in which everyone can work and work well.

The Critic and the Director

The production of the play falls under the jurisdiction of the director. Consequently, all production-specific concerns and complements generated by the critic are to be targeted accordingly, including:

- issues associated with the interpretation of the play;
- general elements of the play's presentation such as its pacing, fluidity, and, in the case of a musical, the consistency of vision and execution across the dialogue and the musical numbers;
- choices associated with production values and aesthetics; as well as
- casting and artistic designer hiring choices.

Although specifics associated with set design, lighting, sound, costuming, music, and choreography fall under the jurisdiction of their individual designers and specialists, and should be aimed at these individuals in a review, the director is ultimately responsible for everything associated with the successes and failures of a production.

From a director's perspective, criticism primarily offers:

- **Status conferral.** Positive or negative reviews place artists and the theaters that house them in the limelight. Such exposure has the potential to impact a director and the designers' reputations within the arts community and their professional profiles within the general community; and
- **Serving as standard bearer of the arts.** For young directors, critical assessment of their work serves as a reality check and often guides their approach to future projects. Although harsh reviews are unlikely to have a director second guess his/her decisions, tweaks mid-production are not unheard of.

Actors

Directors cast, coach, and work intensely and extensively with actors. However, actors are the ones on stage and, once a play goes into production, it is the actors who take possession and ownership of the play. Despite the collaboration that is theater, actors are the ones who breathe life into their characters, relay the meaning to the words in the script, are the reason for the lighting, sound, set, and costume design, and are the focus of attention for the audience. No matter the production values, if the actors fail the play with their performances, the production fails. Sure,

artistic directors can choose a wrong play and a director's missteps can wreck a pro-
duction, but when the acting goes wrong it is only the actor on stage to bear the
burden and the blame from the audience. Conversely, when all goes brilliantly it is
only the actor on stage to accept the credit from the audience during the curtain
call, not the playwright, director, or any of the designers. Actors are the most vis-
ible and most high-profile of the storytellers.

As is the case with the director, an actor's job is to comprehend the dramatic
form of the play, do all necessary research in order to understand the period and
the idiom particular to the play, analyze the text in terms of its action, and show up
for rehearsals fully prepared and ready to engage in a collaborative process with the

Actors' Equity, in profile

Actors are rarely in control of their own destinies. They have no say over the
plays that are staged, so they have no control over the availability of a suitable
role. They have to audition for parts in competition with other actors that are
ultimately cast by a director. Actors have to revolve their lives around rehearsal
and performance schedules that are created by others. Earning a living this
way is particularly tough.

Actors' Equity Association (AEA) is a union that began in 1913 with a few
actors banding together to gain some control over the profession and to put
an end to the exploitation of the professional stage performer. By 1919, Equity
became strong enough to organize a strike that crippled the theatrical scene
and forced producers to finally negotiate for better pay and working conditions.

Currently, AEA members are guaranteed benefits when they are employed
by Equity theaters that include:[16] Union-negotiated salaries and a guarantee
of payment; overtime and extra pay for additional duties; free housing and/or
per diem when on tour; work rules (length of day, breaks, days off, safe and
sanitary conditions); health benefits and Worker's Comp insurance; pension
and 401(k) benefits; and contract dispute resolution assistance. Members are
also given access to Equity-only auditions via casting call and Equity hotlines.

A non-AEA professional actor can join the Association by being offered
employment under an Equity contract at an Equity theater. In this case, mem-
bership is only valid during the length of the contract. Most AEA memberships
are earned over time, as professional actors get paid to work at Equity theaters
for an accumulative total of 50 weeks. Equity's initiation fee is currently $1,100.
Basic dues is $118 per year and 2.25% of all earnings are paid as a working dues.

"Rhetoric is of utmost importance to me. It is a word most people do not even know the true meaning of: the art of persuasion through language, either written or spoken. I try and identify every rhetorical device being used by the playwright and make sure I convey this in my speaking. Alliteration, metaphor, onomatopoeia, chiasmus, oxymoron, antithesis, pun, and epimone: these are just a few of the devices I try and identify and use to my advantage. I am always trying to persuade either another character or, in soliloquy, the audience with my speaking."

~David Anthony Smith, AEA actor[17]

director, designers, and fellow actors. Of course, the actors also have to memorize their lines, movement, music, and choreography, and, to the absolute best of their ability, become their characters completely and consistently during the course of a production. They must keep their performances fresh throughout the run of the play, such that each performance creates the impression that this is the first time these ideas have been formulated, these words have been spoken, and these actions have been taken.

Although there are many schools of thought that have created systems and methods that guide actor training and preparation, it is generally agreed that good acting entails conviction, virtuosity, and presence.

Conviction implies that acting is not the mere presentation or representation of a character and the delivery of dialogue, but the embodiment of that character and the internalization of that dialogue. By studying a role closely and meticulously, the actor becomes the character—that is, s/he lives the life and feels the emotions—for the duration of a production and is absolutely convincing. Clearly, the desired degree of realism in a staged performance changes with the times, but the conviction associated with generating that portrayal has always been a priority and a key acting commodity.

Virtuosity encompasses the specific skill set associated with transforming conviction into convincing action on stage. Virtuosity is the factor that separates impersonation and imitation from good acting technique, and centers around an actor's expertise in employing his/her voice and capacity for movement for dramatic effect. It comes from training, study, and experience, and is the most obvious distinguishing factor between amateur and professional theater. Conviction evolves organically, but virtuosity is acquired after extensive effort. "To make a character or situation real," noted *New Yorker* critic Hilton Als,[18] "your body, and the emotions

and thoughts it contains, has to infuse it all with their real blood, and tendons. That is where their training comes in; Sandy Meisner, Stanislavsky, Strasberg, not only helped the performer free themselves, but to build up their internalized shrink's office, a place where they can gain some distance, perspective, on the fictional skin they inhabit for real."

One Actor's Process, in profile[19]

From April 21–June 17, 2012, Nathan Lane—a two-time Tony Award winner and much beloved musical-comedy star—played hardware salesman Theodore Hickman in Eugene O'Neill's *The Iceman Cometh* at the Goodman Theater in Chicago. How one prepares for this formidable role, which sits at the center of the American theatrical canon, was the subject of an email exchange between Lane and a fellow actor. Here is how he strips away the illusions that sustain the seedy New York bar dwellers that populate this play, as well as the 4-hour and 45-minute production of it:

> My preshow ritual really involves the entire day leading up to the play. I think about it when I go to bed, and when I wake up in the morning. I can't do too much. I try to be quiet, except for a vocal warm-up. If I'm good, I go to the gym, or swim a little, maybe read or watch a little television. Often I go back to the play, reading my scenes, or research articles and books about O'Neill. I have to eat around 5, nothing heavy, but enough fuel to get me through to 11:50. I get to the theater around 5:45; I like to get dressed and ready early, even though I don't enter until an hour and 10 minutes into the first act, which gives me plenty of time to think about where I've been, why I'm going to the bar, what I want and how I'm going to get it.
>
> Hickey has a huge and complicated back story. Sometimes I talk to the cast before the play begins. Sometimes I let my entrance be the first time they see me. Brian [Dennehy, who plays Larry Slade] and I always have a little preshow chat about the day's events, and how tired we are. I listen to the play a bit, go over the first scene, occasionally I walk around backstage thinking about Hickey's inner monologue as he walks all the way from Queens to the West Village. Sometimes I just sit and think in my dressing room.
>
> I always check in with [fellow actors] Kate Arrington and Marc Grapey, who play Cora and Chuck, before they go on. They mention seeing Hickey outside the bar. We always say this is the longest hour of our lives. Then Sal Inzerillo [who plays Rocky Pioggi] says, "Here's the old son of a bitch," and I'm on.

The third component of good acting is stage presence, also referred to as "charisma," "magnetism," and the "it factor." This is a quality that is difficult to define but is easily and universally recognized. Presence is innate but, unlike conviction, it cannot be self-manufactured. Unlike virtuosity, it cannot be learned. Presence exists or it does not. It is as likely to surface on the amateur stage as the professional stage, and is often a determining factor when an actor attempts to transition from one to the other.

The Critic and the Actor

The performance of a play is the responsibility of the performers. Consequently, all performance-specific concerns and complements generated by the critic are to be targeted accordingly, including:

- the degree of conviction evident in a performance—that is, whether and to what degree the actor is believable in his/her portrayal and convincing that his/her words, actions, and emotions are spontaneous and seemingly unrehearsed;
- issues associated with virtuosity—that is, whether or not the actor has the desired skill set to effectively perform a leading role, a supporting role, or be a part of an ensemble, and employs appropriate innovation and risk in his/her acting choices;
- issues associated with consistency, including the application of energy, characterization, focus, and accents throughout a performance; and
- whether the performer has sufficient presence to carry a performance or, if necessary, carry a production.

From an actor's perspective, criticism offers:

- **Status conferral.** The relationship between performers and critics has been fraught ever since Solon, a magistrate of ancient Greece, banged his staff on the ground after a performance and accused the great actor Thespis of gross lies and rabble-rousing.[20] Positive or negative reviews place artists and the theaters that house them in the limelight. Such exposure has the potential to impact their reputations within the arts community which, in turn, impacts on their landing future roles; and
- **Serving as standard bearer of the arts.** For young or amateur actors, critical assessment of their work serves as a reality check and often guides their approach to future roles.

Summary

This chapter identified the various artists who contribute to a theatrical production and described the nature of their respective contributions. Their independent functions and the interdependency of their creative collaboration were explored with the intention of allowing criticism to find the proper source of its inspiration so that credit and blame can be cast where credit and blame are due. Collectively, thoughtful and critical reflection of the story and the handicraft of the storytellers is the stuff that a critique is made of.

As was noted earlier, critical concerns and complements are typically tempered by whether productions are created by a community, collegiate, professional, hybrid, or equity theater. After all, each type of theater has a disproportionate allocation of financial resources, physical space, and artistic expertise based on its particular creative mission and adopted business model. Similarly, different forms of theatrical presentation bring to the stage unique demands and challenges for the production team that also need to be taken into account in the course of a critique. Once the critic has an understanding of and appreciation for the conventions of a particular art form and the personnel involved in the collaboration of its production, it is time to engage in the critical evaluation of that enterprise. The next two chapters put the knowledge and insight generated from the previous chapters into practice. The processes associated with researching an art work, observing and evaluating the work on display, and writing a critical review are explored.

KEY CONCEPTS FROM THIS CHAPTER

Actor	Librettist
Actors' Equity Association	Lyricist
Artistic director	Managing director
Blocking	Music director
Casting the audience	Playwright
Choreographer	Presence
Cognitive complacency	Professional theater
Collegiate theater	Regional theater
Community theater	Royalties
Composer	Scenic designer
Conviction	Sliding scale of expectations
Critical third-eye	Sound designer

Costume designer

Director

Dramaturg

Equity theater

Heretical directors

Hybrid theater

Lighting designer

Suspended disbelief

Theatrical vision

Virtuosity

Workshopping

World premiere production

Worshipful directors

NOTES

1 Cited in http://novan.com/storytel.htm (accessed January 30, 2012). The cover page photograph is of (left to right) Director and Steppenwolf ensemble member K. Todd Freeman and assistant director Nathan Green in rehearsal for Steppenwolf Theatre Company's 2012 production of *Good People* by David Lindsay-Abaire.

2 There are, of course, exceptions. In fact, there are forms of art that purposefully and effectively agitate their audiences or call attention to their storytelling methodologies.

3 Dennis J. Spore, *The Art of Theater* (Englewood Cliffs, NJ: Prentice Hall, 1993), 94.

4 Occasionally the Pulitzer Prize for Drama has gone to a play on the strength of its script as opposed to a production. The most recent example occurred in 2012 with Quiara Alegría Hudes's *Water by the Spoonful*; none of the five jurors saw the world premiere at Hartford Stage in late 2011. Nilo Cruz's *Anna in the Tropics* won sight unseen in 2003 and the theater critic John Lahr of *The New Yorker* noted that it was "as absurd as giving a restaurant four stars on the basis of its menu." Cited in Eric Grode, "A Good Play Can Be Read as Well as Seen, *The New Yorker*, April 18, 2012, http://artsbeat.blogs.nytimes.com/2012/04/18/theater-talkback-a-good-play-can-be-read-as-well-as-seen/ (accessed April 18, 2012).

5 Cited in a personal correspondence with Rajiv Joseph. Joseph's first production, *Huck & Holden*, debuted at the Cherry Lane Theatre in New York in 2005 and had a West Coast run at the Black Dahlia Theater in Los Angeles the following year. More recently, Joseph's Pulitzer finalist production of *Bengal Tiger at the Baghdad Zoo*, directed by Moises Kaufman, debuted at the Kirk Douglas Theatre in Culver City, CA, in May 2009, ran at the Mark Taper Forum in Los Angeles in 2010, and premiered on Broadway in 2011.

6 http://jasonrobertbrown.com/2012/10/31/how-i-insulted-sondheim-and-the-wisdom-received-thereby/ (accessed October 31, 2010). Used by permission of the author.

7 Cited in "At25: An Eye on the Future," *American Theatre*, http://www.tcg.org/publications/at/apr09/bobgan.cfm (accessed April 18, 2012).

8 Cited in a personal correspondence with Tim Dang, Producing Artistic Director of East West Players, Los Angeles, CA. East West Players is an Asian American theater and the longest running theater of color in operation in the U.S.

9 Cited in Chris Coleman, "Low Expectations," *Theater*, January 1, 2002, 82–83.

10 Cited in David Herskovitz, "This Essay Is Not Something Else," *Theater*, January 1, 2002, 84–85.

11 http://www.howlround.com/nytcriticwatch-com-asks-what-do-we-actually-want-from-a-the-ater-review/ (accessed May 22, 2012.

12 See Kenneth M. Cameron, Patti P. Gillespie, Jim Hunter, and Jim Patterson, *The Enjoyment of Theatre* (New York: Pearson, 2008), 130–132.

13 Cited in a personal correspondence with Risa Brainin, freelance director, associate professor and director of performance at the University of California, Santa Barbara.

14 Cited in Robert Cohen, *Theatre* (Boston, MA: McGraw-Hill, 2003), 124.

15 Cited in a personal correspondence with freelance choreographer Martín Céspedes.

16 Cited in http://www.actorsequity.org/ (accessed April 18, 2012).

17 Cited in a personal correspondence with David Anthony Smith, a classically trained Equity actor currently working with Great Lakes Theater in Cleveland and its partnerships with Idaho Shakespeare Festival and Lake Tahoe Shakespeare Festival.

18 Hilton Als, "The Actor's Body," *The New Yorker*, June 26 2012, http://www.hiltonals.com/2012/06/the-actors-body/ (accessed July 14, 2012).

19 Scott Heller, "Two Journeys Into O'Neill," *The New York Times*, June 14 2012, http://www.nytimes.com/2012/06/17/theater/nathan-lane-and-laurie-metcalf-on-acting-in-oneill.html?pagewanted=1&_r=2&seid=auto&smid=tw-nytimesTheater (accessed June 14, 2012).

20 Cited in Julie York Coppens, "Tough Times on the Theatre Beat," *Dramatic Magazine*, November 2010, http://schooltheatre.org/publications/dramatics/2010/11/tough-times-beat (accessed April 18, 2012).

"Sharpen your instincts. Develop your voice. Be authoritative. Recognize a good argument and learn to craft one of your own."

~Misha Berson, theater critic, *Seattle Times*[1]

Chapter 9 Abstract

This chapter applies what has been learned about arts criticism in the previous chapters to the preparation involved in writing a piece of criticism. The process of researching and preparing to report on a theatrical production will be examined, as will the development of a critical voice, the application of several sliding scales to critical evaluation, and the engagement of participant-observation.

Prelude to a Critique

The process of writing arts criticism begins long before one sits in front of a computer screen and starts tapping keys. In fact, the process of writing arts criticism begins long before one walks into an event, initiates any form of observation, or attempts to describe and explain the experience to others. It begins in the preparation for the event; in the prelude to a critique.

The first stage of preparation is recognizing that there are specific characteristics required in order to become an effective and interesting arts critic—characteristics that have been touched on in previous chapters, but which will be specifically discussed at length here. Some are applicable to all those who engage in arts journalism, but they are particularly germane to arts critics. Once recognized, these characteristics need to be developed into specific skills that will be refined through repeated application over time. They include:

- the development of a critical third eye;
- the desire to seek;
- the establishment of a critical voice;
- adherence to a sliding scale of critical evaluation; and
- possession of keen powers of observation

A Critic's Characteristics

Development of a Critical Third Eye

It was noted in an earlier chapter that arts consumers develop an appreciation for art by recognizing and understanding its core conventions. In terms of theater, this entails an understanding of its sense of pretense, its employment of storylines grounded in the human condition, the mandatory collaboration between the storytellers and an audience, its genre classifications, and its narrative parameters.

Art appreciation is a learned enterprise, beginning with exposure to these conventions through experience, which establishes the realization that these conventions are not random or haphazard, but must somehow contribute to the storytelling. Repeated exposure reinforces the notion that these conventions are not anomalies but, rather, are recognizable and repeatable practices in the arts. Eventually assimilation of these conventions occurs, which creates a general, holistic understanding of a particular form of storytelling. For theatergoers, suspension of disbelief eventually kicks, where the pretense of theater is accepted, which allows the audience to see and relate to the characters (not actors) and give in to the story being told. Then cognitive complacency occurs, which allows these storytelling conventions to become seamless and invisible parts of the play's narrative and the theater going experience. They no longer call attention to themselves or require conscientious

The National Standards for Arts Education, in profile[2]

In recognition of theater being an acquired skill, the developmental differences that exist in children of various ages, and their corresponding abilities to understand theater, The Kennedy Center established the National Standards for Arts Education. The Standards outline what every K–12 student should know and be able to do in the arts and were developed by the Consortium of National Arts Education Associations.

It was noted that kindergarten through 4th-grade children learn through their social pretend play. They use pretend play as a means of making sense of the world; they create situations to play and assume roles; they interact with peers and arrange environments to bring their stories to life; they direct one another to bring order to their drama; and they respond to one another's drama. In other words, children arrive at school with rudimentary social skills that translate to skills as playwrights, actors, designers, directors, and audience members. What is lacking and must be learned is the transition from the natural skills of pretend play to the study of theater, and the integration of the two.

During the middle school years, children are now capable of comprehending that artists create an imagined world and to see that visual, aural, and oral world through the eyes of the playwright, actor, designer, and director. Children at this stage are able to understand artistic choices and to critique dramatic works.

In grades 9–12, students can view and construct dramatic works as metaphorical visions of life that embrace connotative meanings, juxtapositions, ambiguity, and varied interpretations. By creating, performing, analyzing, and critiquing dramatic performances, they develop a deeper understanding of personal issues and a broader worldview that includes global issues.

effort to comprehend, for the audience members by this stage are experienced, fully on board, totally invested, and engaged.

A critic, of course, must go through this orientation and acquisition process as well, for critics are audience members and speak on their behalf. As was noted earlier in this book, the critic serves as the surrogate audience member who is also sucked into the vortex of the theatrical experience, but who has the wherewithal, discipline, and responsibility to remain partially removed from the experience. Critics are the designated drivers of the arts—the ones who remain sober enough to reflect on, describe, explain, and analyze the entertainment, the vortex, and the mechanics behind the suckage. This, in turn, facilitates the more casual audience members' own reflections and augments their own conclusions.

In order to do this—to engage in critical thinking and partake in the activities to be examined in the following chapters—the critic must be more than merely art literate. There is an additional stage of development. A critic must acquire a critical third eye. While lost in the vortex of cognitive complacency, which is fundamental in enjoying a theatrical production, the critic must remain partially removed from the experience and thoughtfully aware of the mechanics involved in its creation. Thomas Hoving, the former director of the Metropolitan Museum of Art, liked to speak of the arts journalist's ability to see what is intended to be invisible as the "ineffable sixth sense of connoisseurship."[3]

"When I see a picture, in most cases, I recognize it at once as being or not being by the master it is ascribed to; the rest is merely a question of how to fish out the evidence that will make the conviction as plain to others as it is to me."
~Bernard Berenson, art historian[4]

"The common man," suggested art critic Theodore Greene,"[5] is too close to life to see it in perspective without subjective prejudice. The scientist is too far removed from life to comprehend its human quality and import. Only the artist is able to mediate between these extremes." So, too, is the critic. This, according to Hoving, comes from accumulated experience upon which "your spirit sets unconsciously on things unseen by others."[6] It also comes from the desire to seek.

The Desire to Seek

Art consumers think but art critics engage in critical thinking, which is a more purposeful, elaborate, and time-consuming process. Engaging in critical thinking

is the lining up of all the essential elements of the subject matter in question and cautiously analyzing them before deliberating and rendering a decision or an opinion. In order to do this, the critic must possess what 16th–17th century philosopher Francis Bacon referred to as the "desire to seek."[7] That is, rather than relying solely on personal memory, past experience, an existing knowledge base, and exposure to the event itself, critics seek out supplementary, alternative, and potentially contradictory information from reliable secondary sources to flesh out their own observations, thoughts, and critical perspective.

Rare is the arts journalist who knows everything about every aspect of their chosen art form and, in the case of a specific play or exhibit, a particular example of it. The desire to seek allows the critic to be an informed consumer and a knowledgeable advocate. A critic's position comes with a built-in assumption of some degree of expertise and authority; of knowledge and insight above and beyond that of an average consumer. To some extent, a critic is in a position to educate the consumer and, thus, has an obligation to present accurate information and insight, as well as learned opinion. Novice arts critics with limited experience cannot make up for this lack of experience by doing research, but they can fill in gaps, compensate for weaknesses, and learn. Clearly, the desire to seek information is a fundamental criterion for critical analysis and an important trait for a critic.

Rather than allowing personal memory of a past performance or exhibition to automatically trump one's reactions to the performance or exhibition at hand, the arts critic is expected to tap those memories but remain open to a change of position and perspective based on new-found information. Personal memory tends to be sentimental, highly subjective, potentially distorted by time and circumstance, and, thus, biased. And, according to Bacon,[8] it is human nature and, thus, all too easy to give in to instinct and gut reaction ("idols of the tribe"), assumptions and inertia ("idols of the cave"), fallacy ("idols of the marketplace"), and convention ("idols of the theater") when generating an opinion or drawing conclusions.

Nothing can take the place of vivid first-hand impressions. However, the acquisition of information and the generation of knowledge and perspective from that information can help inform, give voice to, and explain those first-hand impressions. It can focus and sensitize the critic's senses and feelings. It can lead to a more colorful, dimensional, and robust review.

In addition, gathering and reporting factual information about a work highlights the work itself—after all, what is being critiqued is someone else's creation—and helps distinguish one's feelings about and reactions to a work from the work itself. It is important for the reader to know where that creation leaves off and a critic's opinions about it begin. This information allows the critic to back up specific observations and opinions with undisputable facts.

"Nothing can take the place, in criticism, of vivid, first hand impressions. The critic must apprehend with his senses and his feelings, before he can bring his thought processes into play. If he cannot in some sense think with his feelings, his critique will be flat, shadowy, and colorless."
~Samuel Stephenson Smith, literary critic[9]

Critical misjudgments frequently result when a critic has an insufficient understanding of the subject. A working and well-rounded knowledge of the subject must be established. The critic must know about the nature and parameters of the art form being reviewed and share that knowledge with a reader. The critic should not wrongly attribute blame or praise, such as an actor being criticized or credited for the playwright's characterization, an ensemble faulted for poor direction, or a set designer receiving credit without the director's vision also receiving acknowledgement.

In short, research is an important prerequisite to art criticism. The issue becomes how much and when it should take place. The general rule of thumb is to do the work before the arts event, so the information gathered through research can guide one's focus, inform one's impressions, and begin the formation of a critical perspective of a play or production that will work its way into the written review. Many critics believe that pre-production research still allows the critic to get lost in a performance while remaining partially removed from the experience and thoughtfully aware of the mechanics involved in its creation.

Some experienced critics—those with extensive knowledge about the conventions of theater and experience critiquing plays—like to step into a performance of a play as a tabula rasa—a blank slate—so that the play, the production choices, and the individual performances take them by surprise and are engaged on their own terms. The critics' fresh impressions are influenced only by their own experiences with the play or the subject matter on which it is based. Some critics believe that too much pre-production research will keep them from buying into the pretense of theater and everything that a production's creative team is doing to facilitate the audience's transportation to a state of cognitive complacency. Research can be performed post hoc, to support and give greater authority to first-hand observations and opinions.

Using theater criticism as an example, this desire to seek should take several forms:

- **Researching the play and the playwright.** The performing arts are ephemeral; that is, a performance happens live, in the moment, and then is over. Audience members and critics alike can miss something through lapse of

> *"No critic approaches a work of art from a position of blissful ignorant objectivity."*
> ~Jason Zinoman, critic, *The New York Times*[10]

attention, distraction, or disengagement and it is gone. Researching the play gives focus to observation during a production as well as an opportunity to check story-specific references and confirm impressions afterward. Plus, every piece of theater criticism contains a descriptive overview of the work for readers who have not yet witnessed the play and for witnesses to help recall the play, and research can help provide that information. Without verbal imagery to capture and reflect what transpired, efforts to explain what transpired will fall short. Also, learning about the playwright and his/her other works sheds light on the play being reviewed and places it in the context of a larger body of work. The stylistic traits and thematic motifs that serve as playwright's signature can be identified and analyzed across that individual's work, and applied to the current production. Where to find this information?

- o Read the play. If the play is published, obtain a copy. If a production is a world or regional premiere, it may be possible to obtain a copy of the script from the playwright or the artistic director of the production company.
- o Often, a production's playbill will offer some insight and information about the play and about the playwright. Read the playbill.
- o Many theaters' websites have posts from the artistic director, the dramaturg or the publicist that elaborate on playbill information.

- ▪ **Learning about the genre of the play and its theatrical conventions.** A critic must be able to identify and describe the constellation of recurring substantive and stylistic features—such as narrative structure, character types, plots, and settings—to characterize, describe, and discuss a play. Knowing that a play is a comedy, a melodrama or a musical, for example, informs the critic as to what to expect from the production in general terms. Knowing that a comedy is a farce, a dark comedy, or a comedy of manners does that as well. For never-before seen plays or for innovative productions of classic plays, this information can serve as a measuring stick to help define and evaluate the work. One can best identify liberties and risks being taken or creative mistakes being made if one understands the classic forms of genre and their standard or expected modes of presentation. Where to find this information?

o The first thing arts critics have to do is consume the arts; to survey their own field and let their exposure to the arts shape their critical perspective. The more exposure you have, the more you will understand the art form.

o Theater appreciation texts provide solid base-line information, as does this text.

o *American Theatre* magazine is a periodical about not-for-profit professional theater. The country's leading arts journalists as well as top professionals from the field contribute articles about the state of the art, explore individual artists and their work, and publish a complete schedule of every production taking place that season at theaters across the country.

- **Researching other productions of the play being reviewed.** Reading what other credible critics have said about the play and other productions of it can be useful in evaluating the current director's interpretation of the work and the creative team's envisioning of it on stage. Learning about the traditional staging of Shakespeare's *The Taming of the Shrew*, for example, offers the critic the necessary background to understand and critique a production that chooses to transport the work from the 1590s to the 1980s and from the Italian city of Padua to a fashionable L.A. boardwalk. Similarly, reading about how other actors approached their characters gives critical insight into what the current actors bring to their performances. Only by seeing or researching past productions of, say, *Cabaret* can it be clear whether the scant, sadomasochistic costuming in a current production is normative or unique. Chances are the creative team staging the current production has done similar research. Where to find this information?

 o Find the links to major media outlets' websites and search for the theater critic. Another option would be to enter the name of the play in a search engine with the words "reviews" afterward.

 o *Aisle Say* is one of several online magazines that contain stage reviews and opinion from around the nation.

- **Researching the theater company offering the play.** Knowing the nature of the theater performing a particular production sheds some light on what is to be expected of that production. Different types of theater companies have different levels of capabilities in storytelling, as reflected in their particular creative mission and adopted business model. Some theaters are more endowed than others when it comes to financial resources, physical space, and capabilities in terms of technical equipment, and artistic expertise and experience. This, in turn, impacts on the types of plays and play-

wrights they embrace, the size and scope of productions they are capable of staging, the creative risks their team is willing or able to take. Where to find this information?

o The website of a theater company is the best place to begin this research. Once a critic is ingrained in a community and becomes aware of each theater's mission and offerings, this form of research is no longer necessary.

- **Researching the current production of the play.** A production's playbill often includes a note from the director or artistic director that gives insight into the choice of and approach to this play, as well as a synopsis of the storyline. It also includes information about the creative team—that is, the bios of performers and the various designers. Most theaters provide critics with a press release that offers the same information as well as the occasional factual nugget, such as recognition of the production as a world or regional premiere. All of this can inform a review. Where is the best source for insider information?

 o Interview members of the creative team. The professional responsibilities of many critics have expanded in light of budget cuts and layoffs. The theater beat might be paired with other performing arts or critics might also be asked to write entertainment news, feature stories, personality profiles, or promotional previews for the very productions they will be reviewing in a separate article the following week. If this is the case, writing a preview might also serve a subsequent review, for previews typically entail one-on-one interviews with members of the creative team. This allows the critic to not only gain information about an upcoming performance that could serve to promote the production in a preview, but can also provide critical insight for a review. Here are some tips:

 1. Plan the interview. Arrange for interviews through the theater's publicist or public relations/media relations director. Conduct your research prior to the interview, so questions can be focused and answers can be targeted to specific realms of interest. The more intelligent your questions, the more intelligent and insightful the answers. Let your subject know that this interview is for a promotional piece but that you will also be doing an independent review of the production.
 2. Face-to-face interviews are preferred, for they help establish a relationship and rapport with the subject, and allow for more elaborate answers and follow-up questions. However, interviews can certainly be conducted by phone or email. If not face-to-face, limit the number of questions and keep them brief.
 3. Let your questions do the talking for you. This is not the time to insert your opinions; this is the time to gather information that will inform them. If (and

only if) you have a relationship with the interviewee, feel free to ask probing or leading questions toward the end of the interview—that is, questions that start with "Don't you think that…." This allows you to test your own ideas about a play or production without you becoming the subject of the interview.

4. Ask open-ended questions. They create avenues for ideas and points of view to be expressed, whereas questions that can be answered "yes" or "no" simply provide finite facts. An interview with a playwright, director, or designer for a preview gives the critic insight into the work that no other form of research can generate. Why guess at the motivation behind a creative choice when you can ask about it first-hand, in your role as a feature writer?

5. Previews describe but reviews also explain and analyze. Questions need to inquire about the who, what, when, where, and why, but also gain some insider information regarding the how.

6. Quote your source in a preview piece. In a review, use that insight and information only to inform your own observations and critical perspective. Quotations in a review lessen the critic's authoritative voice and should be avoided.

Risks Associated With the Desire to Seek

Although the desire to seek is fundamental to critical thinking and critical writing, and a core characteristic of an arts critic, it comes with potential risks that must be recognized:

INACCURACY. The Internet can be an arts journalist's best friend and worst enemy. Just because the information you seek is accessible does not necessarily mean the information is accurate or can be attributed to a credible source. It needs to be before that information works its way into one's thinking or one's written critique.

CONFLICT OF INTEREST. As was noted earlier, if you are writing a preview as well as a review, an interview with the artistic director, director, or designers can provide information and insight that could serve to promote the production as well as inform the review. Not everyone is comfortable with or capable of wearing both hats, in which case the interview should not be conducted.

OVERRELIANCE. Although a critic is in a position to educate the reader, reviews written for general consumption should not read as if they were tutorials or lessons. One's knowledge of the playwright or the play should not overshadow the production and the performances. Also, overreliance mixed with carelessness can lead to incidental acts of plagiarism, particularly among novice critics. It is essential that others' ideas and opinions inform your own and not be claimed as your own, particularly since reviews tend not to identify sources or use direct quotes.

Overreliance on secondary information to guide or develop one's own critical judgments can also lead to a second-hand mind, where one's opinions are ham-

pered, intimidated, or distorted by what others say. Worse, it can lead to a preset mind, where critics bring to a production such firm and inflexible beliefs about the play or unrealistic ideals about a production that they are impervious to change, no matter what happens on stage.

IMPATIENCE. Critical thinking pioneer Francis Bacon addressed this issue directly. He noted that critical thinkers need the patience to doubt. A critic should not allow personal memory and past experience to automatically trump reliable secondary information, but secondary information should not automatically trump personal memory and past experience. Bacon also suggested that critical thinkers develop a fondness to mediate, which implies that the critic should contemplate and reconcile contradictions between personal perception and secondary information. Before any one opinion is adopted and rendered, it needs to be evaluated, thoroughly thought through, and defended to see if it holds up. Arts criticism is impactful on audience perception and attendance, as well as on the state of the art itself, so there must be, according to Bacon, a slowness to assert. A lot of thinking occurs during the prelude to a critique.

..

"Criticism, like any other art—whatever else it may be— is a mode of self-expression."

~A.B. Walkley, drama critic[11]

..

The Establishment of a Critical Voice

Not only is it important that a critic make up his or her own mind, but a critic must find his or her own voice. Interestingly, although a review is clearly one critic's opinion, it is customary and preferred to write in the third person and not the first. First person narrative means writing from the "I" point of view, as in "I found this production to be pretentious." Third person narrative is omniscient, as in "This production is pretentious." It establishes a sense of authority and places the emphasis on the work being criticized and its impact on an audience rather than on the individual critic, and rightly so. It gives the impression that the critic is speaking on behalf of the audience rather than merely him/herself.

There are exceptional circumstances when the use of the first person narrative is appropriate and necessary. This would include when the critic needs to express an opinion that clearly deviates from the norm or needs to identify a personal bias that unavoidably impacts on a review and needs to be recognized. Upon occasion, dropping into the first person can give immediate emphasis on a point being made

or an exceptionally strong, personal reaction to a work of art. There are also occasions when the critic's unique area of expertise comes into play and needs to be explicitly referenced.

Of course, behind the seemingly removed and authoritative stance of the third person narrative lies the personal judgment of the one critic whose picture is at the top of the page, blog, or website and whose name is right underneath it. There is no doubt whose option is being expressed in the review even without the use of "I," "me," or the royal "we."

> *"At best, the critic is an artist whose point of departure is another artist's work."*
>
> ~Harold Clurman, theater critic[12]

Still, it is important that each critic find a distinctive voice with which to approach a production and through which to relay his/her opinions about it to readers. A critical voice is what separates one critic from another. Recall from a previous chapter how *The New York Times* critic George S. Kaufman was known as a deeply unsentimental writer who never used more words than were necessary and whose words were crisp and curt to the point of being sardonic. *Times* critic Brooks Atkinson was identified as a man of the people[13] and was described by fellow critic Eric Bentley[14] as "[W]ell-educated, dry, not too intellectual, very much on the level, extremely liberal." Much of Walter Kerr's work was intellectual and grounded in dramatic theory.[15] Frank Rich earned the moniker "The Butcher of Broadway" for the acidity of his reviews and their ability to kill shows. Kenneth Tyson was most known for his "gem-cut sentences" in the *London Observer* that were "crafty, bravura events, detonations of deadly wit and mordancy."[16] Former *New York* magazine critic John Simon defined himself by his considerable erudition[17] and his offensive and often malicious style of writing, while current *New Yorker* magazine critic Hilton Als is renowned for being "acerbic."[18] A critical voice is a composite of several key ingredients: Expertise, tone, style, and orientation.

EXPERTISE. The critics just identified come from a range of professional backgrounds that have helped make their voices distinctive. They are academicians, hard news journalists, literary critics, or playwrights. Their background and exposure to the art they cover comes across in their approach to that art and the particular focus of their review. A critic's expertise is likely to influence whether his/her analysis of the complexities, complications, and implications of the work being critiqued leans toward sociological criticism (focusing on the potential impact of art

on society and culture), genre criticism (concerned with identifying and describing the basic structural similarities among forms of artistic expression), auteur criticism (concerned with identifying and describing the basic structural similarities of work produced by a single artist or a specific production house), or anthropological criticism (concerned with analyzing a piece of art within its historical real-world contexts). What a critic brings to the table in terms of expertise frames and gives a specific voice and emphasis to their observations and conclusions.

TONE. Being "critical" has negative connotations. Criticism is often perceived as a fault-finding activity filled with skepticism, and critics are often characterized as those who are overly judgmental, unduly exacting, or perversely hard to please. In his book *Criticism*,[19] musician and music critic Hans Keller went so far as to psychoanalyze the profession of arts journalism and diagnosed arts critics as victims of J.C. Flugel Polycrates Complex, "which drives us to find smallness in greatness."[20]

Of course, criticism need not be negative although it has been argued[21] that negative reviews are an essential part of the critical process; if a critic does not write them, no one would believe the good ones. "Suppose we were without *The Book of Job* or *The Inferno*," suggested literary critic Samuel Stephenson Smith,[22] and "remove Iago from *Othello*. Blot out those sinister pictures of Caesars from Tacitus' works. Would not our knowledge of life and art be infinitely poorer?" Individual critics need to decide on the proper tone of their criticism, ranging from what Smith identified as "The Pollyananias Spirit," which approaches the arts from a unilaterally supportive posture, where no art is bad art, to Frank Richian butchery.

STYLE. Criticism should be a thought-provoking and intriguing read. It should be storytelling about storytelling. As such, critics should write stylishly, concentrating on the perfect word, the excellent sentence, the fluid prose, and the graceful turn of a phrase, all in their distinctive and singular voices and from their defining perspectives. "Critical authority," suggests arts journalism scholar Katie Roiphe,[23] "comes from the power of the critic's prose, the force and clarity of her language; it is in the art of writing itself that information and knowledge are carried.... If critics can fulfill this single function, if they can carry the mundane everyday business of arts criticism to the level of art, then they can be ambitious and brash." Critical writing should never be pedestrian or pedantic.

ORIENTATION. A critic's relationship with the arts and the audience impacts his/her approach to a review. This can range from unflappable advocate of the arts, to what *New York Post* theater critic Clive Barnes[24] referred to as an "informed enthusiast," to standard bearer of the arts and responsible for challenging the artists, to standard bearer for audience, where critics challenge the audience to be more perceptive, receptive, and demanding consumers.

Do Critics Need To Be Practitioners, in profile

Arts journalist Roanna Forman of *bostonjazzblog.com* asked readers if jazz journalists needed to be musicians. Here are some typical responses from respected critics[25] and musicians[26] that generalize to the coverage of other art forms:

Patrick Jaren Wattananon (critic): "A good critic needs to understand what he or she is covering in order to cover it. Playing music isn't a prerequisite for that understanding, but it can only help. But considering all the foregoing, it seems as if what is most needed from jazz journalism today is not strictly criticism of sounds themselves, but also explication: gathering context, making connections, lending new perspectives or otherwise giving a "way into" this stuff for the common non-musician.... It seems to me that skill set is all about storytelling, and it's not taught in music theory classes at conservatory. It has to do with sharp observation and close listening and critical thinking and asking questions and doing your research and assembling it all into a coherent narrative."[27]

Bob Blumenthal (critic): "I've always taken the position that, unless music is created exclusively for those who know how to play music, the reactions of those who don't know how to play, when informed with historical perspective, intelligence and taste, have value."

Dominique Eade (musician): "I think it is more important that critics listen well whether they play jazz or not. With the amount of music available we need trusted ears who have clocked in all those hours with recorded and live music more than ever."

Joe Lovano (musician): "I think the question should be 'Do jazz critics need to know how to listen to jazz?' To be a frustrated jazz musician turned critic could be a true nightmare for everybody. Musicians and critics alike have various degrees of experience playing, listening and studying the history of the music and the people that create it. They either have *no* roots, *shallow* roots, *substantial* roots or *deep* roots. As a serious musician I love and live the music day and night. A serious jazz critic should as well, so his or her viewpoints will be informative, clear and honest."

Tia Fuller (musician): "My experience has been that it is important for jazz critics to be educated and articulate in the jazz vernacular, not necessarily to know how to play jazz."

Randy Sandke (critic): "I would say no, but it helps. I think a good working knowledge of the fundamentals of music is important, but good ears and an open mind are the most essential attributes. A good critic needs to have a healthy appreciation for technique, but just like one needn't be an artist to be an art critic, or playwright to judge plays, playing jazz is not an absolute prerequisite for being a good jazz critic."

> *"The idea is to balance enthusiasm, critical distance, skepticism, understanding of the scene, hunger for innovation, respect for tradition, and the desire to entertain and inform the reader."*
>
> David Cote, theater editor, *Time Out New York*[28]

Adherence to a Sliding Scale

It has already been noted that critics, unlike typical audience members, need to acquire a sixth sense or a critical third eye through which to watch and engage a work and see what is intended to be invisible. While lost in the vortex of cognitive complacency, which is fundamental in enjoying a work of art, the critic must remain partially removed from the experience and thoughtfully aware of the mechanics involved in its creation. But just how partially removed? Consider the sliding scale of perspective.

THE SLIDING SCALE OF PERSPECTIVE. There is no "best" perspective—no "best" balance between complacency and engagement—nor is this vantage point fixed. It is, in fact, a potentially fluctuating factor based on the nature of the work being experienced as well as the critic's own comfort level. Perspective exists on a continuum that stretches from being thoroughly detached from the work to being thoroughly absorbed in it.

DETACHED ABSORBED

Criticism that is too detached explores the work without feeling the work. Detachment suppresses intuition and critics become locked into what art critic Theodore Greene called "the frigidity of conceptual abstraction and impersonal calculation."[29] Thoroughly detached critics fail to become participant-observers and, thus, are too far removed from the experience encountered by everyone else in the room to be able to write about it in a way that others can relate to. A critic cannot speak for the audience if s/he is not invested in being a part of the audience.

Criticism that is too absorbed fails to see the "big picture" or the total complexity of the work. Critics run the risk of becoming subjectively involved in the work, the same way that hard news journalists too close to their subjects or the subject matter become acculturated. Overly absorbed critics are living the experience encoun-

tered by everyone else in the room and lose necessary objectivity and critical edge. As a result, they lose authority.

It is little wonder that theaters attempt to sit critics not too close to the stage—for fear that such a vantage point both prohibits a panoramic view of the production and facilitates absorption into the production—or too far from the stage—for fear that the critic will be disengaged from the action by being too removed from the performance. Most critics have their own particular preference for just where they sit in relation to the stage. "The critic's duty," noted Benedict Nightingale,[30] theater critic for London's *The Times* newspaper, "is perhaps to be part, yet apart; to surrender, yet hold back; to ensure that there's at least some tiny, guarded bit of himself watching himself in his more unguarded moments."

THE SLIDING SCALE OF INTENTION. For some, the nature of the work being experienced is one of the factors that might impact on where in the sliding scale of perspective a critic might place him/herself. Some works are created as works of art while others are clearly intended to be works of entertainment, and should be critiqued accordingly. This is not to suggest that one type of work is harder to create than another, or that one is more significant or valuable than another. Rather, they simply might demand, inspire, or allow for different levels of engagement.

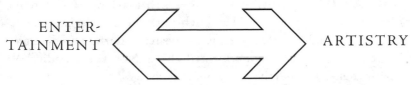

ENTER-
TAINMENT ARTISTRY

Presentational performances such as concerts, for example, engage an audience differently than representational performances such as plays. Musicals, which tend to combine presentational and representational performances, are a whole other matter. According to drama critic and historian Martin Gottfried,[31] "As much as we love them, there have not yet been any musicals to rank with the great classics of the dramatic literature. There are many beloved shows—even great ones—but they are not works of art." A recent research report on the intrinsic value of theater[32] found that straight plays generate higher levels of intellectual stimulation among audience members while musicals generate higher levels of feeling "emotionally charged," higher levels of aesthetic validation, and greater social connectedness with others in the audience. Also, representational works come in varying degrees of verisimilitude—the appearance of being real—which make different demands on their audience and the critics, and may justify different degrees of engagement. Again, this is a personal choice on the part of the critic.

THE SLIDING SCALE OF EXPECTATIONS. Developing a critical voice establishes a writer's position and paradigm regarding his/her approach to the arts

"I hate theater. Well, it's so disappointing, isn't it? You know what I do when I am sitting in the darkened theater waiting for the show to begin? I pray. 'Oh, Dear God, please let it be a good show. And let it be short, oh Lord in heaven, please. Two hours is fine; three hours is too much. And keep the actors out of the audience. God. I didn't pay good money to have the fourth wall crashing down around my ears. I just want a good story, and a few good songs that will take me away. I just want to be entertained. I mean, isn't that the point? Amen.'"

~Man in Chair,
from the musical farce *The Drowsy Chaperone*[33]

and relationship with the audience. This voice needs to be consistent across reviews and come to define the critic. While necessarily consistent, it is important to note that this definitive voice can and should be modulated based on several circumstances and can fall between the extremes on the sliding scale of expectations.

Many critics cover a variety of theater beats that include national tours, local equity houses, regional professional and hybrid theaters, collegiate theaters, and community theaters. It is unfair to treat all theaters and their productions alike, even if the same play is being performed there. Not to contradict William Shakespeare, but sometimes the play is not "the thing."

AMATEUR ⟨⟩ EQUITY

As was noted previously, different types of theater companies have different levels of storytelling capabilities, as reflected in their particular creative mission and adopted business model (see Theater Mission Statements, in profile). Some theaters are more endowed than others when it comes to financial resources, physical space, and capabilities in terms of technical equipment, and the artistic expertise and experience of its directors, designers, and actors. This, in turn, impacts on the types of plays and playwrights they embrace, the size and scope of productions they are capable of staging, the creative risks their team is willing to take, and the subsequent ticket price for their productions. Audience expectations are often influenced accordingly. Going to see a Broadway play is clearly different than seeing a non-equity national tour of that same Broadway show. Regional professional companies offer a different product than do local community theaters and collegiate theaters.

Different does not necessarily mean better or worse, for equity productions can disappoint just as well as amateur productions can astound. However, when this happens it means that the equity production fell below expectations while the community theater production exceeded expectations. "Different" refers to different levels of expectations—which can be met, missed, or surpassed—and there are several areas of expectation that apply to every theatrical performance:

- **The expectation of technical competence in a production.** One expects a minimum level of technical competence from all theaters that charge admission (as well as established theaters that choose not to charge admission when, say, offering Shakespeare in the park). However, a higher level of technical wherewithal and more mechanical gadgets to master are expected in more professional venues. Everyone should know their craft, but experience and training pay dividends in terms of actual production values and need to be taken into consideration by the critic;
- **The expectation of artistic competence in a performance.** One expects a minimum level of artistic competence from all theaters that charge admission, but a higher level of artistic expression is expected among professional performers. Everyone should know their craft, but experience, training specialization, and technique pay dividends in terms of the quality of actual performances and need to be taken into consideration by the critic; and
- **The expectation of creative risk.** This is not to suggest that the more professional a theater, the more risks that are taken. This is clearly not the case since many commercial theaters operate risk-free and many collegiate theaters take risks as a matter of mission and for their educational value. However, it is expected that greater risks are more likely to be successful among more professional theaters.

In short, a theatrical production meeting, missing, or surpassing expectation is the very crux of any review. Judgments of performance need a starting point which, in the case of theater criticism, is variable across a spectrum of expectations. As do most audience members, critics should always approach a production expecting the best…whatever that level of expectation might be. Still, where on that sliding scale of expectations a production resides should be determined before entering the theater.

The sliding scale of expectations should also serve to temper and influence what appears in a review and the intensity of expression. For example, if there are acting performances that do not meet expectations in an equity production, the critic has every right—in fact, has the obligation—to call out individual artists, who are highly trained and well-paid professionals, in the review. Those artists need to know that they need to step up their game and the audience needs to know whether the typically high cost of attendance is justified. If there are acting performances that

Theater Mission Statements, in profile

Forbes magazine recently ranked Cleveland as the most "miserable city in the nation."[34] Cleveland, the 45th largest city in the U.S. and the second largest city in Ohio, landed the top spot because of its weather (brutal winters), crime rate (high), tortured sports history, and the migration of residents from its metropolitan area. Not taken into account was the city's theater scene, including the PlayhouseSquare complex (the nation's second largest theater district) and its highly diverse professional, collegiate, and amateur theater community. Their mission statements speak to the range of theaters throughout the city, their offerings, and their expertise—which is typical of most cities.

> Since **Great Lakes Theater's** inception in 1962, programming has been rooted in Shakespeare, but the company's commitment to great plays spans the breadth of all cultures, forms of theater and time periods, and provides for the occasional mounting of new works that complement the classical repertoire…. The Great Lakes Theater seeks to create visceral, immediate experiences for participants, asserting theater's historic role as a vehicle for advancing the common good, and helping people make the most joyful and meaningful connections between classic plays and their own lives.[35]

> **Cleveland Public Theatre's** mission is to raise consciousness and nurture compassion through ground breaking performances and life changing educational programs. CPT develops new, adventurous work; and nurtures Northeastern Ohio artists—particularly those whose work is inventive, intelligent, and socially conscious. CPT's acclaimed education programs engage underserved communities in devising new works that speak to contemporary issues, and empower participants to work for positive change in our community.[36]

> Most theatres are like mirrors, reflecting the familiar. You go to a show, you sit, you watch a play, and then you go home. You watch the actors from across the chasm of a 'fourth wall.' Everything is nicely laid out for you as you view what is comfortably, safely beyond that wall, confident that you will be made, indeed are expected, to understand the experience in terms of conventional logic. Aren't we all tired of that by now? What if theatre weren't a mirror reflecting the familiar, but an opening into unknown territory? What if there were no fourth wall? What if, instead of going to the theatre to watch a play, you crossed the threshold into the world of the play to experience it. Theatre that expands the imagination and extends the conventional boundaries of language, structure, space, and performance that

challenges the conventional notions of what theatre is. What sort of theatre would this be? We are **convergence-continuum**.[37]

Cleveland Play House is an artist-driven theatre that serves the Greater Cleveland community by holding true to its mission: To inspire, stimulate and entertain diverse audiences in Northeast Ohio by producing plays and theatre education programs of the highest professional standards. As the flagship theatre of Northeast Ohio, our primary purpose is to produce consistently high-quality productions commensurate with a top-tier theatre. We are driven by excellence and lead the region with a diverse repertoire of high-quality programming.[38]

Dobama Theatre's mission is to premiere the best contemporary plays by established and emerging playwrights. Through educational and outreach programming, Dobama Theatre nurtures the development of theatre artists and builds new audiences for the arts while provoking an examination of our contemporary world.[39]

Music Theatre performance training at **Baldwin-Wallace University** is among the finest in the nation, with a dynamic curriculum focused on mastering a wide range of acting, voice, and dance styles. B-W performance faculty maintain active professional careers, giving B-W students a decisive edge in a competitive marketplace. Current students perform professionally in greater Cleveland, nationally, and on Broadway. Graduating students perform a Senior Showcase attended by over 200 industry professionals, and an overwhelming majority of graduates sign with agents shortly afterward.[40]

Over the years, **Aurora Community Theatre** has earned the admiration of our patrons and the reputation of presenting fine community theatre. The philosophy of ACT entails respect for the individual, willing cooperation of all involved and a striving for excellence. We look forward to bright and prosperous years to come where all who want to become involved can.[41]

do not meet expectations at a community theater production, the critic may choose to call attention to that fact without calling out the individual artists. They are, in all likelihood, untrained and unpaid amateur performers incapable of or unlikely to be stepping up their game. Similarly, minor technical or performance snafus on opening night can justifiably be ignored in a review of a community production, with the realization that they will be mended by the next performance. For a professional production, those snafus should never occur and warrant attention. It is important to note that lowering expectations for an amateur production is not the same as having no expectations or standards.

..

*"I try to evaluate a show according to what standards it sets
for itself and how successfully it realizes its own ambitions."*
~Ben Brantley, chief theater critic,
The New York Times[42]

..

Risks Associated With Sliding Scales

Where on these sliding scales a critic finds him/herself is a matter of personal choice. Choosing a position on the sliding scale of perspective is a matter of comfort, capability, and preference. Choosing a position on the sliding scale of expectations is a matter of perceived fairness. Choosing a position on the sliding scale of intention is a matter of interpretation. For critics, personal choices such as these come with professional risks:

RELATIONSHIPS. Over time, critics establish relationships with the members of the arts community they critique. This is unavoidable since arts are collaborative enterprises that include criticism as an integral component and, in most cases, are in the community in which the critic resides. Personal relations with artistic directors or performers can inadvertently influence where a critic finds him/herself on the sliding scale of perspective—that is, it may be harder for some critics to take a position of detachment when there is a degree of familiarity with an artist whose work is on display. Personal relationships can inadvertently influence where a critic finds him/herself on the sliding scale of expectations as well, for one can easily become a harsher or more lenient critic of work with which s/he is intimately familiar or personally vested. Of course, some critics can still be critically objective regardless of their personal relationships. It is imperative that relationships not factor into critical judgments. A solid rule of thumb is that critics avoid or excuse themselves from situations where personal bias can become a factor or where they can be perceived as a factor by others.

DAMNED IF YOU DO; DAMNED IF YOU DON'T. Adjusting ones expectations for technical competence, artistic competence, and creative risk-taking, while well intended, is a kindness often invisible to readers. It is not uncommon for those critiquing amateur productions and giving a "bad" review to receive consternation from members of the community because the critic is perceived as being "too hard" on amateurs who are "doing their best." Some don't think that community or collegiate theater productions should ever get a bad review, given their amateur status. Critics need to take a position and stick with it. They need to decide for themselves what "the best" is along this sliding scale and consistently apply that standard, whatever it is. If this is done, there is no excuse not to write a harsh or favorable review when warranted, for adjustments have been made even if

International Association of Theater Critics Code of Practice, in profile[43]

"Theater is among the most interactive of the performing arts. As privileged spectators, theater critics share with audiences and performers the same time and space, the same individual and collective stimuli, the same immediate and long-term experiences. As working theater commentators, we seek in our individual ways to articulate these interactions as a frame for discussion and as a meaningful part of the interpretation and significance of theatrical performance. The International Association of Theater Critics therefore urges its members worldwide to accept as an agreed starting point the core professional guidelines articulated in this document.

1. As writers and thinkers in the media and/or as scholars connected to various branches of academic discourse, theater critics should always remain aware of normative professional practices, respect artistic and intellectual freedom, and should write in what they believe to be the best interests of the ideals of the art of theater.

2. Theater critics should recognize that their own imaginative experience and knowledge is often limited and should be open to new ideas, forms, styles and practice.

3. Theater critics should speak truthfully and appropriately while respecting the personal dignity of the artists to whom they are responding.

4. Theater critics should be open-minded and reveal (as appropriate) prejudices—both artistic and personal—as part of their work.

5. Theater critics should have as one of their goals a desire to motivate discussion of the work.

6. Theater critics should strive to come to the theatrical performance in their best physical and mental condition, and should remain alert throughout the performance.

7. Theater critics should try to describe, analyze, and evaluate the work as precisely and specifically as possible, supporting their remarks with concrete examples.

8. Theater critics should make every possible effort to avoid external pressures and controls, including personal favors and financial enticements.

9. Theater critics should make every possible effort to avoid situations which are or which can be perceived to be conflicts of interest by declining to review any production with which they are personally connected or by serving on juries with which they are personally connected.

10. Theater critics should not do anything that would bring into disrepute their profession or practice, their own integrity or that of the art of the theater."

they go unrecognized by others. Critics need to have the courage to stand by their judgments, no matter where on the sliding scale of expectations they reside.

Possessing Keen Powers of Observation

One of the primary functions of the critic is to serve as a surrogate audience member. Critics help explain and analyze a play, a production, and performances for those in attendance who are ill equipped or not interested in doing so on their own, or who are merely seeking another opinion. However, the critic is also reporting to all those not in attendance.

At the heart of this enterprise is a descriptive overview of the work. For a theater review, this means a brief re-creation of the play's plot and a description of its key characters. Without such verbal imagery and the mental images this provides to the reader, the play exists only in the abstract, rendering explanation and analysis ineffective if not meaningless. Similarly, explanation and analysis of the production—of the director's and designers' choices and the actors' performances, for example—can't be effective without being preceded by some degree of description of those choices and performances. Description entails the act of transposing what is occurring in one venue, such as live performance on a stage, into another: the written word.

At the heart of any act of description are the powers of observation. To a very large extent, performing arts critics are participant-observers. The term comes from the disciplines of cultural anthropology, sociology, and social psychology. One method for researchers to gather information in the field—that is, in the foreign and unfamiliar world that is the focus of their investigation—and attempt to understand it, is by being a part of yet removed from that world. As was noted in the previous discussion of the sliding scale of perspective, the participant-observer allows him/herself to get ensconced in that world while, at the same time, employing the insights and understanding of a learned observer. The point, regarding performing arts journalism, is that the critic is able to observe and experience the world unfolding on stage as a member of the audience, and give in to the same impulses a theatrical production elicits, while at the same time retaining an observer's identity and separation, and a critical eye for understanding, analysis, and explanation. Critics are the Jane Goodalls of the arts. There is an art to watching and listening—of knowing how to notice, when to notice, and whom to notice—that is key in being able to "visualize" an event through words. This will be explored in the next chapter, as well as other aspects of writing a review.

Summary

Clearly, there is a bit of preparation involved in writing a review before the actual writing kicks in. There are decisions that need to be made about how much research

Participant-Observer Exercises, in profile

The more a critic engages in the act of participant-observation, the easier it becomes to find the right balance of engagement and detachment. Similarly, through practice and experience, our observational skills develop and become more refined. There are exercises[44] a novice critic can do to move along the learning curve, if desired:

MEMORY EXERCISE. Think of a familiar place, such as a room in your home, and make field notes that include a physical description of as much as you can remember of what is contained in that setting. Compare the recollections with the actual setting to see what you were able to remember and how accurate the notes were in reflecting what exists. The purpose of this exercise is to help realize how easy it is to overlook things in one's observations and note taking, and become more attentive to big picture items as well as small details.

SIGHT WITHOUT SOUND. Find a natural setting where you are able to see activity but unable to hear what is being said in the interaction. For 5 to 10 minutes, observe the action/interaction and record in brief notes as much descriptive information as possible in as much detail as possible. Another option: turn off the sound on the television and observe the actions/interactions unfolding in an unfamiliar program. The purpose of the exercise is to begin observing and taking in information using only the powers of visual observation. This exercise can be modified so that you only listen to an interaction and record notes from those audio observations, which helps generate the ability to write notes while still attending to an event. Another option is to write one's observations and then immediately write one's thoughts, feelings, and ideas about what was just observed.

WORKING WITH A NET. Perform trial runs of participant-observation at an arts event of your choosing. Engage in the actual process of note taking without the pressure of deadlines or the subsequent production of a review. This exercise allows the budding critic to find a comfortable position on the sliding scale of perspective, to master being an observant participant, and to learn how to jot down notes in the dark without writing on one's leg or the leg of the person next to you.

to perform and when to perform it. There are decisions that need to be made regarding the establishment of a critical voice. Critics need to find a comfortable position on the continuum of the sliding scales of perception, intention, and evaluation. There are also powers of observation that need to be honed. The desire to seek, the

establishment of a critical voice, adherence to sliding scales, and the application of the powers of observation are all a prelude to experiencing an art event or exhibition and the writing of a review.

Here are the Top-10 priorities in preparing for a review:

- Do your homework about the play and the playwright. Understand what you are about to encounter on stage.
- Become familiar with production choices that have been done in other stagings of the work being reviewed. This helps identify and evaluate choices being made for the current production.
- Purposeful choices have been made in the technical and artistic execution of this production. Come hoping and expecting that good choices were made.
- Set expectations consistent with a theater's technical competence, artistic competence, and capacity for creative risk.
- Find a critical voice all your own, reflective of your expertise and orientation, and in a style and tone that suits you, your outlet, and your audience.
- Prepare to be engaged in a production while simultaneously detached from it. While those around you are lost in cognitive complacency, you are actively observing and critically thinking.
- Never lose objectivity. Once you do, you lose critical authority.
- During a production, see the big picture that has been created for you but look for the mechanics of its creation and focus in on the little things being done to accomplish them.
- Establish relationships with the members of the arts community but never to the point that will compromise objectivity.
- Avoid or excuse yourself from situations where personal bias can become a factor or where it can be perceived as a factor by others.

The next chapter takes us through the actual process of writing a review.

KEY CONCEPTS FROM THIS CHAPTER

Acculturation	Pollyananias Spirit
Assimilation	Powers of observation
Cognitive complacency	Preset mind
Conflict of interest	Repeated exposure
Critical standards	Reporting tools
Critical thinking	Research
Critical third eye	Second-hand mind
Critical voice	Sixth sense of connoisseurship

Descriptive overview

Desire to seek

Exposure

First person narrative

Fondness to mediate

Idols

J.C. Flugel Polycrates Complex

Open-ended interview questions

Participant-observer

Patience to doubt

Plagiarism

Sliding scale of expectations

Sliding scale of intention

Sliding scale of perspective

Slowness to assert

Suspension of disbelief

Tabula rasa

The expectation of artistic competence

The expectation of creative risk

The expectation of technical competence

Third person narrative

NOTES

1 Misha Berson, personal interview with author, August 20, 2011.

2 Cited in http://artsedge.kennedy-center.org/educators/standards/full-text/9-12%20Standards%20 by%20Arts%20Subject.aspx (accessed on February 4, 2012).

3 Cited in David Grann, "The Mark of a Masterpiece," *The New Yorker*, July 12, 2010, www. newyorker.com/reporting/2010/07/12/100712fa_fact_grann (accessed July 12, 2010).

4 Ibid.

5 Theodore Greene, *The Arts and the Art of Criticism* (Princeton, NJ: Princeton University Press, 1940), 240. Cited in David James Anderson, *Theatre Criticism: A Minor Art With a Major Problem* (Unpublished doctoral dissertation, Ohio State University, 1988), 14.

6 Cited in Grann, "The Mark of a Masterpiece."

7 Cited in Forrest E. Baird and Walter Kaufmann, *From Plato to Derrida* (Upper Saddle River, NJ: Pearson Prentice Hall, 2008).

8 Cited in Joseph Devey (Ed.), *The Physical and Metaphysical Works of Lord Bacon* (London: Bell and Sons, 1911), 19–20.

9 Cited in Samuel Stephenson Smith, *The Craft of The Critic* (New York: Thomas Y. Crowell Company, 1931), 15.

10 Jason Zinoman, "Theater Talkback: The Good That Comes From Bad Reviews," *The New York Times Arts Beat*, August 25, 2011, http://artsbeat.blogs.nytimes.com/2011/08/25/theater-talkback-the-good-that-comes-from-bad-reviews/ (accessed February 4, 2012).

11 A.B. Walkley, *Dramatic Criticism: Three Lectures Delivered at the Royal Institute, February 1903* (London: John Murray, 1903), 51.

12 Harold Clurman, *The Divine Pastime* (New York: Macmillan, 1974), 95.

13 Ken Bloom, *Broadway: Its History, People and Places* (New York: Routledge, 2004), 271.

14 Bert Cardullo, "The Theater Critic as Thinker," *New Theater Quarterly*, 2009, 25, 314–315.

15 Roderick Bladel, *Walter Kerr: An Analysis of his Criticism* (Mahwah, NJ: Scarecrow Press, 1976).

16 Nelson Pressley, "'Tynan': A Show to Please the Critic," *The Washington Post*, January 27, 2011, http://www.studiotheatre.org/calendar/view.aspx?id=1601 (accessed January 27, 2011).

17 Robert Simonson, "John Simon to Leave Long-Held Post at *New York* Magazine, *Playbill.com*, May 10, 2005, http://www.playbill.com/news/article/92861-John-Simon-to-Leave-Long-Held-Post-at-New-York-Magazine-McCarter-Named-New-Critic (accessed February 4, 2012).

18 Cited in Coco Fusco, "Hilton Als," *BOMB 58*, Winter 1997, http://bombsite.com/issues/58/articles/2028 (accessed February 4, 2012).

19 Hans Keller, *Criticism* (London, Faber, 1987), 235.

20 Cited in Irving Wardle, *Theatre Criticism* (London: Routledge, 1992), 35.

21 Zinoman, "Theater Talkback."

22 Cited in Smith, *The Craft of The Critic*, 8.

23 Cited in Roiphe, "With Clarity and Beauty."

24 Cited in Palmer, *The Critics' Canon*, (New York: Greenwood Press, 1988), 15.

25 Cited in http://www.bostonjazzblog.com/2011/08/21/do-jazz-critics-need-to-know-how-to-play-jazz/ (accessed February 4, 2012).

26 Cited in Ran Xia, "The Role of Theater Criticism," Theatermania.com, November 7, 2012, http://www.theatermania.com/new-york-city-theater/tmu/11-2012/the-role-of-theater-criticism-_63676.html (accessed March 20, 2013).

27 Http://www.npr.org/blogs/ablogsupreme/2011/08/22/139862077/does-a-jazz-critic-have-to-be-a-jazz-musician-too?sc=fb&cc=fp (accessed February 4, 2012).

28 Stanley Kauffmann, *Persons of the Drama: Theatre Criticism and Comment* (New York: Harper, 1976), 380.

29 Greene, *The Arts and the Art of Criticism*, 240.

30 Benedict Nightingale, *Fifth Row Center: A Critic's Year on and off Broadway* (New York: Random, 1986), 235.

31 Martin Gottfried, *Broadway Musicals* (New York: Harry N. Abrams, Inc., 1979), 6–7.

32 See Alan Brown and Rebecca Razkin, *Understanding the Intrinsic Impact of Live Theatre: Patterns of Audience Feedback across 18 Theatres and 58 Productions* (San Francisco: WolfBrown, 2012), http://www.theatrebayarea.org/Programs/upload/execsummary_samples.pdf, (accessed February 4, 2012).

33 The musical comedy *The Drowsy Chaperon* was written by Bob Martin and Don McKeller, with music and lyrics by Lisa Lambert and Greg Morrison.

34 Kurt Badenhausen, "America's Most Miserable Cities," *Forbes*, February 2, 2010, retrieved from http://www.forbes.com/2010/02/11/americas-most-miserable-cities-business-beltway-miserable-cities.html (accessed February 2, 2010).

35 http://www.greatlakestheater.org/about/mission (accessed April 1, 2012).

36 http://www.cptonline.org/about-cleveland-public-theater.php (accessed April 1, 2012).

37 http://www.convergence-continuum.org/index.php?subject=aboutthecompany&sub=index (accessed April 1, 2012).

38 http://www.clevelandplayhouse.com/about/overview-and-mission (accessed April 1, 2012).

39 http://dobama.org/mission/ (accessed April 1, 2012).

40 http://www.bw.edu/academics/conservatory/academics/mtheatre/ (accessed April 1, 2012).

41 http://www.auroracommunitytheatre.com/about_us.html (accessed April 1, 2012).

42 Don McLeese, *The New York Times Reader: Arts & Culture* (Washington, DC: CQ Press, 2011), 113.

43 Cited in http://www.aict-iatc.org/documents/Code%20of%20Practice.pdf (accessed April 1, 2012).

44 Cited in Barbara B. Kawulich, "Participant Observation as a Data Collection Method," *Forum: Qualitative Social Research*, 6(2) 2005, http://www.qualitative-research.net/index.php/fqs/article/view/466/996 (accessed February 4, 2012).

"Going to the theatre shouldn't be a test, and writing a review isn't the same as doing an exam. There's not a right or wrong answer; often you don't even know what the question is. All any theatregoer or reviewer can do is to talk or write honestly about their response to a piece of work."
~Lyn Gardner, theater critic, *The Guardian*[1]

Chapter 10 Abstract

This chapter takes the reader into the theater during a production and dissects the process of participant-observation and taking field notes. The actual writing of a review is explored as a creative enterprise but one steeped in journalistic traditions. As such, a review needs to be a good, interesting read as well as an informative, insightful, and well-structured read that offers critical opinion, backed by interpretation and explanation, informed by description that leads to a conclusion. The specific components of a review are examined.

Writing a Critique

▌▌ Wait," says Mark Rothko, eminent abstract expressionist painter, to his young assistant in the opening moments of John Logan's 2010 Tony Award-winning drama *Red*.[2] Staring into the audience as if one of his emotionally raw black-on-red oversized painted canvases was hanging overhead, Rothko continues:

> Stand closer. You've got to get close. Let it pulsate. Let it work on you. Closer. Too close. There. Let it spread out. Let it wrap its arms around you; let it embrace you, filling even your peripheral vision so nothing else exists or has ever existed or will ever exist. Let the picture do its work—But work with it. Meet it halfway for God's sake! Lean forward, lean into it. Engage with it!... Now, *what do you see?*

The play *Red* is a profile of a great American artist from the 1950s. But it is also a treatise on the creative process—on the making of art, the appreciation of art, the collection of art, and even the critiquing of art. In his opening monologue, Rothko asks the questions we should be asking ourselves when we encounter the product of great creativity:

> So, now, what do you see?—Be specific. No, be exact. Be exact—but sensitive. You understand? Be kind. Be a human being, that's all I can say. Be a human being for once in your life! These pictures deserve compassion and they live or die in the eye of the sensitive viewer, they quicken only if the empathetic viewer will let them. That is what they cry out for. That is why they were created. That is what they deserve.... Now...*What do you see?*

What Do You See

The Application of Observation

As was noted at the end of the previous chapter, the writing of a review begins with keen observation. One can't explain and critically analyze what one doesn't first experience, observe, and attempt to describe. While all audience members are observers, it was suggested that critics best serve their craft by being participant-

observers. This is a term taken from the fields of cultural anthropology, sociology, and social psychology that describes how a researcher in the field can allow him/herself to be ensconced in what is being observed while at the same time being removed from it and employing the insights and understanding of a learned observer. Theater critics should be able to give in to the same impulses a play and its production elicit in their audience, but all the while keeping a critical eye open and evaluating the play and the production with the intention of explaining and analyzing them both to readers.

While at the theater during a performance, there are three distinctive gears of participant-observation that kick in when a critic is watching a play unfold. They range from macroscopic to microscopic, and shift the critic's mindset from that of casually watching a production to purposefully seeing a production. Throughout a performance, the critic is constantly and, overtime, effortlessly changing gears, which include:[3]

1. **Descriptive observation,** also referred to as "wide-eyed observation," in which one observes anything and takes in everything. For the theater critic, whose "field" is the stage, descriptive observations entail immediate first impressions of and gut reactions to:

 o the atmosphere in the theater before a show begins and what has been done to create it. For example, the choice of a closed curtain can build anticipation while an open curtain can help establish the world of the play and bring the audience into it;

 o The nature of the set, scenery, lighting, sound, and costuming, and the emotional impact upon seeing/hearing them for the first time when the curtain opens or when the lights come up;

 o The world of the play, and the initial and most general choices being made by the director and the various designers to help transport the audience into that world; and

 o the choices being made by performers upon the introduction of their characters and the utterance of their first pieces of dialogue that establish who they are, their relationships with others, and what their place is in the world of the play.

 Once first impressions occur and are duly noted, descriptive observation shifts to idle, where the critic allows cognitive complacency to kick in and the play to unfold. That is, until shifting into the next gear is warranted.

2. The second gear, **focused observation**, emphasizes occurrences supported by research and past experience, in which the participant-observer's insights

> *"The first impression is an empirical and inductive pro-cess; it starts with the observable facts, but it instinctively aims at a grasp of the very life of the machine which is… deeper…than the surface appearances offer."*
> ~Francis Fergusson, drama theorist[4]

guide specific things to look for. Herein lies one of the advantages of doing research prior to a performance or exhibition. For the theater critic:

o knowing the play's storyline and being knowledgeable about traditional or previous productions of the work helps guide observations about possible deviations in interpretation and the creative risks being taken. Focused observation keys in on these things;

o knowing that a theater company is stretching its creative limitations or taking particular creative risks with its current production allows the critic to concentrate on these things in order to evaluate their success; and

o knowing about production challenges or possible innovative approaches to a particular character allows the critic to look for these things and note how the theater's personnel responded accordingly.

Unlike more casual consumers in the audience, critics take nothing for granted and do not allow anything to pass by without thoughtful reflection. These focused observations help break down the big picture into less general areas of interest regarding the play, the production, and the performances.

3. The third gear of observation is **selective observation**, in which the partici-pant-observer focuses on the specific nature of different types of activities as they transpire. For the theater critic this entails:

o allowing the production to unfold and interesting, intriguing, or prob-lematic moments to reveal themselves. When they do, the critic becomes overtly attentive and microscopic, concentrating on that interesting, intriguing, or problematic occurrence. While some can be so powerful that they entice the audience further into the world of the play and the vortex of cognitive complacency, such as a particularly moving perfor-mance, the critic needs to be particularly attentive and detached, for these occurrences eventually need to be dissected, described, explained, and evaluated; and

o shifting, for a moment, from a "wide" to a "narrow" angle perspective when these interesting, intriguing, or problematic moments call atten-tion to themselves. This entails focusing on a single person, a solitary

activity or a specific interaction, and then returning to a view of the overall situation.

The first two types of observation are largely proactive—that is, the participant-observer critic is purposefully and intently looking for and listening to things preordained to be significant or relevant. The critic is actively seeking information about the mechanics of a production and a performance with the intention of eventually addressing them. Selective observation, however, is largely responsive and dictated by the experience itself. These are more organic observations that result from creative choices or mishaps by the playwright, performers, or production team. It is here that the critic's acquisition of a critical third eye—the "ineffable sixth sense of connoisseurship"[5] really kicks in and automatically focuses in on things of interest.

Theater Critic Poem, in profile[6]

> The critic leaves at curtain fall
> To find, in starting to review it,
> He scarcely saw the play at all
> For watching his reaction to it.
> ~E.B. White, writer for *The New Yorker*

Note Taking

All of these observations need to be complemented by diligent and simultaneous note taking, or they will be lost over time. A written review is not unlike the peopled ethnographies[7] that result from social scientific field research in anthropology and sociology, where the participant-observer makes observations and takes descriptive field notes that are later used to create a holistic understanding of the setting, recreate the experience of engagement, and then document opinions and evaluations. Good field notes taken in the deepest jungles, as well as those written in the darkened seating of the most lavish theaters, should:

- be taken unobtrusively, so as not to impact on what is being observed or on the other participants. This means no pens with lights or florescence, no recording devices, and no activated cell phones for tweeting or texting. Use a small note pad and a reliable pen;
- include brief but recognizable notations. The more you are lost in thought while writing, finding the right words to describe what is being witnessed, the less you are engaged in observation and the more you are missing. Keep notes brief so that they allow for uninterrupted observation and facilitate

recall after the event. A key word, a descriptive phrase, or a short sentence should suffice. Also, it is hard to write legibly while in the dark, so the shorter the better;

- use exact quotes when appropriate and if possible. Arts journalism is journalism, and accuracy is paramount. Misquoting undermines authority and credibility. Quotes may come in handy later, when attempting to capture a key or transitional moment in a play best expressed by the playwright him/herself;

- describe activities in the order in which they occur. This will facilitate later recall since most plays and critiques of them are linear;

- provide descriptions without inferring meaning. In separate notes, offer interpretation; and

- include some descriptive context to situate an event or a quote. Many critics have a formative visual memory that can summon into consciousness the sights and sounds of the stage hours later. For the rest of us, note taking will facilitate later recall and add substance to the description that works its way into the review.

Clearly, all of this descriptive note taking can lead to the collection of minutiae that may or may not be relevant to the written review. Much of this will be discarded later on. However, all this serves as a record of experience and will facilitate recall when reflecting on the production and performances while writing the review. These observations help paint the big picture of the play, the production, and the performances, and reflect specific memorable moments.

What Do You Write

After an event, with note pad in hand, it is time to gather one's thoughts and write a review. To a very large extent, writing a review is engaging in storytelling about storytelling. A review is both a piece of creative writing as well as a piece of journalism. As such, it needs to be a good, interesting read as well as an informative, insightful, and well-structured read.

There are specific components a review needs to possess in order to accomplish this. As we've discussed, a piece of criticism offers critical opinion, backed by interpretation and explanation, informed by description, which leads to a conclusion. For a piece of theater criticism, it is also necessary to specifically and explicitly address the play, the production, and the performances. However, how these components are approached, how much emphasis each is given, and in what order they appear is up to the critic and his/her critical voice. In addition, there are other

> *"If you write for only the theatergoer, you're cutting off a large part of your potential readership. Part of my job is to seduce people who might not go to the theater ordinarily into taking a chance on it."*
>
> ~Ben Brantley, chief theater critic,
> *The New York Times*[8]

factors that might influence a review's tone and structure, such as the nature of the audience one is writing for and how much they are likely to know about the subject matter, as well as requirements or length restrictions set by whatever medium for which one is writing. "Most people who read a Sunday theater column," notes *The Observer* theater critic Michael Ratcliffe,[9] "will never see the shows, so one of my first responsibilities is to make them almost feel as if they had."

Trained journalists are used to writing a hard news story as if it was structured like an inverted pyramid; it starts general and increasingly moves on to the specifics. While some pieces of arts journalism embrace this model, the layout of a review can be as creative as the art it is describing and evaluating. In fact, often the layout of a review is dictated by the nature of the event being reviewed. In generating a piece of creative writing, the critic needs to be free to be creative in a way that best serves the art and the reader. With that said, it still needs to possess the following components:

Naming Names

As a piece of storytelling about storytelling, a review must mention by name the key storytellers—that is, those associated with the play, the production, and the performances. Where in the review they are mentioned, in what order, and what and how much is said about them is largely dictated by the production itself and the critic's determination of what warrants attention, how much attention, and what kind of attention. Typically, the mention of a storyteller by name is followed by some critical evaluation of his/her contribution to the production. At the very least, the following names need to be named in the course of a review:

- The title of the play and, if warranted, its awards or other meritorious or infamous accomplishments such as a Pulitzer Prize or Tony Award;
- The name of the playwright and, if warranted within the context of the critique, a brief description of his/her other works. If the work is a musical, the names of the librettist, composer, and lyricist are required;

- The name of the theater or production company producing the performance being reviewed. Typically, the artistic director is left out of a review of an individual production unless the choice of that production or other "big picture" issues warrant discussion;
- The play's director and, if a musical, the music director and choreographer;
- The artistic and technical designers. Which designers to mention are largely dependent on merit, as reflected in the production. For example, if the costumes are particularly noteworthy, so too is the costume designer; and
- The actors in featured roles and, if warranted, the secondary actors or impressive others.

The Lead

The lead is typically the first thing written by a critic and its location in the review is non-negotiable. The lead is the opening paragraph of the review and typically is no longer than one to three sentences. It immediately brings to light the central, overriding critical point in a review—that is, the critic's reaction to and opinion about a piece of storytelling. It informs the reader where this review is heading before actually heading there and offers insight into a conclusion that will be explained in detail in subsequent paragraphs. The lead has also been referred to as the "hook," "thesis statement," "purpose sentence," and the "talking point" and, in the past, was called "the lede." In journalism, the failure to mention upfront the most central, significant, and interesting elements in an article has long been referred to as "burying the lead."

This opening lead paragraph serves the following key functions:

- It is intended to capture the attention of the reader by being audacious, inquisitive, and intriguing…in one-to-three sentences;
- It immediately sets the critical focus and the tone of the review, and establishes the writer's critical voice. This means that the critic needs to come to terms with his/her disposition on the subject being critiqued by the time s/he writes the lead, for the lead reflects the critic's opinion. It is here that the sliding scale of expectations is a factor, for this serves to temper and influence opinion and the intensity of expression, starting with the lead. Everything written in subsequent paragraphs serves to reinforce and explain the opening paragraph; and
- An enticing piece of creative writing. This opening paragraph needs to lure readers in and encourage them to continue reading. This is accomplished by offering clever wordplay, intriguing content, and bold opinion void of explanation. In fact, the lead does not necessarily need to name names, including the name of the play. Part of the allure of the lead is that

it presents a strong opinion about or reaction to something. What is that something? What justifies that opinion? What caused that reaction? If the reader reads on, s/he will find out.

Those accustomed to posting a 140 character status update on Twitter should have no trouble generating a one-to-three sentence lead that is alluring, attention-getting, and thematically focused.

Although the term "lead" comes from the world of journalism, an alluring, attention-getting, thematically focused opening is not unique to journalistic writing. In fact, examine the opening scene of your favorite movie and see if the cinematic equivalent of the lead doesn't reveal itself and serve the same key functions. Watch the opening moments of your favorite television program and you'll notice the same thing. It is not by coincidence that the alluring, attention-getting, thematically focused opening monologue in the play *Red* (yes, most plays have the equivalent of a lead as well) serves as the alluring, attention-getting, thematically focused opening to this chapter.

Leads are also prevalent in literature (see Follow the Leader, in profile). Let's look at the opening paragraph of Charles Dickens' classic historical novel *A Tale of Two Cities* (1859), which centers on the years leading up to the French Revolution. Dickens not only writes about a nation suddenly in conflict with its own past, but also generations of individual families within that nation struggling to cope with and ultimately break away from the actions of those who preceded them. From this opening statement, *A Tale of Two Cities* moves the reader through a world of paradox and contradiction, which is then supported in the rest of the novel:

> It was the best of times, it was the worst of times, it was the age of wisdom, it was the age of foolishness, it was the epoch of belief, it was the epoch of incredulity, it was the season of Light, it was the season of Darkness, it was the spring of hope, it was the winter of despair, we had everything before us, we had nothing before us, we were all going direct to Heaven, we were all going direct the other way.

Another fine example of a lead in literature is the opening statement of the *Bible* (Genesis 1:1). "In the beginning God created the heavens and the earth" is probably the most famous lead ever written and one that eloquently and concisely sets up all that follows. Attention-getting? Yes. Thematically focused? You bet. Enticing? Most certainly. The lead in a review about the arts needs to be the same.

In a review, the lead also has the freedom to be an audacious and intriguing piece of writing. In fact, because the lead also serves to distinguish one critic's voice from another, it could be argued that it must also be distinctive in tone and temperament. Here are the leads from several reviews of the Broadway revival of *Evita*, which premiered in April 2012. The musical tells the story of Eva Perón, who used her smarts and charisma to rise meteorically from the slums of Argentina to the

Follow the Leader, in profile

Here is a list of the 15 best leads from novels, as determined by the *American Book Review*, a non-profit journal published at the Unit for Contemporary Literature at Illinois State University:[10]

1. "Call me Ishmael." ~Herman Melville, *Moby-Dick* (1851)
2. "It is a truth universally acknowledged that a single man in possession of a good fortune must be in want of a wife." ~Jane Austen, *Pride and Prejudice* (1813)
3. "A screaming comes across the sky." ~Thomas Pynchon, *Gravity's Rainbow* (1973)
4. "Many years later, as he faced the firing squad, Colonel Aureliano Buendía was to remember that distant afternoon when his father took him to discover ice." ~Gabriel García Márquez, *One Hundred Years of Solitude* (1967; trans. Gregory Rabassa)
5. "Lolita, light of my life, fire of my loins." ~Vladimir Nabokov, *Lolita* (1955)
6. "Happy families are all alike; every unhappy family is unhappy in its own way." ~Leo Tolstoy, *Anna Karenina* (1877; trans. Constance Garnett)
7. "riverrun, past Eve and Adam's, from swerve of shore to bend of bay, brings us by a commodius vicus of recirculation back to Howth Castle and Environs." ~James Joyce, *Finnegans Wake* (1939)
8. "It was a bright cold day in April, and the clocks were striking thirteen." ~George Orwell, *1984* (1949)
9. "I am an invisible man." ~Ralph Ellison, *Invisible Man* (1952)[11]
10. "The Miss Lonelyhearts of the New York Post-Dispatch (Are you in trouble?—Do-you-need-advice?—Write-to-Miss-Lonelyhearts-and-she-will-help-you) sat at his desk and stared at a piece of white cardboard." ~Nathanael West, *Miss Lonelyhearts* (1933)
11. "You don't know about me without you have read a book by the name of *The Adventures of Tom Sawyer*; but that ain't no matter." ~Mark Twain, *Adventures of Huckleberry Finn* (1885)
12. "Someone must have slandered Josef K., for one morning, without having done anything truly wrong, he was arrested." ~Franz Kafka, *The Trial* (1925; trans. Breon Mitchell)
13. "You are about to begin reading Italo Calvino's new novel, If on a winter's night a traveler." ~Italo Calvino, *If on a winter's night a traveler* (1979; trans. William Weaver)
14. "The sun shone, having no alternative, on the nothing new." ~Samuel Beckett, *Murphy* (1938)

> 15. "If you really want to hear about it, the first thing you'll probably want to know is where I was born, and what my lousy childhood was like, and how my parents were occupied and all before they had me, and all that David Copperfield kind of crap, but I don't feel like going into it, if you want to know the truth."
> ~J. D. Salinger, *The Catcher in the Rye* (1951)

presidential mansion as First Lady. She became one of the most powerful women in the world, but her greed, outsized ambition, and fragile health made her one of the most tragic. Note the differences in critical voice.

> Ben Brantley, *The New York Times*:[12] "This just in: Eva Perón is still dead. Anyone questioning the veracity of this assertion need only visit the Marquis Theater, where a lavish, worshipful wake is being held for Mrs. Perón."

> Terry Teachout, *The Wall Street Journal*:[13] "Andrew Lloyd Webber gets a lot of abuse, and deserves most of it—but not for *Evita*, which is so much better than *Jesus Christ Superstar* that you wonder how both scores could have been composed by the same man. Whatever its deficiencies as history, *Evita* is a formidable piece of theater."

> Mark Kennedy, *Huffington Post*:[14] "Much of the buzz coming from the new revival *Evita* has been about the spitfire Argentine playing the title role. But all of the heat actually comes from the guy shaking his bon-bon. Ricky Martin is easily the best thing about this revival of Andrew Lloyd Webber's bio of Eva Peron."

> Elisabeth Vincentelli, *The New York Post*:[15] "Last night, *Evita* returned after a 30-year absence from Broadway. The wait was worth it: This is a big, fat, juicy blockbuster of a show."

The Nut Graph

The "nut graph" is a paragraph that states the focus of the review. It should be relatively short and to the point—that is, told "in a nutshell"—and typically follows the lead. While the lead brings to light the central, overriding critical point in a review, the nut graph brings that point into focus. While the lead is intentionally vague or illusive, the nut graph offers clarification. If the lead has not yet mentioned the specific play by name or in any detail, the nut graph does. The nut graph is a transitional paragraph that brings the reader into the body of the review, where all the description, opinion, explanation, and critical analysis lay waiting.

The Descriptive Overview

The heart of the review is the one or two paragraphs that offer a descriptive overview of the work being critiqued. For a theater review, this means a re-creation of the highlights of the play's plot and a description of the play's key characters and

"Ruben Brown made that play there…. Well, I mean he missed the guy completely but he was able to create just enough room for Thomas Jones by whiffing. The air he created on the miss gave Jones enough space to score."
~John Madden, TV sports commentator[16]

their relationships. Subsequent opinion, explanation, and critical analysis is facilitated by the subject being adequately isolated, identified, and described, although this information does not necessarily need to precede it. The description needs to be general enough not to take away the fun of discovery for those who will be seeing the work after reading the review, but detailed enough to accurately capture the essence of the work and the playwright's vision. The descriptive overview is the point of common reference for the critic and the reader, which serves to orient the reader who did not witness the event and helps recall the event for those that did.

Although the enterprise of creating this descriptive overview sounds more like reporting than creative writing, it is both. Condensing and capturing the story behind a two-hour play in one or two interesting paragraphs takes great creativity. It also takes great restraint, for there are three things the descriptive overview should never possess:

TOO MUCH MADDEN. John Madden is a former American professional football player turned Super Bowl-winning head coach, turned color commentator for NFL telecasts including ABC's *Monday Night Football*. He is also known for fronting and serving as color commentator for the popular *Madden NFL* video game. He is famous for his insider's knowledge of the game and infamous for stating the obvious and going on and on when describing a particular play. Herein lies a danger of the descriptive overview in a review: too much Madden. Critics should offer just enough information about a play without ever providing a play-by-play narrative that describes the action scene by scene. Similarly, just enough information about the playwright should be offered to provide sufficient insight into the play. For little-known works, and particularly for world premiere performances of new works, more information about the playwright might serve to place the play into proper perspective. There is a fine line between too much and just enough, and a critic needs to find it, particularly if his/her venue places a word limit on reviews.

SPOILERS. A spoiler is any piece of information that reveals a pivotal plot twist in or outcome of a story. Because enjoyment of fiction sometimes depends upon the dramatic tension, suspense, and surprise that arise within it, the revelation of pivotal plot elements will spoil the experience for those who have not yet partaken in it. So too will the quoting of punch lines. A review should relay an experience, not ruin it.

Ira Glass on Writing, in profile

Ira Glass is the host and producer of *This American Life*, which is a weekly public radio show broadcast on more than 500 stations to about 1.8 million listeners. It is produced by Chicago Public Media, distributed by Public Radio International, and has won all of the major broadcasting awards. It is also often the most popular podcast in the country, with around 700,000 people downloading each week.

This quote comes from a series of programs that Ira Glass did on storytelling that has direct pertinence to those new to writing reviews:[17]

> Nobody tells this to people who are beginners, I wish someone told me. All of us who do creative work, we get into it because we have good taste. But there is this gap. For the first couple years you make stuff, it's just not that good. It's trying to be good, it has potential, but it's not. But your taste, the thing that got you into the game, is still killer. And your taste is why your work disappoints you. A lot of people never get past this phase, they quit. Most people I know who do interesting, creative work went through years of this. We know our work doesn't have this special thing that we want it to have. We all go through this. And if you are just starting out or you are still in this phase, you gotta know it's normal and the most important thing you can do is do a lot of work. Put yourself on a deadline so that every week you will finish one story. It is only by going through a volume of work that you will close that gap, and your work will be as good as your ambitions. And I took longer to figure out how to do this than anyone I've ever met. It's gonna take awhile. It's normal to take awhile. You've just gotta fight your way through.

OPINION. Description tells the reader what there is to experience. Opinion tells whether the experience was worthy and interpretation explains why, which requires elaboration and critical context beyond the scope of a descriptive paragraph. Opinion and interpretation should follow the descriptive overview, not be a part of it.

The "So," "How," and "So What"

Let's go back to the play *Red*. When the artist Mark Rothko asked "What do you see?" to his young assistant as they looked at his latest work-in-progress, this was not meant to be answered with just a description. What Rothko was looking for was an opinion. Not knowing this, the assistant simply answered "Red." When asked "But do you like it," which implied the provision of a reaction to the work, the intimidated assistant simply answered "yes." Rothko railed: "Where's the discernment? Where's the arbitration that separates what I 'like' from what I 'respect,'" what I deem worthy, what has…listen to me now…significance?"

> *"Criticism doesn't mean delivering petty, ill-tempered Simon Cowell-like put-downs. It doesn't necessarily mean heaping scorn. It means making fine distinctions. It means talking about ideas, aesthetics and morality as if these things matter (and they do). It's at base an act of love. Our critical faculties are what make us human."*
> ~Dwight Garner, book critic, *The New York Times*[18]

Rothko is calling for opinion grounded in critical thinking—that is, the provision of evidence and explanation that serves to support an opinion. Like the readers of our reviews, he will not accept opinions that are not convincingly supported by evidence and a strong argument. In fact, without evidence and a strong argument, readers will be frustrated and a critic's credibility will diminish in the eyes of the artists being critiqued.

In terms of writing a review, the paragraphs that offer critical thinking need to be in support of the lead; that is, they serve to justify, explain, and offer elaboration on the opinion expressed in the lead. They are to be guided by the notes gathered during the performance and they need to be bolstered by evidence in the form of description from key moments in the work itself. In short, these paragraphs need to ask and answer the following:

- The "so," as in "So, what is particularly intriguing—in both a positive and negative sense—about this play (in terms of its fabricated world and population, its employment of storytelling conventions, and the story being told), this production (in terms of the many creative choices associated with interpreting and staging this play), and these performers (in terms of the degree of conviction, virtuosity, presence, and consistency evident in their performances)? It is here that the previous discussion of critical context comes into play. Beyond simply identifying and discussing what is particularly intriguing about a work, the critic must also critically analyze the complexities, complications, and implications associated with the work—perhaps by demonstrating its similarities and differences with other works by the same artist (auteur criticism), other works within the same genre (genre criticism), other works of the time period in which it was created (anthropological criticism), or by discussing the impact of the work on the audience (sociological criticism);

- The "how," as in "How is this play, this production, and these performances able to accomplish what they did? In addition to dissecting the work and attempting to explain the mechanisms of its creation and pre-

sentation—that is, the playwright, director, designer, and actors' choices—some description of those choices are in order. Explanation and analysis can't be effective without being accompanied by evidence that allows the reader to experience what the critic and audience experienced. "The purpose of a critic," wrote music critic Allan Rich,[19] is "not to lead his readers into blindly accepting his truths, but to stimulate them, delight them, even irritate them into formulating truths which are completely their own." This is accomplished here; and

- The "so what," as in "So What? What are we to take away from this play and this production of it," which makes sense of the significance of the event at hand. Recall that the "so what" is the bottom line of critical analysis—the definitive answer to the most important questions raised about the work; questions first raised by Johann Wolfgang von Goethe, a 19th century author, philosopher, and intellectual: What is the artist trying to say? Did the artist succeed? Was it worth the effort?

> *"[Opinion is] the main ingredient. That's the risk that a writer takes, similar to the risk that an artist takes. And opinions are just great fun to read."*
> ~Roberta Smith, visual arts critic[20]

The Kicker

A short, alluring, attention-getting, thematically focused, and opinionated lead paragraph has been written, followed by a short, clarifying, transitional nut graph. One or two paragraphs that offer a descriptive overview of the work being critiqued have also been written, as have additional paragraphs that serve to describe, explain, and critically analyze the work in an effort to justify and bolster the opinion expressed in the lead. Within them, the "so," "how," and "so what" have been asked and answered. The work has been placed into an appropriate critical context that helps showcase the work's complexities, complications, and implications. What needs to be written next is a final paragraph that serves to summarize what has transpired in the review and turn all that enterprise into action.

This paragraph, referred to as the "kicker," typically does the following:

- Recalls the sentiments first expressed in the lead. These sentiments have carried over to the rest of the review and served to guide explanation and critical analysis, but the point can and should be reinforced and driven

home in the final graph. That way, the review—storytelling about story-
telling—is a complete and comprehensive tale with an enticing beginning,
descriptive and analytical middle, and a conclusive ending;

- The "so what" addressed in a previous paragraph asked the question, albeit
 implicitly, "was experiencing the work worthwhile?" This final paragraph
 condenses and clarifies the answer that has been provided in subsequent
 paragraphs; and

- Offers a recommendation. Critics are standard bearers for the audience.
 As such, they must challenge the audience to be more perceptive and selec-
 tive consumers of the arts they attend, more receptive to the ambitious
 and innovative arts they do not attend, and more demanding of the arts
 in their community.

The Title

Editors tend to prefer to write their own titles for a critic's work, although most
critics would prefer to write their own and occasionally get their way. Much like your
lead, the title needs to be short, eye-catching, enticing, and reflective of the major
point made or conclusion drawn in the review. A good strategy (see Guidelines to
Writing a Good Headline, in profile) is to mine through the completed review and
find a cleverly worded phrase or key idea and turn it into a suitable title. Clearly,
the title is typically the final thing that is written by a critic.

Characteristics of a Good Read

It was noted earlier that a review is both a piece of creative writing as well as a piece
of arts journalism. As such, it needs to be a good, interesting read as well as an infor-
mative, insightful, and well-structured read. This far, this chapter has examined the
key components of a review that make it an informative, insightful, and well-struc-
tured read. What follows are the ingredients that help make a review a good read:

1. **Present tense.** Although you are reporting on an event that has transpired and
 will be tempted to write in the past tense, the event is still ongoing—that is,
 the play or art exhibit being critiqued is still in production. Your readers may
 be future audience members. The review will come across as more dynamic,
 immediate, and relevant if written in the present tense and with an active voice.

2. **Style as well as substance.** It has been suggested that each critic find a dis-
 tinctive voice with which to approach a work of art and through which to relay
 his/her opinions about it to readers. A critical voice is often what separates
 one critic from another. As was noted in the previous chapter, a critical voice
 is developed through a composite of expertise, tone, style, and orientation, and

Guidelines for Writing a Good Headline, in profile[21]

KEEP IT SHORT. Seven words or less is a good rule of thumb. Shorter headlines are eye-catching and easier to read.

CREATE CURIOSITY. This can be done by asking a provocative question or making a seemingly outrageous statement. Word play, alliteration, or take-offs on familiar phrases or clichés work as well. However, avoid ambiguity. If your readers have to guess at what you mean or at the focus of the review, they'll stop reading.

STATE THE BENEFIT. Tell your readers about the primary benefit found in the review. Offer a solution to a problem.

DON'T REPEAT THE LEAD. The headline, like the lead, should focus on the main point of the review. But if the title and the lead are too similar, the lead will become redundant, less interesting, and less functional.

MAKE YOUR HEADLINE APPROPRIATE TO THE STORY. The tone of the headline should match the tone of the review. Similarly, make sure that your headline supports the body of the review. If you ask a question, be sure to provide an answer. If you promise to solve a problem, be sure to offer a solution.

HEADLINES SHOULD SING. Headlines should have a rhythm about them. The words should flow, which creates a smooth transition to the review that follows.

FOLLOW THE RULES. Follow the same rules established for the review itself: present tense, critical voice, third-person perspective.

FACILITATE SEARCH ENGINES. Search engines use headlines in their search results to help users find information on the web. To facilitate traffic to your outlet's website, a headline needs to strike a balance between utilitarian and creative. It should include a key word or phrase that someone looking for your topic will use, but it's also important because it actually convinces the reader to go to your writing in the first place.

BE ACCURATE. The pursuit of keywords to facilitate Internet traffic can lead to inaccuracies. For example, the *Huffington Post* used the headline "Tiger Woods Sex (Video)" to successfully entice users to a nature video.

develops over time and through experience. Whatever the voice, it is important that it remain consistent from the lead to the kicker and from one review to the next. It is also important to be engaging, entertaining, and grammatically sound.

3. **Fluidity.** As storytelling about storytelling, a review should flow from beginning to end and be an easy, enjoyable read. As such, each paragraph should naturally and fluidly transition from one to the next without being abrupt or awkward. Individual sentences should not be run-on constructions that go on for too long or contain too much information, and they should naturally and fluidly transition from one to the next. Also, short paragraphs are quite permissible in reviews.

4. **Balance.** Theater critic Jonathan Kalb noted that, for many, entertainment entails "renting a video and watching it on a private box inside a private box," which is an "unthinking envelopment" of an enterprise.[22] The critic serves as the surrogate audience member who is also sucked into the vortex of entertainment, but has the wherewithal, discipline, and responsibility to remain partially removed from the experience. A well-written review strikes a balance between describing a moment as if lost in it and sober reflection, explanation, and analysis.

5. **Optimism and open-mindedness.** It is typically best to go into an arts experience hoping for the best tempered by realistic expectations. This allows the work itself to meet, surpass, or fall below expectations. It is just as important to be open to new forms of artistic expression and what they have to offer.

6. **Support.** For every opinion there should be evidence—an established reason or basis for judgment.

7. **Proofread your work.** Whether through confusion or carelessness, errors happen. Checking for typos and wrong-word errors is not a job you can hand over to your spell-checker or grammar-checker. Such programs cannot be relied on to catch every error every time—and they may even introduce an occasional wrong-word error, such as using "accept" for "except" or "advice" for "advise." If not caught, such errors reduce your credibility as well as the quality of your observations and critical analysis (see Being Word Savvy, in profile).

Summary

"What do you see?" asks Rothko at the very end of the play *Red*. After 67 pages of dialogue that dissect the creative process—the making of art, the appreciation of art, the collection of art, and the critiquing of art—after 90 minutes of perfor-

Being Word Savvy, in profile

According to Nancy Ragno, in her book *Word Savvy: Use the Right Word Every Time, All the Time*,[23] English has a larger, richer vocabulary than any other language in the world. "With so many words, so many choices," she notes, "it is all too easy to mistakenly choose the wrong word and introduce an error into your writing" (p. 6).

It is up to the writer to catch and correct errors through careful proof-reading. Here are some useful guidelines:

ALLOW SOME TIME TO ELAPSE BETWEEN WRITING AND PROOFREADING. When you proofread immediately after writing, your brain remembers what you just wrote and makes it difficult to proofread objectively.

CONTROL YOUR ENVIRONMENT. Choose a quiet time to proofread and a quiet room. You need to be able to concentrate and not be interrupted.

PROOFREAD WHEN YOU ARE MENTALLY ALERT. You won't spot errors if you are mentally or physically exhausted.

READ OUT LOUD. If you can't read aloud without disturbing others, sub-vocalize; that is, read softly to yourself. Use proper intonation as you read. It will help you spot faulty sentence construction, incorrect punctuation, and grammatical errors.

CONCENTRATE ON READING ONE WORD AT A TIME. As you read aloud word by word, make an effort to concentrate on each individual word and ask yourself if it is the right word. Be aware that we all have a tendency to mentally fill in missing letters we don't see on the page.

READ WITH A DOUBT IN YOUR MIND. Assume that each word is incorrect. Be skeptical. This will help you read word-by-word and not be distracted by the meaning of what you are reading.

BE ON THE ALERT FOR YOUR MOST COMMON MISTAKES. Most of us have certain "pet mistakes" we make repeatedly. Be overtly aware of these as you proofread your work.

PROOFREAD THE ENTIRE DOCUMENT LINE BY LINE. Read methodically line-by-line. If necessary, use a ruler to guide your eyes so you don't miss a line. There is a natural tendency to skip over headings and get to the "real reading." Don't.

READ HARD COPY. It is hard to spot errors on the computer screen, and you may not be able to see an entire page at a time. Print out the document and proofread the hard copy.

PROOFREAD MORE THAN ONCE. Proofread once for misspellings and punctuation errors, another time for wrong-word errors.

IDEALLY, HAVE SOMEONE ELSE PROOFREAD YOUR WORK, AS WELL. Even if you are superb at editing, it is very difficult to spot your own errors. Because you are so familiar with your writing and can almost recite parts of it by heart, you will have a natural tendency to scan what you have written and miss errors.

mance, and after two years of apprenticeship have elapsed in the world of the play, Rothko's young assistant answers the question "What do you see?" with: "Red."

As was just discussed, opinion begins with first impressions and gut reactions. When expanded to include description, opinion, and explanation, first impressions become insightful pieces of critical analysis. When written with precision and artistry, they become effective and interesting reviews. To summarize, here is a checklist of the Top-10 components of an effectively written critical review:

- The lead is alluring, attention-getting, thematically focused, and limited to one-to-three sentences.
- The body of the review serves to support the lead by describing, explaining, and critically analyzing its thematic focus. The review's conclusion—the kicker—is directly connected to the lead.
- The review names the playhouse, the play, the playwright, the director, key designers, and significant performers.
- The review has a distinctive critical voice while avoiding the first person narrative and the past tense.
- The play, the production, and the performance are all touched on in the essay.
- The essay is a fluid piece of storytelling about storytelling. One paragraph flows into the next. There exist transitional statements either at the end of one paragraph that leads into the next or at the beginning of the next paragraph, which ties into the previous paragraph.
- There is not too much Madden, there are no spoilers, and there are no run-on sentences.
- The critic places blame and credit where they belong.
- The review adequately addresses the "what" (description), "so" (opinion), "how" (explanation and analysis), and "so what" (conclusion).

- All opinion is backed up with explanation to prove a point; all explanation is backed up with example and description to demonstrate the point.

The final chapter offers an opportunity to put this checklist into play by dissecting and critiquing a professional review of a professional performance of the play *Red*.

KEY CONCEPTS FROM THIS CHAPTER

Active voice	Participant observer
Burying the Lead	Peopled ethnographies
Critical contexts	Present tense
Descriptive observation	Proofreading
Descriptive overview	Selective observation
Field notes	Sliding scale of expectations
First impressions	Spoilers
Focused observation	The "how"
Inverted pyramid	The "so"
Kicker	The "so what"
Lead	Too much Madden
Nut graph	Visual memory

NOTES

1 Lyn Gardner, "In the Theatre, Sometimes Ignorance is Bliss," *The Guardian*, May 14, 2009, http://www.guardian.co.uk/stage/theatreblog/2009/may/14/ignorant-critics-challenging-theatre (accessed June 3, 2012).

2 Cited in John Logan, *Red* (London: Oberon Books, 2009), 9–10. *Red* was first performed at Donmar Warehouse, London, on December 3, 2009. It was first performed on Broadway at Golden Theatre, New York, on March 11, 2010.

3 From Oswald Werner and G. Mark Schoepfle, *Systematic Fieldwork: Vol. 1. Foundations of Ethnography and Interviewing* (Newbury Park, CA: Sage Publications, 1987). This work was cited in Norman K. Denzin & Yvonna S. Lincoln (Eds.), *Handbook of Qualitative Research* (Thousand Oaks, CA: Sage, 2000), 673–702.

4 Francis Fergusson, *The Idea of a Theatre: A Study of Ten Plays, The Art of Drama in Changing Perspective* (Princeton, NJ: University of Princeton Press, 1949), 11.

5 Cited in David Grann, "The Mark of a Masterpiece," *The New Yorker*, July 12, 2010, www.newyorker.com/reporting/2010/07/12/100712fa_fact_grann (accessed July 12, 2010).

6 Cited in Suzanne Hudson, *How to Write About Theatre and Drama* (New York: Harcourt College Publishers, 2000), 29.

7 Gary A. Fine, "Toward a Peopled Ethnography Developing Theory From Group Life," *Ethnography*, 2003, 4(1), 41–60.

8 Cited in Don McLeese, *The New York Times Reader: Arts & Culture* (Washington, DC: CQ Press, 2011), 114.

9 Michael Ratcliffe, "Non-Parochial View," *Plays International*, April 1988, 22.

10 Cited in http://www.pantagraph.com/news/article_a125216a-649f-5414-88b5-76a688ea3b6a. html#ixzz1qi5grS1a (accessed March 31, 2012). This list is based on the input of dozens of writers, reviewers, and literary scholars across the country, and a few in Europe, who were asked to nominate "great first lines."

11 Charles Dickens' *A Tale of Two Cities* was ranked #9 on this list. Because it is already cited in this chapter, it was excluded to make room for an additional listing.

12 Cited in http://theater.nytimes.com/2012/04/06/theater/reviews/evita-starring-elena-roger-at-the-marquis-theater.html (accessed July 24, 2012).

13 Cited in http://online.wsj.com/article/SB10001424052702303299604577324311953757058.html (accessed July 24, 2012).

14 Cited in http://www.huffingtonpost.com/2012/04/05/evita-review-ricky-martin_n_1407387. html (accessed July 24, 2012).

15 Cited in http://www.nypost.com/p/entertainment/theater/you_must_love_che_WMFrjwJmuK264KxT8MjTOM (accessed July 24, 2012).

16 Quote retrieved from http://thehonolulublue.wordpress.com/2010/08/16/dumbest-john-madden-quotes-of-all-time/ (accessed March 31, 2012).

17 Cited from http://www.youtube.com/watch?v=BI23U7U2aUY (accessed March 31, 2012).

18 Dwight Garner, "A Critic's Case for Critics Who Are Actually Critical," *The New York Times*, August 15, 2012, http://www.nytimes.com/2012/08/19/magazine/a-critic-makes-the-case-for-critics.html?pagewanted=1&_r=2 (accessed August 16, 2012).

19 Cited in Robert D. Thomas, "Obituary: Alan Rich," *Pasadena Star-News*, April 24, 2010, http://classact.typepad.com/robert_d_thomasclass_act/2010/04/index.html (accessed May 11, 2011).

20 Cited in Don McLeese, *The New York Times Reader*, 12.

21 These recommendations are inspired by Jacci Howard Bear, "How to Write Effective Headlines," http://desktoppub.about.com/cs/techwriting/a/headlines.htm (accessed June 6, 2012); Tony Rogers, "Write Great Headlines," http://journalism.about.com/od/writing/a/headlines.htm (accessed June 24, 2012), and cited in Alexandra Fenwick, "Huffington Post and the Art of the Headline," *Columbia Journalism Review*, May 10, 2010, http://www.cjr.org/behind_the_news/huffington_post_and_the_art_of.php (accessed June 27, 2012).

22 Jonathan Kalb, *Play by Play* (New York: Limelight Editions, 2003), 34.

23 Nancy Ragno, *Word Savvy: Use the Right Word Every Time, All the Time* (Ontario, Canada: Writer's Digest Books, 2011).

"Bit by bit, putting it together
Piece by piece, only way to make a work of art
Every moment makes a contribution
Every little detail plays a part"
~Lyrics to "Putting it Together" from
Stephen Sondheim and James Lapine's
Sunday in the Park with George

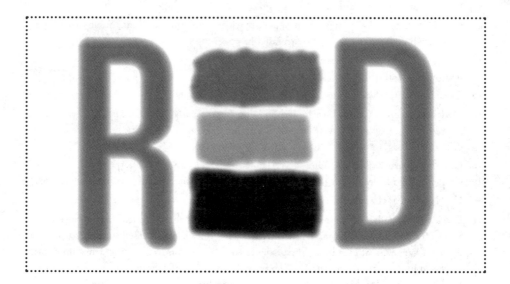

Chapter 11 Abstract

This chapter applies all that was learned in previous chapters to an actual review written by professional theater critic Peter Mark and published in *The Washington Post*. His review of John Logan's 2010 Tony Award-winning *Red* will be thoroughly deconstructed and his explanation for what appears in the review and why will be provided in an effort to transform theory into practice.

Deconstruction of a Critique

R eading about researching before a performance or exhibition, the taking of notes during a performance or exhibition, and the process of writing a piece of arts criticism after a performance or exhibition is not the same thing as actually putting these things into practice. To help facilitate this enterprise, this chapter offers for examination a published theater review that has undergone these various stages of development.

The performance being reviewed was an equity production of the drama *Red* by the Arena Stage in Washington, D.C. The review was written by the chief theater critic for *The Washington Post*, Peter Marks. The review is presented here with a running narrative by its author that offers insight into his creative process—that is, the research that was done, the note taking that was performed, the choices that were made, and the intentions behind them. By deconstructing a critique, it is hoped that we will be able to:

- witness the application of critical thinking and critical writing in a finished piece of arts journalism;
- identify key concepts discussed in previous chapters in a published work; and
- recognize the creative aspects of arts journalism and how there is no set formula or one way to approach and review a work of art.

A Case Study in Criticism

The Critic

In a 2011 *American Theatre* article by David Cote, theater editor at *Time Out New York*, Peter Marks made the cut as one of the "nation's 12 most influential theater critics." According to the article,[1] being influential requires the following ingredients:

Years on the beat, quality of writing, reach of their voice through syndication, and, lastly, understanding of the field…. As such, they form a vital phalanx of critical opinion that chronicles and weighs work that national media outlets are content to ignore.

Here is what *American Theatre* magazine had to say about Peter Marks:

As befits a guy who covers theater in our nation's capital, Peter Marks is politic in his remarks: He admires the companies on his Beltway beat, but sees where they can grow; he cut his teeth on the New York scene, but observes that its influence has waned. He divides his time between Washington, D.C. and New York—a balancing act, he admits.

Born in Brooklyn and raised in New Jersey, Marks was a theater reporter for *The New York Times* when, in 1995, the arts editor asked if he was interested in the second-string critic position. For better or worse, the affable reporter discovered that he harbored a critic inside. From 1996 to '99, Marks distinguished himself as one of the most respected Off-Broadway critics the *Times* ever had: a clear, engaged writer and an open-minded reviewer of new work at the city's nonprofit companies.

It continues:

He took those talents to *The Washington Post* in 2002, where he finds the theatre scene "surprisingly vibrant. It's one of those eternal secrets, because people think of D.C. for politics and museums—they don't think of it as a performing-arts town." Marks often gets asked if there's a lot of political theatre in Washington. "They get so much political theatre during the day," he says with a chuckle. "It's the last thing they want." While he has seen D.C. become more of a conduit of Broadway shows—recent productions of *Next to Normal*, *Ragtime*, and *Follies* all came from his town—Marks would like to see his city develop more of a sense of locality.

It should also be noted that, prior to the *Post* and *Times*, Peter Marks was a reporter for the New Jersey's *The* (Bergen) *Record* and New York's *Newsday*, where he was a member of a team that won a Pulitzer Prize for coverage of a New York City subway crash. He is a graduate of Yale and a lecturer at The George Washington University.

The Critic's Process

Every critic approaches the preparation for and writing of a review in his or her own way. "My process," notes Peter Marks, "is to simply start writing." More specifically, here is how our critic describes his approach to his work.

RESEARCH. "The preparation I do before seeing a play or musical is customized for each show. I virtually never read a new play before I see it—it is meant to be encountered first on a stage, and that's how I like to treat it. If the work is by a playwright who's written another noteworthy piece, I may read that in advance. On occasion, a theater producing a new musical will send me a CD of a couple of songs, and I will listen to that, just to familiarize myself with the show's musical style. For revivals of classics, I often will read the play—because the crux of the evening is what

The Washington Post, in profile

The Washington Post is the most widely circulated newspaper in Washington, D.C.—with an average daily circulation of 507,465 and an average Sunday circulation of 846,019—and is the 6th most read paper in the nation.[2] The majority of its newsprint readership is in the District of Columbia and its suburbs in Maryland and Northern Virginia.

Located in the nation's capital, it has a particular emphasis on national politics. *The Post* has won 47 Pulitzer Prizes, including six separate awards in 2008. *The Post* has also received 18 Nieman Fellowships and 368 White House News Photographers Association awards, among others.

The Post is the oldest existing paper in the area, having been founded in 1877 by Stilson Hutchins who, in 1880, added a Sunday edition. In 1899, during the Spanish–American War, *The Post* printed Clifford K. Berryman's classic illustration "Remember the Maine," which became the battle-cry for American sailors during the War. In 1902, Berryman published another famous cartoon in *The Post*—"Drawing the Line in Mississippi"—that depicted President Theodore Roosevelt showing compassion for a small bear cub. The cartoon inspired New York store owner Morris Michtom to create the teddy bear.[3]

In the early 1970s, in one of *The Post*'s best-known enterprises, reporters Bob Woodward and Carl Bernstein led the investigation into the Watergate scandal that contributed to the resignation of President Richard Nixon. Ben Bradley was the editor at the time. Currently, Marty Baron is executive editor .

this new production of it brings to the work that is novel. If a show is adapted from a book or a movie, I might read or watch the source material. But the rules are not hard and fast, especially in the fall and spring, when the theater schedule tends to be packed with openings, and I have less time for preparation.

During the performance, I do not write anything down during the first five minutes of a play so that the production is afforded the opportunity to work its magic. But even when I don't take notes, the pad is a way of reminding me of the need to be observing as well as experiencing."

PARAMETERS. "I don't have a set word length, but a review of a major production will run between 800 and 1,000 words. The day I file the review, I will discuss a length with my editor. The length can be affected by the day of the week the review runs, because the print version still dictates how long a review can be. Saturdays, for example, are very tight, space-wise [based on the amount of content in proportion

to advertising], so a review that day will be a maximum of 500 words or so. (I don't write longer versions of reviews for the web—that's still viewed as providing print readers lesser service.)

The time lapse between seeing a show can vary, too, but often in Washington, I attend a performance at night, get up the next morning and write and file the review by midday. It's then edited, usually by the theater editor, passed on to a copy editor, and then posted online that evening. And it appears in the print edition of the Style section the next morning. In the case of *Red*, I saw it at Arena Stage on the afternoon of Saturday, January 28, and wrote the review the next morning."

WRITING STYLE. "I write in one take, and in my idiosyncratic process, I have to perfect a paragraph before I can go on to the next. (Of course, I will go back and tweak a sentence, refine a transition, here and there.) The most important paragraph is the lead, and until I've figured out what kind of lead I want, I can't move on. The lead provides me my road map for the rest of the piece. For *Red*, a positive review, I decided to begin with a description of one of the show's strongest moments, so that a reader would instantly feel immersed. It's a play that relies strongly on visual impact, and I wanted to create the same sort of impact for a reader. As I write, I continually go back and read what I've written, to make sure the review flows. I read to myself aloud, so I can hear the words, too. I probably read the piece 15 or 20 times as I'm completing it. Then when I'm finished, I read it once more before I press the 'send' button, to check dates and name-spellings. The *Red* review was 858 words long—a substantial piece—and it probably took me in the neighborhood of three hours to construct."

READERSHIP. "I strive to write for people who are: intelligent, open-minded, seeking to be stimulated. I try to be inclusive, to take into account those who don't know as much about the theater as I do. But I also don't want to talk down to the readers. I figure that if I am going to use a slightly technical term, readers have the option of looking these up. I also include links to other articles in the online versions of my reviews, to provide some easy access to other sources."

The Play

The subject of Peter Marks' review is the Arena Stage production of John Logan's 2010 Tony Award-winning *Red* in Washington, D.C. The play had its premiere run on the West End of London before going to Broadway. Its run at the Arena Stage at the Mead Center for American Theater was from January 20 to March 11, 2012, with ticket prices ranging from $40–$100. Here is a synopsis of the play offered in the Arena Stage's promotion of its production:[4]

A visceral, "superbly taut" (*Chicago Tribune*) battle of wills, *Red* drops you squarely inside the world of painter Mark Rothko and sets your heart pounding. At the height of his career, Rothko struggles with a series of grand-scale paintings for NY's elite Four Seasons restaurant. When his new assistant challenges his artistic integrity, Rothko must confront his own demons or be crushed by the ever-changing art world he helped create.

Elsewhere on the theater's website[5] is this description:

Winner of six Tony Awards, including Best Play, *Red* depicts one of the 20th century's finest artists at his greatest moment of struggle with his painting and his mortality. The brilliant and passionate Mark Rothko has hired a new assistant to help him with his most perplexing challenge yet: to create a definitive group of murals for an exclusive restaurant. As they mix the paint, stretch the canvas, and prime the surface, Rothko must reconcile not only the mix of art and commerce he's creating but also his relationship with the new generation of artists who threaten his very legacy. Hailed as "smart and scintillating" by the *New Yorker, Red* is an "electrifying play of ideas" (*Variety*).

Adjacent to the summary blurb on the theater's website[6] was the following statement from playwright John Logan that offers some insight into his creative vision for this play:

It was the paintings. It all comes back to the Seagram's Murals for me. I was working in London and I happened to go to the Tate Modern museum. Walking into that room and being among those grand and brooding murals for the first time was almost overpowering. They touched me, mostly because of their sense of profound seriousness. I read the little description on the wall of the gallery and knew, immediately, there was a play in Rothko's complicated relationship with his work. Almost as immediately I knew it had to be a two-hander, to reflect the vibrant interplay of the colors on the canvasses. For me *Red* has always been binary: red/black; light/dark; young/old; teacher/student; father/son. In the end if you don't like the play, blame me, not the paintings. They are mute, magnificent and unassailable.

Perhaps most insightful of all are the words of Mark Rothko himself, who describes his paintings using terms from the world of theater in his essay "The Romantics Were Prompted:"[7]

I think of my pictures as dramas; the shapes in the pictures are the performers. They have been created from the need for a group of actors who are able to move dramatically without embarrassment and execute gestures without shame. Neither the action nor the actors can be anticipated, or described in advance. They begin as unknown adventure n an unknown space.

The Playhouse

Founded in 1950 by Zelda Fichandler, Thomas Fichandler, and Edward Mangum, the Arena Stage[8] was one of the nation's original resident theaters, and has a distinguished record of leadership and innovation in the field. With the 2010

The Review

Review: The hues blend evocatively in Arena Stage's 'Red'[10]

A

By Peter Marks, *The Washington Post*

1 For all its highfalutin discourse—on abstract expressionism,
2 Dionysus vs. Apollo, the pernicious advance of pop art—the most
3 engrossing moment of Arena Stage's immensely enjoyable *Red* comes
4 when the two actors dip their brushes into buckets and paint.

B

5 The activity in which the superbly matched Edward Gero and
6 Patrick Andrews engage, in point of fact, is priming a canvas half again
7 as tall as the two of them. The priming becomes primal. As the clas-
8 sical music on a phonograph swells, the painters spring into action,
9 splashing on the liquid in great, rhapsodic strokes. The exercise takes
10 on both a spiritual intensity and an almost sexual energy—a charac-
11 teristic spotlighted when, in the aftermath of the explosive exertion,
12 the panting Gero lights up a cigarette.

C

13 The pleasure of the interlude, as constructed by playwright John
14 Logan and conducted by director Robert Falls, is in the way it conveys
15 the full, symbiotic immersion of the characters: Gero's Mark Rothko,
16 the vain, abrasive creator of all those mesmerizing canvases of migrat-
17 ing mood and undulating color, and Andrews's Ken, a composite of
18 the assistants who toiled in Rothko's Manhattan studio throughout
19 his working life, which ended in suicide in 1970.

D

20 The sequence eloquently reminds us of a joy we rarely get to see:
21 the artist consumed by the everyday physical demands of his work, an
22 act by which the intellectual and emotional weight of his other con-
23 cerns—his reputation, his hubris, his self-doubt—is for the moment
24 banished. It looks like so much fun, such a terrific workout, that we
25 all want to get up on the stage of the Kreeger Theater and splatter
26 primer onto the canvas with them. It helps, too, that set designer Todd
27 Rosenthal has conceived of Rothko's work space as such a vigorously
28 messy environment for genius, and the lighting by Keith Parham
29 puts so luminous an accent on the radiant dimensions of the painter's
30 works-in-progress.

E

31 The convulsive frenzy in which the actors complete the priming is
32 a reflection of other powerful forces at work in *Red*, Logan's portrait
33 of Rothko in the late 1950s, when the painter was in the midst of one
34 of his most important commissions, a series of murals for the new F
35 Four Seasons restaurant occupying the bottom floors of a landmark
36 of 20th-century architecture, Mies van der Rohe and Philip Johnson's
37 Seagram Building.

38 How authentically Logan has framed the issues of *Red* is a mat-
39 ter better left to the art world's keener arbiters. What can be easily
40 deduced from Falls's production—an excellent successor to the Tony-
41 winning version directed by Michael Grandage and starring Alfred
42 Molina and Eddie Redmayne—is that Rothko has been translated G
43 for the stage into a marvelous character. Tyrannical, bombastic, nar-
44 cissistic, he has a bedside manner you wouldn't wish on the most cra-
45 venly ambitious intern.

46 And yet, beyond the vision and the artistry, this Rothko redeems
47 himself in a profound yearning to be tested, to discover whether he
48 truly merits a place in the pantheon. Over the course of the play, per-
49 formed without intermission, Rothko acknowledges anxiety over the
50 pop-art movement that is supplanting abstract expressionism. Ken,
51 for his part, pricks Rothko's conscience, telling him the Four Seasons H
52 commission subverts his long-held values. In the final throes of the
53 drama, after finally letting Rothko have it—decrying his paranoia,
54 self-absorption and lack of generosity—the younger man says he
55 expects now to be fired. "Fired?" the painter replies. "This is the first
56 time you've existed."

57 Gero, in owlish glasses and unsmiling demeanor, is the resonant
58 embodiment of an uncompromising artist with an overdeveloped sense
59 of grievance. He's the advocate here for a rigorous, cerebral rationale for
60 art and though it reeks of self-importance, it's also to be admired. "A
61 generation that does not aspire to seriousness, to meaning, is unwor-
62 thy to walk in the shadow of those who have gone before," Rothko I
63 instructs Ken. Out of Gero's mouth, the words have an almost threat-
64 ening edge—there's a desperation in this artist's pronouncements, a
65 poignant need to shout over what he perceives as the noise of a com-
66 munity that's beginning to turn away from him.

68 Ken is, in a sense, that community: He's the voice of that emerging
69 generation, one that sees the consumer culture as a suitable subject
70 for art and won't yield to Rothko's definition of seriousness no matter
71 how many tantrums he throws. Compact and muscular, with a gaze
72 as stony as Gero's, Andrews proves to be an ideal choice for Ken, who J
73 slowly uncovers his own reservoir of rage and strength. The actor skill-
74 fully negotiates the play's thorniest narrative embellishment, the story
75 of Ken's traumatic childhood. In a lesser production, this confessional
76 element might have pushed *Red* into mushier swampland. But the steel
77 in Andrews's affect keeps the sentimentality at bay.

78 Both the painter and his assistant know from pain; it's as certain
79 an ingredient in their work as the pigments they mix into the buckets.
80 Maybe that helps explain why Rothko and his young employee find K
81 in the act of priming a canvas a cathartic common pursuit. They don't
82 simply aim to prime that canvas. They want to unleash the Furies on it.

83 by John Logan. Directed by Robert Falls. Set, Todd Rosenthal;
84 costumes, Birgit Rattenborg Wise; lighting, Keith Parham; original L
85 composition and sound, Richard Woodbury. About 1 hour, 40 minutes.

opening of the new Mead Center for American Theater, Arena Stage has become
a national center for the production, presentation, development, and study of the
American theater. Under the leadership of Artistic Director Molly Smith and
Executive Producer Edgar Dobie, Arena Stage has become the largest theater in the
country dedicated to American plays and playwrights—that is, American classics
as well as premieres of new American plays and the support of works in progress.
The theater serves a diverse annual audience of nearly 300,000.

Arena Stage's production of *Red* was in partnership with Goodman Theatre
in Chicago,[9] Illinois, where it first ran from September 17 to October 30, 2011,
including a week-long extension due to popular demand. The cast boasts of both
D.C. and Chicago AEA actors. The play opened in Arena Stage's 514-seat Kreeger
Theater, and its 8½ week extended run made it the highest-grossing non-musical
in Arena Stage's history.

The Deconstruction

This section of the chapter does several things. First, it isolates each paragraph
in Peter Marks' review so they can be easily explored and explained. Next, a brief

description of each paragraph is presented that calls attention to its key components, which are often identified by their line (in numbers) or paragraph (in letters) in the finished product. Finally, Peter Marks offers his explanation for why that paragraph does what it does and how it contributes to and serves the entire review. His thought process at the time of writing is also provided.

Paragraph A, the title

The hues blend evocatively in Arena Stage's *Red*.

This title, which plays on the concept of color in reference to the play's title, was created by one of the paper's copy editors and not the critic.

ACCORDING TO THE CRITIC: "Traditionally, headline-writing has been the responsibility of the copy editor, so by training I remain somewhat removed from that task. 'Somewhat' because now, on the electronic form I use to file my stories to my editor, I'm required to suggest a headline. I tend to dash these off in a hurry. To my surprise, they sometimes make it into the paper. Not this time."

Paragraph B, lines 1–4

> For all its highfalutin discourse—on abstract expressionism, Dionysus vs. Apollo, the pernicious advance of pop art—the most engrossing moment of Arena Stage's immensely enjoyable *Red* comes when the two actors dip their brushes into buckets and paint.

Everyone who sees this particular performance of *Red* will have an opinion. The challenge, as the critic, is to immediately hook the reader into the world of artist Mark Rothko, as seen through the eyes of playwright John Logan. Out of the 858 words used across 10 paragraphs that are comprised of 85 lines, Marks' lead uses only 39 words in one paragraph that consists of one sentence. That may seem like too few words for a lead, and a lot of words for one sentence, but that sentence makes its point and flows seamlessly, giving the reader a chance to breathe thanks to the use of dashes. Marks starts this lead with a strong, intelligent, engaging statement and ends with a vivid visual image—an image that will be revisited throughout the review. Note how he chooses to mention the play and the theater by name from the get-go in order to set this one, pivotal action in the production above all else.

ACCORDING TO THE CRITIC: "I've been thinking about my lead since I walked out of the theater. I can key on an aspect of a performance or ask the reader a question. With *Red*, the choice is easy, because there is an extraordinary scene that brings everything together: when the two characters prime the canvas. I was mesmerized by what they were doing. My process is to start writing. I have to have the lead pristine before moving onto the second paragraph. I don't outline. In my head I'm thinking I need to convey immediately what I felt about the play, and this scene came to mind.

It's vital to provide in the initial paragraph—or somewhere at the top of the second—the title of the play you are seeing, as well as the name of the company presenting the work. You have to assume that readers don't have a lot of patience when they read, that they will hang around waiting for you to identify the production you've attended. That's why I'm also conscious of writing in the way that conveys near the top how I felt about the work. Sometimes, that's accomplished with a well-placed adjective or phrase ('*Immensely enjoyable*' does the trick here). [11] Other times, the context alone can make a judgment clear, such as when you begin by describing a particularly powerful scene. I've done both in the lead for *Red*—as a way of making the impact that much more emphatic."

Paragraph C, lines 5–12

> The activity in which the superbly matched Edward Gero and Patrick Andrews engage, in point of fact, is priming a canvas half again as tall as the two of them. The priming

becomes primal. As the classical music on a phonograph swells, the painters spring into action, splashing on the liquid in great, rhapsodic strokes. The exercise takes on both a spiritual intensity and an almost sexual energy—a characteristic spotlighted when, in the aftermath of the explosive exertion, the panting Gero lights up a cigarette.

The critic has not yet offered a descriptive overview of the play's storyline. Instead, he is still referencing and building the most memorable visual impression of the play as established in the lead. Details and description are keys to the success of this second paragraph, as each word is carefully chosen for its impact, which allows the reader to visualize the significant action on stage. The classical music on a phonograph *"swells,"* the painters *"spring"* into action, *"splashing"* on the paint in great, *"rhapsodic strokes"* (lines 8–9). We see how the use of music, and the manner in which the stage is lit, contribute to the atmosphere as the two characters—the still unnamed Rothko and his assistant Ken—continue with the central activity introduced in the lead: They prime the huge canvas with red paint to the rhythm of the music. What is being done by the playwright and the actors to establish what drives this play is, at this point, more important than the specifics of the story in the eyes of this critic. Note the critic's clever wordplay in this regard: *"The priming becomes primal"* (line 7), which calls attention to itself. The paragraph ends on a high note as the two characters complete their task, which leaves the reader with an image that relates both the intensity and the emotion of the moment.

ACCORDING TO THE CRITIC: "You have to have a sixth sense for what the reader needs. I link everything to images. In this case, the activity of the painting helped me characterize the entire production. In these first few moments I am looking for physical impressions, and looking for physical comparisons between the real Rothko and the actor playing Rothko. [Edward Gero] struck me as an artist in late middle age. They had trimmed his hair so he looked like the balding Rothko. And he wore clear glass frames. To me, this man looked like Rothko. I made notes on the set. I saw a realistic rendering of an artist's studio, which looked like the place it was supposed to be and left little to the imagination. To the left was a little entryway. There was a sink on the right, a couple of tables were covered with paints and fluids. One of Rothko's works-in-progress stood in the center. The music in the scene comes from a phonograph on stage, playing mostly classical music. When the assistant gets to choose the music, he chooses jazz.

I don't always mention the actors right off the bat, as I do in the *Red* review. But *Red* is a two-character piece, based on the life of a historical figure—abstract expressionist painter Mark Rothko—so in this instance it felt imperative to define the theatrical landscape immediately by identifying the figures who inhabit it. It's rarely a bad idea, by the way, to mention a performance or two prominently, because it's on the human scale that we respond most potently to drama, and knowing how

good or not the portrayals are can quickly make a production meaningful to someone who hasn't seen it."

Paragraph D, lines 13–19

> The pleasure of the interlude, as constructed by playwright John Logan and conducted by director Robert Falls, is in the way it conveys the full, symbiotic immersion of the characters: Gero's Mark Rothko, the vain, abrasive creator of all those mesmerizing canvases of migrating mood and undulating color, and Andrews's Ken, a composite of the assistants who toiled in Rothko's Manhattan studio throughout his working life, which ended in suicide in 1970.

The critic continues to introduce information crucial to putting the action of the play into context above the storyline. This is the nut graph. It is important to remember that writing theater criticism is not formulaic. The review must contain all the necessary information for the reader who was in the audience and those readers who might be in the future, but its sequence and emphasis is variable. Nut graphs can, and should, be more than facts. They also offer the critic an opportunity to add descriptive overview. The more experienced critic, one who has a strong critical voice and style, might weave the contextual information through more than one paragraph...as is done here. But the purpose is clear: answer the basic journalistic questions of who, what, when, where, and why. In this nut graph, we learn: Who? Mark Rothko, the expressionist artist (line 15). What? Rothko's relationships with his assistants which, in this play by John Logan and directed by Robert Falls, is a representative composite of them (line 17–18). When? Until his death in 1970 (line 19). Where? A Manhattan studio (line 18). Why? To show how the vain, abrasive Rothko created his art (lines 16–17).

ACCORDING TO THE CRITIC: "This paragraph and the next two paragraphs give facts about the production, name the director and playwright, and begin to more fully describe the two characters, Rothko and Ken, and their relationship."

Paragraphs E–F, lines 20–37

> The sequence eloquently reminds us of a joy we rarely get to see: the artist consumed by the everyday physical demands of his work, an act by which the intellectual and emotional weight of his other concerns—his reputation, his hubris, his self-doubt—is for the moment banished. It looks like so much fun, such a terrific workout, that we all want to get up on the stage of the Kreeger Theater and splatter primer onto the canvas with them. It helps, too, that set designer Todd Rosenthal has conceived of Rothko's work space as such a vigorously messy environment for genius, and the lighting by Keith Parham puts so luminous an accent on the radiant dimensions of the painter's works-in-progress.

The convulsive frenzy in which the actors complete the priming is a reflection of other powerful forces at work in *Red*, Logan's portrait of Rothko in the late 1950s, when the painter was in the midst of one of his most important commissions, a series of murals for the new Four Seasons restaurant occupying the bottom floors of a landmark of 20th-century architecture, Mies van der Rohe and Philip Johnson's Seagram Building.

The nut graph continues. The writing is active, descriptive. The critic adds context to the review by imparting additional facts about the production, naming the director and playwright. We learn where the play is being staged, and that the lighting and set designers have created a realistic view of the painter's messy work space. Description is fundamental in this paragraph. The critic successfully makes a connection between the reader and Rothko, and invites the reader into what the critic feels is the key action of the play, the priming of the canvas: "*It looks like so much fun, such a terrific workout, that we all want to get up on the stage of the Kreeger Theater and splatter primer onto the canvas with them*" (lines 24–26). He has worked opinion into his description. It is also here (lines 31–37) that the critic transforms an observation into something more…into the "so," as in "So, what is particularly intriguing about this play, this production, and these performers?" He places the action of the play into an anthropological context, as a reflection of an artist in the 1950s.

ACCORDING TO THE CRITIC: "What is special about this moment? It's that John Logan shows us how enjoyable it is to paint. In my writing, I justify the exuberance I'm feeling being in Logan's world. I'm letting the reader know this play has weight and meaning. The lighting is distinctive; it's luminous and the set is kept fairly dark except for the light on the painting from behind and above, which nests the painting on the stage. At this point [in the theater], I'm trying to multitask: observe physical details, hear the quality of the language and quickly process the story. Is it entertaining me? I'm gauging the importance of what is being said and left unsaid."

Paragraphs G, lines 38–45

How authentically Logan has framed the issues of *Red* is a matter better left to the art world's keep arbiters. What can be easily deduced from Falls's production—an excellent successor to the Tony-winning version directed by Michael Grandage and starring Alfred Molina and Eddie Redmayne—is that Rothko has been translated for the stage into a marvelous character. Tyrannical, bombastic, narcissistic, he has a bedside manner you wouldn't wish on the most cravenly ambitious intern.

We're at the midpoint of the review, which has been largely descriptive thus far. This paragraph flows seamlessly from the previous paragraph, as have the previous paragraphs. From description, we move into opinion and evaluation, sometimes all three combined into one sentence, such as: "*Tyrannical, bombastic, narcissistic, he*

has a bedside manner you wouldn't wish on the most cravenly ambitious intern" (lines 43–45). Also, it is here (line 40) that the critic begins addressing the "How," as in "How is this play, this production and these performances able to accomplish what it did? It begins by noting that this production is *an excellent successor*" to the Tony Award-winning Broadway production of the play (lines 40–43).

ACCORDING TO THE CRITIC: "Logan has created marvelous characters, and I want to let the reader know how great these characters work on stage. I give enough of the plot, but do not overwrite. I want to show the reader a general sense of who Rothko is from the playwright's point of view."

Paragraphs H, lines 46–56

> And yet, beyond the vision and the artistry, this Rothko redeems himself in a profound yearning to be tested, to discover whether he truly merits a place in the pantheon. Over the course of the play, performed without intermission, Rothko acknowledges anxiety over the pop-art movement that is supplanting abstract expressionism. Ken, for his part, pricks Rothko's conscience, telling him the Four Seasons commission subverts his long-held values. In the final throes of the drama, after finally letting Rothko have it—decrying his paranoia, self-absorption and lack of generosity—the younger man says he expects now to be fired. 'Fired?' the painter replies. 'This is the first time you've existed.'

The "How" contained in this paragraph focuses on the power of the storytelling. This paragraph alludes to the play's critical moment, but it does not spoil the drama for those readers who have not seen the play. It does, however, visually reinforce for those readers who have seen the play the "aha" moment—when everything that has happened in the first hour of this 90-minute drama comes together.

ACCORDING TO THE CRITIC: "At this point in the critique I am looking for turning points in the drama. I'm thinking about movement, gestures, something that is distinctive about the character in that particular moment. I'm thinking more about how the characters interact. Using dialogue helps with transitions in my writing. Here's what I wrote down [in my notes]: 'a bit pompous, listening to Rothko go on and on about his place in history.' Looking at my notes takes me back into the play."

Paragraphs I-J, lines 57–77

> Gero, in owlish glasses and unsmiling demeanor, is the resonant embodiment of an uncompromising artist with an overdeveloped sense of grievance. He's the advocate here for a rigorous, cerebral rationale for art and though it reeks of self-importance, it's also to be admired. 'A generation that does not aspire to seriousness, to meaning, is unworthy to walk in the shadow of those who have gone before,' Rothko instructs Ken. Out of Gero's mouth, the words have an almost threatening edge—there's desperation in this artist's

pronouncements, a poignant need to shout over what he perceives as the noise of a community that's beginning to turn away from him.

Ken is, in a sense, that community: He's the voice of that emerging generation, one that sees the consumer culture as a suitable subject for art and won't yield to Rothko's definition of seriousness no matter how many tantrums he throws. Compact and muscular, with a gaze as stony as Gero's, Andrews proves to be an ideal choice for Ken, who slowly uncovers his own reservoir of rage and strength. The actor skillfully negotiates the play's thorniest narrative embellishment, the story of Ken's traumatic childhood. In a lesser production, this confessional element might have pushed *Red* into mushier swampland. But the steel in Andrews's affect keeps the sentimentality at bay.

This review has described and evaluated the overall production. Now the "how" focuses on the quality of performances in this two-character play. The critic emphasizes how Edward Gero succeeded in embodying Rothko in looks (*"Gero, in owlish glasses and unsmiling demeanor"* [line 57]) and includes specific dialogue, which is then described and tied to Gero's actions. In the next paragraph, the critic evaluates Patrick Andrews' performance as Ken, Rothko's assistant: *"Compact and muscular, with a gaze as stony as Gero's, Andrews proves to be an ideal choice for Ken..."* (lines 71–72).

ACCORDING TO THE CRITIC: "Most of my reviews are structured this way, where I elaborate on the quality of performance. Both actors were strong and their performances so harmoniously performed. I'm not just getting to the end of the play, but am aware of my word count. I've sensed that I've explored the areas of the play that needed exploration, but sure, this piece could be twice as long as it is. There's much more detail I could have put in. But we're daily critics and we give readers just a taste, and pack in as much as you can."

Paragraphs K, lines 78–82

Both the painter and his assistant know from pain; it's as certain an ingredient in their work as the pigments they mix into the buckets. Maybe that helps explain why Rothko and his young employee find in the act of priming a canvas a cathartic common pursuit. They don't simply aim to prime that canvas. They want to unleash the Furies on it.

The last paragraph, the kicker, expands upon images introduced in the lead to bring the reader full circle. In four sharply written sentences, the critic focuses on the main action that impressed him so and allows it to create an image (line 82) both powerful and attractive: *"They want to unleash the Furies on it."* While this is not a very explicit or clear "so what"—as in "So What? What are we to take away from this play and this production of it"—it is nonetheless quite effective and definitive. Also, note the reference to the muses—the *"Furies."*

ACCORDING TO THE CRITIC: "I loved that moment, and it spoke to me on so many different levels. You want to urge people to go and see the play, without saying, go see this. You'll enjoy it. You want to find other ways to be persuasive and to spark their imagination."

Paragraphs K, lines 83–85

> by John Logan. Directed by Robert Falls. Set, Todd Rosenthal; costumes, Birgit Rattenborg Wise; lighting, Keith Parham; original composition and sound, Richard Woodbury. About 1 hour, 40 minutes.

This is an obligatory naming of names, should these artists not have been identified in the body of the review. It also includes some public service information, such as the duration of the play, which is typically offered in reviews.

A Point of Comparison

Before undertaking your own writing, here is an opportunity to test your mastery of all the information presented in this and previous chapters and demonstrate your ability to recognize these components in an additional review of *Red*. This one, written by one of the book's authors and published in *The News-Herald*—a mid-sized daily newspaper in Cleveland, Ohio—reviews an equity production performed by the Cleveland Play House not long after the Arena Stage production of *Red*.[12] After reading this review, you should be able to answer the following questions:

1. How would you describe the critical voice of each critic? Put in your own words each writer's style and approach to the play and its production. How would yours differ?
2. Regarding this review's lead in paragraph B, do you find it alluring? Attention-getting? Thematically focused? Does its theme effectively run throughout the body of the review?
3. The critic chose to research and present in paragraphs G and H information about another production by the theater company performing *Red*. In paragraph I, he identifies yet another production. What do you suppose was accomplished in doing this?
4. The critic employed direct quotes from the play in paragraphs B and D. Why do you suppose this strategy was employed? Is this an example of "too much Madden" or was this, in your opinion, effective?
5. What form of criticism is reflected in paragraphs G, H and I? In other words, in what critical context does the author place *Red*?

6. The description needs to be general enough not to take away the fun of discovery for those who will be seeing the work after reading the review, but detailed enough to accurately capture the essence of the work and the playwright's vision. Does that balance exist in this review? Explain.

7. Is the "kicker," found in paragraph R, adequate? Does it sufficiently reflect a conclusion and implicitly or explicitly transform criticism to action?

8. Was this a "good read"? That is, did the paragraphs flow one to the next? Are there run-on sentences? Did you find the review interesting? Explain.

9. Does the review adequately address the "what" (description), "so" (opinion), "how" (explanation and analysis), and "so what" (conclusion)? If not, identify inadequacies.

10. Is opinion backed up with explanation to prove a point? Is explanation backed up with example and description?

The Review

Now that you have applied your knowledge about writing criticism to actual pieces of criticism, let's explore how two critics can approach the same play with very different critical voices, organization, and focus. This serves to reinforce the notion that arts journalism is a creative enterprise that not only allows but encourages such diversity of expression and opinion.

Review: CPH's 'Red' offers a vivid rendering about abstract art[13]

A

by Bob Abelman, *News-Herald*

1 "Wait," says Mark Rothko, the eminent abstract expressionist
2 painter, to his young assistant. "Stand closer. You've got to get close.
3 Let it pulsate. Let it work on you. Closer. Too close."

B

4 Staring into the audience as if one of his emotionally raw black-
5 on-red painted canvases was hanging overhead, Rothko continues:

C

6 "There. Let it spread out. Let it wrap its arms around you; let it
7 embrace you, filling even your peripheral vision so nothing else exists
8 or has ever existed or will ever exist. Let the picture do its work—But
9 work with it. Meet it halfway for God's sake! Lean forward, lean into
10 it. Engage with it! Now, what do you see?"

D

11 So begins the 2010 Tony Award-winning, two-person, one-act
12 play *Red* by John Logan, currently in production at the Cleveland
13 Play House.

E

14 The play is an intriguing profile of an important American artist
15 from the 1950s. It is also a beautifully written treatise on the pain-
16 ful, personal psychodrama that is the creation of art. It could even be
17 argued that the play, more than anything, is an entertaining tutorial
18 on the art of art appreciation.

F

19 In some ways, *Red* is not unlike *My Name Is Asher Lev*, a marvelous
20 play by Aaron Posner that was staged by the Cleveland Play House
21 exactly one year ago.

G

22 Both plays offer an intimate, insider's perspective on a cloistered
23 world non-artists know little about. Both provide insight into how the
24 isolated artist is still impacted by life, with the fictitious Asher Lev's
25 heritage blockading his artistic aspirations and Rothko's tragic child-
26 hood experiences in the Jewish ghetto of tsarist Russia informing his.

H

27 *Red* is not unlike Stephen Sondheim's musical *Sunday in the Park*
28 *with George*, which dissects the creative process, bit by bit, of impres-
29 sionist painter Georges Seurat. In fact, *Red* uses dialogue to create dis-
30 tinctive and often disquieting rhythms and vivid, memorable imagery
31 the way Sondheim, who this play is dedicated to, uses lyrics and music.

I

32 Of course *Red* offers its own story, which is about the passionate
33 relationship between one man—a gruff, cerebral, unconditionally
34 egotistical man—and his art. And, as this play clearly documents
35 and more than amply exhibits during its 90 minutes of uninterrupted J
36 dialogue, this man was a wordy fellow for a visual artist. And damn
37 definitive for an abstract expressionist.

38 This Cleveland Play House co-production with New Jersey's
39 George Street Playhouse, under Anders Cato's intuitive and deli- K
40 cate direction, tells this story beautifully.

41 Bob Ari, as Rothko, is a force to be reckoned with. L

42 He is immediately inaccessible and thoroughly unlikable, but all
43 the while intriguing and intense. Just as wet paint changes its hue
44 and luminosity over time and in a different light, so too does Ari's
45 Rothko. He becomes increasingly comprehendible—which is a prod- M
46 uct of the writing—and less enigmatic—which is largely achieved
47 through Ari's craftsmanship. The moments when he stands before
48 a painting—listening, vulnerable, waiting for it to speak to him and
49 guide his next brush stroke—are mesmerizing.

50 Randy Harrison plays Rothko's assistant during the two years of
51 the artist's commissioned work on a series of mural panels. N

52 Harrison's Ken is interesting even in silence, absorbing Rothko's
53 wrath and deeply camouflaged tutelage. He is wonderful when on
54 the offensive, engaged in fierce discussions over aesthetics or serv-
55 ing as the voice of a new generation of artists. Ken's tragic back story O
56 is a forced contrivance (Ken is the playwright's creation, meant to
57 give Rothko someone to talk to besides paintings and to counterbal-
58 ance his world view), but Harrison handles it with great tenderness.

59 A pivotal moment in the play is when Rothko and Ken argue
60 about color, resulting in both men spewing words that represent
61 different shades of red. The scene could be played as a volatile com-
62 petition; a wordplay with jagged edges. Instead, the two become P
63 engaged in a creative, collaborative exploration, which steers their
64 relationship on a different trajectory. This choice by seasoned per-
65 formers Ari and Harrison, and director Cato, plays beautifully.

66 Lee Savage's set is a fully functioning studio. It is more airy and
67 bare-boned than the claustrophobic set designed for the original
68 Broadway production, and Dan Kotlowitz's lighting is not nearly as
69 dramatic. Initially disappointing, the payoff from the CPH's stag-
70 ing comes when the open set and a flood of backlighting create a Q
71 breathtaking red and black silhouetted still life portrait of the artist
72 pondering his artwork. This captures in image what is not expressed
73 in the play's many words, much like Rothko's own works of art.
74 *Red* is a thoughtful, thought-provoking play and the CPH has R
75 created a worthy rendition of it.
76 *Red* continues through April 8 in Cleveland Play House's Allen
77 Theatre at PlayhouseSquare. For tickets, which range from $49 to S
78 $69, call 216-241-6000 or visit www.clevelandplayhouse.com.

After reading both reviews, you should have been able to note the follow-
ing differences in these two essays:

- Both critics introduce a pivotal dramatic moment in the play that they believe provides the reader with a clear, visual image of the play as a whole. This moment is introduced in the lead and serves to tie all the elements in the review together. Interestingly, they chose different moments. Marks keys in on the priming of the canvas and how this captures the pure emotion of the production. In his own words, "It's a play that relies strongly on visual impact, and I wanted to create the same sort of impact for a reader." Abelman's attention is drawn to an argument over the meaning of color and the underlying intelligence that drives this play and guides performance choices. Nonetheless, both moments give the review focus and its "hook";
- While the decision to choose different moments may be a reflection of each critic's point of view and critical orientation, it may very well be the result of the productions they witnessed and the different dramatic emphasis each projected. The Arena Stage and the Cleveland Play House presented the same play, but they employed different directors, designers, and actors. Recall earlier in the book the discussion of theater being an ephemeral art; that is, a performance of a production is happening live, in the moment. One performance, to some degree, can be different than the next. So, too,

can two productions. Reviews address the unchanging play, but also the variable production of that play and its performances;

- Marks begins his review by concentrating on the performance of the play, mentioning the actors by name before mentioning the names of their characters; Abelman concentrates on the play itself, quoting the fictitious people who populate it. Both serve to give their reviews a different critical orientation, yet both avail themselves to an exploration of the play, the production and the performances;

- Marks' review is largely descriptive at the start and then opinion and critical analysis follows. Abelman chooses to keep description, opinion, and critical analysis more closely aligned. Both approaches manage to offer opinion that is backed up with explanation that is supported by description. Both provide the reader with a clear and vivid impression of what transpired on the stage. Yet, both read differently because of their approach;

- Both authors capture the artistry associated with this production—that is, the play and production's rhythms—but do this in different ways. For Marks: "As the classical music on a phonograph swells, the painters spring into action, splashing on the liquid in great, rhapsodic strokes." For Abelman: "*Red* uses dialogue to create distinctive and often disquieting rhythms and vivid, memorable imagery the way Sondheim, who this play is dedicated to, uses lyrics and music"; and

- The authors' critical voices are, in part, expressed through the length of their paragraphs. Marks employs lengthy paragraphs rich with detail and description. He is eager to have the reader experience what he experienced in the audience during the production before offering explanation and critical analysis. Abelman uses comparatively shorter paragraphs that are more definitive statements about the play's intelligence. He wishes to get right to the explanation and critical analysis.

Summary

The information provided in the previous chapter—Writing a Critique—identified the key steps in critically observing a production as well as the major components in an effective piece of arts criticism. These components, in turn, have been applied in this chapter, through the deconstruction of Peter Marks' *Post* review of the drama *Red*, as performed at the Arena Stage, and courtesy of his commentary on his writing process.

While this positive review no doubt contributed to the extended run of the Arena Stage production, it hopefully served a greater and grander function: the

incitation and instigation of discussion, thereby placing the arts center-most in public discourse and, perhaps, inspiring critical thinking about the arts. As was noted in the very first chapter of this book, when we become critical thinkers about the arts—more specifically, when we apply critical thinking to the theater arts—we:

- recognize the performing arts as a valuable enterprise and one worthy of our attention, support, and patronage;
- make independent and purposeful choices with regard to the selection of theatrical productions to attend;
- develop the skills that allow us to make sense of and interpret the information we receive through theatrical experiences;
- generate an awareness of the potential impact of theater and other art forms on the individual, society, and culture;
- cultivate an enhanced enjoyment, understanding, and appreciation of the theater arts, allowing us to recognize the spark that makes a play combust rather than merely consume time and energy;
- think outside the box regarding the activities that typically take place within the proscenium arch. This affords us the insight and perspective required to recognize theater in places beyond the proscenium arch—the boardroom, the picket line and the political arena, for example—and consider its ramifications; and
- have the potential to be published or posted critics ourselves.

Not everyone's a critic, but everyone can be. The muses' work is never done. Neither is the referees of the muses.

. .

NOTES

1 David Cote, "Critical Juncture," *American Theatre*, November 2011, http://www.tcg.org/publications/at/nov11/critical_juncture.cfm (accessed March 31, 2012).

2 The top five papers in 2011 were *The Wall Street Journal* with an average daily circulation of 2,117,796, *USA Today* with 1,829,099; *The New York Times* with 916,911; *The Los Angeles Times* with 605,243; and *The San Jose Mercury News* with 577,665. *The Washington Post* was No. 6, with 550,821. *The New York Times* topped the list of Sunday newspapers, with a total average circulation of 1,339,462. *The Times* was followed by *The Los Angeles Times*, 948,889; *The Washington Post*, 852,861; *The Chicago Tribune*, 780,601; and *The San Jose Mercury News*, 636,999. *The Wall Street Journal* does not publish a Sunday edition. Cited in http://mediadecoder. blogs.nytimes. com/2011/05/03/wall-street-journal-still-first-in-daily-circulation/ (accessed May 3, 2011).

3 Noted in the Clifford K. Berryman Cartoon Collection, Special Collections Research Center, Estelle and Melvin Gelman Library, The George Washington University.

4 Retrieved from http://www.arenastage.org/shows-tickets/the-season/productions/red/ (accessed March 31, 2012).

5 Retrieved from http://tickets.arenastage.org/single/psDetail.aspx?psn=13137 (accessed March 31, 2012).

6 Ibid.

7 Cited in Herschel Browning Chipp and Peter Howard Selz, *Theories of Modern Art: A Source Book by Artists and Critics* (Berkeley, CA: University of California Press, 1984), 548.

8 Retrieved from http://www.arenastage.org/about/ (accessed March 31, 2012).

9 It has become increasingly typical for professional theater troupes to partner with other professional theater troupes to share the cost and creation of production. The show runs at one theater and then the cast, crew and set moves to the other . Another form of partnership that has come into fashion is between a professional theater and a university or conservatory.

10 Peter Marks, "The Hues Blend Evocatively in Arena Stage's 'Red,' *Washington Post*, January 20, 2012, http://www.washingtonpost.com/gog/performing-arts/red,1212400/critic-review.html#reviewNum1 (accessed January 20, 2012).

11 "Immensely enjoyable" is what the theater pulled from the critique to promote the production.

12 Founded in 1915, Cleveland Play House is America's first regional theatre. More than 12 million people have attended over 1,300 productions at Cleveland Play House including more than 130 American and/or world premieres. The theater operates under the leadership of Artistic Director Michael Bloom and Managing Director Kevin Moore. The Cleveland Play House run of *Red* at the Allen Theatre was from March 16 to April 8, 2012, with ticket prices ranging from $49 to $69.

13 Bob Abelman, "CPH's 'Red' Offers a Vivid Rendering About Abstract Art." *The News-Herald*, March 23, 2012, http://www.news-herald.com/articles/2012/03/23/life/doc4f-6cb52861c65784310313.txt (accessed March 23, 2012).

Index